Dr Betty Edwards is professor emeritus of art
at California State University in Long Beach.
She received her doctorate from UCLA in art,
education, and the psychology of perception.
Dr Edwards has been profiled by the *Los Angeles
Times* and the *Seattle Times*, *Reader's Digest*, *Time*,
New York, *Intuition* magazine and the *Today* show.
She speaks regularly at universities, art schools
and companies including AT&T, the Walt Disney
Corporation and the Apple Corporation.
Edwards lives in Santa Monica, California.

Also by the author:

Drawing on the Artist Within

The New Drawing on the Right Side of the Brain

Betty Edwards

HarperCollins*Publishers*

HarperCollins*Publishers*
77–85 Fulham Palace Road,
Hammersmith, London W6 8JB

www.harpercollins.co.uk

This paperback edition 2008
11

Published in the USA by Jeremy P. Tarcher/Putnam
a member of Penguin Putnam Inc.

Cover drawing: Betty Edwards
Instructional drawings: Betty Edwards and Brian Bomeisler
Design: Joe Molloy

ISBN 978 0 00 711645 4

Printed and bound in China by
Leo Paper Products Limited

To the memory of my father,

who sharpened my drawing pencils

with his pocketknife

when I was a child

Contents

Preface X

Introduction XVII

1. Drawing and the Art of Bicycle Riding I

2. The Drawing Exercises: One Step at a Time II

3. Your Brain: The Right and Left of It 27

4. Crossing Over: Experiencing the Shift from Left to Right 49

5. Drawing on Memories: Your History as an Artist 67

6. Getting Around Your Symbol System: Meeting Edges and Contours 87

7. Perceiving the Shape of a Space: The Positive Aspects of Negative Space 115

8. Relationships in a New Mode: Putting Sighting in Perspective 137

9. Facing Forward: Portrait Drawing with Ease 161

10. The Value of Logical Lights and Shadows 193

11. Drawing on the Beauty of Color 229

12. The Zen of Drawing: Drawing Out the Artist Within 247

Afterword: Is Beautiful Handwriting a Lost Art? 253

Postscript 267

Glossary 275

Bibliography 279

Index 283

Acknowledgments

First, I wish to welcome my new readers and to thank all those who have read this book in the past. It is you who make this twentieth-year edition possible by your loyal support. Over the past two decades, I have received many letters expressing appreciation and even affection. This shows, I think, that in this electronic age, books can still bring authors and readers together as friends. I treasure this thought, because I love books myself and count as friends authors I have never met except through their books.

Many people have contributed to this work. In the following brief acknowledgment, I wish to thank at least a few.

Professor Roger W. Sperry, for his generosity and kindness in discussing the original text with me.

Dr. J. William Bergquist, whose untimely death in 1987 saddened his family, friends, and colleagues. Dr. Bergquist gave me unfailingly good advice and generous assistance with the first edition of the book and with the research that preceded it.

My publisher, Jeremy Tarcher, for his enthusiastic support of the first, second, and now the third edition of the book.

My son, Brian Bomeisler, who has so generously put his skills, energy, and experience as a artist into revising, refining, and adding to these lessons in drawing. His insights have truly moved the work forward over the past ten years.

My daughter, Anne Bomeisler Farrell, who has been my best editor due to her understanding of my work and her superb language skills.

My closest colleague, Rachael Bower Thiele, who keeps everything on track and in order, and without whose dedicated help I'd have had to retire years ago.

My esteemed designer, Joe Molloy, who makes superb design seem effortless.

My friend Professor Don Dame, for generously lending me both his library of books on color and his time, thoughts, and expertise on color.

My editor at Tarcher/Putnam, Wendy Hubbert.

My team of teachers, Brian Bomeisler, Marka Hitt-Burns, Arlene Cartozian, Dana Crowe, Lizbeth Firmin, Lynda Greenberg, Elyse Klaidman, Suzanne Merritt, Kristin Newton, Linda Jo Russell, and Rachael Theile, who have worked with me at various sites around the nation, for their unfaltering devotion to our efforts. These fine instructors have added greatly to the scope of the work by reaching out to new groups.

I am grateful to The Bingham Trust and to the Austin Foundation for their staunch support of my work.

And finally, my warmest thanks to the hundreds of students—actually, thousands by now—I have been privileged to know over the years, for making my work so rewarding, both personally and professionally. I hope you go on drawing forever.

Preface

Twenty years have passed since the first publication of *Drawing on the Right Side of the Brain* in July 1979. Ten years ago, in 1989, I revised the book and published a second edition, bringing it up to date with what I had learned during that decade. Now, in 1999, I am revising the book one more time. This latest revision represents a culmination of my lifelong engrossment in drawing as a quintessentially human activity.

How I came to write this book

Over the years, many people have asked me how I came to write this book. As often happens, it was the result of numerous chance events and seemingly random choices. First, my training and background were in fine arts—drawing and painting, not in art education. This point is important, I think, because I came to teaching with a different set of expectations.

After a modest try at living the artist's life, I began giving private lessons in painting and drawing in my studio to help pay the bills. Then, needing a steadier source of income, I returned to UCLA to earn a teaching credential. On completion, I began teaching at Venice High School in Los Angeles. It was a marvelous job. We had a small art department of five teachers and lively, bright, challenging, and difficult students. Art was their favorite subject, it seemed, and our students often swept up many awards in the then-popular citywide art contests.

At Venice High, we tried to reach students in their first year, quickly teach them to draw well, and then train them up, almost like athletes, for the art competitions during their junior and senior years. (I now have serious reservations about student con-

tests, but at the time they provided great motivation and, perhaps because there were so many winners, apparently caused little harm.)

Those five years at Venice High started my puzzlement about drawing. As the newest teacher of the group, I was assigned the job of bringing the students up to speed in drawing. Unlike many art educators who believe that ability to draw well is dependent on inborn talent, I expected that all of the students would learn to draw. I was astonished by how difficult they found drawing, no matter how hard I tried to teach them and they tried to learn.

I would often ask myself, "Why is it that these students, who I know are learning other skills, have so much trouble learning to draw something that is right in front of their eyes?" I would some-times quiz them, asking a student who was having difficulty draw-ing a still-life setup, "Can you see in the still-life here on the table that the orange is in front of the vase?" "Yes," replied the student, "I see that." "Well," I said, "in your drawing, you have the orange and the vase occupying the same space." The student answered, "Yes, I know. I didn't know how to draw that." "Well," I would say carefully, "you look at the still-life and you draw it as you see it." "I was looking at it," the student replied. "I just didn't know how to draw that." "Well," I would say, voice rising, "you just *look* at it..." The response would come, "I *am* looking at it," and so on.

Another puzzlement was that students often seemed to "get" how to draw suddenly rather than acquiring skills gradually. Again, I questioned them: "How come you can draw this week when you couldn't draw last week?" Often the reply would be, "I don't know. I'm just seeing things differently." "In what way differ-ently?" I would ask. "I can't say—just differently." I would pursue the point, urging students to put it into words, without success. Usually students ended by saying, "I just can't describe it."

In frustration, I began to observe myself: What was I doing when I was drawing? Some things quickly showed up—that I couldn't talk and draw at the same time, for example, and that I lost track of time while drawing. My puzzlement continued.

One day, on impulse, I asked the students to copy a Picasso drawing upside down. That small experiment, more than anything else I had tried, showed that something very different is going on during the act of drawing. To my surprise, and to the students' surprise, the finished drawings were so extremely well done that I asked the class, "How come you can draw upside down when you can't draw right-side up?" The students responded, "Upside down, we didn't know what we were drawing." This was the greatest puzzlement of all and left me simply baffled.

During the following year, 1968, first reports of psychobiologist Roger W. Sperry's research on human brain-hemisphere functions, for which he later received a Nobel Prize, appeared in the press. Reading Sperry's work caused in me something of an Ah-ha! experience. His stunning finding, that the human brain uses two fundamentally different modes of thinking, one verbal, analytic, and sequential and one visual, perceptual, and simultaneous, seemed to cast light on my questions about drawing. The idea that one is shifting to a different-from-usual way of thinking/seeing fitted my own experience of drawing and illuminated my observation of my students.

Avidly, I read everything I could find about Sperry's work and did my best to explain to my students its possible relationship to drawing. They too became interested in the problems of drawing and soon they were achieving great advances in their drawing skills.

I was working on my master's degree in Art at the time and realized that if I wanted to seriously search for an educational application of Sperry's work in the field of drawing, I would need further study. Even though by that time I was teaching full time at Los Angeles Trade Technical College, I decided to return yet again to UCLA for a doctoral degree. For the following three years, I attended evening classes that combined the fields of art, psychology, and education. The subject of my doctoral dissertation was "Perceptual Skills in Drawing," using upside-down drawing as an experimental variable. After receiving my doctoral degree in 1976, I began teaching drawing in the art department of

California State University, Long Beach. I needed a drawing text-book that included Sperry's research. During the next three years I wrote *Drawing on the Right Side of the Brain*.

Since the book was first published in 1979, the ideas I expressed about learning to draw have become surprisingly widespread, much to my amazement and delight. I feel honored by the many foreign language translations of *Drawing on the Right Side of the Brain*. Even more surprising, individuals and groups working in fields not remotely connected with drawing have found ways to use the ideas in my book. A few examples will indicate the diversity: nursing schools, drama workshops, corporate training seminars, sports-coaching schools, real-estate marketing associations, psychologists, counselors of delinquent youths, writers, hair stylists, even a school for training private investigators. College and university art teachers across the nation also have incorporated many of the techniques into their teaching repertoires.

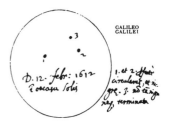

GALILEO GALILEI

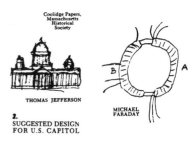

Coolidge Papers, Massachusetts Historical Society

THOMAS JEFFERSON

MICHAEL FARADAY

2.
SUGGESTED DESIGN FOR U.S. CAPITOL

Public-school teachers are also using my book. After twenty-five years of budget cuts in schools' arts programs, I am happy to report that state departments of education and public school boards of education are starting to turn to the arts as one way to help repair our failing educational systems. Educational administrators, however, tend to be ambivalent about the purpose of including the arts, often still relegating arts education to "enrichment." This term's hidden meaning is "valuable but not essential." My view, in contrast, is that the arts are essential for training specific, visual, perceptual ways of thinking, just as the "3 R's" are essential for training specific, verbal, numerical, analytical ways of thinking. I believe that both thinking modes—one to comprehend the details and the other to "see" the whole picture, for example, are vital for critical-thinking skills, extrapolation of meaning, and problem solving.

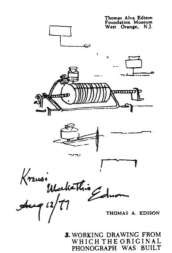

Thomas Alva Edison Foundation Museum West Orange, N.J.

THOMAS A. EDISON

3. WORKING DRAWING FROM WHICH THE ORIGINAL PHONOGRAPH WAS BUILT

In the history of inventions, many creative ideas began with small sketches. The examples above are by Galileo, Jefferson, Faraday, and Edison.

Henning Nelms, *Thinking With a Pencil*, New York: Ten Speed Press, 1981, p. xiv.

To help public-school administrators see the utility of arts education, I believe we must find new ways to teach students how to transfer skills learned through the arts to academic subjects and problem solving. Transfer of learning is traditionally regarded as a most difficult kind of instruction and, unfortunately, transfer is often left to chance. Teachers hope that students will

"get" the connection, say, between learning to draw and "seeing" solutions to problems, or between learning English grammar and logical, sequential thinking.

Corporate training seminars

My work with various corporations represents, I believe, one aspect of transfer of learning, in this instance, from drawing skills to a specific kind of problem solving sought by corporate executives. Depending on how much corporate time is available, a typical seminar takes three days: a day and a half focused on developing drawing skills and the remaining time devoted to using drawing for problem solving.

Groups vary in size but most often number about twenty-five. Problems can be very specific ("What is _____?"— a specific chemical problem that had troubled a particular company for several years) or very general ("What is our relationship with our customers?") or something in between specific and general ("How can members of our special unit work together more productively?").

The first day and a half of drawing exercises includes the lessons in this book through the drawing of the hand. The two-fold objective of the drawing lessons is to present the five perceptual strategies emphasized in the book and to demonstrate each participant's potential artistic capabilities, given effective instruction.

The problem-solving segment begins with exercises in using drawing to think with. These exercises, called analog drawings, are described in my book *Drawing on the Artist Within*. Participants use the so-called "language of line," first to draw out the problem and then to make visible possible solutions. These expressive drawings become the vehicle for group discussion and analysis, guided, but not led, by me. Participants use the concepts of edges (boundaries), negative spaces (often called "white spaces" in business parlance), relationships (parts of the problem viewed proportionally and "in perspective"), lights and shadows (extrapolation from the known to the as-yet unknown), and the gestalt

"Analog" drawings are purely expressive drawings, with no namable objects depicted, using only the expressive quality of line—or lines. Unexpectedly, persons untrained in art are able to use this language—that is, produce expressive drawings—and are also able to read the drawings for meaning. The drawing lessons of the seminar's first segment are used mainly to increase artistic self-confidence and confidence in the efficacy of analog drawing.

of the problem (how the parts fit—or don't fit—together).

The problem-solving segment concludes with an extended small drawing of an object, different for each participant, which has been chosen as somehow related to the problem at hand. This drawing, combining perceptual skills with problem solving, evokes an extended shift to an alternate mode of thinking which I have termed "R-mode," during which the participant focuses on the problem under discussion while also concentrating on the drawing. The group then explores insights derived from this process.

The results of the seminars have been sometimes startling, sometimes almost amusing in terms of the obviousness of engendered solutions. An example of a startling result was a surprising revelation experienced by the group working on the chemical problem. It turned out that the group had so enjoyed their special status and favored position and they were so intrigued by the fascinating problem that they were in no hurry to solve it. Also, solving the problem would mean breaking up the group and returning to more humdrum work. All of this showed up clearly in their drawings. The curious thing was that the group leader exclaimed, "I thought that might be what was going on, but I just didn't believe it!" The solution? The group realized that they needed—and welcomed—a serious deadline and assurance that other, equally interesting problems awaited them.

Another surprising result came in response to the question about customer relations. Participants' drawings in that seminar were consistently complex and detailed. Nearly every drawing represented customers as small objects floating in large empty spaces. Areas of great complexity excluded these small objects. The ensuing discussion clarified the group's (unconscious) indifference toward and inattention to customers. That raised other questions: What was in all of that empty negative space, and how could the complex areas (identified in discussion as aspects of the work that were more interesting to the group) make connection with customer concerns? This group planned to explore the problem further.

Krishnamurti: "So where does silence begin? Does it begin when thought ends? Have you ever tried to end thought?"

Questioner: "How do you do it?"

Krishnamurti: "I don't know, but have you ever tried it? First of all, who is the entity who is trying to stop thought?"

Questioner: "The thinker."

Krishnamurti: "It's another thought, isn't it? Thought is trying to stop itself, so there is a battle between the thinker and the thought.... Thought says, 'I must stop thinking because then I shall experience a marvelous state.' . . . One thought is trying to suppress another thought, so there is conflict. When I see this as a fact, see it totally, understand it completely, have an insight into it . . . then the mind is quiet. This comes about naturally and easily when the mind is quiet to watch, to look, to see."

—J. Krishnamurti
You Are the World, 1972

The group seeking more productive ways of working together came to a conclusion that was so obvious the group actually laughed about it. Their conclusion was that they needed to improve communication within the group. Members were nearly all scientists holding advanced degrees in chemistry and physics. Apparently, each person had a specific assignment for one part of the whole task, but they worked in different buildings with different groups of associates and on individual time schedules. For more than twenty-five years they had never met together as a group until we held our three-day seminar.

I hope these examples give at least some flavor of the corporate seminars. Participants, of course, are highly educated, successful professionals. Working as I do with a different way of thinking, the seminars seem to enable these highly trained people to see things differently. Because the participants themselves generate the drawings, they provide real evidence to refer to. Thus, insights are hard to dismiss and the discussions stay very focused.

I can only speculate why this process works effectively to get at information that is often hidden or ignored or "explained away" by the language mode of thinking. I think it's possible that the language system (L-mode, in my terminology) regards drawing—especially analog drawing—as unimportant, even as just a form of doodling. Perhaps, L-mode drops out of the task, putting its censoring function on hold. Apparently, what the person knows but doesn't know at a verbal, conscious level therefore comes pouring out in the drawings. Traditional executives, of course, may regard this information as "soft," but I suspect that these unspoken reactions do have some effect on the ultimate success and failure of corporations. Broadly speaking, a glimpse of underlying affective dynamics probably helps more than it hinders.

Introduction

The subject of how people learn to draw has never lost its charm and fascination for me. Just when I begin to think I have a grasp on the subject, a whole new vista or puzzlement opens up. This book, therefore, is a work in progress, documenting my understanding at this time.

Drawing on the Right Side of the Brain, I believe, was one of the first practical educational applications of Roger Sperry's pioneering insight into the dual nature of human thinking—verbal, analytic thinking mainly located in the left hemisphere, and visual, perceptual thinking mainly located in the right hemisphere. Since 1979, many writers in other fields have proposed applications of the research, each in turn suggesting new ways to enhance both thinking modes, thereby increasing potential for personal growth.

During the past ten years, my colleagues and I have polished and expanded the techniques described in the original book. We have changed some procedures, added some, and deleted some. My main purpose in revising the book and presenting this third edition is to bring the work up-to-date again for my readers.

As you will see, much of the original work is retained, having withstood the test of time. But one important organizing principle was missing in the original text, for the curious reason that I couldn't see it until after the book was published. I want to reemphasize it here, because it forms the overall structure within which the reader can see how the parts of the book fit together to form a whole. This key principle is: Drawing is a global or "whole" skill requiring only a limited set of basic components.

This insight came to me about six months after the book was published, right in the middle of a sentence while teaching a

Please note that I am referring to the learning stage of basic realistic drawing of a perceived image. There are many other kinds of drawing: abstraction, nonobjective drawing, imaginative drawing, mechanical drawing, and so forth. Also, drawing can be defined in many other ways—by mediums, historic styles, or the artist's intent.

group of students. It was the classic Ah-ha! experience, with the strange physical sensations of rapid heartbeat, caught breath, and a sense of joyful excitement at seeing everything fall into place. I had been reviewing with the students the set of skills described in my book when it hit me that this was it, there were no more, and that the book had a hidden content of which I had been unaware. I checked the insight with my colleagues and drawing experts. They agreed.

Like other global skills—for example, reading, driving, skiing, and walking—drawing is made up of component skills that become integrated into a whole skill. Once you have learned the components and have integrated them, you can draw—just as once you have learned to read, you know how to read for life; once you have learned to walk, you know how to walk for life. You don't have to go on forever adding additional basic skills. Progress takes the form of practice, refinement of technique, and learning what to use the skills for.

This was an exciting discovery because it meant that a person can learn to draw within a reasonably short time. And, in fact, my colleagues and I now teach a five-day seminar, fondly known as our "Killer Class," which enables students to acquire the basic component skills of realistic drawing in five days of intense learning.

Five basic skills of drawing

The global skill of drawing a perceived object, person, landscape (something that you see "out there") requires only five basic component skills, no more. These skills are not drawing skills. They are perceptual skills, listed as follows:

One: the perception of edges

Two: the perception of spaces

Three: the perception of relationships

Four: the perception of lights and shadows

Five: the perception of the whole, or gestalt

I am aware, of course, that additional basic skills are required for imaginative, expressive drawing leading to "Art with a capital A." Of these, I have found two and only two additional skills: drawing from memory and drawing from imagination. And there remain, naturally, many techniques of drawing—many ways of manipulating drawing mediums and endless subject matter, for example. But, to repeat, for skillful realistic drawing of one's perceptions, using pencil on paper, the five skills I will teach you in this book provide the required perceptual training.

Those five basic skills are the prerequisites for effective use of the two additional "advanced" skills, and the set of seven may constitute the entire basic global skill of drawing. Many books on drawing actually focus mainly on the two advanced skills. Therefore, after you complete the lessons in this book, you will find ample instruction available to continue learning.

I need to emphasize a further point: Global or whole skills, such as reading, driving, and drawing, in time become automatic. As I mentioned above, basic component skills become completely integrated into the smooth flow of the global skill. But in acquiring any new global skill, the initial learning is often a struggle, first with each component skill, then with the smooth integration of components. Each of my students goes through this process, and so will you. As each new skill is learned, you will merge it with those previously learned until, one day, you are simply drawing—just as, one day, you found yourself simply driving without thinking about how to do it. Later, one almost forgets about having learned to read, learned to drive, learned to draw.

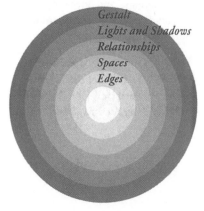

The global skill of drawing

In order to attain this smooth integration in drawing, all five component skills must be in place. I'm happy to say that the fifth skill, the perception of the whole, or gestalt, is neither taught nor learned but instead seems to emerge as a result of acquiring the other four skills. But of the first four, none can be omitted, just as learning how to brake or steer cannot be omitted when learning to drive.

In the original book, I believe I explained sufficiently well the first two skills, the perception of edges and the perception of spaces. The importance of sighting (the third skill of perceiving

"You have two brains: a left and a right. Modern brain scientists now know that your left brain is your verbal and rational brain; it thinks serially and reduces its thoughts to numbers, letters, and words. . . . Your right brain is your non-verbal and intuitive brain; it thinks in patterns, or pictures, composed of 'whole things,' and does not comprehend reductions, either numbers, letters, or words."

From *The Fabric of Mind,* by the eminent scientist and neurosurgeon Richard Bergland. New York: Viking Penguin, Inc., 1985, p. 1.

relationships) however, needed greater emphasis and clearer explanation, because students often tend to give up too quickly on this complicated skill. And the fourth skill, the perception of lights and shadows, also needed expanding. Most of the content changes for this new edition, therefore, are in the last chapters.

A basic strategy for accessing R-mode

In this edition, I again reiterate a basic strategy for gaining access at conscious level to R-mode, my term for the visual, perceptual mode of the brain. I continue to believe that this strategy is probably my main contribution to educational aspects of the "right-hemisphere story" that began with Roger Sperry's celebrated scientific work. The strategy is stated as follows:

In order to gain access to the subdominant visual, perceptual R-mode of the brain, it is necessary to present the brain with a job that the verbal, analytic L-mode will turn down.

For most of us, L-mode thinking seems easy, normal, and familiar (though perhaps not for many children and dyslexic individuals). The perverse R-mode strategy, in contrast, may seem difficult and unfamiliar—even "off-the-wall." It must be learned in opposition to the "natural" tendency of the brain to favor L-mode because, in general, language dominates. By learning to control this tendency for specific tasks, one gains access to powerful brain functions often obscured by language.

All of the exercises in this book, therefore, are based on two organizing principles and major aims. First, to teach the reader five basic component skills of drawing and, second, to provide conditions that facilitate making cognitive shifts to R-mode, the thinking/seeing mode specialized for drawing.

In short, in the process of learning to draw, one also learns to control (at least to some degree) the mode by which one's own brain handles information. Perhaps this explains in part why my book appeals to individuals from such diverse fields. Intuitively, they see the link to other activities and the possibility of seeing things differently by learning to access R-mode at conscious level.

Color in drawing

Chapter Eleven, "Drawing on the Beauty of Color," was a new chapter in the 1989 edition, written in response to many requests from my readers. The chapter focuses on using color in drawing—a fine transitional step toward painting. Over the past decade, my teaching staff and I have developed a five-day intensive course on basic color theory, a course that is still a "work in progress." I am still using the concepts in the chapter on color, so I have not revised it for this edition.

I believe the logical progression for a person starting out in artistic expression should be as follows:

From Line to Value to Color to Painting

First, a person learns the basic skills of drawing, which provide knowledge of line (learned through contour drawing of edges, spaces, and relationships) and knowledge of value (learned through rendering lights and shadows). Skillful use of color requires first of all the ability to perceive color as value. This ability is difficult, perhaps impossible, to acquire unless one has learned to perceive the relationships of lights and shadows through drawing. I hope that my chapter introducing color in drawing will provide an effective bridge for those who want to progress from drawing to painting.

Handwriting

Finally, I am retaining the brief section on handwriting. In many cultures, writing is regarded as an art form. Americans often deplore their handwriting but are at a loss as to how to improve it. Handwriting, however, is a form of drawing and can be improved. I regret to say that many California schools are still using handwriting-instructional methods that were failing in 1989 and are still failing today. My suggestions in this regard appear in the Afterword.

An empirical basis for my theory

The underlying theory of this revised edition remains the same: to explain in basic terms the relationship of drawing to visual, perceptual brain processes and to provide methods of accessing and controlling these processes. As a number of scientists have noted, research on the human brain is complicated by the fact that the brain is struggling to understand itself. This three-pound organ is perhaps the only bit of matter in the universe—at least as far as we know—that is observing itself, wondering about itself, trying to analyze itself, and attempting to gain better control of its own capabilities. This paradoxical situation no doubt contributes—at least in part—to the deep mysteries that still remain, despite rapidly expanding scientific knowledge about the brain.

One question scientists are studying intensely is where the two major thinking modes are specifically located in the human brain and how the organization of modes can vary from individual to individual. While the so-called location controversy continues to engage scientists, along with myriad other areas of brain research, the existence in every brain of two fundamentally different cognitive modes is no longer controversial. Corroborating research since Sperry's original work is overwhelming. Moreover, even in the midst of the argument about location, most scientists agree that for a majority of individuals, information-processing based primarily on linear, sequential data is mainly located in the left hemisphere, while global, perceptual data is mainly processed in the right hemisphere.

Clearly, for educators like myself, the precise location of these modes in the individual brain is not an important issue. What is important is that incoming information can be handled in two fundamentally different ways and that the two modes can apparently work together in a vast array of combinations. Since the late 1970s, I have used the terms L-mode and R-mode to try to avoid the location controversy. The terms are intended to differentiate the major modes of cognition, regardless of where they are located in the individual brain.

Over the past decade or so, a new interdisciplinary field of

brain-function study has become formally known as cognitive neuroscience. In addition to the traditional discipline of neurology, cognitive neuroscience encompasses study of other higher cognitive processes such as language, memory, and perception. Computer scientists, linguists, neuroimaging scientists, cognitive psychologists, and neurobiologists are all contributing to a growing understanding of how the human brain functions.

Interest in "right brain, left brain" research has subsided somewhat among educators and the general public since Roger Sperry first published his research findings. Nevertheless, the fact of the profound asymmetry of human brain functions remains, becoming ever more central, for example, among computer scientists trying to emulate human mental processes. Facial recognition, a function ascribed to the right hemisphere, has been sought for decades and is still beyond the capabilities of most computers. Ray Kurzweil, in his recent book *The Age of Spiritual Machines* (Viking, 1999) contrasted human and computer capability in pattern seeking (as in facial recognition) and sequential processing (as in calculation):

> The human brain has about 100 billion neurons. With an estimated average of one thousand connections between each neuron and its neighbors, we have about 100 trillion connections, each capable of a simultaneous calculation. That's rather massive parallel processing, and one key to the strength of human thinking. A profound weakness, however, is the excruciatingly slow speed of neural circuitry, only 200 calculations per second. For problems that benefit from massive parallelism, such a neural-net-based pattern recognition, the human brain does a great job. For problems that require extensive sequential thinking, the human brain is only mediocre. (p. 103)

In 1979, I proposed that drawing required a cognitive shift to R-mode, now postulated to be a massively parallel mode of processing, and away from L-mode, postulated to be a sequential processing mode. I had no hard evidence to support my proposal, only my experience as an artist and a teacher. Over the years, I have been criticized occasionally by various neuroscientists for overstepping the boundaries of my own field—though not by

In a conversation with his friend André Marchand, the French artist Henri Matisse described the process of passing perceptions from one way of looking to another:

"Do you know that a man has only one eye which sees and registers everything; this eye, like a superb camera which takes minute pictures, very sharp, tiny—and with that picture man tells himself: 'This time I know the reality of things,' and he is calm for a moment. Then, slowly superimposing itself on the picture, another eye makes its appearance, invisibly, which makes an entirely different picture for him.

"Then our man no longer sees clearly, a struggle begins between the first and second eye, the fight is fierce, finally the second eye has the upper hand, takes over and that's the end of it. Now it has command of the situation, the second eye can then continue its work alone and elaborate its own picture according to the laws of interior vision. This very special eye is found here," says Matisse, pointing to his brain.

Marchand didn't mention which side of his brain Matisse pointed to.

—J. Flam
Matisse on Art, 1973

A recent article in an educational journal summarizes neuroscientists' objections to "brain-based education."

"The fundamental problem with the right-brain versus left-brain claims that one finds in educational literature is that they rely on our intuitions and folk theories about the brain, rather than on what brain science is actually able to tell us. Our folk theories are too crude and imprecise to have any scientific predictive or instructional value. What modern brain science is telling us—and what brain-based educators fail to appreciate—is that it makes no scientific sense to map gross, unanalyzed behaviors and skills—reading, arithmetic, spatial reasoning—onto one brain hemisphere or another."

But the author also states: "Whether or not [brain-based] educational practices should be adopted must be determined on the basis of the impact on student learning."

—John T. Bruer
"In Search of . . .
Brain-Based Education,"
Phi Delta Kappan, May
1999, p. 603

Roger Sperry, who believed that my application of his research was reasonable.

What kept me working at my "folk" theory (see the margin excerpt) was that, when put into practice, the results were inspiring. Students of all ages made significant gains in drawing ability and, by extension, in perceptual abilities, since drawing well depends on seeing well. Drawing ability has always been regarded as difficult to acquire, and has nearly always been additionally burdened by the notion that it is an extraordinary, not an ordinary, skill. If my method of teaching enables people to gain a skill they previously thought closed off to them, is it the neurological explanation that makes the method work, or is it something else that I may not be aware of?

I know that it is not simply my style of teaching that causes the method to work, since the hundreds of teachers who have reported equal success using my methods obviously have widely differing teaching styles. Would the exercises work without the neurological rationale? It's possible, but it would be very difficult to persuade people to accede to such unlikely exercises as upside-down drawing without some reasonable explanation. Is it, then, just the fact of giving people a rationale—that any rationale would do? Perhaps, but I have always been struck by the fact that my explanation seems to make sense to people at a subjective level. The theory seems to fit their experience, and certainly the ideas derive from my own subjective experience with drawing.

In each edition of this book I have made the following statement:

The theory and methods presented in my book have proven empirically successful. In short, the method works, regardless of the extent to which future science may eventually determine exact location and confirm the degree of separation of brain functions in the two hemispheres.

I hope that eventually scholars using traditional research methods will help answer the many questions I have myself about this work. It does appear that recent research tends to corroborate my basic ideas. For example, new findings on the function of the huge bundle of nerve fibers connecting the two hemispheres, the

corpus callosum, indicate that the corpus callosum can inhibit the passage of information from hemisphere to hemisphere when the task requires noninterference from one or the other hemisphere.

Meanwhile, the work appears to bring a great deal of joy to my students, whether or not we fully understand the underlying process.

A further complication

One further complication of seeing needs mentioning. The eyes gather visual information by constantly scanning the environment. But visual data from "out there," gathered by sight, is not the end of the story. At least part, and perhaps much of what we see is changed, interpreted, or conceptualized in ways that depend on a person's training, mind-set, and past experiences. We tend to see what we expect to see or what we decide we have seen. This expectation or decision, however, often is not a conscious process. Instead, the brain frequently does the expecting and the deciding, without our conscious awareness, and then alters or rearranges—or even simply disregards—the raw data of vision that hits the retina. Learning perception through drawing seems to change this process and to allow a different, more direct kind of seeing. The brain's editing is somehow put on hold, thereby permitting one to see more fully and perhaps more realistically.

This experience is often moving and deeply affecting. My students' most frequent comments after learning to draw are "Life seems so much richer now" and "I didn't realize how much there is to see and how beautiful things are." This new way of seeing may alone be reason enough to learn to draw.

"The artist is the confidant of nature. Flowers carry on dialogues with him through the graceful bending of their stems and the harmoniously tinted nuances of their blossoms. Every flower has a cordial word which nature directs towards him."

— Auguste Rodin

I

Drawing and the Art of Bicycle Riding

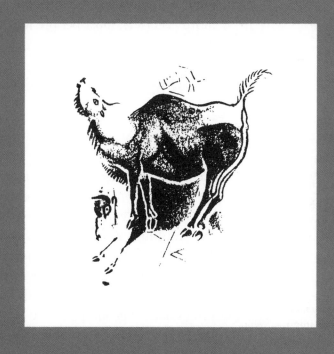

DRAWING IS A CURIOUS PROCESS, so intertwined with seeing that the two can hardly be separated. Ability to draw depends on ability to see the way an artist sees, and this kind of seeing can marvelously enrich your life.

In many ways, teaching drawing is somewhat like teaching someone to ride a bicycle. It is very difficult to explain in words. In teaching someone to ride a bicycle, you might say, "Well, you just get on, push the pedals, balance yourself, and off you'll go."

Of course, that doesn't explain it at all, and you are likely finally to say, "I'll get on and show you how. Watch and see how l do it."

And so it is with drawing. Most art teachers and drawing textbook authors exhort beginners to "change their ways of looking at things" and to "learn how to see." The problem is that this different way of seeing is as hard to explain as how to balance a bicycle, and the teacher often ends by saying, in effect, "Look at these examples and just keep trying. If you practice a lot, eventually you may get it." While nearly everyone learns to ride a bicycle, many individuals never solve the problems of drawing. To put it more precisely, most people never learn to see well enough to draw.

Drawing as a magical ability

Because only a few individuals seem to possess the ability to see and draw, artists are often regarded as persons with a rare God-given talent. To many people, the process of drawing seems mysterious and somehow beyond human understanding.

Artists themselves often do little to dispel the mystery. If you ask an artist (that is, someone who draws well as a result of either long training or chance discovery of the artist's way of seeing), "How do you draw something so that it looks real—say a portrait or a landscape?" the artist is likely to reply, "Well, I just have a gift for it, I guess," or "I really don't know. I just start in and work things out as I go along," or "Well, I just *look* at the person (or the landscape) and I draw what I see." The last reply seems like a logical and straightforward answer. Yet, on reflection, it clearly

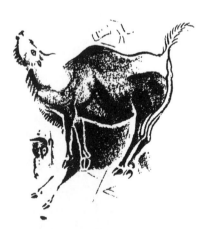

Fig. 1-1. *Bellowing Bison.* Paleolithic cave painting from Altamira, Spain. Drawing by Brevil. Prehistoric artists were probably thought to have magic powers.

doesn't explain the process at all, and the sense that the skill of drawing is a vaguely magical ability persists (Figure 1-1).

While this attitude of wonder at artistic skill causes people to appreciate artists and their work, it does little to encourage individuals to try to learn to draw, and it doesn't help teachers explain to students the process of drawing. Often, in fact, people even feel that they shouldn't take a drawing course because they don't know already how to draw. This is like deciding that you shouldn't take a French class because you don't already speak French, or that you shouldn't sign up for a course in carpentry because you don't know how to build a house.

Drawing as a learnable, teachable skill

You will soon discover that drawing is a skill that can be learned by every normal person with average eyesight and average eye-hand coordination—with sufficient ability, for example, to thread a needle or catch a baseball. Contrary to popular opinion, manual skill is not a primary factor in drawing. If your handwriting is readable, or if you can print legibly, you have ample dexterity to draw well.

We need say no more here about hands, but about eyes we cannot say enough. Learning to draw is more than learning the skill itself; by studying this book you will learn *how to see*. That is, you will learn how to process visual information in the special way used by artists. That way is *different* from the way you usually process visual information and seems to require that you use your brain in a different way than you ordinarily use it.

You will be learning, therefore, something about how your brain handles visual information. Recent research has begun to throw new scientific light on that marvel of capability and complexity, the human brain. And one of the things we are learning is how the special properties of our brains enable us to draw pictures of our perceptions.

Roger N. Shepard, professor of psychology at Stanford University, recently described his personal mode of creative thought during which research ideas emerged in his mind as unverbalized, essentially complete, long-sought solutions to problems.

"That in all of these sudden illuminations my ideas took shape in a primarily visual-spatial form without, so far as I can introspect, any verbal intervention is in accordance with what has always been my preferred mode of thinking. . . . Many of my happiest hours have since childhood been spent absorbed in drawing, in tinkering, or in exercises of purely mental visualization."

— Roger N . Shepard
Visual Learning, Thinking, and Communication, 1978

"Learning to draw is really a matter of learning to see—to see correctly—and that means a good deal more than merely looking with the eye."

— Kimon Nicolaides
The Natural Way to Draw, 1941

Drawing and seeing

The magical mystery of drawing ability seems to be, in part at least, an ability to make a shift in brain state to a different mode of seeing/perceiving. *When you see in the special way in which experienced artists see, then you can draw.* This is not to say that the drawings of great artists such as Leonardo da Vinci or Rembrandt are not still wondrous because we may know something about the cerebral process that went into their creation. Indeed, scientific research makes master drawings seem even more remarkable because they seem to cause a viewer to shift to the artist's mode of perceiving. But the basic skill of drawing is also accessible to everyone who can learn to make the shift to the artist's mode and see in the artist's way.

The artist's way of seeing: A twofold process

Drawing is not really very difficult. Seeing is the problem, or, to be more specific, shifting to a particular way of seeing. You may not believe me at this moment. You may feel that you are seeing things just fine and that it's the drawing that is hard. But the opposite is true, and the exercises in this book are designed to help you make the mental shift and gain a twofold advantage. First, to open access by *conscious volition* to the visual, perceptual mode of thinking in order to experience a focus in your awareness, and second, to see things in a different way. Both will enable you to draw well.

Many artists have spoken of seeing things differently while drawing and have often mentioned that drawing puts them into a somewhat altered state of awareness. In that different subjective state, artists speak of feeling transported, "at one with the work," able to grasp relationships that they ordinarily cannot grasp. Awareness of the passage of time fades away and words recede from consciousness. Artists say that they feel alert and aware yet are relaxed and free of anxiety, experiencing a pleasurable, almost mystical activation of the mind.

Drawing attention to states of consciousness

The slightly altered consciousness state of feeling transported, which most artists experience while drawing, painting, sculpting, or doing any kind of art work, is a state probably not altogether unfamiliar to you. You may have observed in yourself slight shifts in your state of consciousness while engaged in much more ordinary activities than artwork.

For example, most people are aware that they occasionally slip from ordinary waking consciousness into the slightly altered state of daydreaming. As another example, people often say that reading takes them "out of themselves." And other kinds of activities which apparently produce a shift in consciousness state are meditation, jogging, needlework, typing, listening to music, and, of course, drawing itself.

Also, I believe that driving on the freeway probably induces a slightly different subjective state that is similar to the drawing state. After all, in freeway driving we deal with visual images, keeping track of relational, spatial information, sensing complex components of the overall traffic configuration. Many people find that they do a lot of creative thinking while driving, often losing track of time and experiencing a pleasurable sense of freedom from anxiety. These mental operations may activate the same parts of the brain used in drawing. Of course, if driving conditions are difficult, if we are late or if someone sharing the ride talks with us, the shift to the alternative state doesn't occur. The reasons for this we'll take up in Chapter Three.

The key to learning to draw, therefore, is to set up conditions that cause you to make a mental shift to a different mode of information processing—the slightly altered state of consciousness—that enables you to see well. In this drawing mode, you will be able to draw your perceptions even though you may never have studied drawing. Once the drawing mode is familiar to you, you will be able to consciously control the mental shift.

"If a certain kind of activity, such as painting, becomes the habitual mode of expression, it may follow that taking up the painting materials and beginning work with them will act suggestively and so presently evoke a flight into the higher state."

— Robert Henri
The Art Spirit, 1923

Drawing on your creative self

I see you as an individual with creative potential for expressing yourself through drawing. My aim is to provide the means for releasing that potential, for gaining access at a conscious level to your inventive, intuitive, imaginative powers that may have been largely untapped by our verbal, technological culture and educational system. I am going to teach you how to draw, but drawing is only the means, not the end. Drawing will tap the special abilities that are *right* for drawing. By learning to draw you will learn to see differently and, as the artist Rodin lyrically states, to become a confidant of the natural world, to awaken your eye to the lovely language of forms, to express yourself in that language.

In drawing, you will delve deeply into a part of your mind too often obscured by endless details of daily life. From this experience you will develop your ability to perceive things freshly in their totality, to see underlying patterns and possibilities for new combinations. Creative solutions to problems, whether personal or professional, will be accessible through new modes of thinking and new ways of using the power of your whole brain.

Drawing, pleasurable and rewarding though it is, is but a key to open the door to other goals. My hope is that *Drawing on the Right Side of the Brain* will help you expand your powers as an individual through increased awareness of your own mind and its workings. The multiple effects of the exercises in this book are intended to enhance your confidence in decision making and problem solving. The potential force of the creative, imaginative human brain seems almost limitless. Drawing may help you come to know this power and make it known to others. Through drawing, you are made visible. The German artist Albrecht Dürer said, "From this, the treasure secretly gathered in your heart will become evident through your creative work."

Keeping the real goal in mind, let us begin to fashion the key.

My approach: A path to creativity

The exercises and instructions in this book have been designed specifically for people who cannot draw at all, who may feel that they have little or no talent for drawing, and who may feel doubtful that they could ever learn to draw—but who think they might like to learn. The approach of this book is different from other drawing instruction books in that the exercises are aimed at opening access to skills *you already have* but that are simply waiting to be released.

Creative persons from fields other than art who want to get their working skills under better control and learn to overcome blocks to creativity will benefit from working with the techniques presented here. Teachers and parents will find the theory and exercises useful in helping children to develop their creative abilities. At the end of the book, I have supplied a brief postscript that offers some general suggestions for adapting my methods and materials to children. A second postscript is addressed to art students.

This book is based on the five-day workshop that I have been teaching for about fifteen years to individuals of widely ranging ages and occupations. Nearly all of the students begin the course with very few drawing skills and with high anxiety about their potential drawing ability. Almost without exception, the students achieve a high level of skill in drawing and gain confidence to go on developing their expressive drawing skills in further art courses or by practice on their own.

An intriguing aspect of the often-remarkable gains most students achieve is the rapid rate of improvement in drawing skills. It's my belief that if persons untrained in art can learn to make the shift to the artist's mode of seeing—that is, the right-hemisphere mode—those individuals are then able to draw without further instruction. To put it another way, you already know how to draw, but old habits of seeing interfere with that ability and block it. The exercises in this book are designed to remove the interference and unblock the ability.

"To be shaken out of the ruts of ordinary perception, to be shown for a few timeless hours the outer and the inner world, not as they appear to an animal obsessed with words and notions, but as they are apprehended, directly and unconditionally, by Mind at Large—this is an experience of inestimable value to everyone."

— Aldous Huxley
The Doors of Perception,
1954

While you may have no interest whatever in becoming a full-time working artist, the exercises will provide insights into the way your mind works, or your two minds work—singly, cooperatively, one against the other. And, as many of my students have told me, their lives seem richer because they are *seeing better and seeing more*. It's helpful to remember that we don't teach reading and writing to produce only poets and writers, but rather to improve thinking.

Realism as a means to an end

Why faces?

A number of the exercises and instructional sequences in this book are designed to enable you to draw recognizable portraits. Let me explain why I think portrait drawing is useful as a subject for beginners in art. Broadly speaking, except for the degree of complexity, *all drawing is the same*. One drawing task is no harder than any other. The same skills and ways of seeing are involved in drawing still-life setups, landscapes, the figure, random objects, even imaginary subjects, and portrait drawing. *It's all the same thing:* You see what's out there (imaginary subjects are "seen" in the mind's eye) and you draw what you see.

Why, then, have I selected portrait drawing for some of the exercises? For three reasons. First, beginning students of drawing often *think* that drawing human faces is the hardest of all kinds of drawing. Thus, when students see that they *can* draw portraits, they feel confident and their confidence enhances progress. A second, more important, reason is that the right hemisphere of the human brain is specialized for recognition of faces. Since the right brain is the one we will be trying to gain access to, it makes sense to choose a subject that the right brain is used to working with. And third, faces are fascinating! Once you have drawn a person, you will really have seen that individual's face. As one of my students said, "I don't think I ever actually *looked at* anyone's face before I started drawing. Now, the oddest thing is that *everyone* looks beautiful to me."

Summing up

I have described to you the basic premise of this book—that drawing is a teachable, learnable skill that can provide a twofold advantage. By gaining access to the part of your mind that works in a style conducive to creative, intuitive thought, you will learn a fundamental skill of the visual arts: how to put down on paper what you see in front of your eyes. Second, through learning to draw by the method presented in this book, you will enhance your ability to think more creatively in other areas of your life.

How far you go with these skills after you complete the course will depend on other traits such as energy and curiosity. But first things first! The potential is there. It's sometimes necessary to remind ourselves that Shakespeare at some point learned to write a line of prose, Beethoven learned the musical scales, and as you see in the margin quotation, Vincent Van Gogh learned how to draw.

"... at the time when you spoke of my becoming a painter, I thought it very impractical and would not hear of it. What made me stop doubting was reading a clear book on perspective, Cassange's *Guide to the ABC of Drawing:* and a week later I drew the interior of a kitchen with stove, chair, table and window—in their places and on their legs—whereas before it had seemed to me that getting depth and the right perspective into a drawing was witchcraft or pure chance."

— Vincent Van Gogh, in a letter to his brother, Theo, who had suggested that Vincent become a painter. Letter 184, p. 331.

2 The Drawing Exercises: One Step at a Time

O VER THE YEARS OF TEACHING, I have experimented with various progressions, sequences, and combnations of exercises. The sequence set out in this book has proved to be the most effective in terms of student progress. We'll take the first step, the all-important preinstruction drawings, in this chapter.

When you begin the drawing exercises in Chapter Four, you'll have some background in the underlying theory, how the exercises have been set up, and why they work. The sequence is designed to enhance success at every step of the way and to provide access to a new mode of information processing with as little upset to the old mode as possible. Therefore, I ask you to read the chapters in the order presented and to do the exercises as they appear.

I have limited the recommended exercises to a minimum number, but if time permits, do more drawings than are suggested: Seek your own subjects and devise your own exercises. The more practice you provide for yourself, the faster you will progress. To this end, in addition to the exercises that appear in the text, supplementary exercises often appear in the margin. Doing these exercises will reinforce both your skills and your confidence.

For most of the exercises, I recommend that you read through all of the directions before you start drawing and, where directed, view the examples of students' drawings before beginning. Keep all of your drawings together in a folder or large envelope, so that by the time you've come to the end of the book you can review your own progress.

Definitions of terms

A glossary of terms appears at the end of the book. Certain terms are defined fairly extensively in the text, and the glossary contains other terms not so extensively defined. Words that are commonly used in everyday language, such as "value" and "composition," have very specific, and often different, meanings in art terminology. I suggest that you glance through the glossary before starting to read the chapters.

Drawing materials

The materials list for the first two editions was very simple: some inexpensive bond typing paper or a pad of inexpensive drawing paper, a pencil, and an eraser. I mentioned that a #4B drawing pencil is pleasant to use, as the lead is smooth and makes a clear, dark line, but an ordinary number 2 writing pencil is nearly as good. For this edition, you still need these basic materials, but I wish to suggest a few additional aids that will help you learn to draw quickly.

- You will need a piece of clear plastic, about 8" x 10" and about ¹⁄₁₆" thick. A piece of glass is fine, but the edges must be taped. Use a *permanent* marker to draw two crosshairs on the plastic, a horizontal line and a vertical line crossing at the center of the plane. (See the sketch in the margin.)

- Also, you will need two "viewfinders," made of black cardboard about 8" x 10". From one, cut a rectangular opening of 4¼" x 5¼" and from the other, cut out a larger opening of 6" x 7⅝". See Figure 2-1.

- A nonpermanent black felt-tip marker

- Two clips to fasten your viewfinders to the plastic picture plane
- A "graphite stick," #4B, available at most art supply stores

- Some masking tape

- A pencil sharpener—a small, hand-held sharpener is fine

- An eraser, such a "Pink Pearl" or a white plastic eraser

Gathering these materials requires a bit of effort, but they will truly help you to learn rapidly. You can buy them at any art materials or crafts store. My staff of teachers and I no longer attempt to teach our students without using viewfinders and the plastic picture plane, and they will help you just as much. Because these items are so essential to students' understanding of the basic nature of drawing, for years now we have put together—by hand!—portfolios containing the special learning tools that we have developed for our five-day intensive workshops. The portfolios also contained all of the necessary drawing materials and a lightweight drawing board. Now I have made our Portfolio avail-

Construct a viewfinder as follows:

1. Take a sheet of paper or use thin cardboard of the same size as the paper you use for drawing. The viewfinder must be the same format, that is, the same proportional shape, as the paper you are using to draw on.

2. Draw diagonal lines from opposite corners, crossing in the center. In the center of the paper, draw a small rectangle by connecting horizontal and vertical lines at points on the diagonals. The rectangle should be about 1 x 1¼". (See Figure 2-1.) Constructed this way, the inner rectangle has the same proportion of length to width as the outer edges of the paper.

3. Next, cut the small rectangle out of the center with scissors. Hold the paper up and compare the shape of the small opening with the shape of the whole format. You can see that the two shapes are the same, and only the size is different. This perceptual aid is called a viewfinder. It will help you to perceive negative spaces by establishing an edge to the space around forms.

Fig. 2-1.

able for purchase. It includes as well a two-hour instructional video of the lessons in this book.

If you are interested in purchasing a Portfolio, you will find an order slip at the end of the book, or you can contact my website at www.drawright.com. But the few items listed above will be sufficient if you would rather put together your own set of materials.

Pre-instruction drawings: A valuable record of your art skills

Now, let's get started. First, you need to make a record of your present drawing skills. This is important! You don't want to miss the pleasure of having a real memento of your starting point to compare with your later drawings. I'm fully aware how difficult this is, but just do it! As the great Dutch artist Vincent Van Gogh wrote (in a letter to his brother, Theo):

"Just dash something down if you see a blank canvas staring at you with a certain imbecility. You do not know how paralyzing it is, that staring of a blank canvas which says to a painter, 'You don't know anything.'"

Soon, you will "know something," I promise. Just gear yourself up and do these drawings. Later, you'll be very happy that you did. The drawings have proved to be invaluable in aiding students to see and recognize their own progress. A kind of amnesia seems to set in as drawing skills improve. Students forget what their drawing was like before instruction. Moreover the degree of *criticism* keeps pace with progress. Even after considerable improvement, students are sometimes critical of their latest drawing because it's "not as good as da Vinci's." The *before* drawings provide a realistic gauge of progress. After you do the drawings, put them away and we will look at them again later on in the light of your newly acquired skills.

What you'll need:

- Paper to draw on—plain white bond paper is fine
- Your #2 writing pencil
- Your pencil sharpener
- Your masking tape
- A small mirror, about 5" x 7", that could be attached to a wall, or any available wall or door mirror
- Something to use as a drawing board—a breadboard or a sturdy piece of cardboard, about 15" x 18"
- An hour to an hour and a quarter of uninterrupted time

What you'll do:

You will do three drawings. This usually takes our students about an hour or so, but feel free to take as long as you wish for each of them. I will first list the drawing titles. Instruction for each drawing follows.

- "Self-Portrait"
- "A Person, Drawn from Memory"
- "My Hand"

Pre-instruction drawing #1: Your "Self-Portrait"

1. Tape a stack of two or three sheets of paper to your drawing board or work in your pad of paper. (Stacking the sheets provides a "padded" surface to draw on—much better than the rather hard surface of the drawing board.)
2. Sit at arm's length (about 2 to 2½ feet) from a mirror. Lean your board up against the wall, resting the bottom of the board on your lap.
3. Look at the reflection of your head and face in the mirror and draw your "Self-Portrait."
4. When you have finished, title, date, and sign the drawing in the lower right-hand or lower left-hand corner.

Pre-instruction drawing #2: A person, drawn from memory

1. Call up in your mind's eye an image of a person—perhaps someone from the past or a person you know now. Or you may recall a drawing you did in the past or a photograph of a person well known to you.
2. To the best of your ability, make a drawing of that person. You may draw just the head, a half-figure, or the whole figure.
3. When you have finished, title, sign, and date your drawing.

Pre-instruction drawing #3: Your hand

1. Seat yourself at a table to draw.
2. If you are right-handed, draw your left hand in whatever position you choose. If you are left-handed, draw your right hand.
3. Title, date and sign your drawing.

When you have finished the pre-instruction drawings:

Be sure that you have titled, signed, and dated each of the three drawings. Some of my students have enjoyed writing a few comments on the back of each drawing, noting what is pleasing and what is perhaps displeasing, what seemed easy and what seemed difficult in the process of drawing. You'll find these comments interesting to read later on.

Spread the three drawings on a table and look at them closely. If I were there with you, I would be looking for small areas in the drawings that show you were observing carefully—perhaps the way a collar turns or a beautifully observed curve of an eyebrow. Once I encounter such signs of careful seeing, I know the person will learn to draw well. You, on the other hand, may find nothing admirable and perhaps dismiss the drawings as "childish" and "amateurish." Please remember that these drawings are made before instruction. Would you expect yourself to solve problems in algebra with-

out any instruction? On the other hand, you may be surprised and pleased with parts of your drawings, perhaps especially the drawing of your own hand.

The reason for doing the memory drawing

I'm sure that drawing a person from memory was very difficult for you, and rightfully so. Even a trained artist would find it difficult to draw a person from memory. Visual information from the real world is rich, complicated, and unique to each thing we see. Visual memory is necessarily simplified, generalized, and abbreviated—frustratingly so for artists, who often have only a limited repertoire of memorized images. "Then why do it?" you may well ask.

The reason is simply this: Drawing a person from memory brings forth a memorized set of symbols, practiced over and over during childhood. While doing the drawing from memory, can you recall that your hand seemed to have a mind of its own? You knew that you weren't making the image you wanted to, but you couldn't keep your hand from making those simplified shapes—perhaps the nose shape, for example. This is the so-called "symbol system" of children's drawing, memorized by countless repetitions during early childhood. You'll learn more about this in Chapter Five.

Now, compare your Self-Portrait with your memory drawing. Do you see the symbols repeated in both drawings—that is, are the eyes (or the nose or mouth) similar in shape, or even identical? If so, this indicates that your symbol system was controlling your hand even when you were observing the actual shapes in the mirror.

The symbol system of childhood

This "tyranny" of the symbol system explains in large part why people untrained in drawing continue to produce "childish" drawings right into adulthood and even old age. What you will learn from me is how to set your symbol system aside and accurately draw what you see. This training in perceptual skills is the

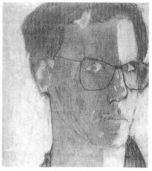
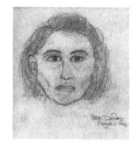
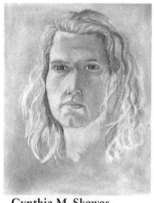

Tony Schwartz

Cynthia M. Skewes

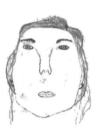
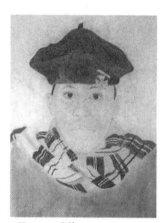
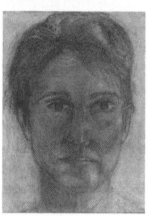

Yvonne Olive

Susan W. Dryfoos

rockbottom "ABC" of drawing, necessarily—or at least ideally—learned before progressing to imaginative drawing, painting, and sculpture.

With this information about the symbol system in mind, you may want to add a few more notes on the back of your drawings. Then, put all three drawings away for safekeeping. Do not look at them again until after you have completed my course and have learned to see and draw.

Student showing: A preview of before-and-after drawings

Now I would like to show you some drawings done by my students. The drawings show typical changes in students' drawing

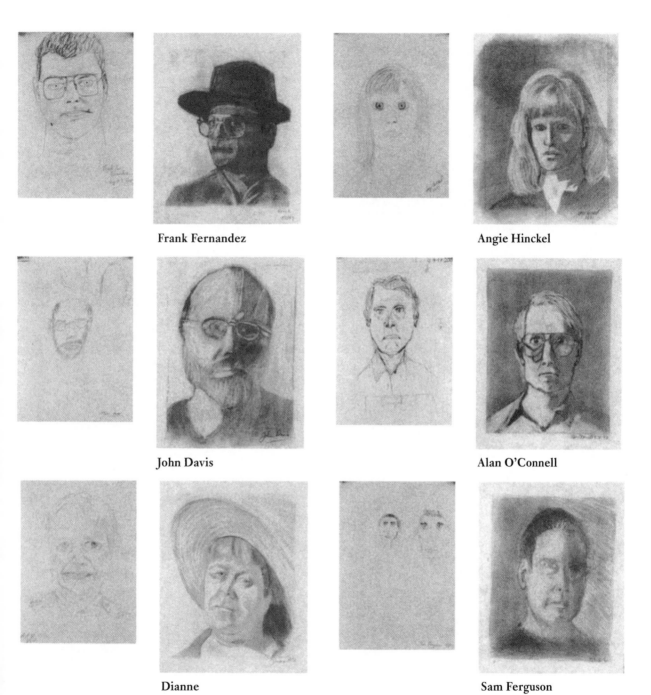

Frank Fernandez

Angie Hinckel

John Davis

Alan O'Connell

Dianne

Sam Ferguson

The drawings on this page and the following page show
Before-and-After drawings of an entire five-day class,
held in Seattle, August 4, 1997, to August 8, 1997.

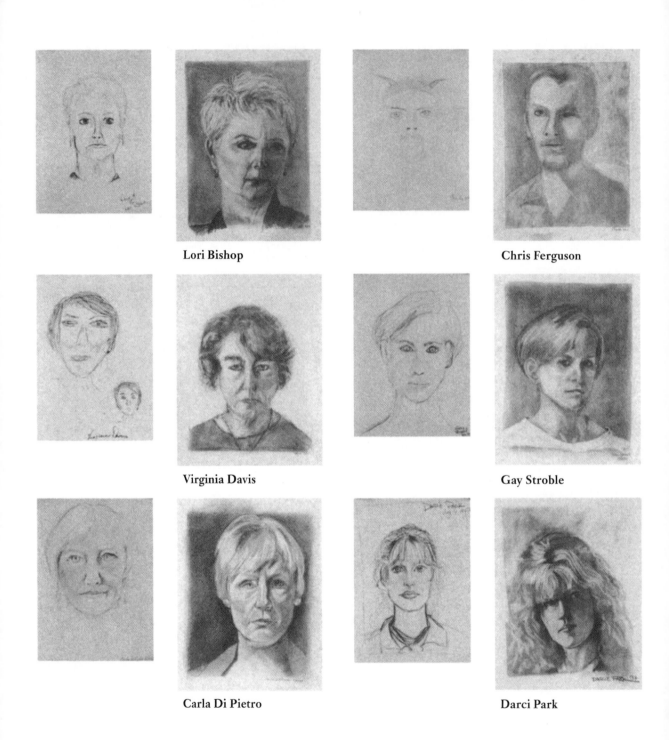

Lori Bishop

Chris Ferguson

Virginia Davis

Gay Stroble

Carla Di Pietro

Darci Park

Drawings from the five-day Seattle class, continued.

ability from the first lesson (before instruction) to the last lesson. Most of these students attended five-day workshops, eight hours a day for the five days. Both the Pre-instruction and Post-instruction drawings are self-portraits, drawn by students observing their own images in mirrors. As you can see, the Before-and-After drawings in the student examples demonstrate that the students have transformed their ways of seeing and drawing. The changes are significant enough that it almost seems as though two different persons have done the drawings.

Learning to perceive is the basic skill that the students acquired. The change you see in their ability to draw possibly reflects an equally significant change in their ability to see. Regard the drawings from that standpoint: as a visible record of the students' improvement in perceptual skills.

On pages 19–20 I present Before-and-After drawings by an entire class, a group of adult students in Seattle, Washington. Looking at the "Before" drawings, you will see that students came to the five-day class with different levels of existing drawing skills and backgrounds in art. The "After" drawings, done five days later, however, show a remarkably consistent high level of skills. This overall success rate, I believe, demonstrates our goal with every group: that every student will gain high-level drawing skills regardless of their existing (or non-existing) skill level.

Expressing yourself in drawing: The nonverbal language of art

The purpose of this book is to teach you basic skills in seeing and drawing. The purpose of this book is *not* to teach you to express yourself, but instead to provide you with the skills that will *release* you from stereotypic expression. This release in turn will open the way for you to express your individuality—your essential uniqueness—*in your own way,* using your own particular drawing style.

If, for a moment, we could regard your handwriting as a form of expressive drawing, we could say that you are already expressing yourself with a fundamental element of art: line.

"The art of archery is not an athletic ability mastered more or less through primarily physical practice, but rather a skill with its origin in mental exercise and with its object consisting in mentally hitting the mark.

"Therefore, the archer is basically aiming for himself. Through this, perhaps, he will succeed in hitting the target—his essential self."

— Herrigel

On a sheet of paper, right in the middle of the sheet, write your own name the way you usually sign your name. Next, regard your signature from the following point of view: you are looking at a **drawing** which is your original creation—shaped, it is true, by the cultural influences of your life, but aren't the creations of every artist shaped by such influences?

Every time you write your name, you have expressed yourself through the use of line. Your signature, "drawn" many times over, is expressive of you, just as Picasso's line is expressive of him. The line can be "read" because, in writing your name, you have used the nonverbal language of art. Let's try reading a line. There are signatures in the margin. All are the same name: Luther Gibson. Tell me, what is the first Luther Gibson like?

You would probably agree that Luther Gibson is more likely to be extroverted than introverted, more likely to wear bright colors than subtle ones, and, at least superficially, likely to be outgoing, talkative, even dramatic. Of course, these assumptions may or may not be correct, but the point is that this is how most people would read the nonverbal expression of the signature, because that's what Luther Gibson is (nonverbally) saying.

Let's look at the second Luther Gibson in the margin.

Now, look at the third signature. How would you describe him?

And another, the fourth signature.

And the last signature? How would you read that?

Now regard your own signature and respond to the nonverbal message of its line. Write your name in three different ways, each time responding to the message. Next, think back on how you responded differently to each of these signatures; recall that the name that was formed by the "drawings" did not change. What, then, were you responding to?

You were seeing and responding to the *felt,* individual qualities of each "drawn" line or set of lines. You responded to the felt speed of the line, the size and spacing of the marks, the muscle tension or lack of tension. All of that is precisely communicated by the line, the directional pattern or lack of pattern—in other words, by the whole signatures and all of their parts at once. A person's signature is an individual expression so unique to the writer that it is identified legally as being "owned" by that single person and none other.

Your signature, however, does more than identify you. It also expresses *you* and your individuality, your creativity. Your signature is *true* to yourself. In this sense, you already speak the non-verbal language of art: You are using the basic element of drawing, line, in an expressive way, unique to yourself.

In the chapters to follow, therefore, we won't dwell on what you can do already. Instead, the aim is to teach you *how to see* so that you can use your expressive, individual line to draw your perceptions.

Drawing as a mirror and metaphor for the artist

The object of drawing is not only to show what you are trying to portray, but also to show you. To illustrate how much personal style is embedded in drawings, I wish to show you two drawings on page 24, done at the same time by two different people—myself and artist/teacher Brian Bomeisler. We sat on either side of our model, Heather Allan. We were demonstrating how to draw a profile portrait for a group of students, the same profile portrait you will learn to do in Chapter Nine. The materials we used were identical, and we both drew for the same length of time—30 to 40 minutes. A viewer immediately sees that the model is the same—that is, both drawings achieve a likeness of Heather. But Brian's portrayal expresses his response to Heather in his more "painterly" style (meaning emphasis on shapes), and my portrayal expresses *my* response in my more "linear" style (emphasis on line). By looking at my portrait of Heather, the viewer catches sight of me, and Brian's drawing provides an

Torii Kiyotada (active 1723–1750), *Actor Dancing,* and Torii Kiyonobu I (1664–1729), *Woman Dancer* (c. 1708). Courtesy of The Metropolitan Museum of Art, Harris Brisbane Dick Fund, 1949.

Line expresses two different kinds of dances in the two Japanese prints. Try to visualize each dance. Can you hear the music in your imagination? Try to see how the character of the line controls your response to the drawing.

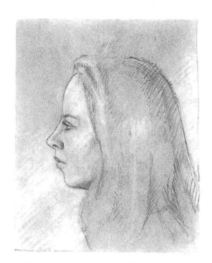

Heather by instructor Brian Bomeisler.

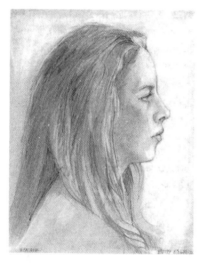

Heather by the author.

insight into him. Thus, paradoxically, the more clearly you can perceive and draw what you see in the external world, the more clearly the viewer can see *you,* and the more you can know about yourself. Drawing becomes a metaphor for the artist.

Because the exercises in this book focus on expanding your *perceptual* powers, not on techniques of drawing, your individual style—your unique and valuable manner of drawing—will emerge intact. This is true even though the exercises concentrate on realistic drawings, which tend to "look alike" in a large sense. (This probably is true only for this century, because we are used to seeing radically different forms of art, both stylistically and culturally.) But a closer look at realistic art reveals subtle differences in line style, emphasis, and intent. In this age of massive self-expression in the arts, this more subtle communication often goes unnoticed and unappreciated.

As your skills in seeing increase, your ability to draw what you see will increase, and you will observe your style forming. Guard it, nurture it, and cherish it, for your style expresses you. As with the Zen master-archer, the target is yourself.

Fig. 2-2. Rembrandt Van Rijn (1606–1669), *Winter Landscape* (c. 1649). Courtesy of The Fogg Art Museum, Harvard University.

Rembrandt drew this tiny landscape with a rapid calligraphic line. Through it, we sense Rembrandt's visual and emotional response to the deeply silent winter scene. We see, therefore, not only the landscape; we see *through* the landscape to Rembrandt himself.

Artists are known by their unique line qualities, and experts in drawing often base their authentication of drawings on these known line qualities. Styles of line have actually been put into named categories. There are quite a few: the "bold line;" the "broken line" (sometimes called "the line that repeats itself"); the "pure line"—thin and precise, sometimes called "the Ingres line" after the 19th century French artist Jean-Auguste Dominique Ingres; the "lost-and-found line," which starts out dark, fades away, then becomes dark again. See samples in figure 2-3.

Beginning students most often admire drawings done in a rapid, self-confident style—the "bold" line that is rather like Picasso's, in fact. But an important point to remember is that *every style of line is valued, one not more than another.*

A "bold" line.

A "broken" line.

A "pure" line.

A "lost-and-found" line.

Fig. 2-3.

3 Your Brain: The Right and Left of It

H OW DOES THE HUMAN BRAIN WORK? That remains the most baffling and elusive of all questions having to do with human understanding. Despite centuries of study and thought and the accelerating rate of knowledge in recent years, the brain still engenders awe and wonder at its marvelous capabilities—many of which we simply take for granted.

Scientists have targeted visual perception in particular with highly precise studies, and yet vast mysteries still exist. The most ordinary activities are awe-inspiring. For example, in a recent contest, people were shown a photograph of six mothers and their six children, arranged randomly in a group. Contestants, strangers to the photographed group, were asked to link the six mother-and-child pairs. Forty people responded, and each had paired all of the mothers and children correctly.

To think of the complexity of that task is to make one's head spin. Our faces are more alike than unlike: two eyes, a nose, a mouth, hair, and two ears, all more or less the same size and in the same places on our heads. Telling two people apart requires fine discriminations beyond the capability of nearly all computers, as I mentioned in the Introduction. In this contest, participants had to distinguish each adult from all the others and estimate, using even finer discriminations, which child's features/head-shape/expression best fitted with which adult. The fact that people can accomplish this astounding feat and not realize how astounding it is forms, I think, a measure of our underestimation of our visual abilities.

Another extraordinary activity is drawing. As far as we know, of all the creatures on this planet, human beings are the only ones who draw images of things and persons in their environment. Monkeys and elephants have been persuaded to paint and draw and their artworks have been exhibited and sold. And, indeed, these works do seem to have expressive content, but they are never realistic images of the animals' perceptions. Animals do not do still-life, landscape, or portrait drawing. So unless there is some monkey that we don't know about out there in the forest drawing pictures of other monkeys, we can assume that drawing

perceived images is an activity confined to human beings and made possible by our human brain.

Both sides of your brain

Seen from above, the human brain resembles the halves of a walnut—two similar appearing, convoluted, rounded halves connected at the center (Figure 3-1). The two halves are called the "left hemisphere" and the "right hemisphere."

The left hemisphere controls the right side of the body; the right hemisphere controls the left side. If you suffer a stroke or accidental brain damage to the left half of your brain, for example, the right half of your body will be most seriously affected and vice versa. As part of this crossing over of the nerve pathways, the left hand is controlled by the right hemisphere; the right hand, by the left hemisphere, as shown in Figure 3-2.

The double brain

With the exception of human beings and possibly songbirds, the greater apes, and certain other mammals, the cerebral hemispheres (the two halves of the brain) of Earth's creatures are

Fig. 3-1.

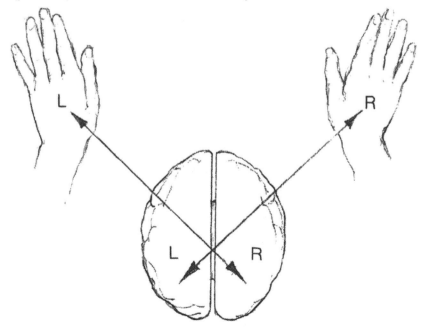

Fig. 3-2. The crossover connections of left hand to right hemisphere, right hand to left hemisphere.

essentially alike, or symmetrical, both in appearance and in function. Human cerebral hemispheres, and those of the exceptions noted above, develop asymmetrically in terms of function. The most noticeable outward effect of the asymmetry of the human brain is handedness, which seems to be unique to human beings and possibly chimpanzees.

For the past two hundred years or so, scientists have known that language and language-related capabilities are mainly located in the left hemispheres of the majority of individuals—approximately 98 percent of right-handers and about two-thirds of left-handers. Knowledge that the left half of the brain is specialized for language functions was largely derived from observations of the effects of brain injuries. It was apparent, for example, that an injury to the left side of the brain was more likely to cause a loss of speech capability than an injury of equal severity to the right side.

Because speech and language are such vitally important human capabilities, nineteenth-century scientists named the left hemisphere the "dominant," "leading," or "major" hemisphere. Scientists named the right brain the "subordinate" or "minor" hemisphere. The general view, which prevailed until fairly

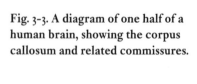

Fig. 3-3. A diagram of one half of a human brain, showing the corpus callosum and related commissures.

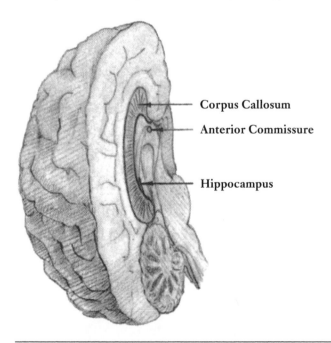

Corpus Callosum

Anterior Commissure

Hippocampus

recently, was that the right half of the brain was less advanced, less evolved than the left half—a mute twin with lower-level capabilities, directed and carried along by the verbal left hemisphere. Even as late as 1961, neuroscientist J. Z. Young could still wonder whether the right hemisphere might be merely a "vestige," though he allowed that he would rather keep than lose his. [Quoted from *The Psychology of Left and Right,* M. Corbalis and Ivan Beale, Hillsdale, NJ: Lawrence Erlbaum Associates, 1976, p. 101.]

A long-time focus of neuroscientific study has been the functions, unknown until fairly recently, of a thick nerve cable composed of millions of fibers that cross-connect the two cerebral hemispheres. This connecting cable, the corpus callosum, is shown in the diagrammatic drawing of half of a human brain, Figure 3-3. Because of its large size, tremendous number of nerve fibers, and strategic location as a connector of the two hemispheres, the corpus callosum gave all the appearances of being an important structure. Yet enigmatically, available evidence indicated that the corpus callosum could be completely severed without observable significant effect. Through a series of animal studies during the 1950s, conducted mainly at the California Institute of Technology by Roger W. Sperry and his students, Ronald Myers, Colwyn Trevarthen, and others, it was established that a main function of the corpus callosum was to provide communication between the two hemispheres and to allow transmission of memory and learning. Furthermore, it was determined that if the connecting cable was severed the two brain halves continued to function independently, thus explaining in part the apparent lack of effect on behavior and functioning.

Then during the 1960s, extension of similar studies to human neurosurgical patients provided further information on the function of the corpus callosum and caused scientists to postulate a revised view of the relative capabilities of the halves of the human brain: that both hemispheres are involved in higher cognitive functioning, with each half of the brain specialized in complementary fashion for different modes of thinking, both highly complex.

As journalist Maya Pines stated in her 1982 book, *The Brain Changers,* "All roads lead to Dr. Roger Sperry, a California Institute of Technology psychobiology professor who has the gift of making—or provoking—important discoveries."

"The main theme to emerge . . . is that there appear to be two modes of thinking, verbal and nonverbal, represented rather separately in left and right hemispheres, respectively, and that our educational system, as well as science in general, tends to neglect the nonverbal form of intellect. What it comes down to is that modern society discriminates against the right hemisphere."

— Roger W. Sperry
"Lateral Specialization of Cerebral Function in the Surgically Separated Hemispheres," 1973

Because this changed perception of the brain has important implications for education in general and for learning to draw in particular, I'll briefly describe some of the research often referred to as the "split-brain" studies. The research was mainly carried out at Cal Tech by Sperry and his students Michael Gazzaniga, Jerre Levy, Colwyn Trevarthen, Robert Nebes, and others.

The investigation centered on a small group of individuals who came to be known as the commissurotomy, or "split-brain," patients. They are persons who had been greatly disabled by epileptic seizures that involved both hemispheres. As a last-resort measure, after all other remedies had failed, the incapacitating spread of seizures between the two hemispheres was controlled by means of an operation, performed by Phillip Vogel and Joseph Bogen, that severed the corpus callosum and the related commissures, or cross-connections, thus isolating one hemisphere from the other. The operation yielded the hoped-for result: The patients' seizures were controlled and they regained health. In spite of the radical nature of the surgery, the patients' outward appearance, manner, and coordination were little affected; and to casual observation their ordinary daily behavior seemed little changed.

The Cal Tech group subsequently worked with these patients in a series of ingenious and subtle tests that revealed the separated functions of the two hemispheres. The tests provided surprising new evidence that each hemisphere, in a sense, perceives its own reality—or perhaps better stated, perceives reality in its own way. The verbal half of the brain—the left half—dominates most of the time in individuals with intact brains as well as in the split-brain patients. Using ingenious procedures, however, the Cal Tech group tested the patients' separated right hemispheres and found evidence that the right, nonspeaking half of the brain also experiences, responds with feelings, and processes information on its own. In our own brains, with intact corpus callosa, communication between the hemispheres melds or reconciles the two perceptions, thus preserving our sense of being one person, a unified being.

In addition to studying the right/left separation of inner

mental experience created by the surgical procedure, the scientists examined the different ways in which the two hemispheres process information. Evidence accumulated showing that the mode of the left hemisphere is verbal and analytic, while that of the right is nonverbal and global. New evidence found by Jerre Levy in her doctoral studies showed that the mode of processing used by the right brain is rapid, complex, whole-pattern, spatial, and perceptual—processing that is not only different from but comparable in complexity to the left brain's verbal, analytic mode. Additionally, Levy found indications that the two modes of processing tend to interfere with each other, preventing maximal performance; and she suggested that this may be a rationale for the evolutionary development of asymmetry in the human brain—as a means of keeping the two different modes of processing in two different hemispheres.

Based on the evidence of the split-brain studies, the view came gradually that both hemispheres use high human-level cognitive modes which, though different, involve thinking, reasoning, and complex mental functioning. Over the past decade, since the first statement in 1968 by Levy and Sperry, scientists have found extensive supporting evidence for this view, not only in brain-injured patients but also in individuals with normal, intact brains.

A few examples of the specially designed tests devised for use with the split-brain patients might illustrate the separate reality perceived by each hemisphere and the special modes of processing employed. In one test, two different pictures were flashed for an instant on a screen, with a split-brain patient's eyes fixed on a midpoint so that scanning both images was prevented. Each hemisphere, then, received different pictures. A picture of a spoon on the left side of the screen went to the right brain; a picture of a knife on the right side of the screen went to the verbal left brain, as in Figure 3-4. When questioned, the patient gave different responses. If asked to name what had been flashed on the screen, the confidently articulate left hemisphere caused the patient to say, "knife." Then the patient was asked to reach behind a curtain with his left hand (right hemisphere) and pick out what had been flashed on the screen. The patient then picked out a

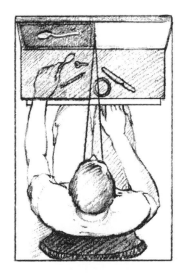

Fig. 3-4. A diagram of the apparatus used to test visual-tactile associations by split-brain patients. Adapted from Michael S. Gazzaniga, "The Split Brain in Man."

spoon from a group of objects that included a spoon and a knife. If the experimenter asked the patient to identify what he held in his hand behind the curtain, the patient might look confused for a moment and then say, "A knife." The right hemisphere, knowing that the answer was wrong but not having sufficient words to correct the articulate left hemisphere, continued the dialogue by causing the patient to mutely shake his head. At that, the verbal left hemisphere wondered aloud, "Why am I shaking my head?"

In another test that demonstrated the right brain to be better at spatial problems, a male patient was given several wooden shapes to arrange to match a certain design. His attempts with his right hand (left hemisphere) failed again and again. His left hand kept trying to help. The right hand would knock the left hand away; and finally, the man had to sit on his left hand to keep it away from the puzzle. When the scientists finally suggested that he use both hands, the spatially "smart" left hand had to shove the spatially "dumb" right hand away to keep it from interfering.

As a result of these extraordinary findings over the past fifteen years, we now know that despite our normal feeling that we are one person—a single being—our brains are double, each half with its own way of knowing, its own way of perceiving external reality. In a manner of speaking, each of us has two minds, two consciousnesses, mediated and integrated by the connecting cable of nerve fibers between the hemispheres.

We have learned that the two hemispheres can work together in a number of ways. Sometimes they cooperate with each half contributing its special abilities and taking on the particular part of the task that is suited to its mode of information processing. At other times, the hemispheres can work singly, with one mode more or less "leading," the other more or less "following." And it seems that the hemispheres may also conflict, one half attempting to do what the other half "knows" it can do better. Furthermore, it may be that each hemisphere has a way of keeping knowledge from the other hemisphere. It may be, as the saying goes, that the right hand truly does not know what the left hand is doing.

The double reality of split-brain patients

But what, you might ask, does all this have to do with learning how to draw? Research on brain-hemisphere aspects of visual perception indicates that ability to draw may depend on whether you can access at conscious level the "minor," or subdominant, R-mode. How does this help a person to draw? It appears that the right brain perceives—processes visual information—in a mode suitable for drawing, and that the left-brain mode of functioning may be inappropriate for complex realistic drawing of perceived forms.

Language clues

In hindsight, we realize that human beings must have had some sense of the differences between the halves of the brain. Languages worldwide contain numerous words and phrases suggesting that the left side of a person has different characteristics from the right side. These terms indicate not just differences in location but differences in fundamental traits or qualities. For example, if we want to compare unlike ideas, we say, "On the one hand ... on the other hand ..." "A left-handed compliment," meaning a sly dig, indicates the differing qualities we assign to left and right.

Keep in mind, however, that these phrases generally speak of hands, but because of the crossover connections of hands and hemispheres, the terms can be inferred also to mean the hemispheres that control the hands. Therefore, the examples of familiar terms in the next section refer specifically to the left and right hands but in reality also refer inferentially to the opposite brain halves—the left hand controlled by the right hemisphere, the right hand by the left hemisphere.

The bias of language and customs

Words and phrases concerning concepts of left and right permeate our language and thinking. The right hand (meaning also the left hemisphere) is strongly connected with what is good, just, moral, and proper. The left hand (therefore the right hemisphere)

Nasrudin was sitting with a friend as dusk fell. "Light a candle," the man said, "because it is dark now. There is one just by your left side." "How can I tell my right from my left in the dark, you fool?" asked the Mulla.

— Indries Shah
The Exploits of the Incomparable Mulla Nasrudin

is strongly linked with concepts of anarchy and feelings that are out of conscious control—somehow bad, immoral, and dangerous.

Until very recently, the ancient bias against the left hand/right hemisphere sometimes even led parents and teachers of left-handed children to try to force the children to use their right hands for writing, eating, and so on—a practice that often caused problems lasting into adulthood.

Throughout human history, terms with connotations of good for the right hand/left hemisphere and connotations of bad for the left hand/right hemisphere appear in most languages around the world. The Latin word for left is *sinister,* meaning "bad," "ominous," "treacherous." The Latin word for right is *dexter,* from which comes our word "dexterity," meaning "skill" or "adroitness."

The French word for left—remember that the left hand is connected to the right hemisphere—is *gauche,* meaning "awkward," from which comes our word "gawky." The French word for right is *droit,* meaning "good," "just," or "proper."

In English, left comes from the Anglo-Saxon *lyft,* meaning "weak" or "worthless." The left hand of most right-handed people is in fact weaker than the right, but the original word also implied lack of moral strength. The derogatory meaning of left may reflect a prejudice of the right-handed majority against a minority of people who were different, that is, left-handed. Reinforcing this bias, the Anglo-Saxon word for right, *reht* (or *riht*), meant "straight" or "just." From *reht* and its Latin cognate *rectus* we derived our words "correct" and "rectitude."

These ideas are also reflected in our political vocabulary. The political right, for instance, admires national power, is conservative, and resists change. The political left, conversely, admires individual autonomy and promotes change, even radical change. At their extremes, the political right is fascist, the political left is anarchist.

In the context of cultural customs, the place of honor at a formal dinner is on the host's right-hand side. The groom stands on the right in the marriage ceremony, the bride on the left—a non-

verbal message of the relative status of the two participants. We shake hands with our right hands; it seems somehow wrong to shake hands with our left hands.

Under "left-handed," the dictionary lists as synonyms "clumsy," "awkward," "insincere," "malicious." Synonyms for "right-handed," however, are "correct," "indispensable," and "reliable." Now, it's important to remember that these terms were all made up, when languages began, by some persons' left hemispheres—the left brain calling the right bad names! And the right brain—labeled, pinpointed, and buttonholed—was without a language of its own to defend itself.

Two ways of knowing

Along with the opposite connotations of left and right in our language, concepts of the duality, or two-sidedness, of human nature and thought have been postulated by philosophers, teachers, and scientists from many different times and cultures. The key idea is that there are two parallel "ways of knowing."

You probably are familiar with these ideas. As with the left/right terms, they are embedded in our languages and cultures. The main divisions are, for example, between thinking and feeling, intellect and intuition, objective analysis and subjective insight. Political writers say that people generally analyze the good and bad points of an issue and then vote on their "gut" feelings. The history of science is replete with anecdotes about researchers who try repeatedly to figure out a problem and then have a dream in which the answer presents itself as a metaphor intuitively comprehended by the scientist. The statement on page 39 by Henri Poincaré is a vivid example of the process.

In another context, people occasionally say about someone, "The words sound okay, but something tells me not to trust him (or her)." Or "I can't tell you in words exactly what it is, but there is something about that person that I like (or dislike)." These statements are intuitive observations that both sides of the brain are at work, processing the same information in two different ways.

Parallel Ways of Knowing

intellect	intuition
convergent	divergent
digital	analogic
secondary	primary
abstract	concrete
directed	free
propositional	imaginative
analytic	relational
lineal	nonlineal
rational	intuitive
sequential	multiple
analytic	holistic
objective	subjective
successive	simultaneous

—J. E. Bogen
"Some Educational Aspects of Hemisphere Specialization" in *UCLA Educator*, 1972

The Duality of *Yin* and *Yang*

Yin	*Yang*
feminine	masculine
negative	positive
moon	sun
darkness	light
yielding	aggressive
left side	right side
cold	warm
autumn	spring
winter	summer
unconscious	conscious
right brain	left brain
emotion	reason

— *I Ching or Book of Changes*, a Chinese Taoist work

The two modes of information processing

Inside each of our skulls, therefore, we have a double brain with two ways of knowing. The dualities and differing characteristics of the two halves of the brain and body, intuitively expressed in our language, have a real basis in the physiology of the human brain. Because the connecting fibers are intact in normal brains, we rarely experience at a conscious level conflicts revealed by the tests on split-brain patients.

Nevertheless, as each of our hemispheres gathers in the same sensory information, each half of our brains may handle the information in different ways: The task may be divided between the hemispheres, each handling the part suited to its style. Or one hemisphere, often the dominant left, will "take over" and inhibit the other half. The left hemisphere analyzes, abstracts, counts, marks time, plans step-by-step procedures, verbalizes, and makes rational statements based on logic. For example, "Given numbers a, b, and c—we can say that if a is greater than b, and b is greater than c, then a is necessarily greater than c." This statement illustrates the left-hemisphere mode: the analytic, verbal, figuring-out, sequential, symbolic, linear, objective mode.

On the other hand, we have a second way of knowing: the right-hemisphere mode. We "see" things in this mode that may be imaginary—existing only in the mind's eye. In the example given just above, did you perhaps visualize the "a, b, c" relationship? In visual mode, we see how things exist in space and how the parts go together to make up the whole. Using the right hemisphere, we understand metaphors, we dream, we create new combinations of ideas. When something is too complex to describe, we can make gestures that communicate. Psychologist David Galin has a favorite example: try to describe a spiral staircase without making a spiral gesture. And using the right-hemisphere mode, we are able to draw pictures of our perceptions.

My students report that learning to draw makes them feel more "artistic" and therefore more creative. One definition of a creative person is someone who can process in new ways information directly at hand—the ordinary sensory data available to

Dr. J. William Bergquist, a mathematician and specialist in the computer language known as APL, proposed in a paper given at Snowmass, Colorado, in 1977 that we can look forward to computers that combine digital and analog functions in one machine. Dr. Bergquist dubbed his machine "The Bifurcated Computer." He stated that such a computer would function similarly to the two halves of the human brain.

"The left hemisphere analyzes over time, whereas the right hemisphere synthesizes over space."

— Jerre Levy
"Psychobiological Implications of Bilateral Asymmetry," 1974

"Every creative act involves . . . a new innocence of perception, liberated from the cataract of accepted belief."

— Arthur Koestler
The Sleepwalkers, 1959

all of us. A writer uses words, a musician notes, an artist visual perceptions, and all need some knowledge of the techniques of their crafts. But a creative individual intuitively sees possibilities for transforming ordinary data into a new creation, transcendent over the mere raw materials.

Time and again, creative individuals have recognized the differences between the two processes of gathering data and transforming those data creatively. Neuroscience is now illuminating that dual process. I propose that getting to know both sides of your brain is an important step in liberating your creative potential.

The Ah-ha! response

In the right-hemisphere mode of information processing, we use intuition and have leaps of insight—moments when "everything seems to fall into place" without figuring things out in a logical order. When this occurs, people often spontaneously exclaim, "I've got it" or "Ah, yes, now I see the picture." The classic example of this kind of exclamation is the exultant cry, "Eureka!" (I have found it!) attributed to Archimedes. According to the story, Archimedes experienced a flash of insight while bathing that enabled him to use the weight of displaced water to determine whether a certain crown was pure gold or alloyed with silver.

This, then, is the right-hemisphere mode: the intuitive, subjective, relational, holistic, time-free mode. This is also the disdained, weak, left-handed mode that in our culture has been generally ignored. For example, most of our educational system has been designed to cultivate the verbal, rational, on-time left hemisphere, while half of the brain of every student is virtually neglected.

Half a brain is better than none: A whole brain would be better

With their sequenced verbal and numerical classes, the schools you and I attended were not equipped to teach the right-hemisphere mode. The right hemisphere is not, after all, under very

The nineteenth-century mathematician Henri Poincaré described a sudden intuition that gave him the solution to a difficult problem:

"One evening, contrary to my custom, I drank black coffee and could not sleep. Ideas rose in crowds; I felt them collide until pairs interlocked, so to speak, making a stable combination." [That strange phenomenon provided the intuition that solved the troublesome problem. Poincaré continued,] "It seems, in such cases, that one is present at his own unconscious work, made partially perceptible to the overexcited consciousness, yet without having changed its nature. Then we vaguely comprehend what distinguishes the two mechanisms or, if you wish, the working methods of the two egos."

Many creative people seem to have intuitive awareness of the separate-sided brain. For example, Rudyard Kipling wrote the following poem, entitled "The Two-Sided Man," more than fifty years ago.

Much I owe to the lands that grew–
　　More to the Lives that fed–
But most to the Allah Who gave me Two
　　Separate sides to my head.
Much I reflect on the Good and the True
　　In the faiths beneath the sun
But most upon Allah Who gave me Two
　　Sides to my head, not one.
I would go without shirt or shoe,
　　Friend, tobacco or bread,
Sooner than lose for a minute the two
　　Separate sides of my head!

— Rudyard Kipling

good verbal control. You can't reason with it. You can't get it to make logical propositions such as "This is good and that is bad, for a, b, and c reasons." It is metaphorically left-handed, with all the ancient connotations of that characteristic. The right hemisphere is not good at sequencing—doing the first thing first, taking the next step, then the next. It may start anywhere, or take everything at once. Furthermore, the right hemisphere hasn't a good sense of time and doesn't seem to comprehend what is meant by the term "wasting time," as does the good, sensible left hemisphere. The right brain is not good at categorizing and naming. It seems to regard the thing as-it-is, at the present moment of the present; seeing things for what they simply are, in all of their awesome, fascinating complexity. It is not good at analyzing and abstracting salient characteristics.

Today, educators are increasingly concerned with the importance of intuitive and creative thought. Nevertheless, school systems in general are still structured in the left-hemisphere mode. Teaching is sequenced: Students progress through grades one, two, three, etc., in a linear direction. The main subjects learners study are verbal and numerical: reading, writing, arithmetic. Nowadays, however, seats often are set circles rather than in rows. Time schedules are more flexible. But learners still converge on "correct" answers to often-ambiguous questions. Teachers still give out grades that often are tied to the "bell curve," which guarantees that one-third of every group will be judged "below average," regardless of achievement. And everyone senses that something is amiss.

The right brain—the dreamer, the artificer, and the artist—is lost in our school system and goes largely untaught. We might find a few art classes, a few shop classes, something called "creative writing," and perhaps courses in music; but it's unlikely that we would find courses in imagination, in visualization, in perceptual or spatial skills, in creativity as a separate subject, in intuition, in inventiveness. Yet educators value these skills and have apparently hoped that students would develop imagination, perception, and intuition as natural consequences of training in verbal, analytic skills.

Fortunately, such development often does occur almost in spite of the school system—a tribute to the survival capacity of creative abilities. But the emphasis of our culture is so strongly slanted toward rewarding left-brain skills that we are surely losing a very large proportion of the potential ability of the other halves of our children's brains. Scientist Jerre Levy has said— only partly humorously—that American scientific training through graduate school may entirely destroy the right hemisphere. We certainly are aware of the effects of inadequate training in verbal, computational skills. The verbal left hemisphere never seems to recover fully, and the effects may handicap students for life. What happens, then, to the right hemisphere that is hardly trained at all?

Perhaps now that neuroscientists have provided a conceptual base for right-brain training, we can begin to build a school system that will teach the whole brain. Such a system will surely include training in drawing skills—an efficient, effective way to teach thinking strategies suited to the right brain.

Handedness, left or right

Students ask many questions about left- and right-handedness. This is a good place to address the subject, before we begin instruction in the basic skills of drawing. I will attempt to clarify only a few points, because the extensive research on handedness is difficult and complicated.

First, classifying people as strictly left-handed or right-handed is not quite accurate. People range from being completely left-handed or completely right-handed to being completely ambidextrous—that is, able to do many things with either hand, without a decided preference. Most of us fall somewhere on a continuum, with about 90 percent of humans preferring, more or less strongly, the right hand, and 10 percent preferring the left.

The percentage of individuals with left-hand preference for handwriting seems to be rising, from about 2 percent in 1932 to about 11 percent in the 1980s. The main reason for this rise is probably that teachers and parents have learned to tolerate left-

"To make biological survival possible, Mind at Large has to be funneled through the reducing valve of the brain and nervous system. What comes out the other end is a measly trickle of the kind of consciousness which will help us to stay alive on the surface of this particular planet. To formulate and express the contents of this reduced awareness, man has invented and endlessly elaborated those symbol-systems and implicit philosophies which we call languages."

— Aldous Huxley
The Doors of Perception

Some famous individuals usually classified as left-handers:

Charlie Chaplin
Judy Garland
Ted Williams
Robert McNamara
George Burns
Lewis Carroll
King George VI of Britain
W. C. Fields
Albert Einstein
Billy the Kid
Queen Victoria
Harry S. Truman
Casey Stengel
Charlemagne
Paul McCartney
Pharoah Rameses II
Cole Porter
Gerald Ford
Cary Grant
Ringo Starr
Prince Charles
Benjamin Franklin
Julius Caesar
Marilyn Monroe
George Bush

Mirror writing reverses the shape of every letter and is written from right to left—that is, backwards. Only when held up to a mirror does it become legible for most readers:

Jabberwocky

'Twas brillig, and the slithy toves
did gyre and gimble in the wabe.
All mimsy were the borogoves,
and the mome raths outgrabe.

The most famous mirror-writer in history is the Italian artist, inventor, and left-hander Leonardo da Vinci. Another is Lewis Carroll, left-handed author of *Alice's Adventures in Wonderland* and its sequel, *Through the Looking-Glass and What Alice Found There*, whose mirror-written poem is shown above.

Most right-handers find mirror writing difficult, but it is quite easy for many left-handers.

Try writing your signature in mirror writing.

handed writing and no longer force children to use the right hand. This relatively new tolerance is fortunate, because forcible change can cause a child to have serious problems, such as stuttering, right/left directional confusion, and difficulty in learning to read.

A useful way to regard handedness is to recognize that hand preference is the most visible outward sign of how an individual's brain is organized. There are other outward signs: eyedness (everyone has a dominant eye, used in sighting along an edge, for example) and footedness (the foot used to step off a curb or to start a dance step). The key reason for not forcing a child to use the nonpreferred hand is that brain organization is probably genetically determined, and forcing a change works against this natural organization. Natural preference is so strong that past efforts to change left-handers often resulted in ambidexterity: children capitulated to pressure (in the old days, even punishment) and learned to use the right hand for writing but continued to use the left for everything else.

Moreover, there is no acceptable reason for teachers or parents to force a change. Reasons proffered run from "Writing with the left hand looks so uncomfortable," to "The world is set up for right-handers and my left-handed child would be at a disadvantage." These are not good reasons, and I believe they often mask an inherent prejudice against left-handedness—a prejudice now rapidly disappearing, I'm happy to report.

Putting prejudice aside, there are important differences between left-handers and right-handers. Left-handers are generally less lateralized than right-handers. Lateralization means the degree to which specific functions are carried out almost exclusively by one hemisphere. For example, left-handers more frequently process language in both hemispheres and process spatial information in both hemispheres than do right-handers. Specifically, language is mediated in the left hemisphere in 90 percent of right-handers and 70 percent of left-handers. Of the remaining 10 percent of right-handers, about 2 percent have language located in the right brain, and about 8 percent mediate language in both hemispheres. Of the remaining 30 percent of left-handers, about

15 percent have language located in the right brain, and about 15 percent mediate language in both hemispheres. Note that individuals with right-hemisphere language location—termed right-hemisphere dominance, since language dominates—often write in the "hooked" position that seems to cause teachers so much dismay. Scientist Jerre Levy has proposed that hand position in writing is another outward sign of brain organization.

Do these differences matter? Individuals vary so much that generalizations are risky. Nevertheless, experts agree in general that a mixture of functions in both hemispheres (that is, a lesser degree of lateralization) creates the potential for conflict or interference. It is true that left-handers statistically are more prone to stutter and to experience the reading difficulty called dyslexia. However, other experts suggest that bilateral distribution of functions may produce superior mental abilities. Left-handers excel in mathematics, music, and chess. And the history of art certainly gives evidence of an advantage for left-handedness: Leonardo da Vinci, Michelangelo, and Raphael were all left-handed.

Former United States Vice President Nelson Rockefeller, a changed left-hander, had difficulty reading prepared speeches because of a tendency to read backward from right to left. The cause of this difficulty may have been his father's unrelenting effort to change his son's left-handedness.

"Around the family dinner table, the elder Mr. Rockefeller would put a rubber band around his son's left wrist, tie a long string on it and jerk the string whenever Nelson started to eat with his left hand, the one he naturally favored."

— Quoted in *The Left-Handers' Handbook* by J. Bliss and J. Morella, 1980

Eventually, young Nelson capitulated and achieved a rather awkward ambidextrous compromise, but he suffered the consequences of his father's rigidity throughout his lifetime.

Aztecs in early Mexico used the left hand for medicine for kidney trouble, the right when curing the liver.

From *The Left-Handers' Handbook*, by J. Bliss and J. Morella.

The Incas of ancient Peru considered left-handedness a sign of good fortune.

Mayan Indians were pro-right: the twitching of a soothsayer's left leg foretold disaster.

A comparison of left-mode and right-mode characteristics

L-mode

R-mode

Verbal	*Using words to name, describe, define.*	**Nonverbal**	*Using non-verbal cognition to process perceptions.*
Analytic	*Figuring things out step-by-step and part-by-part.*	**Synthetic**	*Putting things together to form wholes.*
Symbolic	*Using a symbol to stand for something. For example, the drawn form ◉ stands for eye, the sign ✚ stands for the process of addition.*	**Actual, real**	*Relating to things as they are, at the present moment.*
Abstract	*Taking out a small bit of information and using it to represent the whole thing.*	**Analogic**	*Seeing likenesses among things; understanding metaphoric relationships.*
Temporal	*Keeping track of time, sequencing one thing after another: Doing first things first, second things second, etc.*	**Nontemporal**	*Without a sense of time.*
Rational	*Drawing conclusions based on reason and facts.*	**Nonrational**	*Not requiring a basis of reason or facts; willingness to suspend judgment.*
Digital	*Using numbers as in counting.*	**Spatial**	*Seeing where things are in relation to other things and how parts go together to form a whole.*
Logical	*Drawing conclusions based on logic: one thing following another in logical order— for example, a mathematical theorem or a well-stated argument.*	**Intuitive**	*Making leaps of insight, often based on incomplete patterns, hunches, feelings, or visual images.*
Linear	*Thinking in terms of linked ideas, one thought directly following another, often leading to a convergent conclusion.*	**Holistic**	*(meaning "wholistic") Seeing whole things all at once; perceiving the overall patterns and structures, often leading to divergent conclusions.*

Handedness and drawing

Does left-handedness, then, improve a person's ability to gain access to right-hemisphere functions such as drawing? From my observations as a teacher, I can't say that I have noticed much difference in ease of learning to draw between left- and right-handers. Drawing came easily to me, for example, and I am extremely right-handed—though, like many people, I have some right/left confusion, perhaps indicating bilateral functions. (A person with right/left confusion is one who says "Turn left," while pointing right.) But there is a point to be made here. The process of learning to draw creates quite a lot of mental conflict. It's possible that left-handers are more used to that kind of conflict and are therefore better able to cope with the discomfort it creates than are fully lateralized right-handers. Clearly, much research is needed in this area.

Some art teachers recommend that right-handers shift the pencil to the left hand, presumably to have more direct access to R-mode. I do not agree. The problems with seeing that prevent individuals from being able to draw do not disappear simply by changing hands; the drawing is just more awkward. Awkwardness, I regret to say, is viewed by some art teachers as being more creative or more interesting. I think this attitude does a disservice to the student and is demeaning to art itself. We do not view awkward language, for instance, or awkward science as being more creative and somehow better.

A small percentage of students do discover by trying to draw with the left hand that they actually draw more proficiently that way. On questioning, however, it almost always comes to light that the student has some ambidexterity or was a left-hander who had been pressured to change. It would not even occur to a true right-hander like myself (or to a true left-hander) to draw with the less-used hand. But on the chance that a few of you may discover some previously hidden ambidexterity, I encourage you to try both hands at drawing, then settle on whichever hand feels the most comfortable.

Sigmund Freud, Hermann von Helmholtz, and the German poet Schiller were afflicted with right/left confusion. Freud wrote to a friend:

"I do not know whether it is obvious to other people which is their own or other's right or left. In my case, I had to think which was my right; no organic feeling told me. To make sure which was my right hand I used quickly to make a few writing movements."

— Sigmund Freud
The Origins of Psychoanalysis

A less august personage had the same problem:

Pooh looked at his two paws. He knew that one of them was the right, and he knew that when you had decided which one of them was the right, that the other one was the left, but he never could remember how to begin. "Well," he said slowly . . .

— A. A. Milne
The House at Pooh Corner

In the chapters to follow, I will address the instructions to right-handers and thus avoid tedious repetition of instructions specifically for left-handers, with no intention of the "handism" that left-handers know so well.

Setting up the conditions for the L→R shift

The exercises in the next chapter are specifically designed to cause a (hypothesized) mental shift from L-mode to R-mode. The basic assumption of the exercises is that the nature of the task can influence which mode will "take up" the job while inhibiting the other hemisphere. But the question is what factors determine which mode will predominate?

Through studies with animals, split-brain patients, and individuals with intact brains, scientists believe that the control question may be decided mainly in two ways. One way is speed: Which hemisphere gets to the job the quickest? A second way is motivation: Which hemisphere cares most or likes the task the best? And conversely: Which hemisphere cares least and likes the job the least?

Since drawing a perceived form is largely an R-mode function, it helps to reduce L-mode interference as much as possible. The problem is that the left brain is dominant and speedy and is very prone to rush in with words and symbols, even taking over jobs which it is not good at. The split brain studies indicated that dominant L-mode prefers not to relinquish tasks to its mute partner unless it really dislikes the job—either because the job takes too much time, is too detailed or slow or because the left brain is simply unable to accomplish the task. That's exactly what we need—tasks that the dominant left brain will turn down. The exercises that follow are designed to present the brain with a task that the left hemisphere either can't or won't do.

And now if e'er by chance I put

My fingers into glue

Or madly squeeze a right-hand foot

Into a left-hand shoe. . . .

— Lewis Carroll
Upon the Lonely Moor, 1856

4 Crossing Over: Experiencing the Shift from Left to Right

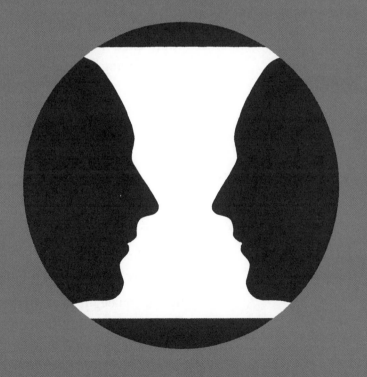

Vases and faces: An exercise for the double brain

The exercises that follow are specifically designed to help you understand the shift from dominant left-hemisphere mode to subdominant R-mode. I could go on describing the process over and over in words, but only you can experience for yourself this cognitive shift, this slight change in subjective state. As Fats Waller once said, "If you gotta ask what jazz is, you ain't never gonna know." So it is with R-mode state: You must experience the L- to R-mode shift, observe the R-mode state, and in this way come to know it. As a first step, the exercise below is designed to cause conflict between the two modes.

Following is a quick exercise designed to induce mental conflict.

What you'll need:

- Drawing paper
- Your #2 writing pencil
- Your pencil sharpener
- Your drawing board and masking tape

Figure 4-1 is a famous optical-illusion drawing, called "Vase/Faces" because it can be seen as either:
- two facing profiles
 or
- a symmetrical vase in the center.

What you'll do:

Your job, of course, is to complete the second profile, which will inadvertently complete the symmetrical vase in the center.

Before you begin: Read all the directions for the exercise.
1. Copy the pattern (either Figure 4-2 or 4-3). If you are right-handed, copy the profile on the left side of the paper, facing toward the center. If you are left-handed, draw the profile on the right side, facing toward the center. Examples are shown of both the right-handed and left-handed drawings. Make up

A puzzle: **"If one picture is worth a thousand words, can a thousand words explicate one picture?"**

— **Michael Stephan**
A Transformational Theory of Aesthetics,
London: Routledge, 1990

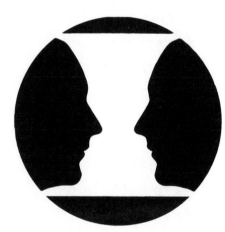

Fig. 4-1.

your own version of the profile if you wish.

2. Next, draw horizontal lines at the top and bottom of your profile, forming top and bottom of the vase (Figures 4-2 and 4-3).

3. Now, redraw the profile on your "Vase/Faces" pattern. Just take your pencil and go over the lines, naming the parts as you go, like this: "Forehead . . . nose . . . upper lip . . . lower lip . . . chin . . . neck." You might even do that a second time, redrawing one more time and really thinking to yourself what those terms mean.

4. Then, go to the other side and start to draw the missing profile that will complete the symmetrical vase.

5. When you get to somewhere around the forehead or nose, you may begin perhaps to experience some confusion or conflict. Observe this as it happens.

6. The purpose of this exercise is for you to self-observe: "How do I solve the problem?"

Begin the exercise now. It should take you about five or six minutes.

Fig. 4-2. For left-handers.

Why you did this exercise:

Nearly all of my students experience some confusion or conflict while doing this exercise. A few people experience a great deal of conflict, even a moment of paralysis. If this happened to you, you may have come to a point where you needed to change direction in the drawing, but didn't know which way to go. The conflict may have been so great that you could not make your hand move the pencil to the right or the left.

Fig. 4-3. For right-handers.

That is the purpose of the exercise: to create conflict so that each person can experience in their own minds the mental "crunch" that can occur when instructions are inappropriate to the task at hand. I believe that the conflict can be explained as follows:

I gave you instructions that strongly "plugged in" the verbal system in the brain. Remember that I insisted that you name each

part of the profile and I said, "Now, really think what those terms mean."

Then, I gave you a task (to complete the second profile and, simultaneously, the vase) that can only be done by shifting to the visual, spatial mode of the brain. This is the part of the brain that can perceive and nonverbally assess relationship of sizes, curves, angles, and shapes.

The difficulty of making that mental shift causes a feeling of conflict and confusion—and even a momentary mental paralysis.

You may have found a way to solve the problem, thereby enabling yourself to complete the second profile and therefore the symmetrical vase.

How did you solve it?

- By deciding not to think of the names of the features?
- By shifting your focus from the face-shapes to the vase-shapes?
- By using a grid (drawing vertical and horizontal lines to help you see relationships)? Or perhaps by marking points where the outermost and innermost curves occurred?
- By drawing from the bottom up rather than from the top down?
- By deciding that you didn't care whether the vase was symmetrical or not and drawing any old memorized profile just to finish with the exercise? (With this last decision, the verbal system "won" and the visual system "lost.")

Let me ask you a few more questions. Did you use your eraser to "fix up" your drawing? If so, did you feel guilty? If so, why? (The verbal system has a set of memorized rules, one of which may be, "You can't use an eraser unless the teacher says it's okay.") The visual system, which is largely without language, just keeps looking for ways to solve the problem according to another kind of logic—visual logic.

To sum up, the point of the seemingly simple "Vase/Faces" exercise is this:

In order to draw a perceived object or person—something that you see with your eyes—you must make a mental shift to a

By the way, I must mention that the eraser is just as important a tool for drawing as the pencil. I'm not exactly sure where the notion "erasing is bad" came from. The eraser allows you to correct your drawings. My students certainly see me erasing when I do demonstration drawings in our workshops.

brain-mode that is specialized for this visual, perceptual task.

The difficulty of making this shift from verbal to visual mode often causes conflict. Didn't you feel it? To reduce the discomfort of the conflict, you stopped (do you remember feeling stopped short?) and made a new start. That's what you were doing when you gave yourself instructions—that is, gave your brain instructions—to "shift gears," or "change strategy," or "don't do this; do that," or whatever terms you may have used to cause a cognitive shift.

There are numerous solutions to the mental "crunch" of the "Vase/Faces" Exercise. Perhaps you found a unique or unusual solution. To capture your personal solution in words, you might want to write down what happened on the back of your drawing.

Thomas Gladwin, an anthropologist, contrasted the ways that a European and a native Trukese sailor navigated small boats between tiny islands in the vast Pacific Ocean.

Before setting sail, the European begins with a plan that can be written in terms of directions, degrees of longitude and latitude, estimated time of arrival at separate points on the journey. Once the plan is conceived and completed, the sailor has only to carry out each step consecutively, one after another, to be assured of arriving on time at the planned destination. The sailor uses all available tools, such as a compass, a sextant, a map, etc., and if asked, can describe exactly how he got where he was going.

The European navigator uses the left-hemisphere mode.

In contrast, the native Trukese sailor starts his voyage by *imaging the position* of his destination *relative to the position* of other islands. As he sails along, he constantly adjusts his direction according to his awareness of his position *thus far.* His decisions are improvised continually by checking relative positions of landmarks, sun, wind direction, etc. He navigates with reference to where he started, where he is going, and the space between his destination and the point *where he is at the moment.* If asked how he navigates so well without instruments or a written plan, he cannot possibly put it into words. This is not because the Trukese are unaccustomed to describing things in words, but rather because the process is too complex and fluid to be put into words.

The Trukese navigator uses the right-hemisphere mode.

—J. A. Paredes and M. J. Hepburn "The Split-Brain and the Culture-Cognition Paradox," 1976

Charles Tart, professor of psychology at the University of California, Davis, states: "We begin with a concept of some kind of basic *awareness*, some kind of basic ability to 'know' or 'sense' or 'cognize' or 'recognize' that something is happening. This is a fundamental theoretical and experiential given. We do not know scientifically what the ultimate nature of awareness is, but it is our starting point."

— Charles T. Tart
Alternate States of Consciousness, 1975

Navigating a drawing in right-hemisphere mode

When you did your drawing of the Vase/Faces, you drew the first profile in the left-hemisphere mode, like the European navigator, taking one part at a time and naming the parts one by one. The second profile was drawn in the right-hemisphere mode. Like the navigator from the South Sea Island of Truk, you constantly scanned to adjust the direction of the line. You probably found that naming the parts such as forehead, nose, or mouth seemed to confuse you. It was better not to think of the drawing as a face. It was easier to use the shape of the space between the two profiles as your guide. Stated differently, it was easiest not to think at all—that is, in words. In right-hemisphere-mode drawing, the mode of the artist, if you do use words to think, ask yourself only such things as:

"Where does that curve start?"

"How deep is that curve?"

"What is that angle relative to the edge of the paper?"

"How long is that line relative to the one I've just drawn?"

"Where is that point as I scan across to the other side—where is that point relative to the distance from the top (or bottom) edge of the paper?"

These are R-mode questions: spatial, relational, and comparative. Notice that no parts are named. No statements are made, no conclusions drawn, such as, "The chin must come out as far as the nose," or "Noses are curved."

A brief review: What is learned in "learning to draw"?

Realistic drawing of a perceived image requires the visual mode of the brain, most often mainly located in the right hemisphere. This visual mode of thinking is fundamentally different from the brain's verbal system—the one we largely rely on nearly all of our waking hours.

For most tasks, the two modes are combined. Drawing a perceived object or person may be one of the few tasks that requires mainly one mode: the visual mode largely unassisted by the ver-

bal mode. There are other examples. Athletes and dancers, for instance, seem to perform best by quieting the verbal system during performances. Moreover, a person who needs to shift in the other direction, from visual to verbal mode, can also experience conflict. A surgeon once told me that while operating on a patient (mainly a visual task, once a surgeon has acquired the knowledge and experience needed) he would find himself unable to name the instruments. He would hear himself saying to an attendant, "Give me the … the … you know, the … thingamajig!"

Learning to draw, therefore, turns out not to be "learning to draw." Paradoxically, learning to draw means learning to access at will that system in the brain that is the appropriate one for drawing. Putting it another way, accessing the visual mode of the brain—the appropriate mode for drawing—causes you to see in the special way an artist sees. The artist's way of seeing is different from ordinary seeing and requires an ability to make mental shifts at conscious level. Put another way and perhaps more accurately, the artist is able to set up conditions that cause a cognitive shift to "happen." That is what a person trained in drawing does, and that is what you are about to learn.

Again, this ability to see things differently has many uses in life aside from drawing—not the least of which is creative problem solving.

Keeping the "Vase/Faces" lesson in mind, then, try the next exercise, one that I designed to reduce conflict between the two brain-modes. The purpose of this exercise is just the reverse of the previous one.

Upside-down drawing: Making the shift to R-mode

Familiar things do not look the same when they are upside down. We automatically assign a top, a bottom, and sides to the things we perceive, and we expect to see things oriented in the usual way—that is, right side up. For, in upright orientation, we can recognize familiar things, name them, and categorize them by matching what we see with our stored memories and concepts.

When an image is upside down, the visual clues don't match.

"The object of painting a picture is not to make a picture—however unreasonable that may sound … The object, which is back of every true work of art, is the attainment of a *state of being* [Henri's emphasis], a state of high functioning, a more than ordinary moment of existence. [The picture] is but a by-product of the state, a trace, the footprint of the state."

From *The Art Spirit* by American artist and teacher Robert Henri, B. Lippincott Company, 1923.

The message is strange, and the brain becomes confused. We see the shapes and the areas of light and shadow. We don't particularly object to looking at upside-down pictures unless we are called on to name the image. Then the task becomes exasperating.

Seen upside down, even well-known faces are difficult to recognize and name. For example, the photograph in Figure 4-4 is of a famous person. Do you recognize who it is?

You may have had to turn the photograph right side up to see that it is Albert Einstein, the famous scientist. Even after you

Fig. 4-4. Photograph by Philippe Halsman.

know who the person is, the upside-down image probably continues to look strange.

Inverted orientation causes recognition problems with other images (see Figure 4-5). Your own handwriting, turned upside down, is probably difficult for you to figure out, although you've been reading it for years. To test this, find an old shopping list or letter in your handwriting and try to read it upside down.

A complex drawing, such as the one shown upside down in the Tiepolo drawing, Figure 4-6, is almost indecipherable. The (left) mind just gives up on it.

Upside-down drawing

An exercise that reduces mental conflict

We shall use this gap in the abilities of the left hemisphere to allow R-mode to have a chance to take over for a while.

Figure 4-7 is a reproduction of a line drawing by Picasso of the composer Igor Stravinsky. The image is upside down. You will be copying the upside-down image. Your drawing, therefore, will be done also upside down. In other words, you will copy the Picasso drawing just as you see it. See Figures 4-8 and 4-9.

What you'll need:

- The reproduction of the Picasso drawing, Fig. 4-7, p. 58.
- Your #2 writing pencil, sharpened.
- Your drawing board and masking tape.
- Forty minutes to an hour of uninterrupted time.

What you'll do:

Before you begin: Read all of the following instructions.
 1. Play music if you like. As you shift into R-mode, you may find that the music fades out. Finish the drawing in one sitting, allowing yourself at least forty minutes—more if possible. And more important, do not turn the drawing right side up until you have finished. Turning the drawing would cause a shift back to L-mode, which we want to avoid while you are

Fig. 4-5. In copying signatures, forgers turn the originals upside down to see the exact shapes of the letters more clearly—to see, in fact, in the artist's mode.

Fig. 4-6. Giovanni Battista Tiepolo (1696–1770), *The Death of Seneca.* Courtesy of The Art Institute of Chicago, Joseph and Helen Regenstein Collection.

Photograph by Philippe Halsman, 1947. © Yvonne Halsman, 1989. This is the full photograph shown upside down on the page 56. We are indebted to Yvonne Halsman for allowing this unorthodox presentation of Philippe Halsman's famous image of Einstein.

learning to experience the focused R-mode state of awareness.

2. You may start anywhere you wish—bottom, either side, or the top. Most people tend to start at the top. Try not to figure out what you are looking at in the upside-down image. It is better not to know. Simply start copying the lines. But remember: don't turn the drawing right side up!

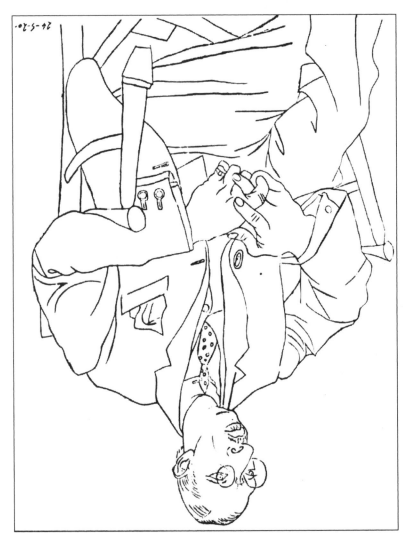

Fig. 4-7. Pablo Picasso (1881–1973), *Portrait of Igor Stravinsky*. Paris, May 21, 1920 (dated). Privately owned.

3. I recommend that you not try to draw the entire outline of the form and then "fill in" the parts. The reason is that if you make any small error in the outline, the parts inside won't fit. One of the great joys of drawing is the discovery of how the parts fit together. Therefore, I recommend that you move from line to adjacent line, space to adjacent shape, working your way through the drawing, fitting the parts together as you go.

4. If you talk to yourself at all, use only the language of vision, such as: "This line bends this way," or, "That shape has a curve there," or "Compared to the edge of the paper (vertical or horizontal), this line angles like that," and so on. What you do not want to do is to name the parts.

5. When you come to parts that seem to force their names on you—the H-A-N-D-S and the F-A-C-E—try to focus on these parts just as shapes. You might even cover up with one hand or finger all but the specific line you are drawing and then uncover each adjacent line. Alternatively, you might shift to another part of the drawing.

6. At some point, the drawing may begin to seem like an interesting, even fascinating, puzzle. When this happens, you will be "really drawing," meaning that you have successfully shifted to R-mode and you are seeing clearly. This state is easily broken. For example, if someone were to come into the room and ask, "How are you doing?" your verbal system would be reactivated and your focus and concentration would be over.

7. You may even want to cover most of the reproduced drawing with another piece of paper, slowly uncovering new areas as you work your way down through the drawing. A note of caution, however: Some of my students find this ploy helpful, while some find it distracting and unhelpful.

8. Remember that everything you need to know in order to draw the image is right in front of your eyes. All of the information is right there, making it easy for you. Don't make it complicated. It really is as simple as that.

Begin your Upside-Down Drawing now.

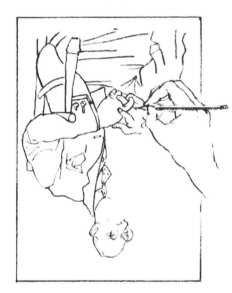

Figs. 4-8, 4-9. Inverted drawing. Forcing the cognitive shift from the dominant left-hemisphere mode to the subdominant right-hemisphere mode.

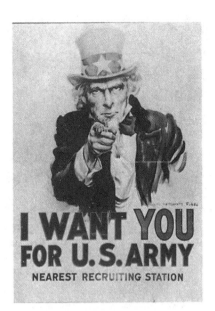

Uncle Sam's arm and hand are "foreshortened" in this Army poster. Foreshortening is an art term. It means that, in order to give the illusion of forms advancing or receding in space, the forms must be drawn just as they appear in that position, not depicting what we know about their actual length. Learning to "foreshorten" is often difficult for beginners in drawing.

Fig. 4-11; near right: The Picasso drawing mistakenly copied right side up by a university student.

Fig. 4-12; far right: The Picasso drawing copied upside down the next day by the same student.

After you have finished:

Turn both of the drawings—the reproduction in the book and your copy—right side up. I can confidently predict that you will be pleased with your drawing, especially if you have thought in the past that you would never be able to draw.

I can also confidently predict that the most "difficult" parts, the "foreshortened" areas, are beautifully drawn, creating a spatial illusion.

Yet, see what you have accomplished, drawing upside down. If you used Picasso's drawing of Igor Stravinsky seated in a chair, you drew the crossed legs beautifully in foreshortened view. For most of my students, this is the finest part of their drawing, despite the foreshortening. How could they draw this "difficult" part so well? Because they didn't know what they were drawing! They simply drew what they saw, just as they saw it—one of the most important keys to drawing well. The same applies to the foreshortened horse in the German drawing, Figure 4-13.

A logical box for L-mode

Figure 4-11 and Figure 4-12 show two drawings by the same university student. This student had misunderstood my instructions to the class and did the drawing right side up. When he came to class the next day, he showed me his drawing and said, "I misunderstood. I just drew it the regular way." I asked him to do another drawing, this time upside down. He did, and Fig. 4-12 was the result.

It goes against common sense that the upside-down drawing

is so far superior to the drawing done right side up. The student himself was astonished.

This puzzle puts L-mode into a logical box: how to account for this sudden ability to draw well, when the verbal mode has been eased out of the task. The left brain, which admires a job well done, must now consider the possibility that the disdained right brain is good at drawing

For reasons that are still unclear, the verbal system immediately rejects the task of "reading" and naming upside-down images. L-mode seems to say, in effect, "I don't do upside down. It's too hard to name things seen this way, and, besides, the world isn't upside down. Why should I bother with such stuff?"

Well, that's just what we want! On the other hand, the visual system seems not to care. Right side up, upside down, it's all interesting, perhaps even more interesting upside down because R-mode is free of interference from its verbal partner, which is often in a "rush to judgment" or, at least, a rush to recognize and name.

Why you did this exercise:

The reason you did this exercise, therefore, is to experience escaping the clash of conflicting modes—the kind of conflict and even mental paralysis that the "Vase/Faces" exercise caused. When L-mode drops out voluntarily, conflict is avoided and R-mode quickly takes up the task that is appropriate for it: drawing a perceived image.

Getting to know the L→R shift

Two important points of progress emerge from the upside-down exercise. The first is your conscious recall of how you felt after you made the L→R cognitive shift. The quality of the R-mode state of consciousness is different from the L-mode. One can detect those differences and begin to recognize when the cognitive shift has occurred. Oddly, the moment of shifting between states of consciousness always remains out of awareness. For example, one can be aware of being alert and then of being in a

"Our normal waking consciousness, rational consciousness, as we call it, is but one special type of consciousness, whilst all about it, parted from it by the filmiest of screens, there lie potential forms of consciousness entirely different. We may go through life without suspecting their existence; but apply the requisite stimulus, and at a touch they are there in all their completeness, definite types of mentality which probably somewhere have their field of application and adaptation."

— William James
The Varieties of Religious Experience, 1902

L-mode is the "right-handed," left-hemisphere mode. The L is foursquare, upright, sensible, direct, true, hard-edged, unfanciful, forceful.

R-mode is the "left-handed," right-hemisphere mode. The R is curvy, flexible, more playful in its unexpected twists and turns, more complex, diagonal, fanciful.

daydream, but the moment of shifting between the two states remains elusive. Similarly, the moment of the cognitive shift from L→R remains out of awareness, but once you have made the shift, the difference in the two states is accessible to knowing. This knowing will help to bring the shift under conscious control—a main goal of these lessons.

The second insight gained from the exercise is your awareness that shifting to the R-mode enables you to see in the way a trained artist sees, and therefore to draw what you perceive.

Now, it's obvious that we can't always be turning things upside down. Your models are not going to stand on their heads for you, nor is the landscape going to turn itself upside down or inside out. Our goal, then, is to teach you how to make the cognitive shift when perceiving things in their normal right-side-up positions. You will learn the artist's "gambit": to direct your attention toward visual information that L-mode cannot or will not process. In other words, you will always try to present your brain with a task the language system will refuse, thus allowing R-mode to use its capability for drawing. Exercises in the coming chapters will show you some ways to do this.

A review of R-mode

It might be helpful to review what R-mode feels like. Think back. You have made the shift several times now—slightly, perhaps, while doing the Vase/Faces drawings and more intensely just now while drawing the "Stravinsky."

In the R-mode state, did you notice that you were somewhat unaware of the passage of time—that the time you spent drawing may have been long or short, but you couldn't have known until you checked it afterward? If there were people near, did you notice that you couldn't listen to what they said—in fact, that you didn't want to hear? You may have heard sounds, but you probably didn't care about figuring out the meaning of what was being said. And were you aware of feeling alert, but relaxed—confident, interested, absorbed in the drawing and clear in your mind?

Most of my students have characterized the R-mode state of

consciousness in these terms, and the terms coincide with my own experience and accounts related to me of artists' experiences. One artist told me, "When I'm really working well, it's like nothing else I've ever experienced. I feel at one with the work: the painter, the painting, it's all one. I feel excited, but calm—exhilarated, but in full control. It's not exactly happiness; it's more like bliss. I think it's what keeps me coming back and back to painting and drawing."

R-mode state is indeed pleasurable, and in that mode you can draw well. But there is an additional advantage: Shifting to R-mode releases you for a time from the verbal, symbolic domination of L-mode, and that's a welcome relief. The pleasure may come from resting the left hemisphere, stopping its chatter, keeping it quiet for a change. This yearning to quiet L-mode may partially explain centuries-old practices such as meditation and self-induced altered states of consciousness achieved through fasting, drugs, chanting, and alcohol. Drawing induces a focused, alert state of consciousness that can last for hours, bringing significant satisfaction.

Before you read further, do at least one or two more drawings upside down. Use either the reproduction in Figure 4-13, or find other line drawings to copy. Each time you draw, try consciously to experience the R-mode shift, so that you become familiar with how it feels to be in that mode.

Recalling the art of your childhood

In the next chapter we'll review your childhood development as an artist. The developmental sequence of children's art is linked to development changes in the brain. In the early stages, infants' brain hemispheres are not clearly specialized for separate functions. Lateralization—the consolidation of specific functions into one hemisphere or the other—progresses gradually through the childhood years, paralleling the acquisition of language skills and the symbols of childhood art.

Lateralization is usually complete by around age ten, and this coincides with the period of conflict in children's art, when the

"I know perfectly well that only in happy instants am I lucky enough to lose myself in my work. The painter-poet feels that his true immutable essence comes from that invisible realm that offers him an image of eternal reality....
I feel that I do not exist in time, but that time exists in me. I can also realize that it is not given to me to solve the mystery of art in an absolute fashion. Nonetheless, I am almost brought to believe that I am about to get my hands on the divine."

— Carlo Carra
"The Quadrant of the Spirit," 1919

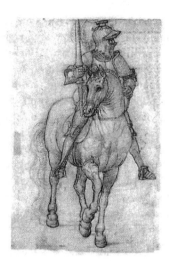

This sixteenth-century drawing by an unknown German artist offers a wonderful opportunity to practice upside-down drawing.

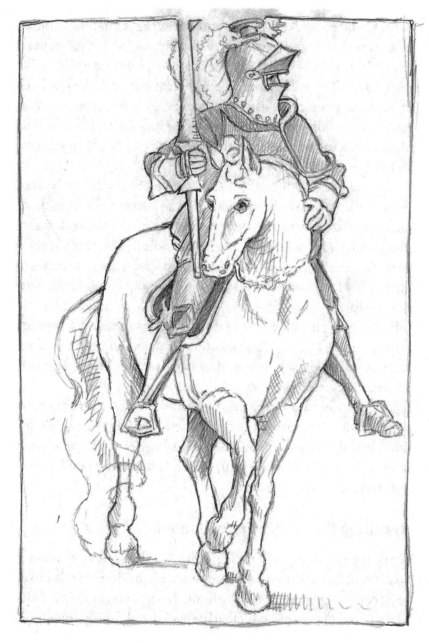

Fig. 4-13. Line drawing copy of the German horse and rider.

symbol system seems to override perceptions and to interfere with accurate drawing of those perceptions. One could speculate that conflict arises because children may be using the "wrong" brain mode—L-mode—to accomplish a task best suited for R-mode. Perhaps they simply cannot work out a way to shift to the visual mode. Also, by age ten, language dominates, adding further complication as names and symbols overpower spatial, holistic perceptions.

Reviewing your childhood art is important for several reasons: to look back as an adult at how your set of drawing symbols developed from infancy onward; to reexperience the increasing complexity of your drawing as you approached adolescence; to recall the discrepancy between your perceptions and your drawing skills; to view your childhood drawings with a less critical eye than you were able to manage at the time; and finally, to set your childhood symbol system aside and move on to an adult level of visual expression by using the appropriate brain mode—the right mode—for the task of drawing.

5 Drawing on Memories: Your History as an Artist

Fig. 5-1.

Fig. 5-2.

THE MAJORITY OF ADULTS IN THE WESTERN WORLD do not progress in art skills much beyond the level of development they reached at age nine or ten. In most mental and physical activities, individuals' skills change and develop as they grow to adulthood: Speech is one example, handwriting another. The development of drawing skills, however, seems to halt unaccountably at an early age for most people. In our culture, children, of course, draw like children, but most adults also draw like children, no matter what level they may have achieved in other areas of life. For example, Figures 5-1 and 5-2 illustrate the persistence of childlike forms in drawings that were done recently by a brilliant young professional man who was just completing a doctoral degree at a major university.

I watched the man as he did the drawings, watched him as he regarded the models, drew a bit, erased and drew again, for about twenty minutes. During this time, he became restless and seemed tense and frustrated. Later he told me that he hated his drawings and that he hated drawing, period.

If we were to attach a label to this disability in the way that educators have attached the label dyslexia to reading problems, we might call the problem dyspictoria or dysartistica or some such term. But no one has done so because drawing is not a vital skill for survival in our culture, whereas speech and reading are. Therefore, hardly anyone seems to notice that many adults draw childlike drawings and many children give up drawing at age nine or ten. These children grow up to become the adults who say that they never could draw and can't even draw a straight line. The same adults, however, if questioned, often say that they would have liked to learn to draw well, just for their own satisfaction at solving the drawing problems that plagued them as children. But they feel that they had to stop drawing because they simply couldn't learn how to draw.

A consequence of this early cutting off of artistic development is that fully competent and self-confident adults often become suddenly self-conscious, embarrassed, and anxious if they are asked to draw a picture of a human face or figure. In this situation, individuals often say such things as "No, I can't! What-

ever I draw is always terrible. It looks like a kid's drawing." Or, "I don't like to draw. It makes me feel so stupid." You yourself may have felt a twinge or two of those feelings when you did the Pre-instruction drawings.

The crisis period

The beginning of adolescence seems to mark the abrupt end of artistic development in terms of drawing skills for many adults. As children, they confronted an artistic crisis, a conflict between their increasingly complex perceptions of the world around them and their current level of art skills.

Most children between the ages of about nine and eleven have a passion for realistic drawing. They become sharply critical of their childhood drawings and begin to draw certain favorite subjects over and over again, attempting to perfect the image. Anything short of perfect realism may be regarded as failure.

Perhaps you can remember your own attempts at that age to make things "look right" in your drawings, and your feeling of disappointment with the results. Drawings you might have been proud of at an earlier age probably seemed hopelessly wrong and embarrassing. Looking at your drawings, you may have said, as many adolescents say, "This is terrible! I have no talent for art. I never liked it anyway, so I'm not doing it anymore."

Children often abandon art as an expressive activity for another unfortunately frequent reason. Unthinking people sometimes make sarcastic or derogatory remarks about children's art. The thoughtless person may be a teacher, a parent, another child, or perhaps an admired older brother or sister. Many adults have related to me their painfully clear memories of someone ridiculing their attempts at drawing. Sadly, children often blame the drawing for causing the hurt, rather than blaming the careless critic. Therefore, to protect the ego from further damage, children react defensively, and understandably so: They seldom ever attempt to draw again.

As an expert on children's art, Miriam Lindstrom of the San Francisco Art Museum, described the adolescent art student:

"Discontented with his own accomplishments and extremely anxious to please others with his art, he tends to give up original creation and personal expression. . . . Further development of his visualizing powers and even his capacity for original thought and for relating himself through personal feelings to his environment may be blocked at this point. It is a crucial stage beyond which many adults have not advanced."

— Miriam Lindstrom
Children's Art, 1957

Art in school

Even sympathetic art teachers, who may feel dismayed by unfair criticism of children's art and who want to help, become discouraged by the style of drawing that young adolescents prefer—complex, detailed scenes, labored attempts at realistic drawing, endless repetitions of favorite themes such as racing cars, and so on. Teachers recall the beguiling freedom and charm of younger children's work and wonder what happened. They deplore what they see as "tightness" and "lack of creativity" in students' drawings. The children themselves often become their own most unrelenting critics. Consequently, teachers frequently resort to crafts projects because they seem safer and cause less anguish—projects such as paper mosaics, string painting, drip painting, and other manipulations of materials.

As a result, most students do not learn how to draw in the early and middle grades. Their self-criticism becomes permanent, and they very rarely try to learn how to draw later in life. Like the doctoral candidate mentioned earlier, they might grow up to be highly skilled in a number of areas, but if asked to draw a human being, they will produce the same childlike image they were drawing at age ten.

From infancy to adolescence

For most of my students, it has proved beneficial to go back in time to try to understand how their visual imagery in drawing developed from infancy to adolescence. With a firm grasp on how the symbol system of childhood drawing has developed, students seem to "unstick" their artistic development more easily in order to move on to adult skills.

The scribbling stage

Making marks on paper begins at about age one and a half, when you as an infant were given a pencil or crayon, and you, by yourself, made a mark. It's hard for us to imagine the sense of wonder a child experiences on seeing a black line emerge from the end of

"The scribblings of any . . . child clearly indicate how thoroughly immersed he is in the sensation of moving his hand and crayon aimlessly over a surface, depositing a line in his path. There must be some quantity of magic in this alone."

— Edward Hill
The Language of Drawing,
1966

a stick, a line the child controls. You and I, all of us, had that experience.

After a tentative start, you probably scribbled with delight on every available surface, perhaps including your parents' best books and the walls of a bedroom or two. Your scribbles were seemingly quite random at first, like the example in Figure 5-3, but very quickly began to take on definite shapes. One of the basic scribbling movements is a circular one, probably arising simply from the way the shoulder, arm, wrist, hand, and fingers work together. A circular movement is a natural movement—more so, for instance, than the arm movements required to draw a square. (Try both on a piece of paper, and you'll see what I mean.)

Fig. 5-3. Scribble drawing by a two-and-a-half-year-old.

The stage of symbols

After some days or weeks of scribbling, infants—and apparently all human children—make the basic discovery of art: A drawn symbol can stand for something out there in the environment. The child makes a circular mark, looks at it, adds two marks for eyes, points to the drawing, and says, "Mommy," or "Daddy," or "That's me," or "My dog," or whatever. Thus, we all made the uniquely human leap of insight that is the foundation for art, from the prehistoric cave paintings all the way up through the centuries to the art of Leonardo, Rembrandt, and Picasso.

With great delight, infants draw circles with eyes, mouth, and lines sticking out to represent arms and legs, as in Figure 5-4. This form, a symmetrical, circular form, is a basic form universally drawn by infants. The circular form can be used for almost anything: With slight variations, the basic pattern can stand for a human being, a cat, a sun, a jellyfish, an elephant, a crocodile, a flower, or a germ. For you as a child, the picture was whatever you said it was, although you probably made subtle and charming adjustments of the basic form to get the idea across.

Fig. 5-4. Figure-image drawing by a three-and-a-half-year-old.

By the time children are about three and a half, the imagery of their art becomes more complex, reflecting growing awareness and perceptions of the world. A body is attached to the head, though it may be smaller than the head. Arms may still grow out

of the head, but more often they emerge from the body—sometimes from below the waist. Legs are attached to the body.

By age four, children are keenly aware of details of clothing—buttons and zippers, for example, appear as details of the drawings. Fingers appear at the ends of arms and hands, and toes at the ends of legs and feet. Numbers of fingers and toes vary imaginatively. I have counted as many as thirty-one fingers on one hand and as few as one toe per foot (Figure 5-4).

Although children's drawings of figures resemble each other in many ways, each child works out through trial and error a favorite image, which becomes refined through repetition. Children draw their special images over and over, memorizing them and adding details as time goes on. These favorite ways to draw various parts of the image eventually become embedded in the memory and are remarkably stable over time (Figure 5-5).

Fig. 5-5. Notice that the features are the same in each figure—including the cat—and that the little hand symbol is also used for the cat's paws.

Pictures that tell stories

Fig. 5-6.

Around age four or five, children begin to use drawings to tell stories and to work out problems, using small or gross adjustments of the basic forms to express their intended meaning. For example, in Figure 5-6, the young artist has made the arm that holds the

Using his basic figure symbol, he first drew himself.

He then added his mother, using the same basic figure configuration with adjustments—long hair, a dress.

He then added his father, who was bald and wore glasses.

umbrella huge in relation to the other arm, because the arm that holds the umbrella is the important point of the drawing.

Another instance of using drawing to portray feelings is a family portrait, drawn by a shy five-year-old whose every waking moment apparently was dominated by his older sister.

Even Picasso could hardly have expressed a feeling with greater power than that. Once the feeling was drawn, giving form to formless emotions, the child who drew the family portrait may have been better able to cope with his overwhelming sister.

He then added his sister, with teeth.

The landscape

By around age five or six, children have developed a set of symbols to create a landscape. Again, by a process of trial and error, children usually settle on a single version of a symbolic landscape, which is endlessly repeated. Perhaps you can remember the landscape you drew around age five or six.

What were the components of that landscape? First, the ground and sky. Thinking symbolically, a child knows that the ground is at the bottom and the sky is at the top. Therefore, the ground is the bottom edge of the paper, and the sky is the top edge, as in Figure 5-7. Children emphasize this point, if they are working with color, by painting a green stripe across the bottom, blue across the top.

Most children's landscapes contain some version of a house. Try to call up in your mind's eye an image of the house you drew. Did it have windows? With curtains? And what else? A door?

Fig. 5-7. Landscape drawing by a six-year-old. This house is very close to the viewer. The bottom edge of the paper functions as the ground. To a child it seems that every part of the drawing surface has symbolic meaning, the empty spaces of this surface functioning as air through which smoke rises, the sun's rays shine, and birds fly.

Fig. 5-8. Landscape drawing by a six-year-old. This house is farther away from the viewer and has a wonderfully self-satisfied expression, enclosed as it is under the arc of a rainbow.

What was on the door? A doorknob, of course, because that's how you get in. I have never seen an authentic, child-drawn house with a missing doorknob.

You may begin to remember the rest of your landscape: the sun (did you use a corner sun or a circle with radiating rays?), the clouds, the chimney, the flowers, the trees (did yours have a convenient limb sticking out for a swing?), the mountains (were yours like upside-down ice cream cones?). And what else? A road going back? A fence? Birds?

At this point, before you read any further, please take a sheet of paper and draw the landscape that you drew as a child. Label your drawing "Recalled Childhood Landscape." You may remember this image with surprising clarity as a whole image, complete in all its parts; or it may come back to you more gradually as you begin to draw.

While you are drawing the landscape, try also to recall the pleasure drawing gave you as a child, the satisfaction with which each symbol was drawn, and the sense of rightness about the placement of each symbol within the drawing. Recall the sense that nothing must be left out and, when all the symbols were in place, your sense that the drawing was complete.

If you can't recall the drawing at this point, don't be concerned. You may recall it later. If not, it may simply indicate that you've blocked it out for some reason. Usually about ten percent of my adult students are unable to recall their childhood drawings.

Before we go on, let's take a minute to look at some recalled childhood landscapes drawn by adults. First, you will observe that the landscapes are personalized images, each different from the other. Observe also that in every case the composition—the way the elements of each drawing are composed or distributed within the four edges—seems exactly right, in the sense that not a single element could be added or removed without disturbing the rightness of the whole (Figure 5-9). Let me demonstrate that by showing you what happens in Figure 5-10 when one form (the tree) is removed. Test this concept in your own recalled landscape by covering one form at a time. You will find that removing

THE NEW DRAWING ON THE RIGHT SIDE OF THE BRAIN

any single form throws off the balance of the whole picture. Figures 5-9 and 5-10 show examples of some of the other characteristics of childhood landscape drawings.

After you have looked at the examples, observe your own drawing. Observe the composition (the way the forms are arranged and balanced within the four edges). Observe distance as a factor in the composition. Try to characterize the expression of the house, at first wordlessly and then in words. Cover one element and see what effect that has on the composition. Think back on how you did the drawing. Did you do it with a sense of sureness, knowing where each part was to go? For each part, did you find that you had an exact symbol that was perfect in itself and fit perfectly with the other symbols? You may have been aware of feeling the same sense of satisfaction that you felt as a child when the forms were in place and the image completed.

Fig. 5-9.

Fig. 5-10.

The stage of complexity

Now, like the ghosts in Dickens's *A Christmas Carol,* we'll move you on to observe yourself at a slightly later age, at nine or ten. Possibly you may remember some of the drawings you did at that age—in the fifth, sixth, or seventh grade.

During this period, children try for more detail in their artwork, hoping by this means to achieve greater realism, which is a prized goal. Concern for composition diminishes, the forms often being placed almost at random on the page. Seemingly, children's concern for where things are in the drawing is replaced with concern for how things look, particularly the details of forms. Overall, drawings by older children show greater complexity and, at the same time, less assurance than do the landscapes of early childhood.

Also around this time, children's drawings become differentiated by sex, probably because of cultural factors. Boys begin to draw automobiles—hot rods and racing cars; war scenes with dive bombers, submarines, tanks, and rockets. They draw legendary figures and heroes—bearded pirates, Viking crewmen and their ships, television stars, mountain climbers, and deep-sea

Children seem to start out with a nearly perfect sense of composition, which they often lose during adolescence and regain only through laborious study. I believe that the reason may be that older children concentrate their perceptions on separate objects existing in an undifferentiated space, whereas young children construct a self-contained conceptual world bounded by the paper's edges. For older children, however, the edges of the paper seem almost nonexistent, just as edges are nonexistent in open, real space.

divers. They are fascinated by block letters, especially monograms; and some odd images such as (my favorite) an eyeball complete with piercing dagger and pools of blood.

Meanwhile, girls are drawing tamer things—flowers in vases, waterfalls, mountains reflected in still lakes, pretty girls running or sitting on the grass, fashion models with incredible eyelashes, elaborate hairstyles, tiny waists and feet, and hands held behind the back because hands are "hard to draw."

Figures 5-11 through 5-14 are some examples of these early adolescent drawings. I've included a cartoon drawing: Cartoons are drawn by both boys and girls and are much admired. I believe that cartooning appeals to children at this age because cartoons employ familiar symbolic forms but are used in a more sophisticated way, thus enabling adolescents to avoid feeling that their drawing is "babyish."

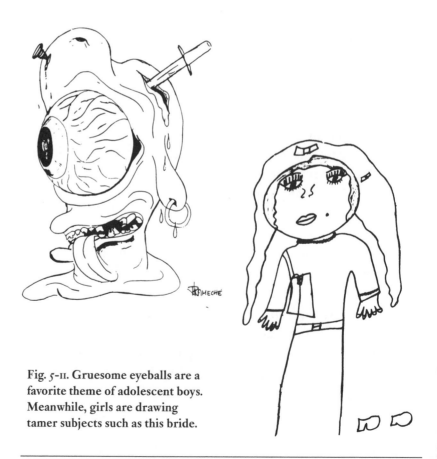

Fig. 5-11. Gruesome eyeballs are a favorite theme of adolescent boys. Meanwhile, girls are drawing tamer subjects such as this bride.

Fig. 5-12. Complex drawing by Naveen Molloy, then ten years old. This is an example of the kind of drawing by adolescents that teachers often deplore as "tight" and uncreative. Young artists work very hard to perfect images like this one of electronic equipment. Note the keyboard and mouse. The child will soon reject this image, however, as hopelessly inadequate.

Fig. 5-13. Complex drawing by a nine-year-old girl. Transparency is a recurrent theme in the drawings of children at this stage. Things seen under water, through glass windows, or in transparent vases—as in this drawing—are all favorite themes. Though one could guess at a psychological meaning, it is quite likely that young artists are simply trying this idea to see if they can make the drawings "look right."

Fig. 5-14. Complex drawing by a ten-year-old boy. Cartooning is a favorite form of art in the early adolescent years. As art educator Miriam Lindstrom notes in *Children's Art*, the level of taste at this age is at an all-time low.

The stage of realism

By around age ten or eleven, children's passion for realism is in full bloom (Figures 5-15 and 5-16). When their drawings don't come out "right"—meaning that they don't look realistic—children often become discouraged and ask their teachers for help. The teacher may say, "You must look more carefully," but this doesn't help, because the child doesn't know what to look more carefully for. Let me illustrate that with an example.

Fig. 5-15. Realistic drawing by a twelve-year-old. Children aged ten to twelve are searching for ways to make things "look real." Figure drawing in particular fascinates adolescents. In this drawing, symbols from an earlier stage are fitted into new perceptions: Note the front-view eye in this profile drawing. Note also that the child's knowledge of the chair back has been substituted for the purely visual appearance of the back of the chair seen from the side.

Fig. 5-16. Realistic drawing by a twelve-year-old. At this stage, children's main effort is toward achieving realism. Awareness of the edges of the drawing surface fades and attention is concentrated on individual, unrelated forms randomly distributed about the page. Each segment functions as an individual element without regard for unified composition.

Say that a ten-year-old wants to draw a picture of a cube, perhaps a three-dimensional block of wood. Wanting the drawing to look "real," the child tries to draw the cube from an angle that shows two or three planes—not just a straight-on side view that would show only a single plane, and thus would not reveal the true shape of the cube.

To do this, the child must draw the oddly angled shapes just as they appear—that is, just like the image that falls on the retina of the perceiving eye. Those shapes are not square. In fact, the child must suppress knowing that the cube is square and draw shapes that are "funny." The drawn cube will look like a cube only if it is comprised of oddly angled shapes. Put another way, the child must draw unsquare shapes to draw a square cube. The child must accept this paradox, this illogical process, which conflicts with verbal, conceptual knowledge. (Perhaps this is one meaning of Picasso's statement that "Painting is a lie that tells the truth.")

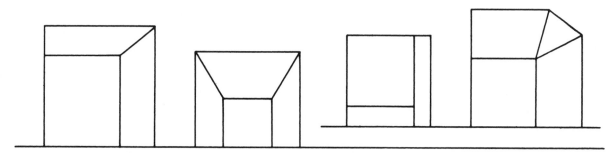

Fig. 5-17. Children's unsuccessful attempts to draw a cube that "looks real."

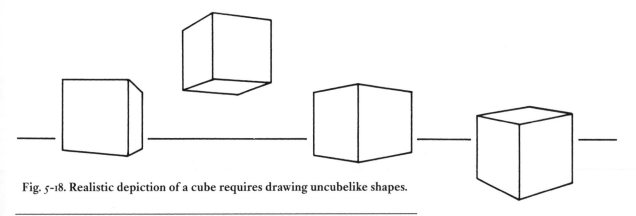

Fig. 5-18. Realistic depiction of a cube requires drawing uncubelike shapes.

"The painter who strives to represent reality must transcend his own perception. He must ignore or override the very mechanisms in his mind that create objects out of images. . . . The artist, like the eye, must provide true images and the clues of distance to tell his magic lies."

— Colin Blakemore
Mechanics of the Mind, 1977

From childhood onward, we have learned to see things in terms of words: We name things, and we know facts about them. The dominant left verbal system doesn't want too much information about things it perceives—just enough to recognize and to categorize. It seems that one of its functions is to screen out a large proportion of contextual perceptions. This is a necessary process and one that works very well for us most of the time, enabling us to focus our attention. The left brain, in this sense, learns to take a quick look and says, "Right, that's a chair (or an umbrella, bird, tree, dog, etc.)." But drawing requires that you look at something for a long time, perceiving lots of details and how they fit together, registering as much information as possible— ideally, everything, as Albrecht Dürer apparently tried to do in Figure 5-19.

If verbal knowledge of the cube's real shape overwhelms the student's purely visual perception, "incorrect" drawing results— drawing with the kinds of problems that make adolescents despair (see Figure 5-17). Knowing that cubes have square corners, students usually start a drawing of a cube with a square corner. Knowing that a cube rests on a flat surface, students draw straight lines across the bottom. Their errors compound themselves as the drawing proceeds, and the students become more and more confused.

Though a sophisticated viewer, familiar with the art of cubism and abstraction, might find the "incorrect" drawings in Figure 5-17 more interesting than the "correct" drawings in Figure 5-18, young students find praise of their wrong forms incomprehensible. In this case, the child's intent was to make the cube look "real." Therefore, to the child, the drawing is a failure. To say otherwise seems as absurd to students as telling them that "two plus two equals five" is a creative and praiseworthy solution.

On the basis of "incorrect" drawings such as the cube drawings, students may decide that they "can't draw." But they can draw; that is, the forms indicate that manually they are perfectly able to draw. The dilemma is that previously stored knowledge— which is useful in other contexts—prevents their seeing the thing-as-it-is, right there in front of their eyes.

Sometimes the teacher solves the problem by showing the students how—that is, by demonstrating the process of drawing. Learning by demonstration is a time-honored method of teaching art, and it works if the teacher can draw well and has confidence enough to demonstrate realistic drawing in front of a class. Unfortunately, most teachers at the crucial elementary level are themselves not trained in perceptual skills in drawing. Therefore, teachers often have the same feelings of inadequacy concerning their own ability to draw realistically as the children they wish to teach.

Many teachers wish children at this age would be freer, less concerned about realism in their artwork. But however much some teachers may deplore their students' insistence on realism, the children themselves are relentless. They will have realism, or

they will give up art forever. They want their drawings to match what they see, and they want to know how to do that.

I believe that children at this age love realism because they are trying to learn how to see. They are willing to put great energy and effort into the task if the results are encouraging. A few children are lucky enough to accidentally discover the secret: how to see things in a different (R-mode) way. I think I was one of those children who, by chance, stumbles on the process. But the majority of children need to be taught how to make that cognitive shift. Fortunately, we are now developing new instructional methods, based on recent brain research, which will enable teachers to help satisfy children's yearning for seeing and drawing skills.

How the symbol system, developed in childhood, influences seeing

Now we are coming closer to the problem and its solution. First, what prevents a person from seeing things clearly enough to draw them?

The left hemisphere has no patience with this detailed perception and says, in effect, "It's a chair, I tell you. That's enough to know. In fact, don't bother to look at it, because I've got a ready-made symbol for you. Here it is; add a few details if you want, but don't bother me with this looking business."

And where do the symbols come from? From the years of childhood drawing during which every person develops a system of symbols. The symbol system becomes embedded in the memory, and the symbols are ready to be called out, just as you called them out to draw your childhood landscape.

The symbols are also ready to be called out when you draw a face, for example. The efficient left brain says, "Oh yes, eyes. Here's a symbol for eyes, the one you've always used. And a nose? Yes, here's the way to do it." Mouth? Hair? Eyelashes? There's a symbol for each. There are also symbols for chairs, tables, and hands.

To sum up, adult students beginning in art generally do not

"By the time the child can draw more than a scribble, by age three or four years, an already well-formed body of conceptual knowledge formulated in language dominates his memory and controls his graphic work. . . . Drawings are graphic accounts of essentially verbal processes. As an essentially verbal education gains control, the child abandons his graphic efforts and relies almost entirely on words. Language has first spoilt drawing and then swallowed it up completely."

— Written in 1930 by psychologist Karl Buhler

really see what is in front of their eyes—that is, they do not perceive in the special way required for drawing. They take note of what's there, and quickly translate the perception into words and symbols mainly based on the symbol system developed throughout childhood and on what they know about the perceived object.

What is the solution to this dilemma? Psychologist Robert Ornstein suggests that in order to draw, the artist must "mirror" things or perceive them exactly as they are. Thus, you must set aside your usual verbal categorizing and turn your full visual attention to what you are perceiving—to all of its details and how each detail fits into the whole configuration. In short, you must see the way an artist sees.

Fig. 5-19. Albrecht Dürer, Study for the *Saint Jerome* (1521).One of the L-mode functions is to screen out a large proportion of incoming perceptions. This is a necessary process to enable us to focus our thinking and one that works very well for us most of the time. But *drawing* requires that you look at something for a long time, perceiving lots of details, registering as much information as possible—ideally, *everything,* as Albrecht Dürer tried to do here.

Given proper instruction, young children can easliy learn to draw. These examples are by third-grade children, age eight.

5-19-94
Nicholas Quesada

NAPLES ELEMENTARY
THIRD GRADE
PERCEPTUAL SKILLS

Marco

April 28, 1994 Jairo Amaya

Again, the key question is how to accomplish that cognitive L→R shift. As I said in Chapter Four, the most efficient way seems to be to present the brain with a task the left brain either can't or won't handle. You have already experienced a few of those tasks: the Vase/Faces drawings and the upside-down drawing. And to some extent, you have already begun to experience and recognize the alternate state of right-hemisphere mode. You are beginning to know that while you are in that slightly different subjective state of mind, you slow down so that you can see more clearly.

As you think back over experiences with drawing since you started this book and over experiences of alternative states of consciousness you may have had in connection with other activities (freeway driving, reading, etc., mentioned in Chapter One), think again about the characteristics of that slightly altered state. It is important that you continue to develop your awareness and recognition of R-mode state.

Lewis Carroll described an analogous shift in Alice's adventures in *Through the Looking Glass:*

"Oh, Kitty, how nice it would be if we could only get through into Looking Glass House! I'm sure it's got, oh! such beautiful things in it! Let's pretend there's a way of getting through into it, somehow, Kitty. Let's pretend the glass has got all soft like gauze, so that we can get through. Why, it's turning to a mist now, I declare! It'll be easy enough to get through. . . ."

THE NEW DRAWING ON THE RIGHT SIDE OF THE BRAIN

Let's review the characteristics of the R-mode one more time. First, there is a seeming suspension of time. You are not aware of time in the sense of marking time. Second, you pay no attention to spoken words. You may hear the sounds of speech, but you do not decode the sounds into meaningful words. If someone speaks to you, it seems as though it would take a great effort to cross back, think again in words, and answer. Furthermore, whatever you are doing seems immensely interesting. You are attentive and concentrated and feel "at one" with the thing you are concentrating on. You feel energized but calm, active without anxiety. You feel self-confident and capable of doing the task at hand. Your thinking is not in words but in images and, particularly while drawing, your thinking is "locked on" to the object you are perceiving. On leaving R-mode state, you do not feel tired, but refreshed.

Our job now is to bring this state into clearer focus and under greater conscious control, in order to take advantage of the right hemisphere's superior ability to process visual information and to increase your ability to make the cognitive shift to R-mode at will.

"The development of an Observer can allow a person considerable access to observing different identity states, and an outside observer may often clearly infer different identity states, but a person himself who has not developed the Observer function very well may never notice the many transitions from one identity state to another."

— Charles T. Tart
Alternate States of Consciousness, 1977

6

Getting Around Your Symbol System: Meeting Edges and Contours

W E HAVE REVIEWED YOUR CHILDHOOD ART and the development of the set of symbols that formed your childhood language of drawing. This process paralleled the development of other symbol systems: speech, reading, writing, and arithmetic. Whereas these other symbol systems formed useful foundations for later development of verbal and computational skills, childhood drawing symbols seem to interfere with later stages of art.

Thus, the central problem of teaching realistic drawing to individuals from age ten or so onward is the persistence of memorized, stored drawing symbols when they are no longer appropriate to the task. In a sense, L-mode unfortunately continues to "think" it can draw long after the ability to process spatial, relational information has been lateralized to the right brain. When confronted with a drawing task, the language mode comes rushing in with its verbally linked symbols. Then afterward, ironically, the left brain is all too ready to supply derogatory words of judgment if the drawing looks childlike or naive.

In the last chapter I said that an effective way to "set aside" the dominant left verbal hemisphere and to "bring forward" your nondominant right brain, with its visual, spatial, relational style, is to present your brain with a task that the left brain either can't or won't work at. We have used the Vase/Faces drawings and upside-down drawings to illustrate this process. Now we'll try another, more drastic strategy that will force a stronger cognitive shift and set aside your L-mode more completely.

Nicolaides's contour drawing

I've called the method of the next exercise "Pure Contour Drawing," and your left hemisphere is probably not going to enjoy it. Introduced by a revered art teacher, Kimon Nicolaides, in his 1941 book, *The Natural Way to Draw,* the method has been widely used by art teachers. I believe that our new knowledge about how the brain divides its workload provides a conceptual basis for understanding why Pure Contour Drawing is effective as a teaching method. At the time of writing his book, Nicolaides apparently

felt that the reason the contour method improved students' drawing was that it caused students to use both senses of sight and touch. Nicolaides recommended that students imagine that they were touching the form as they drew. I suggest an alternate possibility: L-mode rejects the meticulous, complex perceptions of spatial, relational information, thus allowing access to R-mode processing. In short, Pure Contour Drawing doesn't suit the left brain's style. It suits the style of the right brain—again, just what we want.

Using Pure Contour Drawing to bypass your symbol system

In my classes, I demonstrate Pure Contour Drawing, describing how to use the method as I draw—if I can manage to keep talking (an L-mode function) while I'm drawing. Usually, I start out all right but begin trailing off in mid-sentence after a minute or so. By that time, however, my students have the idea.

Following the demonstration, I show examples of previous students' Pure Contour Drawings. See examples of students' drawings on page 95.

What you'll need:

- Several pieces of drawing paper. You will draw on the top sheet and use two or three additional sheets to pad the drawing.
- Your #2 writing pencil, sharpened
- Masking tape to tape your drawing paper to your drawing board
- An alarm clock or kitchen timer
- About thirty minutes of uninterrupted time

What you'll do:

Please read through the following instructions before you begin your drawing.

1. Look at the palm of your hand—the left hand if you are

Woman in a Hat, Kimon Nicolaides. Collection of the author.

"Merely to see, therefore, is not enough. It is necessary to have a fresh, vivid, physical contact with the object you draw through as many of the senses as possible—and especially through the sense of touch."

— Kimon Nicolaides
The Natural Way to Draw,
1941

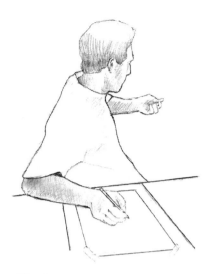

Fig. 6-1.

right-handed and the right if you are left-handed. Bring your fingers and thumb together to create a mass of wrinkles in your palm. Those wrinkles are what you are going to draw—all of them. I can almost hear you saying, "Are you joking?" or "Forget that!"

2. Sit in a comfortable position with your drawing hand on the drawing paper, holding the pencil and ready to draw. Then, put the pencil down and tape the paper in that prearranged position so it won't shift around while you are drawing.

3. Set the timer for 5 minutes. In this way, you won't have to keep track of time, an L-mode function.

4. Then, face all the way around in the opposite direction, keeping your hand with the pencil on the drawing paper, and gaze at the palm of the other hand. Be sure to rest that hand on some support—the back of a chair or perhaps on your knee—because you will be holding this rather awkward position for the allotted 5 minutes. Remember, once you start to draw, you will not turn to look at the drawing until the timer goes off. See figure 6-1.

5. Gaze at a single wrinkle in your palm. Place your pencil on the paper and begin to draw just that edge. As your eyes track the direction of the edge very slowly, one millimeter at a time, your pencil will record your perceptions. If the edge changes direction, so does your pencil. If the edge intersects with another edge, follow that new information slowly with your eyes, while your pencil simultaneously records every detail. An important point: Your pencil can record only what you see—nothing more, nothing less—at the moment of seeing. Your hand and pencil function like a seismograph, responding only to your actual perceptions.

The temptation to turn and look at the drawing will be very strong. Resist the impulse! Don't do it! Keep your eyes focussed on your hand.

Match the movement of the pencil exactly with your eye movement. One or the other may begin to speed up, but don't let that happen. You must record everything at the very instant that

you see each point on the contour. Do not pause in the drawing, but continue at a slow, even pace. At first you may feel uneasy or uncomfortable: Some students even report sudden headaches or a sense of panic.

6. Do not turn around to see what the drawing looks like until your timer signals the end of 5 minutes.

7. Most important, you must continue to draw until the timer signals you to stop.

8. If you experience painful objections from your verbal mode ("What am I doing this for? This is really stupid! It won't even be a good drawing because I can't see what I'm doing," and so forth), try your best to keep on drawing. The protests from the left will fade out and your mind will become quiet. You will find yourself becoming fascinated with the wondrous complexity of what you are seeing, and you will feel that you could go deeper and deeper into the complexity. Allow this to happen. You have nothing to fear or be uneasy about. Your drawing will be a beautiful record of your deep perception. We are not concerned about whether the drawing looks like a hand. We want the record of your perceptions.

9. Soon, this mental chatter will cease, and you will find yourself becoming intensely interested in the complexity of the edges you see in your palm and intensely aware of the beauty of that complex perception. When that change takes place, you will have shifted to the visual mode and again you will be "really drawing."

10. When the timer signals the allotted time, turn and look at your drawing.

After you have finished:

Think back now on how you felt at the beginning of the Pure Contour Drawing compared to how you felt later, when you were deeply into the drawing. What did that later state feel like? Did you lose awareness of time passing? Like Max Ernst, did you become enamored of what you saw? When you return to the alternative state you were in, will you recognize it?

"Blind swimmer, I have made myself see. I have seen. And I was surprised and enamored of what I saw, wishing to identify myself with it. . . ."

— Max Ernst, 1948

Pure Contour Drawing is so effective at producing this strong shift that many artists routinely begin drawing with at least a short session of the method, in order to start the process of shifting to R-mode.

Looking at your drawing, a tangled mass of pencil marks, perhaps you will say, "What a mess!" But look more closely and you will see that these marks are strangely beautiful. Of course, they do not represent the hand, only its details, and details within details. You have drawn complex edges from actual perceptions. These are not quick, abstract, symbolic representations of the wrinkles in your palm. They are painstakingly accurate, excruciatingly intricate, entangled, descriptive, and specific marks—just what we want at this point. I believe that these drawings are visual records of the R-mode state of consciousness. As a witty friend of mine, writer Judi Marks, remarked on viewing a Pure Contour Drawing for the first time, "No one in their left mind would do a drawing like that!"

Why you did this exercise

The most important reason for this exercise is that Pure Contour Drawing apparently causes L-mode to "reject the task," enabling you to shift to R-mode. Perhaps the lengthy, minute observation of severely limited, "non-useful," and "boring" information—information that defies verbal description—is incompatible with L-mode's thinking style.

Note that:
- Your verbal mode may object and object, but eventually will "bow out," leaving you "free" to draw. This is why I asked you to continue drawing until the timer sounds.
- The marks you make in R-mode are different from and often more beautiful than marks made in your more usual L-mode state of consciousness.
- Anything can be a subject for a Pure Contour drawing: a feather, a piece of shredded bark, a lock of hair. Once you have shifted to R-mode, the most ordinary things become inordinately beautiful and interesting. Can you remember the sense of wonder you had as a child, poring over some tiny insect or a dandelion?

The paradox of the Pure Contour Drawing exercise

For reasons that are still unclear, Pure Contour Drawing is one of the key exercises in learning to draw. But it's a paradox: Pure Contour Drawing, which doesn't produce a "good" drawing (in students' estimations), is the best exercise for effectively and efficiently causing students later to achieve good drawing. Even more important, though, this is the exercise that revives our childhood wonder and the sense of beauty found in ordinary things.

A possible explanation

Apparently, in our habitual use of brain modes, L-mode seeks quickly to recognize (and name and categorize) by picking out details, while R-mode wordlessly perceives whole configurations and seeks how the parts fit together—or perhaps whether the parts fit together.

In regarding a hand, for example, the nails, the wrinkles and creases are details and the hand itself is the whole configuration. This "division of labor" works fine in ordinary life. In drawing a hand, however, one must give equal attention—visual attention—to both the configuration and the details and how they fit together into the whole. Pure Contour Drawing may function as a sort of "shock treatment" for the brain, forcing it to do things differently.

Pure Contour Drawing, I believe, causes L-mode to "drop out," perhaps, as I mentioned before, through simple boredom. ("I've already named it—it's a wrinkle, I tell you. They're all alike. Why bother with all this looking.") Once L-mode has "dropped out," it seems possible that R-mode then perceives each wrinkle—normally regarded as a detail—as a whole configuration, made up of even smaller details. Then each detail of each wrinkle becomes a further whole, made up of ever-smaller parts, and so on, going deeper and deeper into ever expanding complexity. There is some similarity, I believe, to the phenomenon of fractals, in which whole patterns are constructed of smaller detailed whole patterns, which are constructed of ever smaller, detailed whole patterns.

"In prose, the worst thing one can do with words is to surrender to them. When you think of a concrete object, you think wordlessly, and then, if you want to describe the thing you have been visualizing, you probably hunt about till you find the exact words that seem to fit it. When you think of something abstract you are more inclined to use words from the start, and unless you make a conscious effort to prevent it, the existing dialect will come rushing in and do the job for you, at the expense of blurring or even changing your meaning. Probably it is better to put off using words as long as possible and get one's meaning clear as one can through pictures or sensations."

— George Orwell
"Politics and the English Language," 1968

If perhaps you did not attain a shift to R-mode in your first Pure Contour Drawing, please be patient with yourself. You may have a very determined verbal system. I suggest that you try again. You might try using a crumpled piece of paper, a flower, or any complex object that appeals to you. My students sometimes have to make two or even three tries in order to "win out" against their strong verbal modes.

Set a timer, perhaps for eight or even ten minutes. In the beginning, it takes time to cause a shift to R-mode. Later on, as American artist Robert Henri proposed in the sidebar quotation on page 5, the shift "to the higher state" will occur just by starting to draw.

These strange marks on the wall of a cave were made by Paleolithic humans. In their intensity, the marks seem to resemble Pure Contour Drawing.

— *Shamans of Prehistory,* J. Clottes and D. Lewis-Williams. New York: Harry N. Abrams, Inc., 1996

Why Pure Contour Drawing is important

Whatever the actual reason may be, I can assure you that Pure Contour Drawing will permanently change your ability to perceive. From this point onward, you will start to see in the way an artist sees and your skills in seeing and drawing will progress rapidly.

Look at the Pure Contour Drawing of your hand one more time and appreciate the quality of the marks you made in R-mode. Again, these are not the quick, glib, stereotypic marks of symbolic L-mode. These marks are true records of perception.

The next exercise will pull together everything learned so far and you will be doing a wonderful "real" drawing.

Student showing: A record of an alternative state

Following is a Student Showing of some Pure Contour Drawings. What strange and marvelous markings are these! Never mind that the drawings don't resemble greatly the overall configuration of a hand—that's to be expected. We will attend to the overall configuration in the next exercise, "Modified Contour Drawing."

In Pure Contour Drawing, it is the quality of the marks and their character that we care about. The marks, these living hieroglyphs, are records of perceptions. To be found nowhere in the drawings are the thin, glib, stereotypic marks of casual, rapid L-mode symbolic processing. Instead, we see rich, deep, intuitive marks made in response to the thing-as-it-is, the thing as it exists out there, marks that delineate the is-ness of the object. Blind swimmers have seen! And seeing, they have drawn.

Before moving on to the next step, Modified Contour Drawing, let's review the important concept of edges in art.

The first component skill: The perception of edges

Pure Contour Drawing has introduced you to the first component skill of drawing: the perception of edges. In drawing, the term *edge* has a special meaning, different from its ordinary definition as a *border* or *outline*.

In drawing, an edge is where two things come together. In the Pure Contour Drawing you just finished, for example, the edge you drew was the place (the wrinkle) where two parts of the flesh of your palm came together to form a single boundary for both parts. That shared boundary, in drawing, is described by a line that is called a contour line. In drawing, therefore, a line (a contour line or, more simply, a contour) is always the border of two things simultaneously—that is, a shared edge. The Vase/Faces exercise illustrates this concept. The line you drew was simultaneously the edge of the profile and the edge of the vase.

To sum up this concept: In drawing, an edge is always a shared boundary.

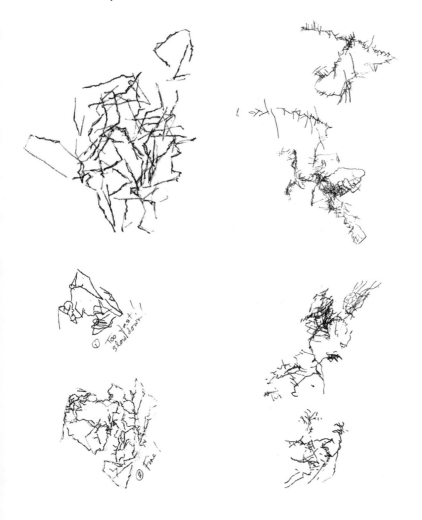

Fig. 6-2.

A good definition of "picture plane" from *The Art Pack,* Key Definitions/Key Styles, 1992.

"Picture plane: Often used—erroneously—to describe the physical surface of a painting, the picture plane is in fact a mental construct—like an imaginary plane of glass . . . Alberti (the Italian Renaissance artist) called it a 'window' separating the viewer from the picture itself . . . "

John Elsum, in his 1704 book *The Art of Painting After the Italian Manner,* gave instructions for making "a handy device":

"Take a Square Frame of Wood about one foot large, and on this make a little grate [grid] of Threads, so that crossing one another they may fall into perfect Squares about a Dozen at least, then place [it] between your Eye and the Object, and by this grate imitate upon your Table [drawing surface] the true Posture it keeps, and this will prevent you from running into Errors. The more Work is to be [fore]shortened the smaller are to be the Squares."

Quoted in *A Miscellany of Artists' Wisdom,* compiled by Diana Craig, Philadelphia: Running Press, 1993, p. 79.

The child's jigsaw puzzle, Figure 6-2, illustrates this important point. The edge of the boat is shared with the water. The edge of the sail is shared with the sky and the water. Put another way, the water stop where the boat begins—a shared edge. The water and the sky stop where the sail begins—shared edges.

Note also that the outer edge of the puzzle—its frame or *format,* meaning the bounding edge of the composition—is also the outer edge of the sky-shape, the land-shapes, and the water-shape.

A quick review of the five perceptual skills of drawing

In this lesson, we are working on the perception of edges as one of the component skills of drawing. Recall that there are four others and together these five components make up the whole skill of drawing:

1. The perception of edges (the "shared" edges of contour drawing).
2. The perception of spaces (in drawing called *negative* spaces).
3. The perception of relationships (known as perspective and proportion).
4. The perception of lights and shadows (often called "shading").
5. The perception of the whole (the gestalt, the "thingness" of the thing).

Modified Contour Drawing: First, drawing on the picture plane

What you'll need:

- Your clear plastic Picture Plane
- Your felt-tip marker
- Both of your viewfinders

Before you begin: Please read through all of the instructions before starting your drawing. In the next section I will define and fully explain the Picture Plane. For now, you will be simply using it. Just follow the instructions.

What you'll do:

1. Rest your hand on a desk or table in front of you (the left hand if you are right-handed, and the right, if you are left-handed) with the fingers and thumb curved upward, pointing toward your face. This is a foreshortened view of your hand. Imagine now that you are about to draw that foreshortened form.

If you are like most of my students, you would simply not know how to go about doing that. It seems far too difficult to draw this three-dimensional form, with its parts moving toward you in space. You would hardly know where to start. The viewfinders and plastic Picture Plane will help you get started.

2. Try out each of the Viewfinders to decide which size fits most comfortably over your hand, which you should be holding in a foreshortened position with the fingers coming toward you. Men often need the larger, women the smaller-sized Viewfinder. Choose one or the other.

3. Clip the Viewfinder you have chosen on top of your clear-plastic Picture Plane.

4. Use your felt-tip marker to draw a "format" line on the plastic Picture Plane, running your marker around the inside of the opening of the Viewfinder. A format line forms the outer boundary of your drawing. See Figure 6-4.

5. Now, holding you hand in the same foreshortened position as before, balance the Viewfinder/plastic Picture Plane on the tips of your fingers and thumb. Move it about a bit until the picture-plane seems balanced comfortably.

6. Pick up your uncapped marking pen, gaze at the hand under the plastic Picture Plane and close one eye. (I'll explain in the next segment why it is necessary to close one eye. For now, please just do it.) See Figure 6-5.

7. Choose an edge to start your drawing. Any edge will do. With the marking pen, begin to draw on the plastic Picture Plane the edges of the shapes just as you see them. Don't try to "second guess" any of the edges. Do not name the parts. Do not wonder why the edges are the way they are. Your job, just as in

Fig. 6-3.

Fig. 6-4.

Fig. 6-5.

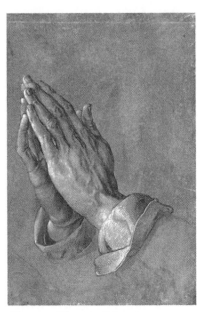

Fig. 6-6. Albrecht Dürer (1471–1528), *Hands in Adoration*. Black and white tempera on blue paper. Albertina Museum, Vienna.

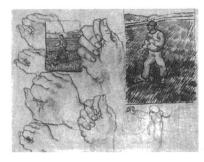

Fig. 6-7. Vincent Van Gogh, *Sketches with Two Sowers.* St. Remy, 1890.

Upside-Down Drawing and in Pure Contour Drawing, is to draw exactly what you see, with as much detail as you can manage with the marking pen (which is not as precise as a pencil).

8. Be sure to keep your head in the same place and keep one eye closed. Don't move your head to try to "see around" the form. Keep it still. (Again, I'll explain why in the next segment.)

9. Correct any lines you wish by just wiping them off with a moistened tissue on your forefinger. It is very easy to redraw them more precisely.

After you have finished:

Place the plastic Picture Plane on a plain sheet of paper so that you can clearly see what you have drawn. I can predict with confidence that you will be amazed. With relatively little effort, you have accomplished one of the truly difficult tasks in drawing—drawing the human hand in foreshortened view. Great artists in the past have practiced drawing hands over and over. Observe the examples by Albrecht Dürer and Vincent Van Gogh, Figures 6-6 and 6-7.

How did you accomplish this so easily? The answer, of course, is that you did what a trained artist does: You "copied" what you saw on the picture-plane—in this instance, an actual plastic plane. I fully define and explain the Picture Plane in the next section. For now, you are simply using it. I have found that the explanation makes more sense after students have used the plastic plane.

For further practice: I suggest that you erase your felt-tip pen drawing from the Picture Plane with a damp tissue and do several more, with your hand in a different position each time. Try for the really "hard" views—the more complicated the better. Oddly enough, the flat hand is the hardest to draw; a complex position is actually easier. Therefore, arrange your hand with the fingers curved, entwined, crossed, fist clenched, whatever. Try to include some foreshortening. Remember, the more you practice each of these exercises, the faster you will progress. Save your last (or

best) drawing for the next exercise.

This brings us to a crucial question—that is, an all-important question in terms of your understanding: What is drawing?

The quick answer: Drawing is "copying" what you see on the picture-plane. In the drawing you did just now, your own hand in foreshortened view, you "copied" the "flattened" image of your hand that you "saw" on the plastic Picture Plane.

And now, a more complete answer to the question, "What is drawing?"

In art, the concept of "the picture plane" is extremely abstract and difficult to explain, and even more difficult to comprehend. But this concept is one of the most important keys to learning to draw, so stay with me. I'll try to be clear.

The picture plane is a mental concept. See this in your "mind's eye": the picture plane is an imaginary transparent plane, like a framed window, that is always hanging out in front of the artist's face, always parallel to the "plane" of the artist's two eyes. If the artist turns, the plane also turns. What the artist sees "on the plane" actually extends back into the distance. But the plane enables the artist to "see" the scene as though it were magically smashed flat on the back of the clear glass plane—like a photograph, in a sense. Put another way, the 3-D image behind the framed "window" is converted to a 2-D (flat) image. The artist then "copies" what is seen "on the plane" onto the flat drawing paper.

This trick of the artist's mind, so difficult to describe, is even more difficult for beginning students to discover on their own. In this course, therefore, you need an actual picture plane (your plastic Picture Plane) and actual window frames (the Viewfinders).

These devices seem to work like magic in causing students to "get" what drawing is—that is, to understand the fundamental nature of drawing perceived objects or persons.

To further help beginners in drawing, I asked you to draw crosshairs on your sheet of plastic (the plastic Picture Plane). These two "grid" lines represent vertical and horizontal, the two constants that the artist absolutely depends on to assess relation-

It might help your understanding of the picture plane to realize that photography grew out of drawing. In the years before photography was invented, artists generally understood and used the concept of the picture-plane. You can imagine the artists' excitement (and, perhaps, dismay) to see that a photograph could, in an instant, capture the image on the picture-plane—an image that would have taken an artist hours, days, or even weeks to render in a drawing. Artists, deposed from realistic depiction, began exploring other aspects of perception, such as the effects of light (Impressionism). After photography became common, the concept of the picture plane was less necessary and began to fade away.

The picture plane is an imaginary vertical surface, like a window, through which you look at your subject. In this way, you copy your three-dimensional view of the world to your two-dimensional surface onto your drawing paper.

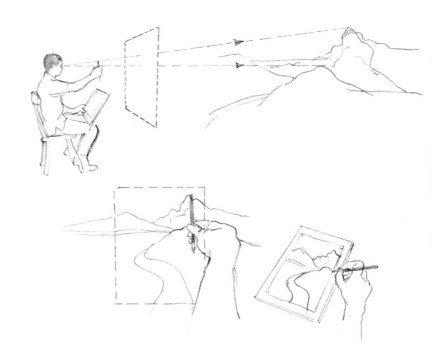

Dozens of picture planes and perspective devices are recorded in the U.S. Patent Office. Here are two examples.

ships. Early on in my classes, I used a grid of many lines, but I found that students were counting up—"two spaces over and three down." This is just the kind of L-mode activity we didn't want. I then reduced the "grid" lines to one vertical and one horizontal and found that was sufficient.

Later on, you will need neither the plastic Picture Plane with its gridlines nor the Viewfinders. You will replace these technical devices with the imaginary, internalized mental picture-plane that every artist uses, whether consciously or subconsciously. The actual plane (your plastic Picture Plane) and the actual Viewfinders are simply very effective aids during the time you are learning how to draw.

Try this: Fasten your Viewfinder, the one with the largest opening, on top of the Picture Plane, using your clips. Close one eye and hold the Picture Plane/Viewfinder together up in front of your face. See Figure 6-8.

Look at the "framed" image, whatever is in front of your eye (singular). You can change the "composition" by bringing the Viewfinder closer to or farther away from your face, much as a camera viewfinder works. Check out the angles of the edges of the ceiling, or perhaps of a table, relative to the crosshairs—that is, relative to vertical and horizontal. These angles may surprise you. Next, imagine that you are drawing with your felt-tip marker what you see on the plane, just as you did in drawing your hand. See Figure 6-9.

Then turn to see another view, and then another, always keeping the picture-plane parallel to the front of your face. Don't slant it in any direction! One way to practice not slanting the plane is to bring the plastic Picture Plane right up to your face, then quickly extend your arms straight out together.

Next, choose a view that you like, framed by your Viewfinder on the plastic Picture Plane. Imagine that you are "copying" what you see on the plane onto a piece of drawing paper. Remember, all of the angles, sizes, spaces, and relationships will be just what you see on the plane. See Figure 6-10.

These two images, your (imagined) drawing on the paper and the image on the plastic Picture Plane will be (approximately)

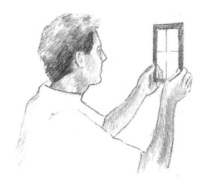

Fig. 6-8.

Fig. 6-9.

Fig. 6-10.

"Dear Theo,
In my last letter you will have found a little sketch of that perspective frame I mentioned. I just came back from the blacksmith, who made iron points for the sticks and iron corners for the frame. It consists of two long stakes; the frame can be attached to them either way with strong wooden pegs.

"So on the shore or in the meadows or in the fields one can look through it *like a window* [the artist's emphasis]. The vertical lines and the horizontal line of the frame and the diagonal lines and the intersection, or else the division in squares, certainly give a few pointers which help one make a solid drawing and which indicate the main lines and proportion . . . of why and how the perspective causes an apparent change of direction in the lines and change of size in the planes and in the whole mass.

"Long and continuous practice with it enables one to draw quick as lightning—and once the drawing is done firmly, to paint quick as lightning, too."

From Letter 223, *The Complete Letters of Vincent Van Gogh*, Greenwich, Conn.: The New York Graphic Society, 1954, p. 432–33.

the same. If perfectly drawn—very hard to do!—they will be identical. At its most basic level, that is what drawing is. To reiterate, basic realistic drawing is copying what is seen on the picture-plane.

"If that is so," you may object, "why not just take a photograph?" I believe one answer is that the purpose of realistic drawing is not simply to record data, but rather to record your unique perception—how you personally see something—and, moreover, how you understand the thing you are drawing. By slowing down and closely observing something, personal expression and comprehension occur in ways that cannot occur simply by taking a snapshot. (I am referring, of course, to casual photography, not the work of artist-photographers.)

Also, your style of line, choices for emphasis, and subconscious mental processes—your personality, so to speak—enters the drawing. In this way, again paradoxically, your careful observation and depiction of your subject give the viewer both the image of your subject and an insight into you. In the best sense, you have expressed yourself.

Use of the picture-plane has a long tradition in the history of art. The great Renaissance artist Leone Battista Alberti discovered that he could draw in perspective the cityscape beyond his window by drawing directly on the glass pane the view he saw behind the pane. Inspired by Leonardo da Vinci's writing on the subject, German artist Albrecht Dürer developed the picture-plane concept further, building actual picture-plane devices. Dürer's writings and drawings inspired Vincent Van Gogh to construct his own "perspective device," as he called it, when he was laboriously teaching himself to draw (see Figure 6-11). Later on, after Van Gogh had mastered basic drawing, he discarded his device, just as you will.

Note that Van Gogh's device must have weighed twenty pounds or more. I can picture him in my mind's eye laboriously dismantling the parts, tying them up, carrying the bundle—along with his painting materials—on his long walk to the seashore, unbundling and setting the device up, and then repeating the whole sequence to get home at night. This gives us some insight

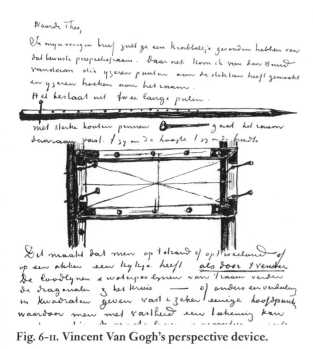

Fig. 6-11. Vincent Van Gogh's perspective device.

Fig. 6-12. The artist using his device at the seashore.

From *The Complete Letters of Vincent Van Gogh.*
Greenwich: The New York Graphic Society, 1954.
The drawings are reproduced by permission of
The New York Graphic Society.

into how resolutely Van Gogh labored to improve his drawing skills (see Figure 6-12).

Another renowned artist, the 16th-century Dutch master Hans Holbein, who had no need for help with his drawing, also used an actual Picture Plane. Art historians recently discovered that Holbein used a glass pane on which he directly drew images of his sitters for the overwhelming number of portrait drawings required of him when he lived in the English court of Henry VIII. Art historians speculate that Holbein, one of the great draughtsmen of art history, did this to save time—the overworked artist could then quickly transfer the drawing on glass to paper and get on to the next portrait.

One more important point: "Drawing" means drawing a single view.

Recall that when you drew your hand directly on the plastic Picture Plane, I asked you to keep your hand still and your head still in order to see one view only on the Picture Plane. Even a slight movement of your hand or a slight change in the position of your head will give you a different view of your hand. I some-

times see students bend their heads around to see something they couldn't see with their head in the original position. Don't do it! If you can't see that fourth finger, you don't draw it. To repeat: Keep your hand and your head in an unchanged position and draw just what you see.

For the same reason—to see one view only—you kept one eye closed. By closing one eye, you removed binocular vision, the slight variance in images, called "binocular disparity," that occurs when we view an object with both eyes open.

Binocular vision allows us to see the world as three-dimensional. This ability is sometimes called "depth perception." When you close one eye, the single image is two-dimensional—that is, it is flat, like a photograph. The paper we draw on is also two-dimensional or flat.

Here is yet another of the paradoxes of drawing:

The flat, two-dimensional image you see (with one eye closed) on the picture-plane, when copied onto your drawing paper, miraculously "looks" three-dimensional to the person who views your drawing. One necessary step in learning to draw is to believe that this miracle will happen. Often, students struggling with a drawing will ask, "How can I make this table look like it's going back in space?" or "How do I make this arm look like it's coming toward me?" The answer, of course, is to draw—to copy!—just what you see flattened on the picture-plane. Only then will the drawing convincingly depict these "movements" through three-dimensional space (see Figure 6-13).

You may be wondering, "Is it always necessary to close one eye while drawing?" Not always, but most artists do quite a lot of one-eye closing while drawing. The closer the viewed object, the more eye-closing. The farther away the object, the less eye closing, because the binocular disparity referred to above diminishes with distance.

In this next exercise, you will use your technical aids (your plastic Picture Plane and your Viewfinders) to enable you to do a realistic drawing of your own hand—a "real" drawing depicting a three-dimensional form on a flat sheet of paper.

Fig. 6-13. Brian Harking.

Students often become very frustrated at the start of a drawing—perhaps because the starting of a drawing is always difficult. Also I think students beginning in drawing believe that drawings just "flow out." They don't. You will be making numerous intense relational calculations at the start, and it's only after the drawing is well started—in fact, nearing completion—that it begins to "flow."

Modified Contour Drawing of your hand

What you'll need:

- Several sheets of the smaller drawing paper
- Your graphite stick and some paper napkins or paper towels
- Your #2 writing pencil or your #4B drawing pencil, sharpened
- Your eraser
- Your plastic Picture Plane
- Your felt-tip marker
- The Viewfinder you used for your drawing on the Picture Plane
- An hour of uninterrupted time

What you'll do:

Before you begin: Please read through all of the instructions.

In this drawing, we are modifying the instructions for Pure Contour Drawing. You will sit in a normal position and therefore be able to glance at your drawing to monitor its progress (see Figure 6-14). Nevertheless, I hope you will use the same focused concentration that you used in Pure Contour Drawing.

Fig. 6-14. The position for Modified Countour Drawing is the usual drawing position.

Most of my students greatly enjoy this process of toning their paper, and the physical action of "working up" the tone seems to help them get started with a drawing. A possible reason is that, having marked the paper and made it their own, so to speak, they escape the intimidation of that blank sheet of white paper staring at them.

1. Tape a stack of several sheets of paper to your drawing board. Tape all four corners securely, so that the paper will not shift around. One of your hands will be "posing" and must remain still. The other will be drawing and perhaps erasing. If the paper shifts under your hand while you are drawing or erasing, it is very distracting.

2. Draw a format on your drawing paper, using the inside edge of your Viewfinder.

3. The next step is to tone your paper. Make sure you have a stack of several sheets of paper to pad your drawing. Begin to tone your paper by rubbing the edge of the graphite stick very lightly over the paper, staying inside the format. You want to achieve a pale, even tone—don't worry too much about staying within the lines. You can clean up the edges at a later time. Figure 6-15.

4. Once you have covered the paper with a light application of graphite, begin to rub the graphite into the paper with your

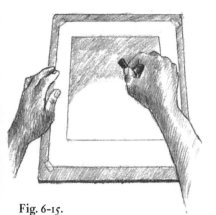

Fig. 6-15.

Fig. 6-16.

Fig. 6-17.

Fig. 6-18. Pose your hand under the Picture Plane.

paper towels. Rub with a circular motion, applying even pressure right up to the edge of the format. You want to achieve a very smooth, silvery tone. Figure 6-16.

5. Next, lightly draw horizontal and vertical crosshairs on your toned paper. The lines will cross in the center just as they do on your plastic Picture Plane. Use the crosshairs on the plastic plane to mark the position of the crosshairs on the format of your toned paper. A caution: Don't draw the lines too dark. They are only guidelines and later you may want to eliminate them. Figure 6-17.

6. Retrieve your Picture Plane with the felt-tip drawing that you did at the start of this chapter, or, if you wish, you can do a new drawing (Figure 6-18). Place the plane down on a light surface, perhaps a sheet of paper, so that you can clearly see the drawing on the plastic. This image will act as a guide for you when you next draw your hand without the actual plane. Figure 6-19.

Fig. 6-19. Draw the edges as you see them on the Picture Plane.

Fig. 6-20. Transfer the main points from your drawing or plastic to your toned drawing paper.

Fig. 6-21.

Try to observe the shapes of the lights and shadows. I realize you haven't yet had any instruction of the fourth drawing skill, the perception of lights and shadows. I've found, however, that students do well just plunging in and they often enjoy it very much.

7. An important step: Now, you will transfer the main points and edges of your drawing on plastic to your drawing paper (Figure 6-20). The formats are the same size, so it is a one-to-one scale transfer. Using the crosshairs, place the point where an edge of your hand contacts the format. Transfer several of these points. Then, begin to connect the edges of your hand, fingers, thumb, palm, wrinkles, and so on with the points you have established. This is just a light sketch to help you place the hand within the format. Recall that drawing is copying what you see on the picture plane. For this drawing, you will take this actual step, to get used to the process. Don't worry about erasing the ground if you have to change a line. Erase, then just rub the erased area with your finger or a paper napkin and the erasure disappears.

8. Once this rough, light sketch is on your paper, you are ready to start drawing.

9. Reposition your "posing" hand, using the drawing-on-plastic to guide the positioning. Then, set aside your drawing-on-plastic, but place it where you can still refer to it.

10. Then, closing one eye, focus on a point on some edge in your posing hand. Any edge will do to make a start. Place your pencil point on this same point in the drawing. Then, gaze again at this point on your hand in preparation to draw. This will start the mental shift to R-mode and help to quiet any mutterings from L-mode.

11. When you begin to draw, your eyes—or rather, eye—will move slowly along the contour and your pencil will record your perceptions at the same slow speed that your eye is moving. Just as you did in Pure Contour Drawing, try to perceive and record all of the slight undulations of each edge (Figure 6-21). Use your eraser whenever needed, even to make tiny adjustments in the line. Looking at your hand (with one eye closed, remember), you can estimate the angle of any edge by comparing it to the crosshairs. Check these angles in your drawing-on-plastic that you did earlier, but also try to see these relationships by imagining a picture-plane hovering

over your hand, with its helpful crosshairs and the edge of the format to guide you.

12. About 90 percent of the time, you should be looking at your hand. That is where you will find the information that you need. In fact, all the information you need to do a wonderful drawing of your hand is right in front of your eyes. Glance at the drawing only to monitor the pencil's recording of your perceptions, to check for relationships of sizes and angles, or to pick a point to start a new contour. Concentrate on what you see, wordlessly sensing to yourself, "How wide is this part compared to that? How steep is this angle compared to that?" And so on.

13. Move from contour to adjacent contour. If you see spaces between the fingers, use that information as well: "How wide is that space compared to the width of that shape?" (Remember, we are not naming things—fingernails, fingers, thumb, palm. They are all just edges, spaces, shapes, relationships.) Be sure to keep one eye closed at least a good portion of the time. Your hand is quite close in proximity to your eyes, and the binocular disparity can confuse you with two images.

When you come to parts that impose their names on you—fingernails, for example—try to escape the words. One good strategy is to focus on the shapes of the flesh around the fingernails. These shapes share edges with the fingernails. Therefore, if you draw the shapes around the nails, you will have also drawn the edges of the fingernails—but you'll get both right! In fact, if mental conflict sets in over any part of the drawing, move to the next adjacent space or shape, remembering the "shared edge" concept. Then, return later with "new eyes" to the part that seemed difficult. (Figure 6-22)

14. You may want to erase out the spaces around your hand. This makes the hand "stand out" from the negative spaces.

You can work up the drawing with a little shading by observing where you see areas of light (highlights) and areas of shadow appear on your posing hand. Erase out the highlights and draw in the shadows.

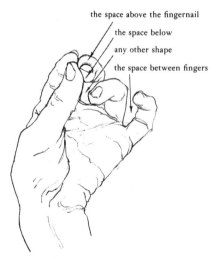

the space above the fingernail

the space below

any other shape

the space between fingers

Fig. 6-22. Drawing the hand by using shapes and spaces.

Suggestions for practice: Using the method for Modified Contour Drawing, draw a preliminary "copy" of the object first on the Picture Plane. Then draw the object itself, using the drawing-on-plastic as a guide. Try these subjects:

A shoe, or shoes

A pair of eyeglasses

A kitchen whisk or wine bottle opener

A flower

Drawing takes many forms. In this course, you are acquiring the basic perceptual skills of drawing, comparable to learning the basic ABC's of reading and writing.

15. Finally, when the drawing begins to become intensely interesting, like a complicated and beautiful jigsaw puzzle gradually taking shape under your pencil, you will be really drawing.

After you have finished: This is your first "real" drawing and I can assume with some confidence that you are pleased with the results. I hope you now see what I meant about the miracle of drawing. Because you drew what you saw on the flat picture-plane, your drawing appears authentically three-dimensional.

Furthermore, some very subtle qualities will show in your drawing. For example, a sense of the volume—the three-dimensional thickness—of the hand will be there, as well as the precise tension of certain muscles or the pressure of a finger on the thumb. And all of this comes from simply drawing what you see on the plane.

In the following group of drawings, the hands are three-dimensional, believable, and authentic. They seem to be made of flesh, muscles, skin, and bones. Even very subtle qualities are depicted, such as the pressure of one finger on another, the tension of certain muscles, or the precise texture of the skin.

I've included some demonstration drawings by me and others of our teaching staff. As you see, these drawings are done on a toned ground, which we'll also be using in the next exercise.

Before we move on to the next step, think back on your mental state during the drawing of your hand. Did you lose track of time? Did the drawing at some point become interesting, even fascinating? Did you experience any distraction from your verbal mode? If so, how did you escape it?

Also, think back on this basic conception of the picture-plane and our working definition of drawing: "copying" what you see on the picture-plane. From now on, each time you pick up the pencil to draw, the strategies learned in this drawing will become better integrated and more "automatic."

You might want to do a second Modified Contour Drawing of your hand, perhaps this time holding some complex object: a twisted handkerchief, a flower, a pinecone, a pair of eyeglasses. For this drawing, you can again work on a lightly "toned" ground.

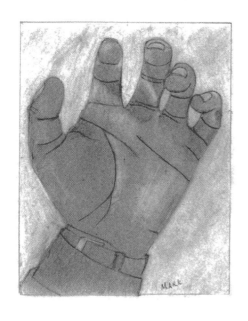

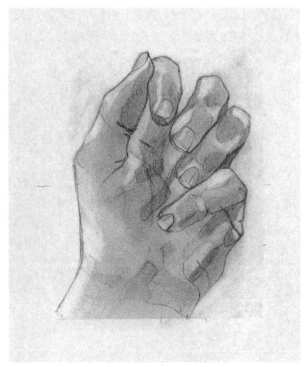

The next step: Tricking L-mode with empty space

So far, we have located some gaps in the abilities of the left hemisphere. It has problems with mirror images (as in the Vase/Faces drawing). It can't deal with upside-down perceptual information (as in the upside-down Stravinsky drawing). It refuses to process slow, complex perceptions (as in the Pure and Modified Contour drawings). We used those gaps to give R-mode a chance to process visual information without interference from L-mode.

The next lesson on negative space is designed to reestablish your grasp of the unity of spaces and forms in composition, which you had as a child.

7 Perceiving the Shape of a Space: The Positive Aspects of Negative Space

I N THIS CHAPTER, we'll take up the next component skill of drawing—the perception of negative spaces. You will use your new skills of seeing and drawing complicated edges in order to draw the edges of negative spaces.

This exercise will be a stretch for some, a joy for others. There is an antic or whimsical quality to seeing negative spaces. In a sense, you are seeing what is not there. In American life, it is often a new experience to realize that spaces are important. We tend to focus on objects; we are an objective culture. In other cultures, working "within the space of a problem" is common practice. My aim is to make spaces become "real" for you and to provide a new experience in seeing.

In this chapter, you will also learn to find and use a "Basic Unit" that will enable you to correctly size the first shape you draw. And you will dip into lights and shadows by working on a toned ground.

Let's quickly review the five basic skills of drawing. Remember, these are perceptual skills: The perception of

- Edges (line of contour drawing)
- Spaces (negative spaces)
- Relationships (proportion and perspective)
- Lights and shadows (shading)
- The gestalt (the "thingness" of the thing)

What are negative spaces and positive forms?

Two terms traditionally used in art are "negative spaces" and "positive forms." In the drawings of the bighorn sheep, for example, the sheep is the positive form and the sky behind and ground below the animal are the negative spaces.

The word "negative" in negative spaces is a bit unfortunate because it carries, well, a negative connotation. I have searched in vain for a better term, so we'll stick with this one. The terms *negative spaces* and *positive forms* have the advantage of being easy to

Fig. 7-1. Jeanne O'Neil.

remember and they are, after all, commonly used in the whole field of art and design. The main point is that negative spaces are just as important as the positive forms. For the person just learning to draw, they are perhaps more important!

Why is learning to see and draw negative spaces so important?

When a person just beginning in drawing tries to draw a chair, that person knows too much, in an L-mode sense, about chairs. For example, seats have to be big enough to hold a person; all four chair legs are usually all the same length; chair legs sit on a flat surface, and so forth. This knowledge does not help, and in fact can greatly hinder, drawing a chair. The reason is that, when seen from different angles, the visual information may not conform to what we know.

Visually—that is, as seen on the plane—a chair seat may appear as a narrow strip, not nearly wide enough to sit on. The legs may appear to be all of different lengths. The curve of the back of a chair may appear to be entirely different from what we know it to be (Figure 7-1).

What are we to do? An answer: Don't draw the chair at all! Instead, draw the spaces of the chair.

Why does using negative space make drawing easier? I believe that it's because you don't know anything, in a verbal sense, about these spaces. Because you have no pre-existing memorized symbols for space-shapes, you can see them clearly and draw them correctly. Also, by focusing on negative spaces, you can cause L-mode again to drop out of the task, perhaps after a bit of protest: "Why are you looking at nothing? I do not deal with nothing! I can't name it. It's of no use . . ." Soon, this chatter will cease—again, just what we want.

An analogy to clarify the concept of negative spaces

In drawing, negative space-shapes are real. They are not just empty "air."

The following analogy may help you to see that. Imagine that you are watching a Bugs Bunny cartoon. Imagine that Bugs

Bunny is running at top speed down a long hallway, at the end of which is a closed door. He smashes through the door, leaving a Bugs-Bunny shaped hole in the door. What's left of the door is negative space. Note that the door has an outside edge (its format). This edge is the outside edge of the negative space-shape. In this analogy, the hole in the door is the positive form (Bugs Bunny) gone poof!

Now, take your Viewfinder/plastic Picture Plane and look at a chair. Close one eye and move the Viewfinder backward and forward, up and down, as though framing a snapshot. When you have found a composition that pleases you, hold the Viewfinder very still. Now, gazing at a space in the chair, perhaps the space between two back slats, imagine that the chair is magically pulverized and—like Bugs Bunny, in a poof!—disappears, leaving only the negative spaces, the one you are gazing at and all the rest of the spaces. They are real. They have real shapes, just like the remains of the door in the analogy above. These negative space-shapes are what you are going to draw. In short, you will draw the spaces, not the chair.

The reason? Recall our definition of edges: All edges are shared edges where two things come together. The negative spaces share edges with the (now absent) chair. If you draw the edges of the spaces, you also will have drawn the chair, because it shares edges with the spaces. But the chair will "look right," because you will be able to see and draw the spaces accurately. (See the examples of negative-space drawings of chairs.)

Note that the format is also the outer edge of the chair's negative spaces (another shared edge) and together the chair-form and the space-shapes fill the format completely. Technically speaking, the whole image, made up of positive forms and negative space-shapes, is called the composition. The artist composes the forms and the spaces within the format, arranging them according to certain "rules" called the Principles of Art.

Art teachers often laboriously try to teach their students "the rules of composition," but I have discovered that if students pay close attention to negative spaces in their drawings, many compositional problems are automatically solved.

Demonstration drawing by instructor Brian Bomeisler.

Unity: A most important principle of art.

If negative spaces are given equal importance to the positive forms, all parts of a drawing seem interesting and all work together to create a unified image. If, on the other hand, the focus is almost entirely on the positive forms, the drawing may seem uninteresting and disunified—even boring—no matter how beautifully rendered the positive form may be. A strong focus on negative spaces will make these basic instructional drawings strong in composition and beautiful to look at.

Fig. 7-2. A variety of formats.

Defining composition

In drawing, the term composition means the way the components of a drawing are arranged by the artist. Some key components of a composition are positive shapes (the objects or persons), negative spaces (the empty areas), and the format (the relative length and width of the bounding edges of a surface). To compose a drawing, therefore, the artist places and fits together the positive shapes and the negative spaces within the format with the goal of unifying the composition.

The format controls composition. Put another way, the shape of the drawing surface (usually rectangular paper) will greatly influence how an artist distributes the shapes and spaces within the bounding edges of that surface. To clarify this, use your R-mode ability to image a tree, perhaps an elm or a pine. Now fit the same tree into each of the formats in Figure 7-2. You will find that—to "fill the space"—you have to change the shape of the tree and the spaces around the tree for each format. Then test again by imaging exactly the same tree in all of the formats. You will find that a shape that fits one format is all wrong for another.

Experienced artists fully comprehend the importance of the shape of the format. Beginning students in drawing, however, are curiously oblivious to the shape of the paper and the boundaries of the paper. Because their attention is directed almost exclusively toward the objects or persons they are drawing, they seem to regard the edges of the paper almost as nonexistent, almost like the real space that surrounds objects and has no bounds.

This obliviousness to the edges of the paper, which bound both the negative spaces and positive shapes, causes problems with composition for nearly all beginning art students. The most serious problem is the failure to unify the spaces and the shapes—a basic requirement for good composition.

The importance of composing within the format

In Chapter Five, we saw that young children have a strong grasp of the importance of the format. Children's consciousness of the bounding edges of the format controls the way they distribute the

Fig. 7-4.

Fig. 7-3. Joan Miro, *Personages with Star* (1933). Courtesy of The Art Institute of Chicago.

forms and spaces, and young children often produce nearly flawless compositions. The composition by a six-year-old in Figure 7-4 compares favorably with the Spanish artist Miro's composition in Figure 7-3.

Unfortunately, as you have seen, this ability lapses as children approach adolescence, perhaps due to lateralization, increasing dominance of the language system, and the left hemisphere's penchant for recognizing, naming, and categorizing objects. Concentration on things seems to supersede the young child's more holistic or global view of the world, where everything is important, including the negative spaces of sky, ground, and air. Usually it takes years of training to convince students, in the way experienced artists are convinced, that the negative spaces, bounded by the format, require the same degree of attention and care that the positive forms require. Beginning students generally lavish all their attention on the objects, persons, or forms in their drawings, and then more or less "fill in the background." It may seem hard to believe at this moment, but if care and attention are lavished

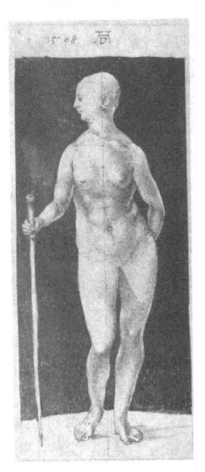

on the negative spaces, the forms will take care of themselves. I'll be showing you specific examples of that.

The quotations by the playwright Samuel Beckett and the Zen philosopher Alan Watts (on page 123) state this concept concisely. In art, as Beckett says, nothing (in the sense of empty space) is real. And as Alan Watts says, the inside and outside are one. You saw in the last chapter that in drawing, the objects and the spaces around them fit together like the pieces of a puzzle. Every piece is important and they share edges. Together they fill up all of the area within the four edges—that is, within the format.

Look at the example of this fitting together of the spaces and shapes in the still-life painting by Paul Cézanne (Figure 7-6) and the figure drawing by Dürer (Figure 7-5). Notice how varied and

Fig. 7-5. Albrecht Dürer (1471–1528), *Nude Woman with a Staff* (1508). Courtesy of The National Gallery of Canada, Ottawa. The negative shapes surrounding the figure are beautifully varied in size and configuration.

Fig. 7-6. Paul Cézanne (1839–1936), *The Vase of Tulips.* Courtesy of The Art Institute of Chicago. By making the positive forms touch the edge of the format in several places, Cézanne enclosed and separated the negative shapes, which contribute as much to the interest and balance of the composition as do the positive forms.

interesting the negative spaces are. Even in the Dürer, which is almost symmetrical, the negative spaces are beautifully varied. Now, back to the drawing lessons.

Summing up, then, negative spaces have two important functions:

1. Negative spaces make "difficult" drawing tasks easy—for example, areas of foreshortening or complicated forms or forms that don't "look like" what we know about them, become easy to draw by using negative space. The chair drawings in the margin and the horns of the sheep on page 116 are good examples.
2. Emphasis on negative spaces unifies your drawing and strengthens composition and—perhaps most important, improves your perceptual abilities.

I realize that it is counter-intuitive—that is, it goes against common sense—to think that focusing on the spaces around objects will improve your drawing of the objects. But this is simply another of the paradoxes of drawing and may help to explain why it is so difficult to teach oneself to draw. So many of the strategies of drawing—using negative space, for example—would never occur to anyone "in their left mind."

Our next bit of preparation is to define the "Basic Unit." What is it and how does it help with drawing?

Choosing a Basic Unit

On looking at a finished drawing, students just beginning to draw often wonder how the artist decided where to start. This is one of the most serious problems that plague students. They ask, "After I've decided what to draw, how do I know where to start?" or "What happens if I start too large or too small?" Using a Basic Unit to start a drawing answers both these questions, and ensures that you will end with the composition you so carefully chose before you started a drawing.

After years of teaching classes and workshops, struggling to find words to explain how to start a drawing, I and my fellow teachers finally worked out a method that helped us to communi-

Fig. 7-7.

cate how a trained artist does this. We had to carefully introspect what we were doing when starting a drawing and then figure out how to teach the process, which is fundamentally non-verbal, extremely rapid, and "on automatic." I have called this method, "Choosing a Basic Unit." This Basic Unit becomes the key that unlocks all of the relationships within a chosen composition: All proportions are found by comparing everything to the Basic Unit.

The Basic Unit—A definition

In Chapter Six, I stated that all parts of a composition (negative spaces and positive forms) are locked into a relationship that is bounded by the outside edge of the format. For realistic drawing, the artist is bound to that relationship in which all the parts fit together: The artist is not at liberty to change the proportional relationships. I'm sure you can see that if you change one part, something else necessarily gets changed. In Chapter Six I used a child's jigsaw puzzle to illustrate the important concept of shared edges. I'll use the same puzzle to illustrate the Basic Unit (Figure 7-7).

The Basic Unit is a "starting shape" or "starting unit" that you choose from within the scene you are looking at through the Viewfinder (the sailboat on the water). You need to choose a Basic Unit of medium size—neither very small nor very large, relative to the format. In this instance, you could choose the straight edge of the sail. A Basic Unit can be a whole shape (the shape of a window or the shape of a negative space) or it can be just a single edge from point to point (the top edge of a window, for example). The choice depends only on what is easiest to see and easiest to use as your Basic Unit of proportion.

In the jigsaw puzzle, I chose to use the straight edge of the sail as my Basic Unit.

Once chosen, all other proportions are determined relative to your Basic Unit. The Basic Unit is always called "One." You can lay your pencil down on the puzzle to compare the relationships. For example, you can now ask yourself, "How wide is the boat compared to my Basic Unit, the long edge of the sail?" (One to

one and one-third.) "How wide is the sail relative to my Basic Unit?" (One to two-thirds.) "Where is the sea/sky edge from the bottom of the format?" (One to one and one-quarter.) Note that for each proportion, you go back to your Basic Unit to measure it on your pencil and then you make the comparison with another part of the composition. I'm sure you can see the logic of this method and how it will enable you to draw in proportion.

As I teach you how to find and use a Basic Unit, this method of starting may seem a bit tedious and mechanical at first. But it resolves many problems, including problems of starting and of composition as well as problems of proportional relationships. It soon becomes quite automatic. In fact, this is the method most experienced artists use, but they do it so rapidly that someone watching would think that an artist "just starts drawing."

An anecdote about French artist Henri Matisse illustrates this point and also illustrates the almost subconscious process of finding a Basic Unit. John Elderfield, curator of drawings at the Museum of Modern Art in New York, in his wonderful catalog of the Matisse Retrospective Exhibition of 1992, states: "There is a 1946 film of Matisse painting *Young Woman in White, Red Background* [see Figure 7-8]. . . . When Matisse saw the slow-motion sequence of the film, he felt 'suddenly naked,' he said, because he saw how his hand 'made a strange journey of its own' in the air before drawing the model's features. It was not hesitation, he insisted: 'I was unconsciously establishing the relationship between the subject I was about to draw and the size of my paper.' " Elderfield goes on to say, "This can be taken to mean that he had to be aware of the entire area he was composing before he could mark a particular section of it."

Clearly, Matisse was finding his "starting shape," the head of the model, to make sure he would have it the right size to show the whole figure in his painting. The curious thing about Matisse's remark, I think, is that he felt "suddenly naked" when he saw himself apparently figuring out how big to make that first shape. I think this indicates the almost entirely subconscious nature of this process.

Later on, you too will rapidly find a starting shape or a Basic

Fig. 7-8. Henri Matisse, *Young Woman in White, Red Background*, 1946.

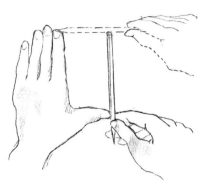

Fig. 7-9.

Unit or your "One"—or whatever you may eventually call it. And someone watching you will think that you "just started drawing."

Getting off to a good start

I hope that you will become used to quickly choosing a Basic Unit to ensure a good composition. I imagine that you have already grasped the (visual) logic of starting your drawing this way, but allow me to put it into words once more.

When students are first learning to draw, they almost desperately want to get something down on the paper. Often, they just plunge in, drawing some object in the scene in front of them without paying attention to the size of that first shape in relation to the size of the format.

The size of the first shape that you draw controls the subsequent size of everything in the drawing. If that first shape is inadvertently drawn too small or too large, the resulting drawing may be an entirely different composition from the one you intended to depict.

Students find this frustrating, because it often happens that the very thing that interested them in the scene turns out to be "off the edge" of the paper. They don't get to draw that part at all simply because the first shape they drew was too large. Conversely, if the first shape is too small, students find that they must include much that is of no interest to them in order to "fill out" the format.

The method I am recommending to you, of correctly sizing the first shape (your Basic Unit) that you set down, prevents this inadvertent problem and becomes quite automatic with a bit of practice. Later on, when you have discarded all of your drawing aids—the Viewfinders and plastic Picture Plane, you will use your hands to form a rough "viewfinder" (as in Figure 7-9), and you will still size the first shape (which, in these lessons, we are calling your Basic Unit) correctly for your chosen composition.

Your Negative Space drawing of a chair

What you'll need:

- Your Viewfinder with the larger opening
- Your Picture Plane
- Your felt-tip marker
- Your masking tape
- Several sheets of drawing paper
- Your drawing board
- Your pencils, sharpened
- Your eraser
- Your graphite stick and several dry paper towels or paper napkins
- About an hour of interrupted time—more, if possible, but at least an hour

Getting set up to draw

You'll be taking some preliminary steps, so please read all of the instructions before you start. The following are the preliminary steps for every drawing and take only a few minutes, once you have learned the process.

- choosing a format and drawing it on your paper
- toning your paper (if you choose to work on a toned ground)
- drawing your crosshairs
- composing your drawing
- choosing a Basic Unit
- drawing the chosen Basic Unit on the Picture Plane with a felt-tip marker
- transferring the Basic Unit to your paper
- then, starting the drawing

I'll describe each step.

1. The first step is to draw a format on your drawing paper. For your Negative Space drawing of a chair, use the *outside* edge of your Viewfinder or the plastic Picture Plane. The drawing will be larger than the opening of your Viewfinder.

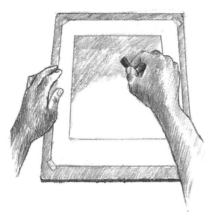 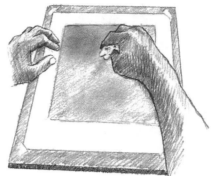 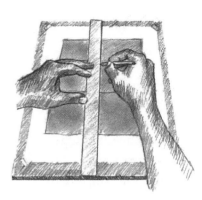

As in any field, the "rules" of art are made to be broken by artists working at advanced levels. While acquiring basic drawing skills, however, I think it is best to stay with the task at hand—learning how to see and draw. Once you have mastered basic drawing, you can take it as far as you want and break the rules intentionally, not by accident.

2. The second step is to tone your paper. Make sure you have a stack of several sheets of paper to pad your drawing. Begin to tone your paper by rubbing the edge of the graphite stick very lightly over the paper, staying inside the format.

3. Once you have covered the paper with a light application of graphite, begin to rub the graphite into the paper with your paper towels. Rub with a circular motion, applying pressure evenly and going right up to the edge of the format. You want to achieve a very smooth, silvery tone.

4. Next, lightly draw horizontal and vertical crosshairs on your toned paper. The lines will cross in the center, just as they do on your plastic Picture Plane. Use the crosshairs on the plastic plane to mark the position of the crosshairs on the format of your toned paper. A caution: Don't make the lines too dark. They are only guidelines, and later you may want to eliminate them.

5. The next step is to choose a chair to use as the subject of your drawing. Any chair will do—an office chair, a plain straight chair, a stool, a cafeteria chair, whatever. If you are lucky, you may find a rocking chair or a bentwood chair or something else very complicated and interesting. But the simplest kind of chair will be fine for your drawing.

6. Place the chair against a fairly simple background, perhaps a room corner or a wall with a door. A blank wall is just fine and will make a beautiful, simple drawing, but the choice of setting is entirely up to you. A lamp placed nearby may throw a

wonderful shadow of the chair on the wall or floor—a shadow that can become part of your composition.

7. Sit in front of your "still life"—the chair and setting you have chosen—at a comfortable distance of about eight to ten feet. Take the cap off your felt-tip marker and place it close beside you.

8. Next, use your Viewfinder to compose your drawing. Fasten the Viewfinder onto your clear plastic Picture Plane. Hold the Viewfinder/ Picture Plane in front of your face, close one eye, and, moving the device forward or backward, "frame" the chair in a composition that you like. (Students are very good at this. They seem to have an intuitive "feel" for composition.) If you wish, the chair can nearly touch the format so that the chair pretty much "fills the space."

9. Hold the Viewfinder very still. Now, gazing at a space in the chair, perhaps between two back slats, imagine that the chair is magically pulverized and—like Bugs Bunny, in a poof!— disappears. What is left are the negative spaces. They are real. They have real shapes, just like the remains of the door in the analogy above. These negative space-shapes are what you are going to draw. I repeat: You will draw the spaces, not the chair. See Figure 7-10.

Fig. 7-10.

Choosing a Basic Unit

1. When you have found a composition you like, hold the Viewfinder/plastic Picture Plane in that position. Pick up the felt-tip marker. Next, choose a negative space within the drawing—perhaps a space-shape between two rungs or between two back-slats. This space-shape should be fairly simple, if possible, and neither too small nor too large. You are looking for a manageable unit that you can clearly see for its shape and size. This is your Basic Unit, your "starting shape," your "One." See Figure 7-10 for an example.

2. With one eye closed, focus on that particular negative space—your Basic Unit. Keep your eye focused on your Basic Unit until it "pops" into focus as a shape. (This always takes a moment—perhaps it is L-mode's protesting time!)

Fig. 7-11.

Note that:

- The toned format on your paper is larger in size than the format of the opening of your Viewfinder.

 Though the sizes are different, the proportion of the two formats—meaning the relationship of width to length—is the same.

- Your felt-tip drawing of your Basic Unit on the plastic Picture Plane and your drawing on the toned paper will be the same, but the one on your paper will be larger.

- Stated another way, the images are the same, but the scale is different. Note that in this instance, you "scale up." At other times, you may "scale down."

3. With your felt-tip marker, carefully draw your Basic Unit on the plastic Picture Plane. This shape will be the start of your negative space drawing on your toned paper (Figure. 7-11).

4. The next step is to transfer your Basic Unit onto the paper you have toned. You will use your crosshairs to place it and size it correctly. (This is called "scaling up." See the sidebar for an explanation.) Looking at your drawing on the plastic plane, say to yourself: "Relative to the format and to the crosshairs, where does that edge start? How far over from that side? From the crosshair? From the bottom?" These assessments will help you draw your Basic Unit correctly. Check it three ways: The shape on your toned paper, the actual space-shape in the chair-model, and the shape in the Picture Plane drawing should all be proportionally the same.

5. Check each angle in your Basic Unit the same way, by comparing three ways as above. To determine an angle, say to yourself, "Relative to the edge of the format (vertical or horizontal), what is that angle?" You can also use the crosshairs (vertical and horizontal) to assess any angles in your Basic Unit. Then, draw the edge of the space at an angle just as you see it. (Simultaneously, of course, you are drawing the edge of the chair.)

6. One more time, check your drawing of your Basic Unit, first with the actual chair-model and then with the rough sketch on the plastic Picture Plane. Even though the scale is different in each, the relative proportions and angles will be the same.

It is worth taking time to make sure your Basic Unit is correct. Once you have this first negative space-shape correctly sized and placed within the format in your drawing, all of the rest of the drawing will be in relationship to that first shape. You will experience the beautiful logic of drawing and you will end with the composition you so carefully chose at the start.

Drawing the rest of the negative spaces of the chair

1. Remember to focus only on the shapes of the negative spaces.

Try to convince yourself that the chair is gone, pulverized, absent. Only the spaces are real. Try also to avoid talking to yourself or questioning why things are the way they are—for example, why any space-shape is the way it is. Draw it just as you see it. Try not to "think" at all, in terms of L-mode logic. Remember that everything you need is right there in front of your eye and you need not "figure it out." Remember also that you can check out any problem area by returning to your plastic Picture Plane and, remembering to close one eye, drawing the troublesome part directly on the plastic plane.

Fig. 7-12.

2. Draw the spaces of the chair one after another. Working outward from your Basic Unit, all the shapes will fit together like a jigsaw puzzle. You don't have to figure out anything about the chair. In fact, you don't have to think about the chair at all. And don't question why the edge of a space goes this way or that. Just draw it as you see it. See Figure 7-12.

3. Again, if an edge is at an angle, say to yourself, "What is that angle compared to vertical?" Then, draw the edge at the angle you see it.

4. Gauge horizontals in the same way: What is the angle, compared to horizontal (that is, the top or bottom edges of your format)?

Fig. 7-13.

5. As you draw, try to take conscious note of what the mental mode of drawing feels like—the loss of the sense of time, the feeling of "locking on" to the image, and the wonderful sense of amazement at the beauty of the perceptions. During the process, you will find that the negative spaces will begin to seem interesting in their strangeness and complexity. If you have a problem with any part of the drawing, remind yourself that everything you need to know in order to do this drawing is right there, perfectly available to you.

6. Continue working your way through the drawing, searching out relationships, both angles (relative to vertical or horizontal) and proportions (relative to each other). If you talk to yourself at all during the drawing, use only the language of relationships: "How wide is this space compared to the one I have just drawn?" "What is this angle compared to horizontal?

Fig. 7-14.

Fig. 7-15.

"How far does that space extend relative to that whole edge of the format?" Soon, you will be "really drawing." The drawing will begin to seem like a fascinating puzzle, the parts fitting together in an entirely satisfying way (Figure 7-14).

7. When you have finished drawing the edges of the spaces, you may want to "work up" the drawing a bit by using your eraser to remove the tone in some areas, perhaps erasing the negative spaces and leaving the chair in tone (Figure 7-15). If you see shadows on the floor or on the wall behind, you may want to add them to your drawing, perhaps adding in some tone with your pencil, or erasing out the negative spaces of the shadows. You may also want to "work up" the positive form of the chair itself, adding some of the interior contours.

After you have finished:

I feel confident that your drawing will please you. One of the most striking characteristics of negative-space drawings is that no matter how mundane the subject—a chair, an eggbeater, a can opener—the drawing will seem beautiful.

Perhaps negative-space drawings remind us of our longing for unity, or perhaps of our actual unity with the world around us. No matter what the explanation, we simply like to look at negative-space drawings. Don't you agree?

With only this brief lesson, you will begin to see negative spaces everywhere. My students often regard this as a great and joyful discovery. Practice seeing negative spaces as you go through your everyday routine and imagine yourself drawing those beautiful spaces. This mental practice at odd moments is extremely helpful in putting perceptual skills "on automatic," ready to be integrated into a learned skill that you own.

What follows is one last example of the usefulness of negative spaces.

The cognitive battle of perception

Figures 7-16 and 7-17 show an interesting graphic record of the struggle and its resolution in two drawings by a student of a cart

and slide projector. In Figure 7-16, the first drawing, the student had great difficulty reconciling his stored knowledge of what the objects were "supposed to look like" with what he saw. Notice in the drawing that the legs of the cart are all the same length, and a symbol is used for the wheels. When he shifted to using a viewfinder and drawing only the shapes of the negative spaces, he was far more successful (Figure 7-17). The visual information apparently came through clearly; the drawing looks confident and as though it were done with ease. And, in fact, it was done with ease, because using negative space enables one to escape the mental crunch that occurs when perceptions don't match conceptions.

It's not that the visual information gathered by regarding spaces rather than objects is really less complex or is in any way easier to draw. The spaces, after all, share edges with the form. But by looking at the spaces, we free R-mode from the domination of L-mode. Put another way, by focusing on information that does not suit the style of the verbal system, we cause the job to be shifted to the mode appropriate for drawing. Thus, the conflict ends, and in R-mode, the brain processes spatial, relational information with ease.

Fig. 7-16.

Showing all manner of negative spaces

These drawings are intriguingly pleasurable to look at, even when the positive forms are as mundane as schoolroom chairs. One could speculate that the reason is that the method of drawing raises to a conscious level the unity of positive and negative shapes and spaces. Another reason may be that the technique results in excellent compositions with particularly interesting divisions of shapes and spaces within the format.

Learning to see clearly through drawing can surely enhance your capacity to take a clear look at problems and to be better able to see things in perspective. In the next chapter, we'll take up the perception of relationships, a skill you can put to use in as many directions as your mind can take you.

Fig. 7-17.

Demonstration drawing by instructor Lisbeth Firmin.

Demonstration drawing by the author.

Demonstration drawing by the author.

Student drawing.

Student drawing by Sandy DePhillippo.

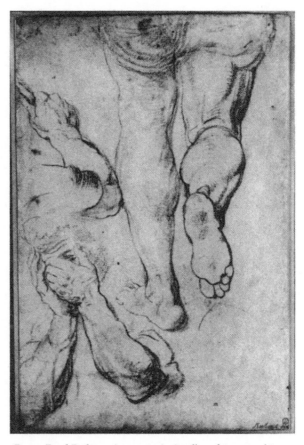

Winslow Homer (1836–1910), *Child Seated in a Wicker Chair* (1874). Courtesy of the Sterling and Francine Clark Art Institute.

Observe how Winslow Homer used negative space in his drawing of a child in a chair. Try copying this drawing.

Peter Paul Rubens (1577–1640). *Studies of Arms and Legs.* Courtesy of Museum Boymans-Van Beuningen, Rotterdam.

Copy this drawing. Turn the original upside down and draw the negative spaces. Then turn the drawing right side up and complete the details inside the forms. These "difficult" *foreshortened* forms become easy to draw if attention is focused on the spaces around the forms.

8

Relationships in a New Mode: Putting Sighting in Perspective

I n this chapter, you will learn the third basic skill of drawing, how to see and draw relationships. You will learn how to draw "in perspective" and "in proportion." Another term for acquiring this skill is "learning how to sight."

Learning this skill is perhaps comparable to learning the rules of grammar in reading and writing. Just as good grammar causes words and phrases to hang together logically and to communicate ideas clearly, skillful sighting of proportions and perspective causes edges, spaces, relationships, lights and shadows to come together with visual logic. Clear perception of relationships enables us to depict on a flat surface the world we see around us. Moreover, just as learning how to use grammar skillfully gives us power with words, learning how to draw in perspective and in proportion will give your drawings power through the illusion of space.

In speaking of grammar, I am referring to the mechanics of language, not the tedious naming of the parts of speech. By mechanics, I mean getting the subject and verb to agree, using the rules of word order and sentence structure, and so on. I couldn't parse a complicated sentence today if I tried my best (which probably indicates its usefulness or lack thereof), but I've learned and practiced the mechanics of language for so long they are on automatic. This is what we are aiming for in this chapter: You will learn to use perspective and proportion in your drawing. You will not learn tedious and cumbersome terminology of vanishing points, converging parallel lines, and perspective of ellipses. You will learn the mechanics of sighting, which is what most artists use.

Some of my students, nevertheless, still complain that learning to sight seems so "left-brained" after the R-mode joy of drawing edges and negative spaces. Indeed, there are lots of little steps and instructions in the beginning. But almost every skill requires a component similar to sighting in drawing. For example, learning to drive a car requires that at some point you learn the rules of the road. Tedious? Yes, but without them, you are very likely to be arrested or to have an accident. Significantly, once these rules are learned and "on automatic," you drive a car by the rules without even thinking of them.

Lupe Ramirez.

It is the same with drawing. Once you have worked your way through the next exercise, you will have learned the "rules of the road" of drawing. With a bit of practice, sighting goes on automatic and you will hardly be aware of taking sights and comparing proportions. Best of all, you will have achieved the power to depict three-dimensional space in your drawings.

Students of drawing who learn everything except how to sight relationships greatly handicap their drawing and find themselves constantly making baffling mistakes in proportion and perspective. This problem plagues students new to drawing and, I might add, some rather advanced students as well.

Why does this skill seem so difficult? First, it is a two-part skill. The first part is sighting angles relative to vertical and horizontal, and the second part is sighting proportions relative to each other. In addition, the skill requires that one deal with ratios and comparisons that seem quite "left-brained." And, finally, it requires that one confronts and deals with paradoxes. For example, we can know that a ceiling is flat and the corner is a right angle. But on the picture plane, the edges of the ceiling are not horizontal and the corner angles are not right angles at all. They are oblique angles. As you can imagine, we'll have to carefully outmaneuver your L-mode, which will soon be saying, "This doesn't make sense!" Or, "This is too complicated! I'll never get it!" Or, "This stuff is stupid!"

On my word, learning how to sight relationships is not boring; it is powerful—it unlocks space. I agree, the skill is complicated, but you've learned other complicated things before this—how to read and write, for example. And sighting is definitely not stupid; it is intellectually fascinating—witness the many great thinkers of the Renaissance who grappled with the problem of how to depict space on a flat surface.

Once L-mode complaints are set aside, I believe you will actually enjoy learning this skill. I'm sure you can see the connection between learning to see and draw what is right there in front of your eyes and learning to be a more "clear-sighted" person, able to deal with contradictory information and the many paradoxes of our world. Be prepared for all of the objections. Your

Demonstration drawing by Grace Kennedy.

Demonstration drawing by the author.

Fig. 8-1. Roll up a tube of paper and check the relationship of sizes of a nearby object (someone's head, for example) and a similar object farther away. You will be surprised at the apparent change in size.

Fig. 8-2. Laurie Kuroyama.

Notice the great change in head size from near to far.

Fig. 8-3.

L-mode will have a field day, but stay with me! I'll try to be as clear as possible.

On dealing with the two-part skill of sighting angles and proportions

The term sighting really means seeing, but seeing in the artist's special way—seeing relationships on the picture plane (See Figures 8-1 and 8-2). All of sighting is comparison: What is this angle compared to vertical? How big is the apple compared to the melon? How wide is the table compared to its length? All comparisons are made relative to constants: Angles are compared to the constants vertical and horizontal. Sizes (proportions) are also compared to a constant—our Basic Unit.

On dealing with ratios: The root of the word "relationship" is ratio. In mathematics, ratios are expressed as numbers—1:2 means one of this to two of that. Ratios seem like a left-brained concept because they are strongly connected in our minds with mathematics. But we use ratios in many ordinary activities. In cooking, for example, candy is one part liquid to two parts sugar—that is, 1:2. In map reading, city X is three times as far as city Y—the ratio is 3:1. In drawing, ratios become handy tags to assess proportional relationships among the parts of a composition. The artist chooses something to be "One," our Basic Unit, and that unit is rationalized or proportionalized with all other parts.

To illustrate, the width of a window can be called "One," the Basic Unit. In comparison, let's say that the window is twice as long as it is wide. The ratio is 1:2. The artist draws the width, calls it "One," measures it as "One" and then measures off two Basic Units, counting "One to one, two." The ratio is 1:2. It's an easy way to tag and remember a proportion long enough to transfer it into your drawing.

On dealing with paradox: Seen flattened on the plane, a table may appear (by taking a sight) to be narrower than you know it to be (see Figure 8-3). The sighted ratio might be 1:8, for example. You must learn to "swallow" this visual paradox and draw what you have seen on the plane. Only then will the table in your

Sighting can be used to determine the relationship of lengths and widths of forms. When drawing a table viewed from an oblique angle, for example, an artist first determines angles of the edges relative to horizontal and vertical by sighting, as in Figure 8-4.

Fig. 8-4.

The next perception required is how wide the table is (from this viewpoint) in relation to its length. This apparent width relative to length will vary from viewpoint to viewpoint, depending on where the viewer's eye level happens to be.

1. Holding the pencil on a plane parallel to your eyes and at arm's length, with the elbow locked to keep the scale constant, measure the width of the table. Place the eraser of the pencil so it coincides with one corner of the table and place your thumb at the other corner. This is your Basic Unit (Figure 8-5).

2. Still keeping your elbow locked and with the pencil still parallel to your eyes, carry that measurement to the long side of the table (Figure 8-5). How long is the table, relative to its width? In this instance, the ratio is one to one and a half (1:1½) (Figure 8-6).

3. Next, you will take a sight on the table legs by holding your pencil vertically, taking note of the angle of one leg relative to vertical. Are the table legs perfectly vertical or are they at an angle? Draw the leg closest to you. You can take a sight on the length of the leg relative (again) to the width, your Basic Unit (Figure 8-7).

Fig. 8-5.

Fig. 8-6.

Fig. 8-7.

drawing appear, paradoxically, to be the size and shape you know it to be. Moreover, the angles of the tabletop may appear to be different from what you know to be right angles. You must "swallow" this paradox as well.

Perspective and proportion

Learning to draw in perspective requires that we see things as they are out there in the external world. We must put aside our prejudgments, our stored and memorized stereotypes and habits of thinking. We must overcome false interpretations, which are often based on what we think must be out there even though we may never have taken a really clear look at what is right in front of our eyes.

I'm sure you can see the connection to problem solving. One of the first steps in solving problems is to scan the relevant factors and to put things "into perspective" and "into proportion." This process requires the capacity to see the various parts of a problem in their true relationship.

Defining perspective

The term "perspective" comes from the Latin word "prospectus," meaning "to look forward." Linear perspective, the system most familiar to us, was perfected during the Renaissance by European artists. Linear perspective enabled artists to reproduce visual changes of lines and forms as they appear in three-dimensional space.

Various cultures have developed different conventions or perspective systems. Egyptian and Oriental artists, for example, developed a kind of stair-step or tiered perspective, in which placement from bottom to top of the format indicated position in space. In this system, which is often used intuitively by children, the forms at the very top of the page—regardless of size—are considered to be the farthest away. More recently, artists have rebelled against rigid conventions of perspective and have invented new systems employing abstract spatial qualities of colors, textures, lines, and shapes.

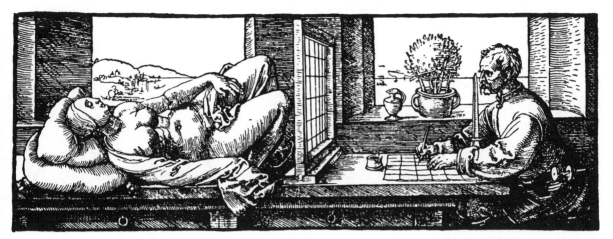

Fig. 8-8. Albrecht Dürer, *Draughts-man Making a Perspective Drawing of a Woman* (1525). **Courtesy of The Metropolitan Museum of Art, New York. Gift of Felix M. Warburg, 1918.**

Traditional Renaissance perspective conforms most closely to the way people in our Western culture perceive objects in space. In our perceptions, parallel lines appear to converge at vanishing points on a horizon line (the viewer's eye level) and forms appear to become smaller as distance from the viewer increases. For this reason, realistic drawing depends heavily on these principles. The Dürer etching (Figure 8-8) illustrates this perceptual system.

Dürer's device

The great sixteenth-century Renaissance artist, Albrecht Dürer, invented a device to help him draw in proportion and in perspective. Your plastic Picture Plane is a simplified version of Dürer's device. Let's look at the artist's depiction of his device in Figure 8-8. Dürer's draughtsman, holding his head in a stationary position (note the vertical marker for his viewpoint), looks through an upright wire grid. The artist peers at his model from a viewpoint that foreshortens his visual image of the model—that is, a viewpoint in which the main axis of the woman's figure from head to foot coincides with the artist's line of sight. This view causes the more distant parts of the figure (the head and shoulders) to appear to be smaller than they actually are, and the nearby parts (the knees and lower legs) to appear to be larger.

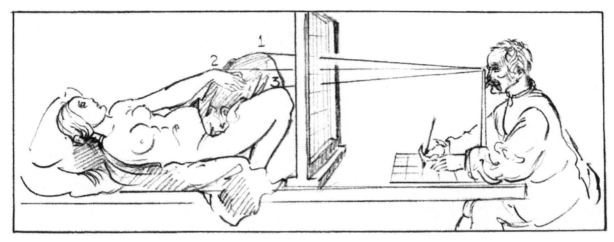

Fig. 8-9. What Dürer saw: Sighting parts one by one.

In front of Dürer's draughtsman on his drawing table is a paper the same size as the wire grid, marked off with an identical grid of lines. The artist draws on the paper what he perceives through the grid, matching in his drawing the exact angles and curves and lengths of lines compared to the verticals and horizontals of the grid. In effect, he is copying what he sees flattened on the picture plane. If he copies just what he sees, he will produce on the paper a foreshortened view of the model. The proportions, shapes, and sizes will be contrary to what the artist knows about the actual proportions, shapes, and sizes of the human body; but only if he draws the untrue proportions he perceives will the drawing look true to life.

What did Dürer see through his grid? (See Figure 8-9.) Dürer sights point one, the top of the left knee, and marks that point on his gridded paper. Next, he sights point two, the top of the left hand, and then point three, the top of the left knee. Beyond these points he sights the torso and the head. He connects all the points and ends with a foreshortened drawing of the entire figure.

The problem with foreshortening in drawing is that what we know about the subject of a drawing somehow intrudes into the drawing, and we draw what we know rather than what we see. The purpose of Dürer's device, using the grid and the fixed viewpoint, was to force himself to draw the form exactly as he saw it, with all of its "wrong" proportions. Then, paradoxically, the drawing "looked right." A viewer of the drawing, then, might

A foreshortened view of a leg and foot, as seen flattened on the Picture Plane.

wonder how the draughtsman was able to make the drawing look "so real."

The achievement, therefore, of Renaissance perspective was to codify and systematize a method of bypassing artists' knowledge about shapes and forms. The science of "formal" perspective provided a means by which they could draw forms just as they appeared to the eye—including distortions created optically by a form's position in space relative to the viewer's eye.

The system worked beautifully and solved the problem of how to create an illusion of deep space on a flat surface, of re-creating the visible world. Dürer's simple device evolved into a complicated mathematical system, enabling artists from the Renaissance onward to overcome their mental resistance to optical distortions of the true shapes of things and to draw realistically.

Formal perspective versus "informal" perspective

But the system of formal perspective is not without problems. Followed to the letter, strictly applied perspective rules can result in rather dry and rigid drawings. Perhaps the most serious problem with the formal perspective system is that it is so "left-brained." It employs the style of left-hemisphere processing: analysis, sequential logical cogitation, and mental calculations within a pre-prescribed system. There are vanishing points, horizon lines, perspective of circles and ellipses, and so on. The system is detailed and cumbersome, the antithesis of R-mode style with its antic/serious, pleasurable quality. For example, in anything but the simplest one-point perspective setup (Figure 8-10), vanishing points may be several feet beyond the edge of the drawing paper, requiring pins and strings to mark them.

Fortunately, once you understand "informal" perspective (sighting), you don't really need to know formal perspective at all. That's not to say the study of perspective is not useful and interesting. In my view, knowledge never hurts! But sighting is sufficient for basic drawing skills.

Graham Collier, professor of art, states that in the early days of the inception and development of Renaissance perspective it was used creatively and imaginatively to impart what must have been a thrilling sense of space to art.

"Effective as perspective is, however, it becomes a deadening influence on an artist's natural way of seeing things once it is accepted as a system—as a mechanical formula."

— Graham Collier
Form, Space, and Vision,
1963

Fig. 8-10. The classic perspective illustration. Note that vertical lines remain vertical; horizontal edges converge at a vanishing point (or points) on the horizon line (which is always at the artist's eye level). That's one-point perspective in a nutshell. Two-point and three-point perspective are complex systems, involving multiple vanishing points that often extend far beyond the edges of the drawing paper and requiring a large drawing table, T-squares, straight-edges, etc., to draw. Informal sighting is much easier and is sufficiently accurate for most drawing.

Fig. 8-11. Draw the top of the doorway on your plastic Picture Plane. This is your Basic Unit.

Fig. 8-12. Transfer your Basic Unit to your toned drawing paper. Since the paper is larger than the Picture Plane, you need to scale up (proportionally enlarge) your Basic Unit.

A brief practice in sighting before you do a "real" perspective drawing

What you'll need:

- Your drawing board
- Several sheets of scratch paper
- Your drawing pencils, sharpened, and your eraser
- Your plastic Picture Plane and your felt-tip marker
- Your larger Viewfinder

What you'll do:

First, you will practice sighting proportions and angles, using your pencil as a sighting device. Once you've practiced a bit, then you'll do your "real" sighting drawing. Begin by seating yourself in front of a doorway, at about ten feet away.

Hold up your Viewfinder/Picture Plane and compose your drawing so that you can see the whole doorway. Hold the Picture Plane very still and use your felt-tip marker to draw the top of the doorway on the plastic plane. See Figure 8-11. (The line will be somewhat shaky.) This is your Basic Unit. Transfer this unit to a piece of paper, estimating the size and position so that it is the same as on your Picture Plane. Set the Picture Plane aside. See Figure 8-12.

Now, pick up your pencil. Hold it at arm's length toward the top of the doorway with the flat (eraser) end out and with your elbow locked. Close one eye and move the pencil so that the end coincides with one side of the top of the doorway. (Choose either the outside of the molding or the inside edge.) Then, with one eye still closed, move your thumb along the pencil until your thumbnail coincides with the other side of the doorway. Hold that measure. You have "taken a sight" on the width of the doorway.

A test: What happens if you open both eyes or if you relax your elbow?

Keep your thumb at the same position and try bending your elbow just slightly, just barely pulling the pencil toward you.

What happens? The "measurement" has changed, hasn't it? Therefore, the reason you must lock your elbow when sighting proportions is to maintain the same scale. When your elbow is locked, you are always taking sights using the same position.

Then, relock your elbow, and resight the width of the doorway on your pencil (Figure 8-13). We'll call this your Basic Unit, or your "One." Now, keeping your thumb in the same position, turn your pencil vertically and find the relationship (the ratio or proportion) of width to length.

Still holding the pencil at arm's length, and still with one eye closed and your elbow locked, measure from the top corner: "One (width), to one (height)" (Figure 8-14), then drop down, measure "One to two" (Figure 8-15), drop it again and measure the remainder, "One to two and two-thirds" (Figure 8-16). You have now "taken a sight" on the proportion of the width relative to the height of the doorway. This proportion is expressed as a ratio: $1:2\frac{2}{3}$, or, in words, "One to two and two-thirds."

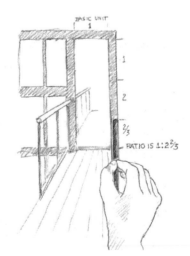

Fig. 8-13. Measure "One . . ."

Now, turn back to your sketch

By sighting the doorway, you determined that the width-to-height proportion of the doorway was $1:2\frac{2}{3}$. That is the proportion of the doorway "out there" in the real world. Your job is to transfer that proportion from "out there" into your drawing.

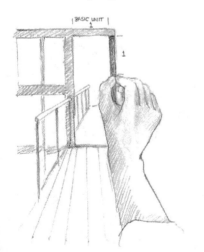

Fig. 8-14. ". . . to one . . ."

Fig. 8-15. ". . . two . . ."

Fig. 8-16. ". . . and two-thirds."

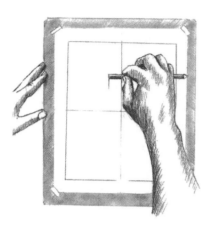

Fig. 8-17. Measure "One . . ."

Obviously, the door in your drawing will be smaller—much smaller—than the real doorway. But it must be proportionally the same, width to length.

Now, therefore, use your pencil and thumb to take a new measure: the width you have drawn on your paper (Figure 8-17). Then turn the pencil to vertical on your paper and measure off "One to one, two, and two-thirds" (Figures 8-18, 8-19, and 8-20). Make a mark and draw in the two sides of the doorway. The doorway you have just drawn has the same proportion—width to height—as the real doorway you were looking at.

To set this idea, draw a new "One," smaller than the first one. Now, measure that width with your pencil and again mark off the proportional height. This doorway will be smaller, but it will be proportionally the same as your first drawing and the real doorway.

Summing up: In sighting proportions, you find out what the proportions are "out there" in the real world and then, holding the proportion in your mind as a ratio (your Basic Unit or "One"—in relation to something else), remeasure in the drawing to transfer the proportion to the drawing. Obviously, in drawings, sizes are almost always on a different scale (smaller or larger) than what we see "out there," but the proportions are the same.

Fig. 8-18. ". . . to one . . ."

Fig. 8-19. ". . . two . . ."

Fig. 8-20. ". . . and two-thirds."

As a clever student of mine put it: "You use your pencil to find the ratio 'out there.' You remember it, wipe the measure off the pencil, and remeasure with your pencil in the drawing."

The next step: Sighting angles

Remember, sighting is a two-part skill. You have just learned the first part: sighting proportions. Your pencil, used as a sighting device, enables you to see "How big is this compared to that?" "How wide is that compared to my Basic Unit?" And so on. Proportions are sighted relative to each other and to your Basic Unit.

Sighting angles is different. Angles are sighted relative to vertical and horizontal. Remember, both angles and proportions must be sighted on the plane.

Take up your Viewfinder/Picture Plane and your felt-tip marker again and seat yourself in front of another corner of a room. Hold up the Picture Plane and look at the angle formed where the ceiling meets the two walls. Be sure to keep the Picture Plane vertical in front of your face, on the same plane as the plane of your two eyes. Don't tilt the plane in any direction.

Again, compose your view, and use your marker on the Picture Plane to draw the corner (a vertical line). Then, on the plane, draw the edges where the ceiling meets the two walls, and, if possible, the edges where the floor meets the walls.

Then, put your Picture Plane down on a piece of paper so you can see the drawing and transfer those lines to a piece of drawing paper.

You have just drawn a corner in perspective. Now, let's do that without the aid of the Picture Plane.

Move to a different corner or a different position. Tape a piece of paper to your drawing board. Now, take a sight on the vertical corner. Close one eye and hold your pencil perfectly vertically at the corner. Having checked, you can now draw a vertical line for the corner.

Next, hold up your pencil perfectly horizontally, staying on the plane, to see what the angles of the ceiling are relative to horizontal (Figure 8-21). You will see them as angles between the pencil and the edges of the ceiling. Remember these angles as

Fig. 8-21.

Fig. 8-22.

Verticals in human-built structures remain vertical. Horizontals—that is, edges parallel to the face of the earth—appear to change and converge and must be sighted. But you can pretty much count on verticals remaining vertical. In your drawing, they will be parallel to the edges of your paper. There are exceptions, of course. If you stand at street level, looking up, to draw a tall building, those vertical edges will converge and must be sighted. This situation, however, is fairly rare in drawing.

shapes. Then, again estimating, draw the angles into your drawing. Use the same procedure for the floor angles (Figure 8-22).

These fundamental sighting movements or measuring gestures in drawing are not difficult to master, once you have a real understanding of the purpose of the movements.

- The purpose of closing one eye, as I explained earlier, is to see a 2-D image only, not a 3-D binocular image.
- The purpose of locking the elbow is to ensure using a single scale in sighting proportions. Relaxing the elbow even slightly can cause errors by changing the scale of the sights. In sighting angles, it is not necessary to take the sights at arm's length, but you must stay on the plane.
- The purpose of comparing angles to vertical or horizontal is obvious. Angles can vary infinitely around 360 degrees. Only true vertical and true horizontal are constant and reliable. And since the edges of the paper (and the edges of the format you have drawn) also represent vertical and horizontal, any angle can be assessed on the plane and transferred into the drawing in relation to those constants.

Some important points about sighting angles

- All angles are sighted relative to the two constants: vertical and horizontal.
- In your drawing, the edges of your format represent the constants vertical and horizontal. Once you have determined an angle "out there" in the real world, you will draw it into the drawing relative to the edges of your format.
- All angles are sighted on the picture-plane. This is a solid plane. You cannot "poke through" it to align your pencil with an edge as it moves through space. You determine the angle as it appears on the plane (Figure 8-23).
- You can sight angles by holding your pencil either vertically or horizontally and comparing the angle with the edge of the pencil. You can also use the crosshairs on your clear plastic Picture Plane or even the edge of one of the Viewfinders. You just need some edge that you can hold up in a vertical or hori-

Fig. 8-23. Later, when you have learned to sight and have discarded the actual Picture Plane, you must still remember to sight *on the plane* and be careful to not "poke through" the imaginary plane.

zontal position on the plane to compare the angle you intend to draw. The pencil is simply the easiest to use and doesn't interrupt your drawing.

- Visual information seen on the plane is nearly always different from what you know about things. Say you are facing a corner of a room. You know that the ceiling is flat—that is, horizontal—and that it meets the wall at right angles. But if you hold up your pencil perfectly horizontally, close one eye, and, staying on the plane, line up the corner so that it touches the center of your horizontal pencil, you will find that the edges of the ceiling go off at odd angles. Perhaps one angle is steeper than the other. See Figure 8-22, page 149.

- You must draw these angles just as you see them. Only then will the ceiling look flat and the right angles of the walls appear to be correct in your finished drawing. This is one of the great paradoxes of drawing.

- You must put these paradoxical angles into your drawing just as you perceive them. To do this, you remember the shape of one of the triangles made by the edge of the ceiling and your horizontal pencil. Then, imagining a horizontal line in your drawing (parallel to the top and bottom edges of your format), draw the same triangle. Use the same process to draw the other angled edge of the ceiling. See Figure 8-21, page 149, for an illustration of this.

I realize that sighting sounds very "left-brained" at this point. But remember we are searching out relationships. The right hemisphere is specialized for the perception of relationships—how things compare. As I said before, the "counting up" of sighting is just a simple way of "tagging" our perceptions. The Basic Unit is always "One," because it is the first part of a comparison. After you practice sighting a bit, you are hardly aware of the process and it is very rapid. Also, with practice in drawing, you will be doing a lot of "eyeballing," meaning estimating rather than needing to sight everything. But for any difficult perception, as in foreshortening, an experienced artist gladly uses sighting. Like negative space, sighting helps to make drawing easy.

I usually recommend that students not try to designate an angle by degrees: a 45-degree angle; a 30-degree angle; etc. It really is best to simply remember the shape the angle makes when compared to vertical and horizontal and carry that visual shape in your mind to draw it. You may have to double-check angles a few times at first, but my students learn this skill very quickly.

The decision whether to use vertical or horizontal as the constant against which to see a particular angle occasionally puzzles students. I recommend that you choose whichever will produce the smaller angle.

Try to remember that drawing always produces an approximate version of the subject, even for a person highly skilled in drawing. Drawing is not photography. The person who is drawing consciously or subconsciously edits, emphasizes (or minimizes), or otherwise slightly changes various aspects of the subject. Students are often very critical of their work because it is not an exact rendition, but the subconscious choices made during drawing are part of the expressiveness of drawings.

Please note that in public places you will attract an audience of viewers who will very likely want to talk with you—not a good situation for maintaining an R-mode, wordless state of mind. On the other hand, if you would like to make some new friends, drawing in a public spot will work every time. For some reason, people who ordinarily would not approach a stranger do not hesitate to talk with someone who is drawing.

A "real" perspective drawing

What you'll need:

- Your drawing board
- Several sheets of drawing paper, in a stack for padding
- Your masking tape
- Your drawing pencils, sharpened, and your eraser
- Your graphite stick and several paper towels or paper napkins
- Your plastic Picture Plane and your felt-tip marker
- Your larger Viewfinder

Before you start:

Tape a stack of several sheets of drawing paper to your drawing board. Draw a format on your drawing paper and tone the paper within the format to a medium gray tone. Draw the crosshairs on the toned paper.

1. Choose your subject. Learning how to draw "in proportion" and "in perspective" are the two great challenges—the Waterloo, even—of most drawing students in art schools. You will want to prove to yourself that you can achieve this skill. Therefore, pick your subject with that objective in mind: Choose a view or a site that you think would be really hard to draw—one with lots of angles or a complicated ceiling or a long view down a hall. See the student drawing on page 153. The best way to choose a site is to walk around, using your Viewfinder to find a composition that pleases you—much in the same way as composing with a camera's viewfinder.

 Possible sites:
 - A kitchen corner
 - A hallway
 - A view through an open doorway
 - A corner of any room in your house
 - A porch or balcony
 - Any street corner where you can sit in your car or on a bench and draw
 - An entrance to any public building, inside or out

Set yourself up to draw at your chosen site. You will need two chairs, one for sitting on and one on which to lean your drawing board. If you are drawing outside, folding chairs are convenient. Make sure that you are directly facing your chosen view.

2. Clip your larger Viewfinder and the plastic Picture Plane together. Draw a format edge on the plastic plane by running the felt-tip marker around the inside edge of the Viewfinder opening. Closing one eye, move the Viewfinder/plastic Picture Plane backward and forward to find the best composition—the one you like best.

3. Having found a composition you like, choose your Basic Unit. Your Basic Unit should be of medium size and of a shape that is not too complicated. It might be a window or a picture on the wall or a doorway. It can be a positive form or a negative space. It can be a single line or a shape. Draw your Basic Unit directly on the plastic with your felt-tip marker.

A student's drawing of an interesting and challenging view.

After you have drawn your Basic Unit on the plastic Picture Plane, you may also wish to draw one or two of the more important edges on the plastic Picture Plane, but be aware that the line will be very shaky and uncertain. The essential piece of information is your Basic Unit, and that is really all you need.

A perspective drawing by Cindy Ball-Kingston. You will find interesting compositions in unexpected places.

4. Set aside your Viewfinder/plastic Picture Plane on a piece of white paper so that you can see what you have drawn on it. You will next draw your Basic Unit on your paper. It will be the same shape but larger, just as your toned format is larger than the Viewfinder opening.

5. Transfer your Basic Unit onto the toned paper using your crosshairs as a guide. On both the Picture Plane and on your toned paper, the crosshairs divide the drawing area into four quadrants. Refer to Figures 8-11 and 8-12 on page 146 for how to transfer your Basic Unit from your Picture Plane to your toned paper by using these quadrants.

How to re-find your composition: Sometimes it is useful to go back to the Picture Plane to check on an angle or proportion. To re-find your composition, simply hold up your Viewfinder/plastic Picture Plane, close one eye and move the plane forward or backward until your Basic Unit "out there" lines up with the felt-tip drawing of Basic Unit on the plastic plane. Then check out any angle or proportion that may be puzzling you.

For most people just learning to draw, the hardest part of drawing is believing their own sights of both angles and proportions. Many times I have watched students take a sight, shake their heads, take the sight again, again shake their heads, even say out loud, "It [an angle] can't be that steep," or, "It [a proportion] can't be that small."

With a little more experience in drawing, students are able to accept the information they obtain by sighting. You just have to swallow it whole, so to speak, and make a decision not to second-guess your sights. I say to my students, "If you see it so, you draw it so. Don't argue with yourself about it."

Of course, the sights have to be taken as correctly and carefully as possible. When I demonstrate drawing in a workshop, students see me making a very careful, deliberate movement to extend my arm, lock my elbow, and close one eye in order to carefully check a proportion or an angle on the plane. But these movements become quite automatic very quickly, just as one quickly learns to brake a car to a smooth stop.

To complete your perspective drawing:

1. Again, you will fit the pieces of your drawing together like a fascinating puzzle. Work from part to adjacent part, always checking the relationships of each new part to the parts already drawn. Also, remember the concept of edges as shared edges, with the positive forms and negative spaces fitted into the format to create a composition. Remember that all the information you need for this drawing is right there before your eyes. You now know the strategies artists use to "unlock" that visual information and you have the correct devices to help you.

2. Be sure to use negative spaces as an important part of your drawing as in Figure 8-24. You will add strength to your drawing if you use negative space to see and draw small items such as lamps, tables, signs with lettering, and so on. If you do not, and focus only on the positive shapes, they will tend to weaken your drawing. If you are drawing a landscape, trees and foliage in particular are much stronger when their negative spaces are emphasized.

3. Once you have completed the main parts of the drawing, you can focus on the lights and shadows. "Squinting" your eyes a bit will blur the details and allow you to see large shapes of lighted areas and shadowed areas. Again using your new sighting skills, you can erase out the shapes of lights and use your pencil to darken in the shapes of shadows. These shapes are sighted in exactly the same way as you have sighted the other parts of the drawing: "What is the angle of that shadow relative to horizontal? How wide is that streak of light relative to the width of the window?"

4. If any part of the drawing seems "off" or "out of drawing," as such errors are called, check out the troublesome area with your clear plastic Picture Plane. Look at the image on the plane (with one eye closed, of course) and alternately glance down at your drawing to double-check angles and proportions. Make any corrections that seem reasonably easy to make.

Fig. 8-24. Remember to emphasize negative spaces in your drawing.

Artist/teacher Robert Henri sends a stern warning to his students:

"If in your drawing you habitually disregard proportions you become accustomed to the sight of distortion and lose critical ability. A person living in squalor eventually gets used to it."

— *The Art Spirit*, 1923.

After you have finished:

Congratulations! You have just accomplished a task that many university art students would find daunting if not impossible.

Sighting is an aptly named skill. You take a sight and you see things as they really appear on the picture-plane. This skill will enable you to draw anything you can see with your own eyes. You need not search for "easy" subjects. You will be able to draw anything at all.

The skill of sighting takes some practice to master, but very soon you will find yourself "just drawing," taking sights automatically, at times even without needing to measure proportions or assess angles. I think it's significant that this is called "eyeballing." Also, when you come to the difficult foreshortened parts, you will have just the skills needed to make the drawing seem easy.

Fig. 8-25. Charles White, *Preacher* (1952). Courtesy of the Whitney Museum.

This drawing by Charles White demonstrates a foreshortened view. Study it. Copy it, turning the drawing upside down if necessary. You might use the length of the man's left hand from the wrist to the tip of the pointing finger as your Basic Unit. Perhaps you'll be surprised to find that the ratio of the head to the model's left hand is 1:1²⁄₃.

Each time you experience the fact that drawing just what you see works the wonder of creating the illusion of space and volume on the flat surface of the paper, the methods will become more securely integrated as your way of seeing— the artist's way of seeing.

Fig. 8-26. Edgar Degas (1834–1917), *Dancer Adjusting Her Slipper* (1873). Courtesy of The Metropolitan Museum of Art, bequest of Mrs. H. O. Havemeyer, 1929. The H. O. Havemeyer Collection

The Use of Sighting in Figure Drawing

This technique of using the constants, vertical and horizontal, against which to gauge angles is an important basic skill in drawing figures as well as objects. Many artists' sketches still show traces of sight lines drawn in by the artist, as in the Edgar Degas drawing entitled *Dancer Adjusting Her Slipper* (Figure 8-26). Degas was probably sighting such points as the location of the left toe in relation to the ear and the angle of the arm compared to vertical.

Note that Degas's Basic Unit was from the topmost edge of the hair to the neckband. The artist used the same Basic Unit in Figure 11-6, shown in the chapter on color.

The visible world is replete with foreshortened views of people, streets, trees, and flowers. Beginning students sometimes avoid these "difficult" views and search instead for "easy" views. With the skills you now have, this limiting of subject matter for your drawing is unnecessary. Edges, negative spaces, and sightings of relationships work together to make drawing foreshortened forms not just possible—they become downright enjoyable. As in learning any skill, learning the "hard parts" is challenging and exhilarating.

Looking ahead

The technique I have just taught you, "informal perspective," relies only on sights taken on the plane. Most artists use informal perspective, even though they may have complete knowledge of formal perspective. One of the advantages of learning informal sighting is that it can be used for any subject matter, as you will see in the next exercise. You will be drawing a profile portrait, putting to use your skills of perceiving edges, spaces, and proportional relationships in drawing the human head.

Remember that realistic drawings of perceived subjects always require the same basic perceptual skills—the skills you are learning right now. Of course, this is true of other R-mode global skills. For example, once you have learned to drive, you can very likely drive any make of automobile.

In your next drawing, you will enjoy drawing the human head, a most intriguing and challenging subject.

Randa Caldwell.

Instructor Dana Crowe.

9 Facing Forward: Portrait Drawing with Ease

HUMAN FACES HAVE ALWAYS FASCINATED ARTISTS. To catch a likeness, to show the exterior in such a way that the inner person can be seen, is a challenging, inviting prospect. Moreover, a portrait can reveal not only the appearance and personality (the gestalt) of the sitter but also the soul of the artist. Paradoxically, the more clearly the artist sees the sitter, the more clearly the viewer can see through the likeness to perceive the artist. These revelations beyond the likeness are not intentional. They are simply the result of close, sustained R-mode observation.

Therefore, because we are searching for you through the images you draw, you will be drawing human faces in the next set of exercises. The more clearly you see, the better you will draw, and the more you will express yourself to yourself and to others.

Since portrait drawing requires very fine perceptions in order to produce a likeness, faces are effective for training beginners in seeing and drawing. The feedback on the correctness of perception is immediate and certain, because we all know when a drawing of a human head is correct in its general proportions. And if we know the sitter, we can make even more precise judgments about the accuracy of the perceptions.

But perhaps more important for our purposes, drawing the human head has a special advantage for us in our quest for ways to gain conscious access to our right-hemisphere functions. The right hemisphere of the human brain is specialized for the recognition of faces. People with right-hemisphere injury caused by a stroke or accident often have difficulty recognizing their friends or even recognizing their own faces in the mirror. Left-hemisphere-injured patients usually do not experience this deficit.

Beginners often think that drawing people is the hardest of all kinds of drawing. It isn't, actually. As with any other subject matter, the visual information is right there, ready and available. Again, the problem is seeing. To restate a major premise of this book, drawing is always the same task—that is, every drawing requires the basic perceptual skills you are learning. Aside from complexity, one subject is not harder or easier than another. However, certain subjects often seem harder than others, probably because embedded symbol systems, which interfere with

clear perceptions, are stronger for some subjects than for others.

Most people have a very strong, persistent symbol system for drawing the human head. For example, a common symbol for an eye is made of two curved lines enclosing a small circle (the iris). Your own unique set of symbols, as we discussed in Chapter Five, was developed and memorized during childhood and is remarkably stable and resistant to change. These symbols actually seem to override seeing, and therefore few people can draw a realistic human head. Even fewer can draw recognizable portraits.

Summing up, then, portrait drawing is useful to our goals for these reasons: First, it is a suitable subject for accessing the right hemisphere, which is specialized for recognition of human faces and for making the fine visual discriminations necessary to achieve a likeness. Second, drawing faces will help you to strengthen your ability to perceive proportional relationships, since proportion is integral to portraiture. Third, drawing faces is excellent practice in bypassing embedded symbol systems. And fourth, the ability to draw portraits with credible likenesses is a convincing demonstration to your ever-critical left hemisphere that you have—dare we say it?—talent for drawing. And you'll find that drawing portraits is not difficult once you can shift to the artist's way of seeing.

In drawing your profile portrait, you will be using all of the skills you have learned so far:

- How to perceive and draw edges
- How to perceive and draw spaces
- How to perceive and draw relationships
- How to perceive and draw (a bit of) lights and shadows (I will present more in-depth instruction on lights and shadows in Chapter Ten.)
- And in addition, you will acquire a new skill, how to perceive and draw the gestalt of your model—the character and personality behind the drawn image—by focussing intently on the first four skills.

Our main strategy for accessing R-mode remains the same: to present the brain with a task that L-mode will turn down.

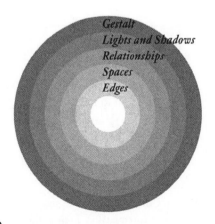

A reminder: The global skill of drawing has five component skills.

Fig. 9-1. The four figures are the same size.

Fig. 9-2. Mark the size of one figure on a piece of paper.

Fig. 9-3. Cut out a notch the size of one figure and measure each of the figures by fitting it into the cut-out notch.

The importance of proportion in portrait drawing

All drawing involves proportion, whether the subject is still life, landscape, figure drawing, or portrait drawing. Proportion is important whether an artwork's style is realistic, abstract, or completely nonobjective (that is, without recognizable forms from the external world). Realistic drawing in particular depends heavily on proportional correctness. Therefore, realistic drawing is especially effective in training the eye to see the thing-as-it-is in its relational proportions. Individuals whose jobs require close estimations of size relationships—carpenters, dentists, dressmakers, carpet-layers, and surgeons—develop great facility in perceiving proportion. Creative thinkers in all fields benefit from enhanced awareness of part-to-whole relationships—from seeing both the trees and the forest.

On believing what you think you see

One of the problems of seeing comes from the brain's ability to change visual information for the purpose of fitting incoming information to pre-existing concepts or beliefs. The parts that are important (that is, provide key information), or the parts that we decide are larger, or the parts that we think should be larger, we see as larger than they actually are. Conversely, parts that are unimportant, or that we decide are smaller, or that we think should be smaller, we see as being smaller than they actually are.

Let me give you a couple of examples of this perceptual phenomenon. Figure 9-1 shows a diagrammatic landscape with four men. The man at the far right appears to be the largest of the four. But all four figures are exactly the same size. Lay a pencil alongside first the left-hand man and the right-hand man to measure and test the validity of that statement. Even after measuring and proving to yourself that the figures are the same size, however, you will probably find that the man on the right will still look larger (Figure 9-2, 9-3).

The reason for this misperception of proportionate size probably derives from our past knowledge and experience of the effect

THE NEW DRAWING ON THE RIGHT SIDE OF THE BRAIN

of distance on the apparent size of forms: Given two objects of the same size, one nearby and one at a distance away, the distant object will appear to be smaller. If they look the same size, the far object must be a great deal larger than the near object. This makes sense, and we don't quarrel with the concept. But coming back to the drawing, apparently the brain enlarges the far object to make the concept truer than true. This is overdoing it! And this is precisely the kind of overdoing—of overlaying memorized verbal concepts onto visual perceptions—that causes problems with proportion for beginning drawing students.

Even after we have measured the men in the drawing and have determined with irrefutable evidence that they are the same size, we still wrongly see the right-hand man as being larger than the left. On the other hand, if you turn this book upside down and view the drawing in the inverted orientation that the verbal, conceptual mode apparently rejects, you will find that you can more easily see that the two men are the same size. The same visual information triggers a different response. The brain, apparently now less influenced by the verbal concept of diminishing size in distant forms, allows us to see the proportion correctly.

For an even more striking example of perceptual illusion, look at the drawing of two tables, Figure 9-4. Will you believe me that the two tabletops are exactly the same shape and size? You may have to use your plastic Picture Plane and trace one of the tabletops, then slide the Plane over the other tabletop to believe this. This wonderfully original illusion drawing is by Roger N. Shepard, a renowned psychologist of perception and cognition.

On not believing what you see

One more example: Stand in front of a mirror at about arm's distance away. How large would you say is the image of your head in the mirror? About the same size as your head? Using a felt-tip pen or a crayon, extend your arm and make two marks on the mirror—one at the top of the reflected image (the outside contour of your head) and one at the bottom contour of your chin (Figure 9-5). Step to one side to see how long the image is in

Fig. 9-4. From *Mind Sights* by Roger N. Shepard, 1990. Reproduced by permission of the author.

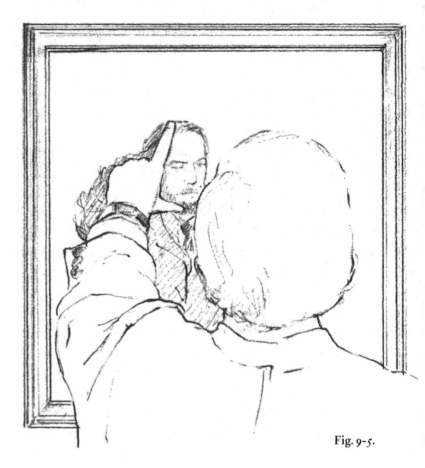

Fig. 9-5.

inches. You'll find it's about four and one half to five inches, or one-half the true size of your head. Yet, when you remove the marks and look again at yourself in the mirror, it seems that the image must be life-size! Again, you are seeing what you believe, not believing what you see.

Drawing closer to reality

Once we have accepted that the brain is changing information and not telling us that it has done so, some of the problems of drawing become clearer, and learning to see what is actually "out there" in the real world becomes very interesting. Note that this perceptual phenomenon is probably essential to ordinary life. It reduces the complexity of incoming data and enables us to have stable concepts. The problems start when we try to see what is

really "out there," for purposes of checking reality, solving real problems, or drawing realistically. To accomplish that, we shall try to prove in a logical way that certain proportions are what they are.

The mystery of the chopped-off skull

Most people find it quite difficult to perceive the relative proportions of the features and the skull.

In this introduction to profile-portrait drawing, I'll concentrate on two critical relationships that are persistently difficult for beginning drawing students to correctly perceive: the location of eye level in relation to the length of the whole head; and the location of the ear in the profile view. I believe these are two examples of perceptual errors caused by the brain's propensity to change visual information to better fit its concepts.

Let me explain. To most people, the eye level line (an imaginary horizontal line that passes through the inside corners of the eyes) appears to be about one-third of the way down from the top of the head. The actual measure is one-half. I think this misperception occurs because we tend to see that the important visual information is in the features, not in foreheads and hair areas. Apparently, the top half of the head seems less compelling than the features, and therefore is perceived as smaller. This error in perception results in what I've called the "chopped-off-skull error," my term for the most common perceptual error made by beginning drawing students (Figures 9-6, 9-7).

I stumbled on this problem one day while teaching a group of beginning drawing students at the university. They were working on portrait drawings and one after another had "chopped off" the skull of the model. I went through my "Can't you see that the eye level line is halfway between the bottom of the chin and the top edge of the hair?" queries. The students said, "No. We can't see that." I asked them to measure the model's head, then their own heads, and then each others' heads. "Was the measure one to one?" I asked. "Yes," they said. "Well," I said, "now you can see on the model's head that the proportional relationship is one to one,

Fig. 9-6. A student drawing illustrating the chopped-off-skull error.

Fig. 9-7. The same facial features traced from the student's drawing with two corrections: the size of the skull and placement of the eye on the right-hand side of the drawing.

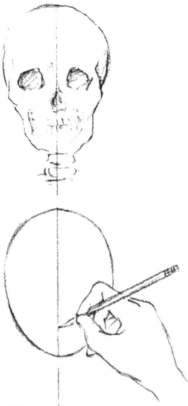

Fig. 9-8. Central axis.

Fig. 9-9.

isn't that true?" "No," they said, "we still can't see it." One student even said, "We'll see it when we can believe it."

This went on for a while until finally the light dawned and I said, "Are you telling me that you really can't see that relationship?" "Yes," they said, "we really can't see it." At that point I realized that brain processes were actually preventing accurate perception and causing the "chopped-off-skull" error. Once we all agreed on this phenomenon, the students were able to accept their sightings of the proportion, and soon the problem was solved.

Now we must put your own brain into a logical box (by showing it irrefutable evidence) that will help it accept your sightings of the proportions of the head.

Drawing a blank to see better than ever

1. Draw a "blank," an oval shape used by artists to represent the human skull in diagrams. The shape is shown in Figure 9-8. Draw a vertical line through the center of the blank, dividing the shape in half. This is called the central axis.

2. Next, you will locate the horizontal "eye level line," which crosses the central axis at a right angle. Use your pencil to measure on your own head the distance from the inside corner of your eye to the bottom of your chin. Do this by placing the eraser end (to protect your eye) at the inside corner of your eye and marking with your thumb where your chin hits the pencil, as in Figure 9-9. Now, holding that measurement, raise the pencil, as in Figure 9-10, and compare the first distance (eye level to chin) with the distance from your eye level to the top of your head (feel across from the end of the pencil to the topmost part of your head). You will find that those two distances are approximately the same.

3. Repeat the measurement in front of a mirror. Regard the reflection of your head. Without measuring, visually compare the bottom half with the top half of your head. Then use your pencil to repeat the measurement of eye level one more time.

4. If you have newspapers or magazines handy, check this proportion in photographs of people, or use the photo of English writer George Orwell, Figure 9-11. Use your pencil to measure. You will find that:

Eye level to chin equals eye level to the top of the skull. This is an almost invariant proportion.

5. Check the photographs again. In each head, is the eye level at about the middle, dividing the whole shape of the head about in half? Can you clearly see that proportion? If not, turn on television to a news program and measure heads right on the television screen by placing your pencil flat on the screen, measuring first eye level to chin, then eye level to the top edge of the head. Now, take the pencil away and look again. Can you see the proportion clearly now?

Fig. 9-10.

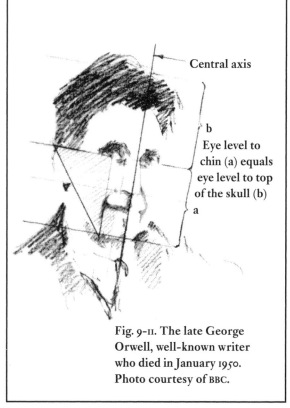

Central axis

b
Eye level to chin (a) equals eye level to top of the skull (b)
a

Fig. 9-11. The late George Orwell, well-known writer who died in January 1950. Photo courtesy of BBC.

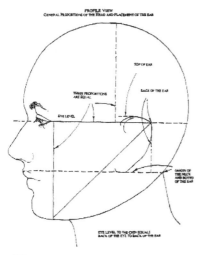

Fig. 9-12.

When you finally believe what you see, you will find that on nearly every head you observe, the eye level is at about the halfway mark. The eye level is almost never less than half—that is, almost never nearer to the top of the skull than to the bottom of the chin (See Figure 9-12). And if the hair is thick, the top half of the head—eye level to the topmost edge of the hair—is bigger than the bottom half.

The "chopped-off skull" creates the masklike effect so often seen in children's drawings, abstract or expressionistic art, and in so-called "primitive" or "ethnic" art. This masklike effect of enlarging the features relative to the skull size, of course, can have tremendous expressive power, as seen, for example, in works by Picasso, Matisse, and Modigliani, and great works of other cultures. The point is that master artists, especially of our own time and culture, use the device by choice and not by mistake. Let me demonstrate the effect of misperception.

Irrefutable evidence that the top of the head is important after all

First, I have drawn the lower part of the faces of two models, one in profile and one in three-quarter view (see Figure 9-13). Contrary to what one would expect, most students have few serious problems in learning to see and draw the features. The problem is not the features; it's in perceiving the skull that things go wrong. What I want to demonstrate is how important it is to provide the full skull for the features—not to cut off the top of the head because your brain is less interested and makes you see it as smaller.

In Figure 9-13 are two sets of three drawings: First, the features only, without the rest of the skull; second, the identical features with the cut-off-skull error; and third, the identical features, this time with the full skull, which complements and supports the features.

You can see that it's not the features that cause the problem of wrong proportion; it's the skull. Now turn to Figure 9-14 and see that Van Gogh in his 1880 drawing of the carpenter apparently

Fig. 9-13. The features only.

The cut-off-skull error, using the same features.

The same features again, this time with the full skull.

Fig. 9-14. Vincent Van Gogh (1853–1890), *Carpenter* (1880). Courtesy of Rijksmuseum Kröller-Müller, Otterlo.

Van Gogh worked as an artist only during the last ten years of his life, from the age of 27 until he died at 37. During the first two years of that decade, Van Gogh did drawings only, teaching himself how to draw. As you can see in the drawing of the carpenter, he struggled with problems of proportion and placement of forms. By 1882, however—two years later—in his *Woman Mourning,* Van Gogh had overcome his difficulties with drawing and increased the expressive quality of his work.

made the "chopped-off skull" error in the carpenter's head. Also, see the Dürer etching in Figure 9-16 in which the artist demonstrates the effort of diminishing the relative proportion of the skull to the features. Are you convinced? Is your logical left hemisphere convinced? Good. You will save yourself innumerable hours of baffling mistakes in drawing.

Fig. 9-15. Vincent Van Gogh,
Woman Mourning (1882). Courtesy
of Rijksmuseum Kröller-Müller,
Otterlo.

Drawing another blank and getting a line on the profile

Draw another blank now, this time for a profile. The profile blank
is a somewhat different shape—like an oddly shaped egg. This is
because the human skull (Figure 9-17), seen from the side, is a
different shape than the skull seen from the front. It's easier to

Incorrect proportion Correct proportion

Fig. 9-16. Albrecht Dürer, *Four Heads* (1513 or 1515). Courtesy of The Nelson Gallery-Atkins Museum. Kansas City, Missouri (Nelson Fund).

draw the blank if you look at the shapes of the negative spaces around the blank in Figure 9-17. Notice that the negative spaces are different in each corner.

If it helps you to see, draw in some symbolic shapes for nose, eye, mouth, and chin, making sure that you have first drawn the eye level line at the halfway point on the blank.

Fig. 9-17. The side-view blank. Note that (a) eye level to chin equals (b) eye level to highest part of the skull.

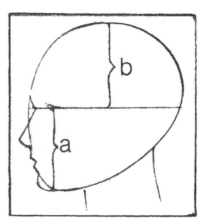

Placing the ear in a profile portrait

The next measurement is extremely important in helping you perceive correctly the placement of the ear, which in turn will help you perceive correctly the width of the head in profile and prevent chopping off the back of the skull.

On almost every head, the position of the ear doesn't vary much. On your own face, use your pencil again to measure the length from the inside corner of your eye to the bottom of your chin (Figure 9-18). Now, holding that measurement, lay the pencil horizontally along your eye level line (Figure 9-19) with the eraser end at the outside corner of your eye. That measurement coincides with the back of your ear.

Putting that another way, the length from eye level to chin equals the distance from the back of the eye to the back of the ear. Make a mark for the ear placement on the eye level line of the blank, as in Figure 9-20. This proportion may seem a little complex, but if you will learn the measurement, it will save you from another stubborn problem in drawing the human head: Most beginning students draw the ear too close to the features when drawing a profile. When the ear is placed too close to the features, the skull is once more chopped off, this time at the back. Again, the reason for the problem may be that the expanse of cheek and jaw is uninteresting and boring, and therefore beginning students fail to perceive the width of the space correctly.

You can memorize this important measurement as a saying or mnemonic, similar to "i" before "e," except after "c." To place the ear in a profile portrait, memorize this mnemonic: eye level-to-chin equals back-of-the-eye to the back-of-the-ear.

Note that enlarging the features and diminishing the skull produce strong, expressive, symbolic effects, a device you can always use later if you wish. Right now, for this "basic training," we want you to be able to see things as they really are in their correct proportion.

Visualizing is another useful technique for teaching the correct placement of the ear. Since you now know that two measurements are equal—from eye level to chin, and from the back of the

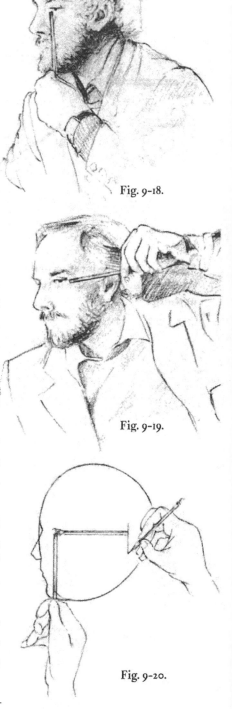

Fig. 9-18.

Fig. 9-19.

Fig. 9-20.

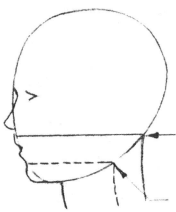

Fig. 9-22. Locate also the point where the neck joins the skull (the place that bends) relative to the upper lip.

Correct point in relation to the facial features.

A common error: misplacement of the point where the neck joins the skull.

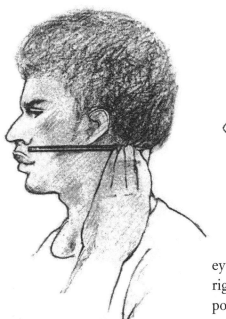

Fig. 9-21. Check the location of the bottom of the ear relative to the upper lip.

eye to the back of the ear—you can visualize an equal-sided right-angle triangle (an isosceles triangle) connecting these three points, as shown in the drawing in Figure 9-12, page 170. This is an easy way to place the ear correctly. The isosceles triangle can be visualized on the model. See Figure 9-20, page 175.

Practice seeing proportional relationships now by looking at photographs or drawings of people in the profile view and visualizing the isosceles triangle, as in Figure 9-12. This technique will save you from a lot of problems and errors in your profile drawings.

We still need to make two more measurements on the profile blank. First, holding your pencil horizontally, just under your ear, slide the pencil forward as in Figure 9-21. You come to the space between your nose and mouth. This is the level of the bottom of your ear. Make a mark on the blank.

Again, holding your pencil horizontally just under your ear, slide the pencil backward this time. You will come to the place where your skull and neck connect—the place that bends, as in Figure 9-22. Mark this point on the blank. The point is higher than you think. In symbolic drawing, the neck is usually placed below the circle of the head, with the point that bends on the level of the chin. This will cause problems in your drawing: The neck will be too narrow. Make sure that you perceive on your model the correct place where the neck begins at the back of the skull.

Now you will need to practice these perceptions. Look at people. Practice perceiving faces, observing relationships, seeing the unique forms of each individual face.

You are ready now to draw a profile portrait. You will be using all of the skills you have learned so far:

- Focusing on complex edges and negative spaces until you feel the shift to an alternative state of consciousness, one in which your right hemisphere leads and your left hemisphere is quiet. Remember that this process requires an uninterrupted block of time.
- Estimating angles in relation to the vertical and horizontal edges of the paper
- Drawing just what you see without trying to identify or attach verbal labels to forms (you learned the value of this in the upside-down drawing)
- Drawing just what you see without relying on old stored-and-memorized symbols from your childhood drawing
- Estimating relationships of sizes—how big is this form compared to that one?

And finally:

- Perceiving proportions as they really are, without changing or revising visual information to fit preconceptions about what parts are important. They are all important, and each part must be given its full proportion in relation to the other parts. This requires bypassing the brain's propensity to change incoming information without "telling" you what it has done. Your sighting tool—your pencil—will enable you to "get at" the true proportions.

If you feel that you need to review any of the techniques at this point, turn to the previous chapters to refresh your memory. Reviewing some of the exercises, in fact, will help to strengthen your new skills. Pure Contour Drawing is particularly useful in strengthening your newfound method of gaining access to your right hemisphere and quieting the left.

If, as occasionally happens, your L-mode remains active as you start to draw, the best remedy is to do a short session of Pure Contour Drawing, drawing any complex object—a crumpled piece of paper is fine. Pure Contour Drawing seems to force the shift to R-mode and therefore is a good warm-up exercise for drawing any subject.

A warm-up exercise

To illuminate for yourself the connection of edges, spaces, and relationships in portrait drawing, I suggest that you copy (make a drawing of) John Singer Sargent's beautiful profile portrait of Mme. Pierre Gautreau, which Sargent drew in 1883 (Figure 9-23). You may wish turn it upside down.

For the past forty years or so, most art teachers have not recommended copying masterworks as an aid to learning to draw. With the advent of modern art, many art schools rejected traditional teaching methods and copying master drawings went out of favor. Now, copying drawings and paintings is coming back into favor as an effective means of training the eye in art.

I believe that copying great drawings is very instructive for beginning students. Copying forces one to slow down and really see what the artist saw. I can practically guarantee that carefully copying any masterwork of drawing will forever imprint the image in your memory. Therefore, because copied drawings become an almost permanent file of memorized images, I recommend that you copy only the work of major and minor masters of drawing. We are fortunate these days to have reproductions of great works readily and inexpensively available.

For how to do an exercise copy of Sargent's profile portrait of *Mme. Pierre Gautreau,* also known as "Madame X," please read all of the instructions before you begin.

What you'll need:

- Your drawing paper
- Your #2B writing pencil and #4B drawing pencils, sharpened, and your eraser
- Your plastic Picture Plane
- An hour of uninterrupted time

What you'll do:

These instructions will be appropriate for either right-side-up or upside-down drawing of the Sargent portrait.

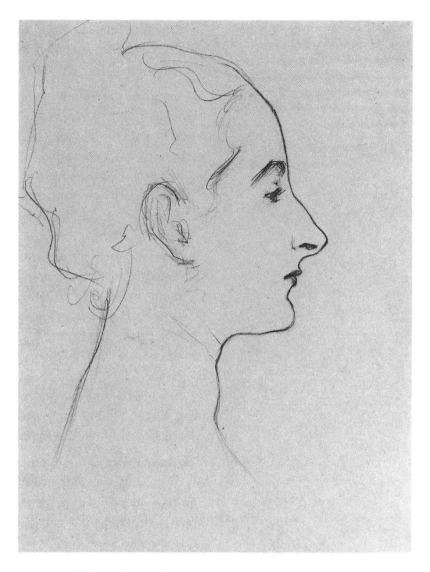

Fig. 9-23. John Singer Sargent. *Mme. Pierre Gautreau*, 1883

1. As always, in starting a drawing, you will first draw a format. Center one of the Viewfinders on your drawing paper and use your pencil to draw around the outside edges. Then, lightly draw crosshairs on your paper.

2. You will be using your new skills of seeing edges, spaces, and relationships in this drawing. Since the original is a line drawing, lights and shadows are not relevant in this exercise.

3. Lay your clear plastic Picture Plane directly on top of the Sargent and note where the crosshairs fall on the portrait drawing. You will immediately see how this will help you in

Fig. 9-24.

deciding on your Basic Unit and starting your copy of the drawing. You can check proportional relationships right on the original drawing and transfer them to your copy.

Ask yourself the following series of questions. (Note that I must name the features in order to give these verbal instructions, but when you are drawing, try to clear your mind of words.) Looking at the Sargent drawing and using the crosshairs as in Figure 9-24, ask yourself the following:

1. Where is the point where the forehead meets the hairline?
2. Where is the outermost curve of the tip of the nose? What are the angles of the forehead?
3. What is the negative shape that lies between those two points?
4. If you draw a line between the tip of the nose and the outermost curve of the chin, what is the angle of that line relative to vertical (or horizontal)?
5. What is the negative shape defined by that line?
6. Relative to the crosshairs, where is the curve of the front of the neck?
7. What is the negative space made by the chin and neck?
8., 9., and 10. Check the position of the back of the ear, bend of the neck, and the slant of the back.

Continue in this fashion, putting the drawing together like a jigsaw puzzle: Where is the ear? How big is it relative to the profile you have just drawn? What is the angle of the back of the neck? What is the shape of the negative space made by the back of the neck and the hair? And so on. Draw just what you see, nothing more. Notice how small the eye is relative to the nose, and notice the size of the mouth relative to the eye. When you have unlocked the true proportion by sighting, you will be surprised, I feel quite sure. In fact, if you lay one finger over the features in Sargent's drawing, you will see what a small proportion of the whole form is occupied by the main features. This is often quite surprising to beginning drawing students.

Now, the real thing: A profile portrait of a person

Now you are ready to draw a real portrait of a person. You'll be seeing the wondrous complexity of contours, watching your drawing evolve from the line that is your unique, creative invention, and observing yourself integrating your skills into the drawing process. You will be seeing, in the artist's mode of seeing, the astounding thing-as-it-is, not a pale, symbolized, categorized, analyzed, memorized shell of itself. Opening the door to see clearly that which is before you, you will draw the image by which you make yourself known to us.

If I were personally demonstrating the process of drawing a portrait profile, I would not be naming parts. I would point to the various areas and refer to features, for example, as "this form, this contour, this angle, the curve of this form," and so on. For the sake of clarity in writing, unfortunately, I'll have to name the parts. I fear that the process may seem cumbersome and detailed when written out as verbal instructions. The truth is that your drawing will seem like a wordless, antic dance, an exhilarating investigation, with each new perception miraculously linked to the last and to the next.

With that caution in mind, read through all of the instructions before you start and then try to do the drawing without interruption.

What you'll need:

1. Most important, you'll need a model—someone who will pose for you in profile view. Finding a model is not easy. Many people strenuously object to sitting perfectly still for any period of time. One solution is to draw someone who is watching television. Another possibility is to catch someone sleeping—preferably upright in a chair, though that doesn't seem to happen too often!
2. Your clear plastic Picture Plane and your felt-tip marking pen
3. Two or three sheets of your drawing paper, taped in a stack onto your drawing board

4. Your drawing pencils and eraser
5. Two chairs, one to sit on and one on which to lean your drawing board. See Figure 9-25 for setting up to draw. Note that it's also helpful to have a small table or a stool or even another chair on which to put your pencils, erasers, and other gear.
6. An hour or more of uninterrupted time

What you'll do:

1. As always, start by drawing a format. You may use the outside edge of your Picture Plane as a template.
2. Lightly tone your paper. This will allow you to erase out lighted areas and to add graphite for shadowed areas. I'll give complete instructions for the fourth perceptual skill, perceiving lights and shadows, in the next chapter. You have already had some experience with "shading," however, and I find that my students greatly enjoy adding at least some lights and shadows to this exercise. On the other hand, you may prefer to do a line drawing without toning the paper, as John Singer Sargent did in his profile portrait of Mme. Gautreau. Whether you tone the paper or not, be sure to add the crosshairs.
3. Pose your model. The model can be facing either right or left, but in this first profile drawing, I suggest that you place your model facing to your left if you are right-handed, and to the right if you are left-handed. With this arrangement, you will not be covering up the features as you draw the skull, hair, neck and shoulders.
4. Sit as close to your model as possible. Two to four feet is about ideal, and this distance can be managed even with the intervening chair for propping up your drawing board. Check the setup again in Figure 9-25.
5. Next, use your plastic Picture Plane to compose your drawing. Close one eye and hold up the Picture Plane with a clipped-on Viewfinder; move it backward and forward until the head of your model is placed pleasingly within the format—that is, not too crowded on any edge and with enough of the neck and shoulders to provide "support" for the head.

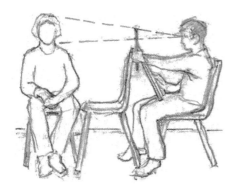

Fig. 9-25.

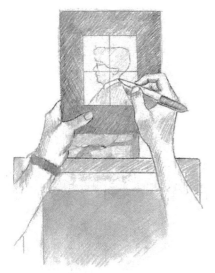

Fig. 9-26.

A composition you certainly don't want is one in which the model's chin is resting on the bottom edge of the format.

6. When you have decided on your composition, hold the plastic Picture Plane as steadily as possible. You will next choose a Basic Unit—a convenient size and shape to guide proportions as you draw. I usually use the span from the model's eye level to the bottom of the chin. You, however, might prefer to use another Basic Unit—perhaps the length of the nose or the span from the bottom of the nose to the bottom of the chin (Figure 9-27).

7. When you have chosen your Basic Unit, mark the unit with your felt-tip marker directly on your plastic Picture Plane. Then, transfer the Basic Unit to your drawing paper, using the same procedure that you have learned in previous exercises. You may need to review the instructions on pages 126–130 and Figures 8-11 and 8-12, page 146. You may want to also mark the topmost edge of the hair and the back of the head at the point opposite eye level. You can transfer these marks to your paper as a rough guide for the drawing (Figure 9-28).

8. At this point, you can begin to draw, confident that you will end up with the composition you have so carefully chosen.

Fig. 9-27.

Fig. 9-28.

Again, I must remind you that although this process seems cumbersome now, later on it becomes so automatic and so rapid that you will hardly be aware of how you start a drawing. Allow your mind to roam over the many complicated processes you accomplish without thinking of the step-by-step methods: making a U-turn on a two-way street; cracking and separating an egg yolk from the white; crossing a busy intersection on foot where there is no stoplight; making a phone call from a pay phone. Imagine how many steps you would need to put instructions into words for any one of those skills.

In time, and with practice, starting a drawing becomes almost completely automatic, allowing you to concentrate on the model and on composing your drawing. You will hardly be aware of choosing a Basic Unit, sizing it and placing it on the drawing paper. I recall an incident when one of my students realized that

Fig. 9-29.

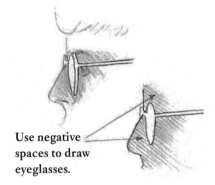

Use negative spaces to draw eyeglasses.

Fig. 9-30.

she was "just drawing." She exclaimed, "I'm doing it!" The same thing will happen to you—in time, and with practice.

9. Gaze at the negative space in front of the profile and begin to draw that negative shape. Check the angle of the nose relative to vertical. It may help to hold up your pencil vertically to check that shape, or you may want to use one of your Viewfinders. Remember that the outside edge of the negative shape is the outer edge of the format, but to make a negative space easier to see, you may want to make a new, closer edge. See Figure 9-29 for how to check the angle formed by holding your pencil on the plane against the tip of the nose and the outermost curve of the chin.

10. You may choose to erase out the negative space around the head. This will enable you to see the head as a whole, separated from the ground. On the other hand, you may decide to darken the negative spaces around the head or to leave the tone as it is, working only within the head. See the demonstration drawings at the end of the chpter for examples. These are aesthetic choices—some of the many that you'll make in this drawing.

11. If your model wears glasses, use the negative shapes around the outside edges of the glasses (remembering to close one eye to see a 2-D image of your model). See Figure 9-30.

12. Place the eye in relation to the innermost curve of the bridge of the nose. Check the angle of the eyelid relative to horizontal.

13. Use the shape under the nostril as a negative shape (Figure 9-31).

14. Check the angle of the centerline of the mouth. This is the only true edge of the mouth—the upper and lower contours only mark a color change. It's usually best to draw this color-change boundary lightly, especially in portraits of males. Note that, in profile, the angle of the centerline of the mouth—the true edge—often descends relative to horizontal. Don't hesitate to draw this angle just as you see it. See Figure 9-32.

15. Using your pencil to measure (Figure 9-33), you can check the

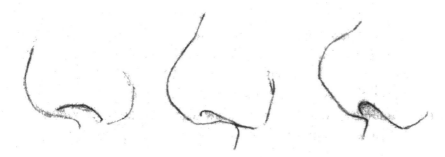

Fig. 9-31. Look for the shape of the space under the nostril. This shape will vary from model to model and should be specifically observed on each individual.

position of the ear (if it is visible). To place the ear in profile portrait, recall our mnemonic: Eye level-to-chin equals back-of-the-eye to the back-of-the-ear. Remember also that this measure forms an isosceles triangle, which can be visualized on the model. See Figure 9-34.

16. Check the length and width of the ear. Ears are nearly always bigger than you expect them to be. Check the size against the features of the profile.

17. Check the height of the topmost curve of the head—that is, the topmost edge of the hair or of the skull if your model happens to have a shaved head or thin hair. See Figure 9-35.

18. In drawing the back of the head, sight as follows:

- Close one eye, extend your arm holding your pencil perfectly vertically, lock your elbow, and take a sight on eye level to chin.

- Then, holding that measure, turn your pencil to horizontal and check how far it is to the back of the head. It will be 1 (to the back of the ear) and something more—perhaps 1:1½ or even 1:2 if the hair is very thick. Keep that ratio in your mind.

- Then, turn back to your drawing to transfer the ratio. Using the pencil, re-measure eye level to chin in the drawing. Holding that measure with your thumb, turning your pencil to the horizontal position, measure from the back of the eye to the back of the ear, then to the back of the head (or hair). Make a mark. Perhaps you will not believe your own sights. If carefully taken, they are true, and your job is to believe what your eyes tell you. Learning to have faith in one's perceptions is one of the principal keys to drawing well. I'm sure you can extrapolate the importance of this to other areas of life.

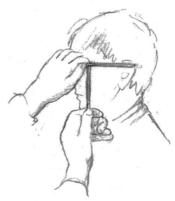

Fig. 9-32.

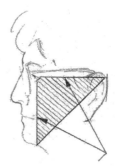

Fig. 9-33.

Fig. 9-34.

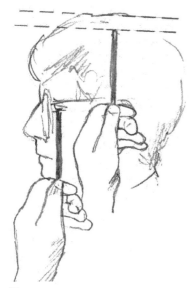

Fig. 9-35.

19. In drawing your model's hair, what you want not to do is to draw hairs. Students often ask me, "How do you draw hair?" I think the question really means, "Give me a quick and easy way to draw hair that looks good and doesn't take too long." But the answer to the question is, "Look carefully at the model's (unique) hair and draw what you see." If the model's hair is a complicated mass of curls, the student is likely to answer, "You can't be serious! Draw all of that?"

But it really isn't necessary to draw every hair and every curl. What your viewer wants is for you to express the character of the hair, particularly the hair closest to the face. Look for the dark areas where the hair separates and use those areas as negative spaces. Look for the major directional movements, the exact turn of a strand or wave. The right hemisphere, loving complexity, can become entranced with the perception of hair, and the record of your perceptions in this part of a portrait can have great impact, as in the portrait of *Proud Maisie* (Figure 9-36). To be avoided are the thin, glib, symbolic marks that spell out h-a-i-r on the same level as if you lettered the word across the skull of your portrait. Given enough clues, the viewer can extrapolate and, in fact, enjoys extrapolating the general texture and nature of the hair. See the demonstration drawings at the end of this chapter for examples.

Drawing hair is largely a light-shadow process. In the next chapter, we'll take up the perception of lights and shadows in depth. For now, I'll set down some brief suggestions. To draw your model's hair, gaze at it with your eyes squinted to obscure details and to see where the larger highlights lie and where the larger shadows fall. Notice particularly the characteristics of the hair (wordlessly, of course, though I must use words for the sake of clarity). Is the hair crinkly and dense, smooth and shiny, randomly curled, short and stiff? Take notice of the overall shape of the hair and make sure that you have matched that shape in your drawing. Begin to draw the hair in some detail where the hair meets the face, transcribing the light-shadow patterns and the direction of angles and curves in various segments of the hair.

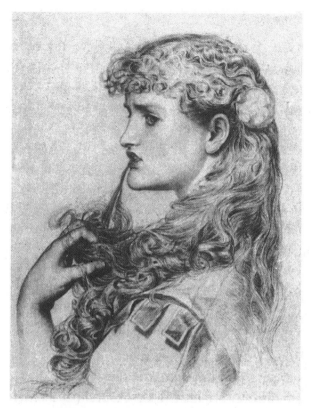

Fig. 9-36. Anthony Frederick Augustus Sandys (1832–1904), *Proud Maisie.* Courtesy of the Victoria and Albert Museum, London.

Fig. 9-37. Note the position of the ear. The placement fits our mnemonic for locating the ear in profile view: Eye level-to-chin equals back-of-the-eye to the back-of-the-ear.

20. Finally, to complete your profile portrait, draw in the neck and shoulders, which provide a support for the profile head. The amount of detail of clothing is another aesthetic choice with no strict guidelines. The major aims are to provide enough detail to fit—that is, to be congruent with—the drawing of the head, and to make sure that the drawing of details of clothing adds to, and does not detract from, your drawing of the head. See Figure 9-36 for an example.

Fig. 9-38.

Fig. 9-39.

Fig. 9-40.

Fig. 9-41.

Some further tips

Eyes: Observe that the eyelids have thickness. The eyeball is behind the lids (Figure 9-38). To draw the iris (the colored part of the eye)—don't draw it. Draw the shape of the white (Figure 9-39). The white can be regarded as negative space, sharing edges with the iris. By drawing the (negative) shape of the white part, you'll get the iris right because you'll bypass your memorized symbol for iris. Note that this bypassing technique works for everything that you might find "hard to draw." The technique is to shift to the next adjacent shape or space and draw that instead. Observe that the upper lashes grow first downward and then (sometimes) curve upward. Observe that the whole shape of the eye slants back at an angle from the front of the profile (Figure 9-38). This is because of the way the eyeball is set in the surrounding bony structure. Observe this angle on your model's eye—this is an important detail.

Neck: Use the negative space in front of the neck in order to perceive the contour under the chin and the contour of the neck (Figure 9-40). Check the angle of the front of the neck in relation to vertical. Make sure to check the point where the back of the neck joins the skull. This is often at about the level of the nose or mouth (Figure 9-22).

Collar: Don't draw the collar. Collars, too, are strongly symbolic. Instead, use the neck as negative space to draw the top of the collar, and use negative spaces to draw collar points, open necks of shirts, and the contour of the back below the neck, as in Figures 9-40 and 9-41. (This bypassing technique works, of course, because shapes such as the spaces around collars cannot be easily named and have generated no preexisting symbols to distort perception.)

After you have finished:

Congratulations on drawing your first profile portrait. You are now using the perceptual skills of drawing with some confidence, I feel sure. Don't forget to practice seeing the angles and propor-

tions you have just sighted. Television is wonderful for supplying models for practice, and the television screen is, after all, a "picture-plane." Even if you can't draw these free models because they rarely stay still, you can practice eyeballing edges, spaces, angles, and proportions. Soon, these perceptions will occur automatically, and you will be really seeing.

Showing of profile portraits

Study the drawings on the following pages. Notice the variations in styles of drawing. Check the proportions by measuring with your pencil.

In the next chapter, you will learn the fourth skill of drawing, the perception of lights and shadows. The main exercise will be a fully modeled, tonal, volumetric self-portrait and will bring us full-circle to your "Before Instruction" self-portrait for comparison. Your "After Instruction" self-portrait will be either a "three-quarter" view or a "full-face" view. I'll define the three portrait views for you before we turn to lights and shadows.

Another example of two styles of drawing. Instructor Brian Bomeisler and I sat on either side of Grace Kennedy, who is also one of our instructors, and drew these demonstration drawings for our students. We were using the same materials, the same model, and the same lighting.

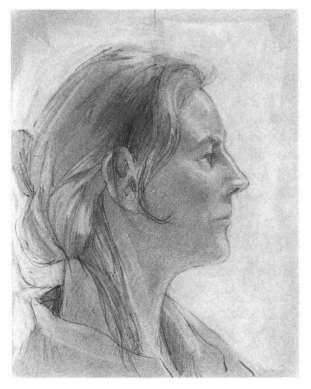

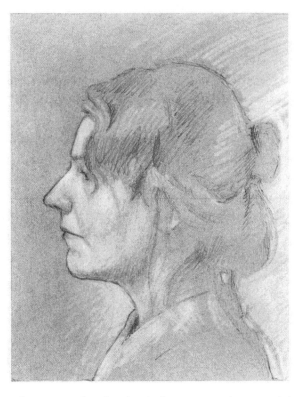

Demonstration drawing by the author.

Demonstration drawing by instructor Brian Bomeisler.

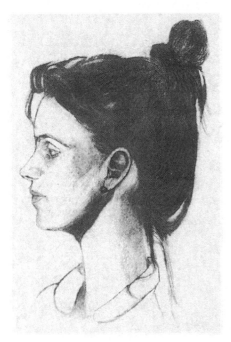

"Portrait of Joy" by student Jerome Broekhuijsen.

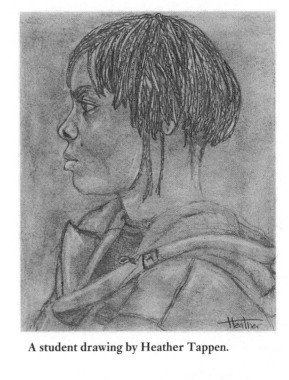

A student drawing by Heather Tappen.

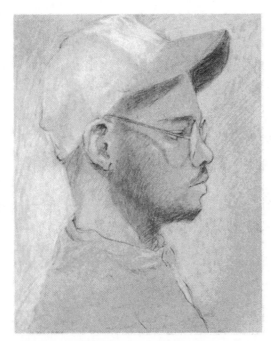

Demonstration drawing by the author.

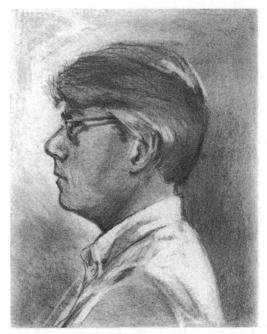

"Portrait of Scott" demonstration drawing by instructor Beth Furmin.

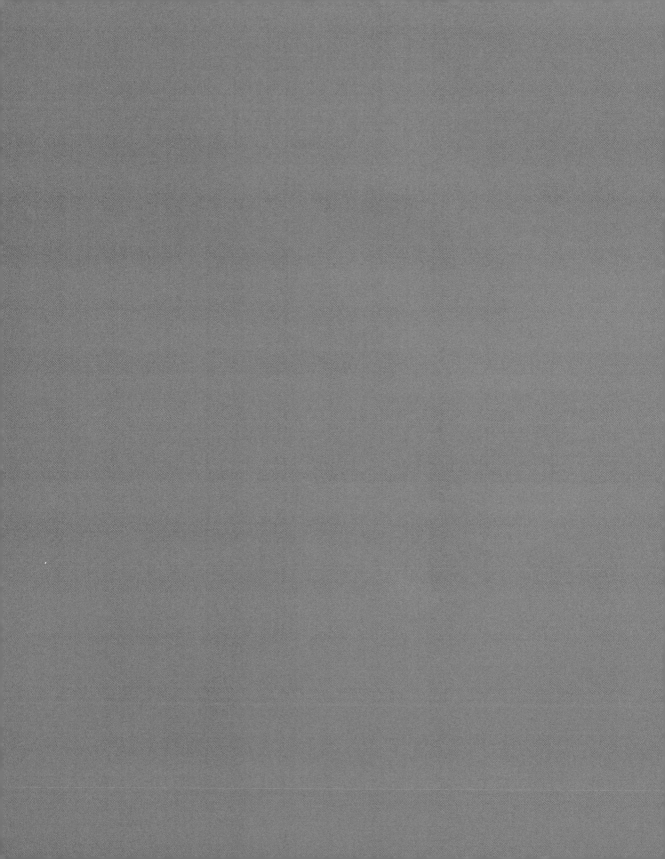

IO The Value of Logical Lights and Shadows

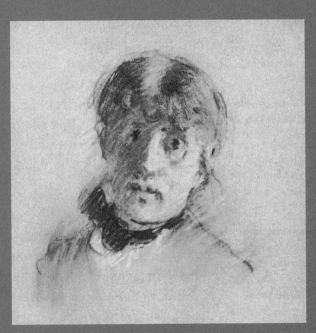

Berthe Morisot (1841–1895). *Self-Portrait*, c. 1885.
Courtesy of The Art Institute of Chicago.

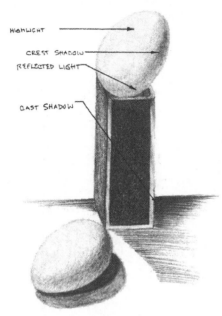

HIGHLIGHT

CREST SHADOW

REFLECTED LIGHT

CAST SHADOW

Fig. 10-1. Drawing by student Elizabeth Arnold.

Light logic. Light falls on objects and (logically) results in the four aspects of light/shadow:

1. *Highlight:* The brightest light, where light from the source falls most directly on the object.

2. *Cast shadow:* The darkest shadow, caused by the object's blocking of light from the source.

3. *Reflected light:* A dim light, bounced back onto the object by light falling on surfaces around the object.

4. *Crest shadow:* A shadow that lies on the crest of a rounded form, between the highlight and the reflected light. Crest shadows and reflected lights are difficult to see at first, but are the key to "rounding up" forms for the illusion of 3-D on the flat paper.

N ow that you have gained experience with the first three perceptual skills of drawing—the perception of edges, spaces, and relationships—you are ready to put them together with the fourth skill, the perception of lights and shadows. After the mental stretch and effort of sighting relationships, you will find that drawing lights and shadows is especially joyful. This is the skill most desired by drawing students. It enables them to make things look three-dimensional through the use of a technique students often call "shading," but which in art terminology is called "light logic."

This term means just what it says: Light falling on forms creates lights and shadows in a logical way. Look for a moment at Henry Fuseli's self-portrait (Figure 10-2). Clearly, there is a source of light, perhaps from a lamp. This light strikes the side of the head nearest the light source (the side on your left, as Fuseli faces you). Shadows are logically formed where the light is blocked, for example, by the nose. We constantly use this R-mode visual information in our everyday perceptions because it enables us to know the three-dimensional shapes of objects we see around us. But, like much R-mode processing, seeing lights and shadows remains below the conscious level; we use the perceptions without "knowing" what we see.

Learning to draw requires learning consciously to see lights and shadows and to draw them with all their inherent logic. This is new learning for most students, just as learning to see complex edges, negative spaces, and the relationships of angles and proportions are newly acquired skills.

Seeing values

Light logic also requires that you learn to see differences in tones of light and dark. These tonal differences are called "values." Pale, light tones are called "high" in value, dark tones "low" in value. A complete value scale goes from pure white to pure black with literally thousands of minute gradations between the two extremes of the scale. An abbreviated scale with twelve tones in evenly graduated steps between light and dark is shown in Figure

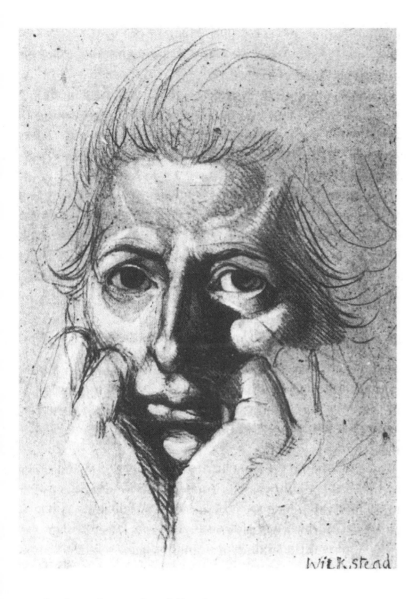

Fig. 10-2. Henry Fuseli (1741–1825), *Portrait of the Artist*. Courtesy of The Victoria and Albert Museum, London.

Find the four aspects of light logic in Fuseli's self-portrait.

1. *Highlights:* Forehead, cheeks, etc.

2. *Cast shadows:* Cast by the nose, lips, hands.

3. *Reflected lights:* Side of the nose, side of the cheek.

4. *Crest shadows:* Crest of the nose, crest of the cheek, temple.

11-4 in the color section following page 210.

In pencil drawing, the lightest possible light is the white of the paper. (See the white areas on Fuseli's forehead, cheeks, and nose.) The darkest dark appears where the pencil lines are packed together in a tone as dark as the graphite will allow. (See the dark shadows cast by Fuseli's nose and hand.) Fuseli achieved the many tones between the lightest light and the darkest dark by various methods of using the pencil: solid shading, crosshatching,

and combinations of techniques. Many of the white shapes he actually erased out, using an eraser as a drawing tool. (See the highlights on Fuseli's forehead.)

In this chapter, I'll show you how to see and draw lights and shadows as shapes and how to perceive value relationships to achieve "depth" or three-dimensionality in your drawings. These skills lead directly to color and subsequently to painting, as I outlined in the Preface.

As we proceed, keep in mind the following: The perception of edges (line) leads to the perception of shapes (negative spaces and positive shapes), drawn in correct proportion and perspective (sighting). These skills lead to the perception of values (light logic), which leads to the perception of colors as values, which leads to painting.

The role of R-mode in perceiving shadows

In the same curious way that L-mode apparently will pay almost no attention to negative space or upside-down information, it seems also to ignore lights and shadows. L-mode, after all, may be unaware that R-mode perceptions help with naming and categorizing.

You will therefore need to learn to see lights and shadows at a conscious level. To illustrate for yourself how we interpret rather than see lights and shadows, turn this book upside down and look at Gustave Courbet's *Self-portrait,* Figure 10-3. Upside down, the drawing looks entirely different—simply a pattern of dark areas and light areas.

Now, turn the book right side up. You will see that the dark/light pattern seems to change and, in a sense, disappear into the three-dimensional shape of the head. This is another of the many paradoxes of drawing: If you draw the shapes of lighted areas and shadowed areas just as you perceive them, a viewer of your drawing will not notice those shapes. Instead, the viewer will wonder how you were able to make your subject so "real," meaning three-dimensional.

"Shadows are capricious. They change constantly—with time of day, wattage of light bulbs, placement of lamps, and changes in your own location. Although you depend on shadow for visual information about the form of an object, you are not usually aware of it as a quality separate from the object itself. You usually discount the shadow and exclude it from conscious perception of the object. After all, shadows change, but objects do not."

— Carolyn M. Bloomer
Principles of Visual Perception, New York: Van Nostrand Reinhold, 1976

Fig. 10-3. *Self-portrait,* Gustave Courbet, 1897. Courtesy of The Wadsworth Atheneum, Hartford, Connecticut.

These special perceptions, like all drawing skills, are easy to attain once you have made a cognitive shift to the artist's mode of seeing. Research on the brain indicates that the right hemisphere, as well as being able to perceive the shapes of particular shadows, is also specialized for deriving meaning from patterns of shadows. Apparently, this derived meaning is then communicated to the conscious verbal system, which names it.

Fig. 10-4.

How does R-mode accomplish the leap of insight required to know what these patterns of light and dark areas mean? Apparently R-mode is able to extrapolate from incomplete information to envision a complete image. The right brain seems undeterred by missing pieces of information and appears to delight in "getting" the picture, despite its incompleteness.

Look, for example, at the patterns in Figure 10-4. In each of the drawings, notice that you first see the pattern, then you perceive it as a gestalt, and then you name it.

Patients with right-hemisphere injuries often have great difficulty making sense of complex, fragmentary shadow patterns such as those in Figure 10-4. They see only random light and dark shapes. Try turning the book upside down to approximate seeing the patterns as these patients do—as unnamable shapes. Your task in drawing is to see the shadow-shapes in this way even when the image is right side up, while holding at arm's length, so to speak, knowledge of what the shapes mean.

This "trick of the artist" is great fun. I'm sure you will enjoy these last exercises in which you will put together all of the basic skills—edges, spaces, relationships, lights and shadows, and, finally, expressing your unique response to the gestalt—the "thingness of the thing." In this chapter, we'll work with the remaining two of the three basic portrait poses.

The three basic portrait poses

In portrait drawing, artists have traditionally posed their models (or themselves in self-portraits) in one of three views:

- Full face: The model faces the artist directly with both sides

of the model's face fully visible to the artist.

- Profile: The view you drew in the last exercises. The model faces toward the artist's left or right and only one side (one half) of the model's face is visible to the artist.
- Three-quarter view: The model makes a half-turn toward the artist's left or right, making visible to the artist three-quarters of the model's face—the profile (one half) plus one quarter of the remaining half-face.

Note that the full-face and profile views are relatively invariant, while the three-quarter view can vary from an almost profile to an almost full-face pose and still be called a "three-quarter view."

John Singer Sargent, 1856–1925. *Study for "Madame X."* Courtesy of The Metropolitan Museum of Art, Gift of Mrs. Frances Ormond and Miss Emily Sargent, 1931

John Singer Sargent, 1856–1925. *Olimpio Fusco,* c. 1905–15? Courtesy of The Corcoran Gallery of Art, Washington.

Dante Gabriel Rossetti, 1828–82. *Jane Burden, Later Mrs. William Morris, as Queen Guinevere.* Courtesy of The National Gallery of Ireland, Dublin.

A warm-up exercise: A copy of the Courbet self-portrait

Imagine that you are honored by a visit from the nineteenth-century French artist, Gustave Courbet (pronounced goos-tav koor-bay), and that he has agreed to sit for a portrait drawing, wearing his jaunty hat and smoking his pipe. The artist is in a rather serious mood, quiet and thoughtful. See Figure. 10-3, page 197.

Imagine further that you have arranged a spotlight so that it shines from above and in front of Courbet, illuminating the top of his face but leaving the eyes and much of the face and neck in rather deep shadow. Take a moment to consciously see how the lights and shadows logically fall relative to the source of light. Then turn the book upside-down to see the shadows as a pattern of shapes. The wall behind is dark, silhouetting your model.

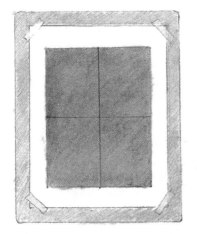

Fig. 10-5.

What you'll need:

1. Your #4B drawing pencil
2. Your eraser
3. Your clear plastic Picture Plane
4. A stack of three or four sheets of drawing paper
5. Your graphite stick and some paper napkins

What you'll do:

Please read through all of the instructions before starting.

1. As always, draw a format edge on your drawing paper, using the outside edge of one of your Viewfinders. This format is in the same proportion, width to height, as the reproduction.
2. Tone your paper with a rubbed graphite ground to a medium-dark silvery gray—about the tone of the wall behind Courbet. Lightly draw the crosshairs as shown in Figure 10-5. You may wish to copy this drawing upside down.
3. Set your Picture Plane on top of the reproduction of the Courbet drawing. The crosshairs on the plastic Picture Plane will instantly show you where to locate the essential points of the drawing. I suggest that you work upside down for at least

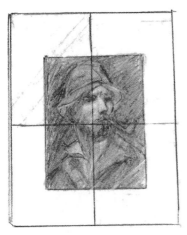

Fig. 10-6.

the first "blocking in" of the lights and shadows (Figure. 10-6).

4. Decide on a Basic Unit, perhaps the light-shape from the center of the hat brim to the top of the upper lip, or perhaps the pipe stem, or you may decide on another Basic Unit. Remember that everything in Courbet's drawing is locked into a relationship. For this reason, you can start with any Basic Unit and end up with the correct relationships. Then, transfer your Basic Unit to the drawing paper, following the instructions on page 130 and in Figures 8-11 and 8-12, page 146.

Note: The step-by-step procedure I offer below is only a suggestion about how to proceed. You may wish to use an entirely different sequence. Also note that I am naming parts of the drawing only for instructional purposes. As you draw, try your best to see the shapes of lights and darks wordlessly. I realize that this is like trying not to think of the word "elephant," but as you continue to draw, thinking wordlessly becomes second nature.

5. You will be "drawing" with an eraser. Sharpen your eraser into a drawing tool by cutting one end into a wedge shape as shown in Figure 10-7.

Begin by erasing out the major shapes of light, on the face, hat, and shirtfront, always checking the size and position of those shapes against your Basic Unit. You might think of these light-shapes as negative shapes that share edges with the dark forms. By correctly seeing and erasing the light shapes, you'll have the dark shapes "for free."

6. Next, carefully erase the lightest parts of the hat, the side of the neck, and the coat. Your toned ground supplies the middle value of the hat and coat (Figure. 10-8).

7. Using your #4B pencil, darken in the area around the head, the shadow under the hat brim, the shadows below the eyebrows, under the nose, under the lower lip, the beard, the shadow of the beard, and the shadows under the shirt collar and the coat collar. Carefully observe the shapes of these shadows. Keep your tones quite smooth, either crosshatching or working a continuous tone or combining the two. Ask yourself: Where is the darkest dark? Where is the lightest light?

Fig. 10-7. Drawing with an eraser.

a. A rubbed graphite ground of middle value

b. An eraser trimmed for precise erasing of light areas. Then use a #4B or #6B pencil to darken shadowed areas

Fig. 10-8.

Fig. 10-9.

Notice also that there is almost no information in the shadowed areas. They are nearly uniform tones. Yet, when you turn the book right side up, the face and features emerge out of the shadows. These perceptions are occurring in your own brain, imaging and extrapolating from incomplete information. The hardest part of this drawing will be resisting the temptation to give too much information! Let the shadows stay shadowy, and have faith that your viewer will extrapolate the features, the expression, the eyes, the beard, everything (Figure. 10-9).

8. At this point you have the drawing "blocked in." The rest is all refinement, called "working up" the drawing to a finish. Note that, because the original drawing was done in charcoal and you are working in pencil, the exact roughness of the charcoal medium is difficult to reproduce in pencil. But also, even though you are copying Courbet's self-portrait, your drawing is your drawing. Your unique line quality and choice of emphasis will differ from Courbet's.

9. At each step, pull back a little from the drawing, squint your eyes a bit, and move your head from side to side slightly to see if the image is beginning to emerge. Try to see (that is, to image) what you have not yet drawn. Use this emerging, imagined image to add to, change, reinforce what is there in the drawing. You will find yourself shifting back and forth: drawing, imaging, drawing again. Be parsimonious! Provide only enough information to the viewer to allow the correct image to occur in the viewer's imagined perception. Do not overdraw.

At this point, I hope you will be really seeing, really drawing, really experiencing the joy of drawing. Later, when drawing a person from life, you will find yourself wondering why you never noticed how beautiful the person is, noticing perhaps for the first time the shape of the nose or the expression of the eyes (Figure. 10-10).

10. As you are working up the drawing, try to focus your attention on the original. For any problem that you encounter, the answer is in the original. For example, you will want to

achieve the same facial expression: the way to accomplish that is to pay careful attention to the exact shapes of the lights and the shadows. For example, notice the exact angle (relative to vertical or horizontal) of the shadow in the corner of the mouth. Notice the exact curve of the shadow under Courbet's right eye and the exact shape of that small shadow under the right cheekbone. Try not to talk to yourself about the facial expression.

11. Draw just what you see, no more, no less. You'll notice that the whites of the eyes are barely lighter than the dark shadow surrounding the eye. You will be tempted to erase out the whites because, well, you know they are called "whites of the eyes." Don't do it! Allow the viewer of your drawing to "play the game" of "seeing" what is not there. Your job is to barely suggest, just as Courbet did.

After you have finished:

In drawing the Courbet portrait, you were bound to be impressed by this work, its subtlety and strength, and how the personality and character of Courbet emerge from the shadows. I'm sure that this exercise has provided you with a taste for the power of light/shadow drawing. An even greater satisfaction, of course, will come from doing your own self-portrait.

Taking the next step

I'm sure you are aware that we have moved from seeing and drawing every detailed edge, as in Pure Contour Drawing, to precisely seeing and drawing negative space, to seeing exact proportional relationships, to accurately seeing and drawing the large and small shapes of lights and shadows. As you continue to draw after completing these lessons, you will begin to find your own unique style of using these fundamental components. Your personal style may evolve into a rapid, vigorous calligraphy (as in the Morisot *Self-Portrait*, Figure 10-11), a beautifully pale, delicate style of drawing, or a strong, dense style. Or your style may become more and more precise, as in the Sheeler drawing, Figure 10-12. Remember, you are always searching for your way of seeing and drawing. No matter how your style evolves, however, you will always be using edges, spaces, relationships, and (usually) lights and shadows, and you will depict the thing itself (the gestalt) in your own way.

 In this lesson, we are relying on the skills you've developed with the first three components to learn the fourth, lights and shadows, so the viewer can correctly see what you have left out.

Fig. 10-11. Berthe Morisot (1841–1895). *Self-Portrait*, c. 1885. Courtesy of The Art Institute of Chicago.

Fig. 10-12. Charles Sheeler (1883–1965), *Feline Felicity*, 1934. Conté crayon on white paper. Courtesy of The Fogg Art Museum, Harvard University. Purchase-Louise E. Bettens Fund.

For this process to work, it is helpful to see the exact shapes of lights and shadows as positive and negative shapes, and to correctly see the angles and proportions of lights and shadows.

More than the other components, this fourth skill apparently strongly triggers the brain's ability to envision a complete form from incomplete information. By suggesting a form with light/shadow shapes, you cause to viewer to see something that is not actually there. And the viewer's brain apparently always gets it right. If you provide the right clues, your viewers will see marvelous things that you don't even have to draw! For examples, see the self-portrait by Edward Hopper, Figure 10-13.

The truth is, you can cause yourself to see what is actually

Fig. 10-13. Edward Hopper (1882–1967), *Self-Portrait*, 1903. Conté crayon on white paper. Courtesy of the National Portrait Gallery, Smithsonian Institution. The artist shadowed the left side of his head in an almost even tone. Yet the viewer "sees" the eye that is bareley suggested.

not there, and you should strive for this phenomenon. Learning this "trick of the artist" is quite intriguing. As you are drawing, constantly squint you eyes to see if you can yet "see" the form you intend. And when you "see" it—that is, the envisioned image is there—stop! So many times in workshops, watching a beginning student draw, I find myself urgently saying, "Stop! It's there. You've got it. Don't overwork it!" There is an amusing saying in art circles that every artist needs someone standing right behind with a sledgehammer to let the artist know when the artwork is finished.

Crosshatching a lighter shadow

Before we advance to the next drawing, your self-portrait, I want to show you how to "crosshatch." This is a technical term for creating a variety of tones or values in a drawing by laying down a sort of "carpet" of pencil strokes, often crossing the strokes at angles. Figure 10-14 is an example of a tonal drawing built almost entirely of crosshatches. I'll also review the proportions of the head in frontal view and in three-quarter view.

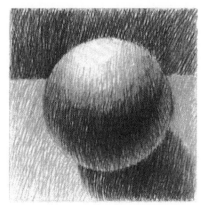

Fig. 10-14.

In former years, I thought that crosshatching was a natural activity, not requiring teaching. Apparently, this is not the case. The technique must be taught and must be learned. In fact, I now believe that the ability to crosshatch is a mark of a trained artist. If you glance through this book at the many reproductions, you will see that almost every drawing has some area of hatching. You will also notice that crosshatching has almost as many forms as there are artists to use them. Each artist, it seems, develops a personal style of hatching, almost a "signature," and, very quickly, so will you.

At this point, I will show you the technique and a few of the traditional styles of hatching. You will need paper and a carefully sharpened pencil.

1. Hold your pencil firmly and make a group of parallel marks, called a "set" (shown in Figure 10-15), by placing the pencil point down firmly, fingers extended. Swing off each mark by moving the whole hand from the wrist. The wrist remains stationary and the fingers pull the pencil back just a bit for each successive hatch. When you have finished one "set" of eight to ten hatch marks, move your hand and wrist to a new position and hatch a new set. Try swinging the mark toward you, and also try swinging it away from you in an outward movement to see which seems more natural for you. Try changing the angle of the marks.

2. Practice making sets until you have found the direction, spacing, and length of marks that seem right for you.

3. The next step is to make the "cross" sets. In classical hatching, the cross set is made at an angle only slightly different from

Fig. 10-15.

Fig. 10-16.

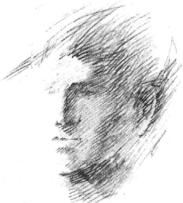

Fig. 10-17.

Fig. 10-18. Some examples of various styles of crosshatching.

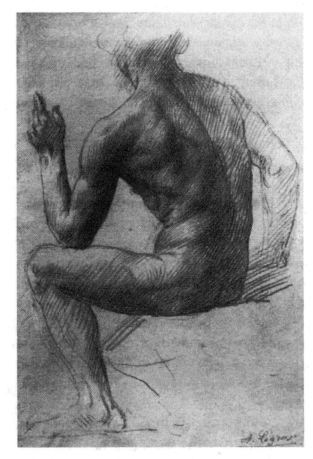

Fig. 10-19. Alphonse Legros, red chalk on paper.
Courtesy of The Metropolitan Museum of Art, New York.

the original set, as shown in Figure 10-16. This slight angle produces a very pretty moiré pattern that causes a drawing to seem to shimmer with light and air. Try this. Figure 10-17 shows how to use crosshatching to create a three-dimensional form.

4. By increasing the angle of crossing, a different style of cross-hatch is achieved. In Figure 10-18, see various examples of styles of hatching: full cross (hatch marks crossing at right angles), cross-contour (usually curved hatches), and hooked hatches (where a slight hook inadvertently occurs at the end of the hatch), as in the topmost example of hatching styles in Figure 10-18. There are myriad styles of hatching.

5. To increase the darkness of tone, simply pile up one set of hatches onto others, as shown in the left arm of the figure drawing by Alphonse Legros, Figure 10-19.

6. Practice, practice, practice. Instead of doodling while talking on the telephone, practice crosshatching—perhaps shading geometric forms such as spheres, or cylinders. (See the examples in Figure 10-20.) As I mentioned, crosshatching is not a naturally occurring skill for most individuals, but it can be rapidly developed with practice. I assure you that skillful, individualized use of hatching in your drawings will be gratifying to you and much admired by your viewers.

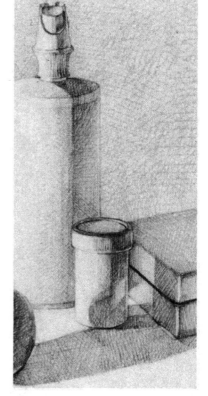

Fig. 10-20.

Shading into a continuous tone

Areas of continuous tone are created without using the separate strokes of crosshatching. The pencil is applied in either short, overlapping movements or in elliptical movements, going from dark areas to light and back again, if necessary, to create a smooth tone. Most students have little trouble with continuous tone, although practice is usually needed for smoothly modulated tones. Charles Sheeler's complex light/shadow drawing of the cat sleeping on a chair (Figure 10-12) superbly illustrates this technique.

Soon you will bring together all of your new skills, the basic component skills of drawing: perceptions of edges, spaces, and

shapes, relationships of angles and proportions, lights and shadows, the gestalt of the thing drawn, and the skills of crosshatching and continuous tone.

Drawing on the logic of light for a fully modeled, tonal, volumetric self-portrait

In these lessons, we began with line drawing and we end with a fully realized drawing. The terms in the subhead above are the technical terms that describe the drawing you will do next. From this exercise onward, you will practice the five perceptual skills of drawing with constantly changing subject matter. The basic skills will soon become integrated into a global skill, and you will find yourself "just drawing." You will shift flexibly from edges to spaces to angles and proportions, lights and shadows. Soon, the skills will be on automatic and someone watching you draw will be baffled by how you do it. I feel sure that you will find yourself seeing things differently, and I hope that, for you, as for many of my students, life will seem much richer by having learned to see and draw.

Before you start your drawing, we need to review briefly the proportions of the frontal or full-face view and the three-quarter view. You will use one of these views for your Self-Portrait.

The frontal view

I believe that this training for precise perceptions is one of the great bonuses of learning to draw. One really does learn to see better through drawing, to see with greater precision and finer discrimination. I feel sure that you can extrapolate the importance of this to general thinking skills. We often describe creative intelligence as "the ability to see things clearly."

Keeping this book open to the diagram on page 212, sit in front of a mirror with the book, a piece of paper, and a pencil. You are going to observe and diagram the relationships of various parts of your own head, as you go step by step through the exercise.

1. First, draw a blank (an oval shape) on your paper and draw the central axis dividing the diagram. Then, observe and measure on your own head the eye level line. It will be halfway. On the blank, draw in an eye level line. Be sure to measure to make sure you make this placement accurately.

Fig. 10-21. Vincent Van Gogh (etching, 1890), B-10, 283. Courtesy of The National Gallery of Art, Washington, D.C., Rosenwald Collection. An interesting example of the expressive effect of skewed features.

Fig. 10-22.

2. Now, looking at your own face in the mirror, visualize a central axis that divides your face and an eye level line at a right angle to the central axis. Tip your head to one side, as in Figure 10-23. Notice that the central axis and the eye level line remain at a right angle no matter what direction you tip your head. (This is only logical, I know, but many beginners ignore this fact and skew the features as in the example in Figure 10-22.)

3. Observe in the mirror: What is the width of the distance between your eyes, compared to the width of one eye? Yes, it's the width of one eye. Divide the eye level in fifths, as shown in Figure 10-24. Mark the outside corners of the eyes.

4. Observe your face in the mirror. Between eye level and chin, where is the end of the nose? This is the most variable of all the features of the human head. You can visualize an inverted triangle on your own face, with the wide points at the outside corners of your eyes and the center point at the bottom edge of your nose. This method is quite reliable. Mark the bottom edge of your nose on the blank. See Figure 10-24.

Fig. 10-23.

Fig. 10-24. The full-face view diagram. Note that this diagram is only a general guide to proportions that vary from head to head. The differences, however, are often very slight and must be carefully perceived and drawn to achieve a likeness.

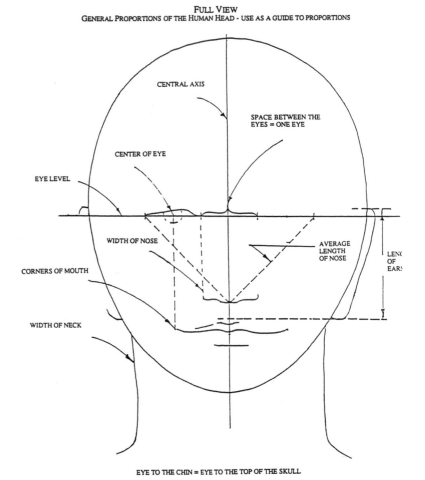

FULL VIEW
GENERAL PROPORTIONS OF THE HUMAN HEAD - USE AS A GUIDE TO PROPORTIONS

CENTRAL AXIS

SPACE BETWEEN THE EYES = ONE EYE

CENTER OF EYE

EYE LEVEL

WIDTH OF NOSE

AVERAGE LENGTH OF NOSE

LEN OF EAR

CORNERS OF MOUTH

WIDTH OF NECK

EYE TO THE CHIN = EYE TO THE TOP OF THE SKULL

5. Where is the level of the centerline of the mouth? About a third between the nose and chin. Make a mark on the blank.

6. Again, observe in the mirror: If you drop a straight line down from the inside corners of your eyes, what do you come to? The edges of your nostrils. Noses are wider than you think. Mark the blank.

7. If you drop a line straight down from the center of the pupils of your eyes, what do you come to? The outside corners of your mouth. Mouths are wider than you think. Mark the blank.

8. If you move your pencil along a horizontal line on the level of your eyes, what do you come to? The tops of your ears. Mark the blank.

9. Coming back from the bottoms of your ears, in a horizontal line, what do you come to? In most faces, the space between your nose and mouth. Ears are bigger than you think. Mark the blank.

10. Feel on your own face and neck: How wide is your neck compared to the width of your jaw just in front of your ears? You'll see that your neck is almost as wide—in some men, it's as wide or wider. Mark the blank. Note that necks are wider than you think.

11. Now test each of your perceptions on people, photographs of people, images of people on the television screen. Practice often, observing—first without measuring, then if necessary corroborating by measuring—perceiving relationships between this feature and that, perceiving the unique, minute differences between faces; seeing, seeing, seeing. Eventually, you will have memorized the general measurements given above and you won't have to analyze in the left-hemisphere mode as we have been doing. But for now it's best to practice observing the specific proportions.

Now we'll turn to the three-quarter view

Recall our previous definition of the three-quarter view: one-half of the head plus one-quarter. Still sitting in front of a mirror, pose your head in this view by starting with a full, frontal view and then turning (either left or right) so that you can only partly see one side of your head. You are now seeing one full side plus one-quarter—in other words a three-quarter view.

Artists of the Renaissance loved the three-quarter view, once they had finally worked through the problems of the proportions. I hope you will choose this view for your self-portrait. It's somewhat complicated, but fascinating to draw.

Young children rarely draw people with heads turned to the three-quarter view. Children generally draw either profiles or the

"When drawing a face, any face, it is as if curtain after curtain, mask after mask, falls away . . . until a final mask remains, one that can no longer be removed, reduced. By the time the drawing is finished, I know a great deal about that face, for no face can hide itself for long. But although nothing escapes the eye, all is forgiven beforehand. The eye does not judge, moralize, criticize. It accepts the masks in gratitude as it does the long bamboos being long, the goldenrod being yellow."

— Frederick Franck
The Zen of Seeing, 1973

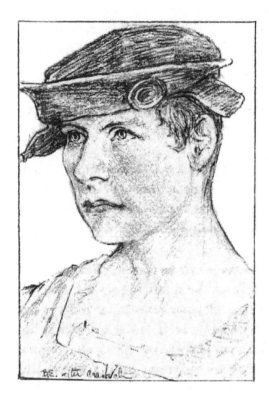

Fig. 10-25. A sketch by the author from a three-quarter view portrait by the German artist Lucas Cranach (1472–1553), *Head of a Youth with a Red Cap.*

full, frontal view. Around age ten or so, children begin to attempt three-quarter view drawings, perhaps because this view can be particularly expressive of the personality of the model. The problems young artists encounter with this view are the same old problems: the three-quarter view brings visual perceptions into conflict with the symbolic forms developed throughout childhood for profile and full-face views, which by age ten are embedded in the memory.

What are those conflicts? First, as you see in Figure 10-25, the nose is not the same as a nose seen in profile. In three-quarter view, you see the top and the side of the nose, making it seem very wide. Second, the two sides of the face are different widths—one side narrow, one side wide. Third, the eye on the turned side is narrower and shaped differently from the other eye. Fourth, the mouth from its center to the corner is shorter on the turned side and shaped differently from the mouth on the other side of the centerline. These perceptions of nonmatching features conflict with the memorized symbols for features that are

usually more symmetrical.

The solution to the conflict is of course to draw just what you see without questioning why it is thus or so and without changing the perceived forms to fit with a memorized-and-stored set of symbols for features. To see the thing-as-it-is in all of its unique and marvelous complexity—that is always the key.

My students have found it helpful if I point out some specific aids to seeing the three-quarter proportions. Let me again take you through the process step by step, giving you some methods for keeping your perceptions clear. Again note that if I were demonstrating the three-quarter-view drawing, I would not be naming any of the parts, only pointing to each area. When you are drawing, do not name the parts to yourself. In fact, try not to talk to yourself at all while drawing.

Fig. 10-26. First, see this whole area as a shape.

1. Again, sit in front of a mirror with paper and a pencil. Now, close one eye and pose in the three-quarter view so that the tip of your nose nearly coincides with the outer contour of the turned cheek, as in Figure 10-25. You can see that this forms an enclosed shape (see Figure 10-26).

2. Observe your head. Perceive the central axis—that is, an imaginary line that passes through the very center of the face. In three-quarter view, the central axis passes through two points: a point at the center of the bridge of the nose and a point at the middle of the upper lip. Image this as a thin wire that passes right through the form of the nose (Figure 10-27). By holding your pencil vertically at arm's length toward your reflection in the mirror, check the angle or tilt of the central axis of your head. Each person may have a different characteristic tilt to the head, or the axis may be perfectly vertical.

3. Next, observe that the eye level line is at right angles to the central axis. This observation will help you to avoid skewing the features as I mentioned on page 212. Next measure on your head to observe that the eye level line is at half of the whole form.

5. Now, practice making a line drawing of a three-quarter view on your scratch paper. You will be using the method of modified contour drawing: drawing slowly, directing your

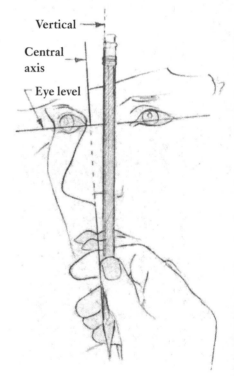

Fig. 10-27. Observe the tilt of the central axis compared to vertical (your pencil). The eye level line is at a right angle compared to the central axis.

This width *equals this width*

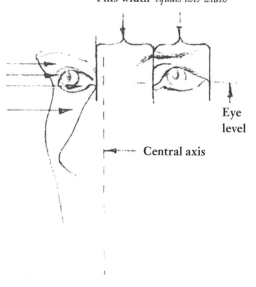

Eye
level

Central axis

Fig. 10-28.

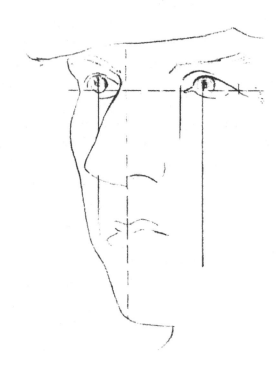

Fig. 10-29.

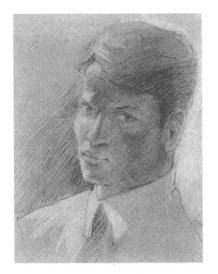

A three-quarter portrait, *Bandalu*,
by the author. Note the tilt of the
central axis.

gaze at edges, and perceiving relational sizes, angles, etc.
Again, you can start anywhere you wish. I tend to start with
that shape between the nose and the contour of the turned
side of the cheek because that shape is easy to see, as in Fig-
ure 10-25. Note that this shape can be used as an "interior"
negative shape—a shape you have no name for. I'll describe a
definite order for the drawing, but you may prefer a different
order.

6. Direct your eyes at the shape and wait until you can see it
clearly. Draw the edges of that shape. Because the edges are
shared, you will have also drawn the edge of the nose. Inside
the shape you have drawn is the eye with the odd configura-
tion of the three-quarter eye. To draw the eye, don't draw the
eye. Draw the shapes around the eye. You may want to use the
order 1, 2, 3, 4 as shown in Figure 10-28, but any order will
work as well. First the shape over the eye (1), then the shape
next to it (2), then the shape of the white part of the eye (3),

then the shape under the eye (4). Try not to think about what you are drawing. Just draw each shape, always shifting to the next adjacent shape.

7. Next, locate the correct placement of the eye on the side of the head closest to you. Observe on your model that the inside corner lies on the eye level line. Note especially how far away from the edge of the nose this eye is. This distance is nearly always a distance equal to the full width of the eye on the near side of your head. Be sure to look at Figure 10-28 for this proportion. The most common error beginning students make in this view of the model is to place the eye too close to the nose. This error throws all of the remaining perceptions off and can spoil the drawing. Make sure that you see (by sighting) the width of that space and draw it as you see it. Incidentally, it took the early Renaissance artists half a century to work out this particular proportion. We benefit, of course, from their hard-won insights (Figures 10-28 and 10-29).

8. Next, the nose. Check on your reflection where the edge of the nostril is in relation to the inside corner of the eye: Drop a line straight down, following (that is, parallel to) the central axis (Figure 10-29). Remember that noses are bigger than you think.

9. Observe where the corner of your mouth lies in relation to the eye (Figure 10-29). Then observe the centerline of the mouth and the exact curve. This curve is important in catching the expression of the model. Don't talk to yourself about this. The visual perceptions are there to be seen. By seeing clearly and drawing exactly what you see—exact angles, edges, spaces, proportions, lights, and shadows. In R-mode, you do respond—but not in words.

10. Observe the upper and lower edges of your lips, remembering that the line is usually light because these are not true edges or strong contours.

11. On the turned side of your head, observe the shapes of the spaces around the mouth. Again, note the exact curve of the centerline on this side.

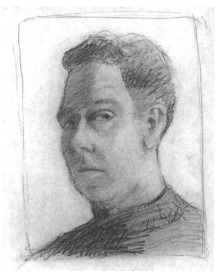

Fig. 10-30. A three-quarter self-portrait by instructor Brian Bomeisler.

12. The ear. The mnemonic for placing the ear in profile view must be slightly changed to account for the added quarter in three-quarter view.

Profile:
Eye level-to-chin = back-of-the-eye to the back-of-the-ear

becomes

Three-quarter:
Eye level-to-chin = *front*-of-the-eye to the back-of-the-ear

You can perceive this relationship by measuring it on your reflection in the mirror. Then note where the top of the ear is, and then the bottom. See Figure 10-30.

Ready to draw!

Now that we've reviewed crosshatching and the general proportions for the frontal and three-quarter views, you are ready for the last drawing exercise, your Self-Portrait in fully articulated lights and shadows.

What you'll need:

- Your drawing paper—three or four sheets (for padding), taped to your drawing board.
- Your pencils, sharpened, and your eraser
- A mirror and tape for attaching the mirror to a wall, or you may want to sit in front of a bathroom mirror or dressing table mirror
- Your felt-tip marker
- Your graphite stick
- A paper tissue or towel for rubbing in a ground
- A dampened tissue for correcting marker-pen marks on plastic
- A floor lamp or a table lamp to illuminate one side of your head (Figure 10-31 shows an inexpensive spot lamp)
- A hat, scarf, or headdress, if that idea appeals to you

Fig. 10-31.

What you'll do:

1. First, prepare your drawing paper with a ground. You may choose any level of tone. You may want to do a "high-key" (meaning light) drawing by starting with a pale ground, or you may decide to use the drama of a dark ground for a "low-key" (meaning dark) drawing. Or, perhaps you prefer a middle value. Be sure to lightly draw in the crosshairs.

 Note that in this drawing, you will not need your plastic Picture Plane. The mirror itself becomes the picture-plane. Try to think that through—I'm sure you will see the logic of it.

2. Once your ground is prepared, set yourself up to draw. Check the setup in Figure 10-32. You will need one chair to sit in and one chair or small table to hold your drawing tools. As you see in the diagram, you will lean your drawing board against the wall. Once you are seated, adjust the mirror on the wall so that you can comfortably see your image. Also, the mirror should be just at arm's length from where you are sitting. You want to be able to take sightings directly on the mirror as well as directly on your face and skull as you observe the measurements in the mirror.

Fig. 10-32.

3. Adjust the lamp and test out various poses by turning your head, raising or lowering your chin, and adjusting your hat or headdress, until you see in the mirror a composition in lights and shadows that you like. Decide whether to draw a full-face view or a three-quarter view, and decide which way you will turn, left or right, if you choose the three-quarter view.

4. Once you have carefully chosen your composition in the mirror and the pose is "set," try to keep all of your gear in the same places until the drawing is finished. If you stand up to take a break, for example, try not to move your chair or the lamp. Students often find it very frustrating if they can't recapture exactly the same view when they sit down again.

5. You are now ready to draw. The instructions that follow are really only a suggestion for one procedure among myriad possible procedures. I suggest that you read through all of the remaining instructions and then begin to draw following the

Fig. 10-33.

suggested procedure. Later on, you'll find your own way to proceed.

A self-portrait in pencil

1. Gaze at your reflection in the mirror, searching for negative spaces, interesting edges, and the shapes of lights and shadows. Try to suppress language entirely, particularly verbal criticism of your face or features. This is not easy to do, because this is a new use of a mirror—not for checking or correcting, but to reflect an image in an almost impersonal way. Try to regard yourself the way you would regard a still-life setup or a photograph of a stranger.

2. Choose a Basic Unit. This is entirely up to you. I generally use eye level to chin, and I often draw in a central axis (a line that vertically bisects the head, running through the center of the bridge of the nose and the center of the mouth). Next, draw in the eye level line.

These two guidelines, the central axis and the eye level line, always cross at right angles, whether in full-face view or three-quarter and whether the person's head is tilted relative to vertical or is held perfectly upright. I suggest drawing the central axis and eye level line directly on the mirror with your felt-tip pen. (You may prefer to start your drawing another way, perhaps relying only on the crosshairs printed on your mirror. Please feel free to do so.) You must, however, be sure to mark the top and bottom of your Basic Unit directly on the mirror.

3. The next step, of course, is to transfer your Basic Unit to your drawing paper with its crosshairs and toned ground. Just make marks at the top and bottom of your Basic Unit. You may wish to add marks for the top edge and side edges of the image in the mirror. Transfer these marks to your drawing.

4. Next, squint your eye a bit to mask out some of the detail in your mirror image and find the large lighted shapes. Note where they are located relative to your Basic Unit and to the crosshairs on the mirror and in your drawing and to the central axis/eye level lines, if you are using them.

5. Begin your drawing by erasing out the largest lighted shapes, as in Figure 10-34. Try to avoid any small forms or edges. Right now you are trying to see the large lights and shadows.

6. You may wish to erase out the ground around the head, leaving the toned ground as the middle value of the head. You may, on the other hand, want to lower the value (darken) the negative spaces. These are aesthetic choices. Figure 10-34 shows both.

7. You may want to add some graphite to the shadowed side of the face. For this, I recommend your #4B pencil, not the graphite stick, which is somewhat hard to control and becomes rather greasy if pressed hard on the paper.

8. I'm sure you've noticed that I have said nothing about eyes, nose, or mouth up to this point. If you can resist the impulse to draw the features first, and allow them to "come out" of the light/shadow pattern, as I describe in the margin, you will be able to exploit the full power of this kind of drawing.

9. Rather than drawing the eyes, for example, I recommend that you rub your #4B pencil point on a scrap of paper, rub your forefinger over the graphite, and, checking back in the mirror for the location of the eyes, rub your graphited finger where the eyes should be. Suddenly you will be able to "see" the eyes, and you need only to reinforce that ghostly perception.

10. Once you have the large shapes of lights and shadows drawn, begin to look for some of the smaller shapes. For example, you may find a shadowed shape under the lower lip or under the chin or under the nose. You may see a shadow-shape on the side of the nose or under the lower lid. You can slightly tone the shadow-shape with your pencil, using crosshatching, or, if you wish, rub the tone in with your finger to smooth it. Be sure that you place and tone the shadow-shapes exactly as you see them. They are the shapes they are because of the bone structure and the particular light that falls on the shape.

11. At this point, you are ready to decide whether you want to leave the drawing at this somewhat rough or "unfinished" stage, or whether you want to work the drawing up to a "high

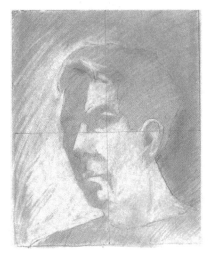

Fig. 10-34.

This lesson leads to one of the two additional basic skills I mentioned in the Introduction: the "dialogue" that goes on in drawing from the imagination. This is drawing at a more advanced level. You check the information "out there" or in your imagination and just barely indicate placement of the first marks. This causes an imagined image in the mind of the artist, who then draws what he or she has already "seen." Thus drawing becomes a kind of dialogue between the artist's intent and what develops on the paper. The artist makes a mark. That mark generates a further image. The artist reinforces the imagined addition, which triggers more imaging, and so on.

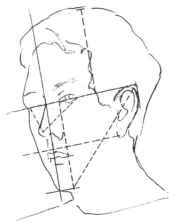

Fig. 10-35. A diagram of the three-quarter self-portrait shown in Fig. 10-37.

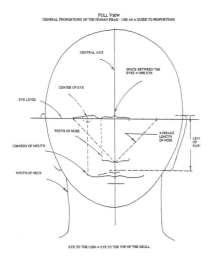

FULL VIEW
GENERAL PROPORTIONS OF THE HUMAN HEAD - USE AS A GUIDE TO PROPORTIONS

CENTRAL AXIS

SPACE BETWEEN THE EYES = ONE EYE

CENTER OF EYE

EYE LEVEL

WIDTH OF NOSE

AVERAGE LENGTH OF NOSE

LENGTH OF EARS

CORNERS OF MOUTH

WIDTH OF NECK

EYE TO THE CHIN = EYE TO THE TOP OF THE SKULL

Fig. 10-36. The full-face view diagram.

finish." Throughout this book, you will find numerous examples of drawings at various degrees of "finish."

12. I will briefly list again some of the main proportions to watch for. Remember that your brain may not be helping you to see what is really "out there," and these reminders may encourage you to take sights on everything!

- For a full-face self-portrait: Eye level to chin = eye level to the top of the skull.
- If the hair is thick, the upper part will be greater than half.
- The space between the eyes is approximately one eye-width.
- Determine the length of the nose by imaging an inverted triangle with the outside points at the outside corners of the eyes and the point at the bottom edge of the nose. This is a variable proportion. The inverted triangle is a particular shape for each particular model.
- The outside edges of the nostrils of the nose are usually directly under the inside corners of the eyes. This proportion also varies.
- The outside corners of the mouth fall under the pupils of the eyes. This proportion varies. Note with special care the position and shape of the outer corners of the mouth, where much of the subtle expression of a face is located.
- The tops of the ears fall approximately at or slightly above eye level line.
- The bottoms of the ears are approximately at (or slightly above or below) the upper lip. Note that if the head is tilted up or down, the location of the ears—as seen on the picture plane—relative to the eye level line will change.
- Observe the neck, collar, and shoulders relative to the head. Make sure that the neck is wide enough by checking the width in relation to the width of the face. Use negative space for the collar (draw the spaces under and around the collar). Notice how wide the shoulders are. A frequent student error is making the shoulders too narrow. Sight the width relative to your Basic Unit.
- In drawing the hair, look for the largest lights and shadows of the hair first and then work down to the finer details later.

Note the major directions in which the hair grows and the places where it parts to shows a darker tone underneath. Note and draw details of how the hair grows and what its texture is close to the face. Give your viewer enough information about the hair to know what it is like.

The portrait drawings throughout this book will demonstrate various ways of drawing different types of hair. There is obviously no one way of drawing hair just as there is no one way to draw eyes, noses, or mouths. As always, the answer to any drawing problem is to draw what you see.

If you have decided on a three-quarter view, please review the proportions for that view that I provided earlier in this chapter. Also, see Figure 10-35. One caution: Beginning students sometimes begin to widen the narrow side of the face and then, because that makes the face seem too wide, they narrow the near side of the face. Often, the drawing ends up a frontal view, even though the person was posing in three-quarter view. This is very frustrating for students, because they often can't figure out what happened. The key is to accept you perceptions. Draw just what you see! Don't second-guess your sightings.

Now that you have read all of the instructions, you are ready to begin. I hope you will find yourself quickly shifting into R-mode.

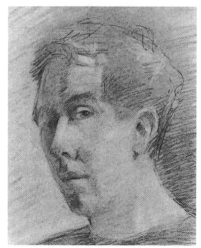

Fig. 10-37. The completed drawing: A self-portrait by instructor Brian Bomeisler.

After you have finished:

When the drawing is finished, observe in yourself that you sit back and regard the drawing in a different way from the way you regarded the drawing while working on it. Afterward, you regard the drawing more critically, more analytically, perhaps noting slight errors, slight discrepancies between your drawing and the model. This is the artist's way. Shifting out of the working R-mode and back to L-mode, the artist assesses the next move, tests the drawing against the critical left brain's standards, plans the required corrections, notes where areas must be reworked. Then, by taking up the brush or pencil and starting in again, the artist shifts back into the working R-mode. This on-off procedure con-

tinues until the work is done—that is, until the artist decides that no further work is needed.

Before and after: A personal comparison

This is a good time to retrieve your pre-instruction drawings and compare them with the drawing you have just completed. Please lay out the drawings for review.

I fully expect that you are looking at a transformation of your drawing skills. Often my students are amazed, even incredulous, that they could actually have done the pre-instruction drawings they now find in front of them. The errors in perception seem so obvious, so childish, that it even seems that someone else must have done the drawing. And in a way, I suppose, this is true. L-mode, in drawing, sees what is "out there" in its own way—linked conceptually and symbolically to ways of seeing and drawing developed during childhood. These drawings are generalized.

Your recent R-mode drawings, on the other hand, are more complex, more linked to actual perceptual information from "out there," drawn from the present moment, not from memorized symbols of the past. These drawings are therefore more realistic. A friend might remark upon looking at your drawings that you had uncovered a hidden talent. In a way, I believe this is true, although I am convinced that this talent is not confined to a few, but instead is as widespread as, say, talent for reading.

Your recent drawings aren't necessarily more expressive than your "Before-Instruction" drawings. Conceptual L-mode drawings can be powerfully expressive. Your "After-Instruction" drawings are expressive as well, but in a different way: They are more specific, more complicated, and more true to life. They are the result of newfound skills for seeing things differently, of drawing from a different point of view. The true and more subtle expression is in your unique line and your unique "take" on the model—in this instance yourself.

At some future time, you may wish to partly reintegrate simplified, conceptual forms into your drawings. But you will do so by design, not by mistake or inability to draw realistically. For

now, I hope you are proud of your drawings as signs of victory in the struggle to learn basic perceptual skills and to control the processes of your brain.

Now that you have, with great care, seen and drawn your own face and the faces of other human beings, surely you understand what artists mean when they say that every human face is beautiful.

A showing of portraits

As you look at the portraits on the following pages, try to mentally review how each drawing developed from start to finish. Go through the measurement process yourself. This will help to reinforce your skill and train your eye. Three of the drawings are instructional demonstration drawings from our five-day workshop.

A suggestion for a next drawing

A drawing suggestion that has proven to be amusing and interesting is a self-portrait as a character from art history. A few such examples might include "Self-Portrait as the Mona Lisa"; "Self-Portrait as a Renaissance Youth"; "Self-Portrait as Venus Rising from the Sea."

"The object, which is back of every true work of art, is the *attainment of a state of being,* a state of high functioning, a more than ordinary moment of existence. . . . We make our discoveries while in the state because then we are clear-sighted."

— Robert Henri
The Art Spirit, 1923

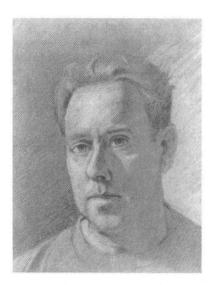

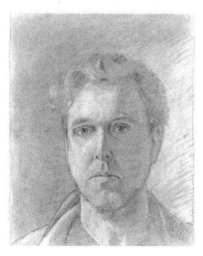

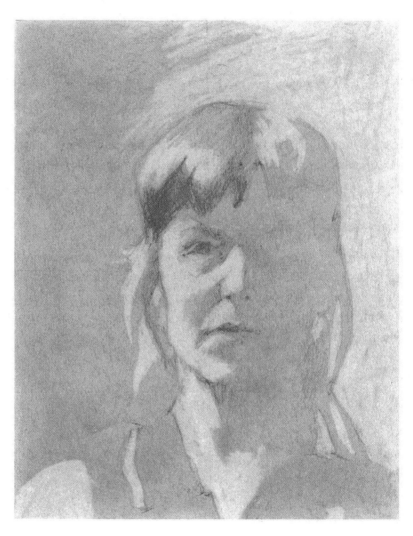

Two additional self-portraits by instructor Brian Bomeisler. Note how they differ one from another. You will find that your self-portraits will differ, reflecting the mood, feeling, and surroundings of each sitting. Remember, drawing is not photography.

A beautiful self-portrait in light/shadow by instructor Grace Kennedy.

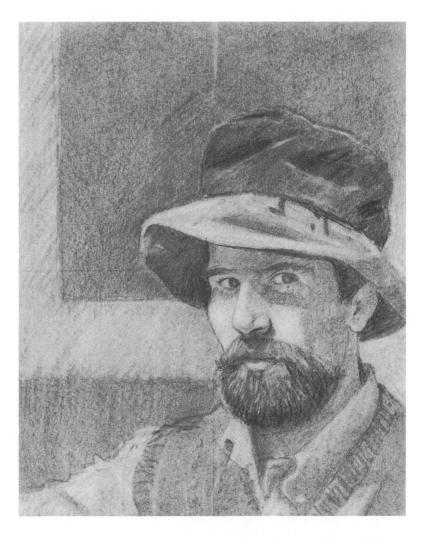

A three-quarter self-portrait by student Mauro Imamoto. The composition is especially fine.

II Drawing on the Beauty of Color

COLOR THEORIST
ALFRED H. MUNSELL

I N AN AGE LIKE OURS, color is not the luxury it was in past centuries. We are inundated by manufactured color—surrounded, immersed, swimming in a sea of color. Because of sheer quantity, color is perhaps in danger of losing some of its magic. I believe that using color in drawing and painting helps us to recapture the beauty of color and to experience once again the almost hypnotic fascination it once had for us.

Human beings have made colored objects from earliest times, but never in such great quantity as now. In past centuries, colored objects were most often owned by only a few wealthy or powerful persons. For ordinary people, color was not available, except as found in the natural world and as seen in churches and cathedrals. Cottages and their furnishings were made of natural materials—mud, wood, and stone. Homespun cloth usually retained the neutral colors of the original fibers or, if dyed with vegetable dyes, was often quick to soften and fade. For most people, a bit of bright ribbon, a beaded hatband, or a brightly embroidered belt was a treasure to guard and cherish.

Contrast this with the fluorescent world we live in today. Everywhere we turn, we encounter human-made color: television and movies in color, buildings painted brilliant colors inside and out, flashing colored lights, highway billboards, magazines and books in full color, even newspapers with full-page color displays. Intensely colored fabrics that would have been valued like jewels and reserved for royalty in times past are now available to nearly everyone, wealthy or not. Thus, we have largely lost our former sense of the wondrous specialness of color. Nevertheless, as humans, we can't seem to get enough color. No amount seems too much—at least not yet. True, quite a few individuals objected to the "colorization" of vintage black-and-white films. These arguments, however, were lost to commerce; most people preferred the colorized versions.

But what is all this color for? In the natural world of animals, birds, and plants, color always has a purpose—to attract, repel, conceal, communicate, warn, or assure survival. For present-day humans, has color even begun to lose its purpose and meaning? Now that we have this huge bulk of manufactured color, is its use

Fig. 11-3. Colour Wheel. Complements are directly opposite each other on the wheel. The complement of each primary colour (yellow, red and blue) is a secondary colour (violet, green and orange). The complement of each tertiary colour is another tertiary colour.

Because any complementary pair always contains, between the two hues, all three primary colours, complements completely cancel colour when mixed together in equal quantities. This characteristic is the key to controlling intensity of hues.

Exercise: The pattern for making your own colour wheel is on page 208.

Fig. 11-4. Value scale. A scale in even steps between the opposites, the white of the paper and the darkest dark the pencil will make.

The inset strip is the same value throughout. The apparent change in value is a perceptual illusion, caused by the differences in contrast between the light-to-dark tones of the scale and the constant value of the central strip.

Exercise: Make a value scale of twelve steps, using pencil.

Fig. 11-5. Heather Heilman, age 6, *The Park*, 12x18". Courtesy of The International Chid Art Collection, Junior Arts Centre, Los Angeles, California.

Children tend to use symbolic colour as well as symbolic forms. These symbol systems are linked to language acquisition: "Trees have green leaves and brown trunks." Learning perceptual skills helps older children to see beyond these symbolic systems.

Exercise: Reveiw Chapter Five on childhood drawing, then redraw your own childhood landscape, this time in colour.

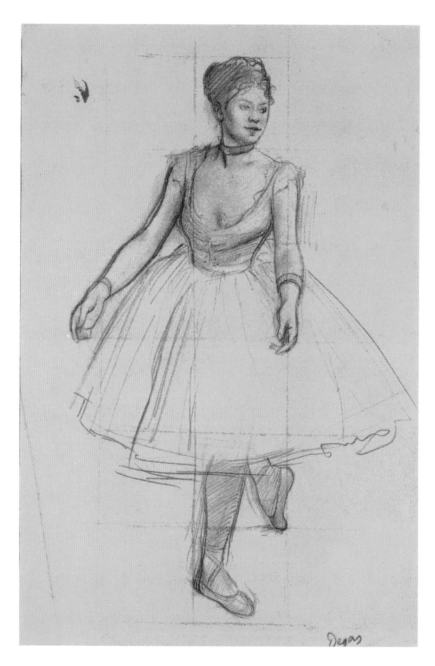

Fig. 11-6. Edgar Degas, *Ballet Dancer in Position Facing ¾ Front* (1872). Soft Black graphite accented with black crayon, heightened with white on pink paper. 16⅛ x 11¼ The Fogg Art Museum, Harvard. Bequest of Meta and Paul J. Sachs.

Exercise: To experience the impact of colour on drawing, compare this drawing with another Degas dancer on page 123. See page 211 for a drawing exercise.

Fig. 11-7. Kathe Kollwitz, *Self-Portrait* (c.1891/92). Pen and black ink with brush and gray wash, heightened with white gouache, on brown wove paper. 15¹³⁄₁₆ x 12¹¹⁄₁₆". The Art Institute of Chicago. Gift of Margaret Day Blake, Mr. and Mrs. Alan Press, and Prints and Drawings Purchase, 1980.
Over her lifetime, the German artist Kathe Kollwitz produced more than fifty probing images of herself. This serious, contemplative self-portrait was drawn when the artist was about twenty-five and reflects her early training in engraving.

Exercise: Try a heightened self-portrait, using the procedure described below.

The artist sits in front of a mirror, cheek resting on hand. The light, as you see, comes from above and to the left of the sitter (note the shadow cast by the nose and the crest shadow along the wrist).

Working on brown paper, quickly paint a dark negative space around the head, using a brush and black ink mixed with water. The brown of the paper supplies the middle value for the face.

Using a tiny brush to draw in the details of the face in black ink, and the same tiny brush to heighten the drawing with white gouache. The heightening lines follow the curve of the surface of the face, almost as though you are *feeling* your way across the forms.

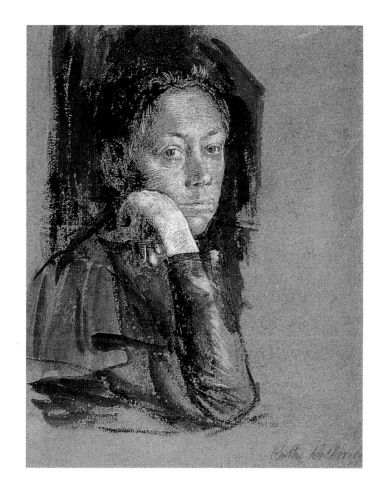

Fig. 11-8. Henri Toulouse Lautrec, *At the Circus: Work in the Ring* (1899). Coloured pencil with pastel and black crayon on ivory wove paper. 21.8 x 31.6 cm. The Artist Institute of Chicago. Gift of Mr. and Mrs. B.E. Bensinger.

Exercise: For practice with colour, negative space, and sighting, copy this drawing using coloured pencil and pastels, but change the colours to those of your own choice to see the effect of colour on drawing.

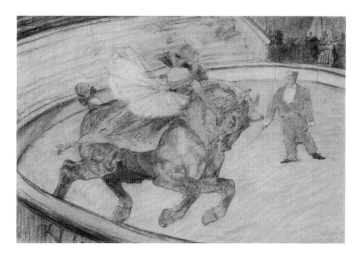

Fig. 11-9. Jean-Baptiste-Simeon Chardin (French, 1699-1779), *Self-portrait with a Visor* (c.1776). Pastel on blue laid paper mounted on canvas. 18 x 14⅝"(457 x 374mm). The Art Institute of Chicago, Clarence Buckingham Collection and Harold Joachim Memorial Fund.

Fig. 11-10. Jean-Baptiste-Simeon Chardin, *Portrait of Madame Chardin* (c.1776). Pastel on blue laid paper mounted on canvas. 18 x 14¹⁵⁄₁₆"(457 x 378mm). The Art Institute of Chicago, Helen Regerstein Collection

Toward the end of a long career as a successful painter of still lifes and scenes of everyday life, Jean-Baptiste-Simeon Chardin turned to pastels, a new medium for him, and to portraiture, an unexplored subject. Only twelve Chardin pastels are known to exist today, foremost among them the two masterpieces shown above. These portraits illustrate a point made in the text: rich and profound colour can be achieved by using very few hues. The basic hues in each of the portraits are the complements blue and orange, each transformed into a complex harmonious medley of balanced values and intensities.

Exercise: Try a portrait or self-portrait on coloured paper using only two complementary hues plus white and black. The masterworks above can guide your efforts to gain control of colour.

Fig. 11-11. Elizabeth Layton, *Self-portrait in a mirror.* Coloured pecil on paper. Reproduced with kind permission of the artist.

Elizabeth Layton first began drawing at age 68 with the hope of finding relief from severe depression following a stroke. Drawing proved therapeutic (she calls it "cure by contour") and she continued to draw. Since then, her work has been exhibited nationwide and is greatly admired. She believes that everyone can learn to draw and that children in particular should be taught to draw at an early stage.

Fig. 11-12. Photograph of Elizabeth Layton. Reproduced with kind permission of the artist.

Exercise: Try a coloured-pencil self-portrait in a mirror, including your hands.

Fig. 11-13. Richard Diebenkorn, *Untitled (Ocean Park)* (1977). Acrylic, gouache, cut-and-pasted paper. 18¼ x 32¾" (47.6 x 83.2 cm). Collection, The Museum of Modern Art, New York. Purchase.

Exercise: Working within an unusual format (tall and narrow, short and wide, circular, oval), divide the space and manipulate the quantities of hues to achieve a pleasing, harmonious balance and tension (a sense of connection or "pull") between colour areas.

Fig. 11-14. Brian Bomeisler, *Adam and Eve*, 1984. Mixed media on paper. 10 x 9". Collection of the artist.

This New York artist explores colour, light and scale through themes from mythology and literature.

Exercise: Experiment with scale by using contrasting sizes—very large to very small. Experiment with light by changing the values of a hue to achieve luminosity in colour. Observe how the artist achieved a wonderful sense of luminous colour in *Adam and Eve*.

Fig. 11-15. Odilon Redon (1840-1916), *Head of a Young Girl*. Pastel on blue-gray laid paper. 20⅝ x 14⅞ The Fogg Art Museum, Harvard.

Exercise: See page 217 for an exercise based on this exceptional drawing.

Fig. 11-16. Student Gary Berberet, *Self-Portrait*. Pastel on gray paper. 18 x 24".

Exercise: Try an intense, close-up self-portrait in pastel on coloured paper. Remember that you always have an available model—yourself. The addition of props such as hats can stimulate interest in each new self-portrait.

Fig. 11-17. Student Laura Wright, *Umbrella Still Life*. A monochromatic colour harmony based on varying values and intensities of orange.

Exercise: Construct a still life with some randomly chosen objects. Do a negative-space drawing on coloured paper (or do a preliminary drawing and transfer it to coloured paper, using carbon paper). Choose coloured pencils that are variations of one hue, the hue of the coloured paper.

Fig. 11-18. Student Ken Ludwig, *Large Stuffed Eagle*. Rubbed pastel on white paper with pen and black ink. 18 x 24".

A few analogous colours can produce a surprising range of harmonious hues. Strong contrast is supplied by the black ink and white paper.

Exercise: Draw an animal or bird from life, if possible, or from photographs. (Habitat groups at natural history museums are wonderful as models-they hold very still.) Rub analogous hues of coloured chalk into white paper and draw with pen and ink.

Fig. 11-19. Piet Mondrian, *Red Amarylis with Blue Background* (c.1907) Watercolour. 18⅜ x 13". The Museum of Modern Art, New York. The Sidney and Harriet Janis Collection.

Exercise: Prismacolor watercolour pencils convert to watercolour when dampened with a wet brush. Using these pencils, try a "portrait" of a flower or plant, paying attention to negative space and using contrasting colours, guided by the superb drawing above.

Fig. 11-20. David Hockney, *Celia in a Black Dress with White Flowers, 1972*. Crayon on paper. 17 x 14". Collection of the artist.

Exercise: Try a half-length or full-length portrait or self-portrait in coloured pencil on white paper. Place an object or objects in front of the figure and use negative space to delineate the space between. Three distances are described: from the artist's eyes to the objects to the figure.

Fig. 11-21. Paul Gauguin, *Tahitian Women*. Pastel on paper. 21⅝ x 19½". The Brooklyn Museum, New York.

Exercise: Combine warm and cool hues in a pastel drawing.

Fig. 11-22. Student Thu Ha Huyung, *Girl in a Flowered Hat*. Coloured pencil on yellow paper. 18 x 24".

Exercise: For a colourful drawing, try a portrait using two sets of complements and black and white on coloured paper.

Fig. 11-23. Hans Baldung Grien, Self-portrait (1502). Offentliche Kunstsammlung, Kupferstichkabinett Basel.

Exercise: This drawing combines three-quarter view and full-face in one drawing, with strangely intriguing results. You might deliberately try this distortion as a step into more abstract portraiture.

Fig. 11-24. Student drawing, *The Arrow Hotel*. Negative space and contrasting colours transform an urban scene.

Exercise: See page 214 for suggestions on drawing an urban landscape.

mostly indiscriminate? Or is purpose and meaning still subliminally inherent in color as a remnant of our biological heritage? Is the pencil I write with painted yellow for a purpose? Did I choose to wear blue today for a reason?

And what is color? Is it merely, as scientists tell us, a subjective experience, a mental sensation that can only occur if three requirements are fulfilled: that there is an observer, an object, and sufficient light in the narrow band of wavelengths called the "visible spectrum"? It certainly is true that at twilight the world turns to shades of gray. Is the world really colorless, only seeming to become full of color again when we turn the lights on?

If color is a mental sensation, how does it happen? Scientists tell us that when light falls on an object—for example, an orange—the surface of the orange has the particular property of absorbing all the wavelengths of the spectrum except that which, when reflected back to our eyes and processed through the visual system, causes the mental sensation we have named the color "orange." My writing pencil is coated with a chemical substance (paint) that absorbs all wavelengths except that which, when reflected back to my eyes, is "yellow." Is the orange really orange? Is the pencil really yellow? We cannot know, because we cannot get outside of our own eye/brain/mind system to find out. What we do know is that when the sun goes down, color disappears.

Placing color in the brain

Given sufficient light to perceive colors, scientists also tell us that the brain's reaction to colors seems to depend on the differences in thinking modes of the various sections of the brain.

Very bright, intense colors (and colors that shine and glitter) draw a response from the so-called "primitive" brain, the limbic system. This response is an emotional one, perhaps connected to our biological heritage of color as communication. For example, many people say, "When I get mad, I see red!" The inverse of this exclamation perhaps describes the situation whereby an intense red elicits an emotional, aggressive response.

The main role of L-mode, generally located in the left hemisphere, is to tag colors with names and attributes, such as "bright

In the Middle Ages, color was used in *heraldry*, the practice of designing the insignia for armor that "heralded" or announced the wearer's status, family connections, and history as a warrior.

Color helped to carry the message of the design:

White = fate and purity

Gold = honor

Red = courage and zeal

Blue = purity and sincerity

Green = youth and fertility

Black = grief and penitence

Orange = strength and endurance

Purple = royalty and high birth

The *limbic system* is a group of structures, as yet incompletely defined, that generally includes areas deep in the brain. These areas are transitional in structure between the "new" cortex and older portions such as the olfactory brain. Scientists believe that the limbic system is involved in patterns of strong emotions.

— H. B. English and
 Ava C. English
 A Comprehensive Dictionary of Psychological and Psychoanalytical Terms,
 1974

"He knows all about art, but he doesn't know what he likes."

blue," "lemon yellow," or "burnt umber," and to translate into words our emotional reactions to colors. (As an example, read in the marginal note how the Irish-Greek writer Lafcadio Hearn translated into words his emotional reactions to the color blue.)

Additionally, L-mode is specialized for designating sequenced steps in mixing colors—for example, "to mix orange, add yellow to red," or "to darken blue, add black."

The right hemisphere (or R-mode) is specialized for the perception of relationships of hues, particularly for subtle linkages of one hue to another. R-mode is biased toward discovering patterns of coherence, specifically toward combinations of hues that balance opposites—for example, red/green, blue/orange, dark/light, dull/bright.

In his 1976 essay "The Dialectics of Color," Dr. Peter Smith states: "Since the right hemisphere has a strong interest in the way things fit together to form a closed system, it may be said to be a decisive factor in the esthetic response." This closed system may be what artists speak of as unified, harmonious color—that is, color in relationships that are locked into balance. Perhaps R-mode recognizes the satisfying wholeness of properly unified color and reacts with a pleasurable sense of "Yes. That's it. That's right."

The converse is also true: R-mode recognizes unbalanced or disunified color arrangements and perhaps longs for unity and the missing parts of the closed system. An individual may experience this longing as vague dislike—a sense that something is missing or out of place.

R-mode has another important role in color: seeing which combination of colors has produced a particular color. Given a range of grays, for example, R-mode sees which one is warmed with red, which is cooled with blue.

Learning the basics of color

Nearly everyone is interested in color, yet most people have surprisingly little comprehensive knowledge about it. We often take it for granted that we know enough about color to know what we

like, and we feel that's sufficient. Yet knowing something of the enormous body of knowledge about color increases pleasure in color, as in almost every subject. In the following pages, you will add a few color skills to your newly acquired basic perceptual skills of drawing.

Something odd happens when a student of drawing begins to add color to the gray, black, and white of drawing. No matter how satiated by our modern color-loaded surroundings, students focus on color as though seeing it for the first time, almost with the naive pleasure of children. And color in drawing does indeed add a tremendous emotional charge to drawing. For an example of this, compare Edgar Degas's drawing of the ballet dancer on pink paper (Figure 11-6) with the almost identical Degas drawing on page 157 of Chapter Eight. But I must caution you: I am not saying that color makes a drawing better. It doesn't. Color changes drawing, adding an element of drama and verve that moves it closer to painting.

For the basic exercises described in this chapter, you will need to buy a few new drawing supplies. I will add to the list of supplies as each technique is introduced.

First, buy a set of colored pencils. "Prismacolor" is a good brand, but there are many others. Prismacolor offers a complete set of sixty pencils, or you can buy individual colors. I suggest the following:

black	sienna brown	vermilion
white	dark brown	violet
ultramarine blue	sepia	slate gray
Copenhagen blue	burnt umber	sand
dark green	yellow ochre	warm gray light
canary yellow	lemon yellow	warm gray medium
scarlet red	flesh	cream
magenta	olive green	orange

Also, buy six sheets of colored paper at least 9" x 12" or larger. Construction paper is fine, or you may prefer another type of paper. Any colored paper that is not too smooth or shiny will do. Avoid bright, intense colors. Choose instead soft green, gray,

"Perhaps the most important point I can make is that you are not to think of painting as something separate from drawing."

— Kimon Nicolaides
The Natural Way to Draw,
1941

Some basic information about color:

The three main attributes of color are:

> hue
> value
> intensity

Hue is simply the name of the color. This is the L-mode attribute.

Value is the lightness or darkness of a hue, relative to the value scale. Value is an R-mode attribute.

Intensity is the brightness or dullness of a hue, *relative* to the utmost brightness available in pigments—generally color straight out of the tube. Intensity is an R-mode attribute.

To balance color, remember the following:

Every hue has its complement.

For every hue of a given intensity, there is the same hue at the opposite intensity.

For every hue of a given value, there is the same hue at the opposite value.

sand, blue, brown, or, as in Degas's dancer, soft pink. You will need a plastic eraser and a kneaded eraser. Buy a hand-held pencil sharpener, or a small knife if you prefer to hand-sharpen your pencils.

A wheel of color

Starting with rock-bottom basics, make a color wheel. The thought of this probably takes you right back to sixth grade, but let me assure you that some of the best minds in human history have delved into color wheels—for example, the great English

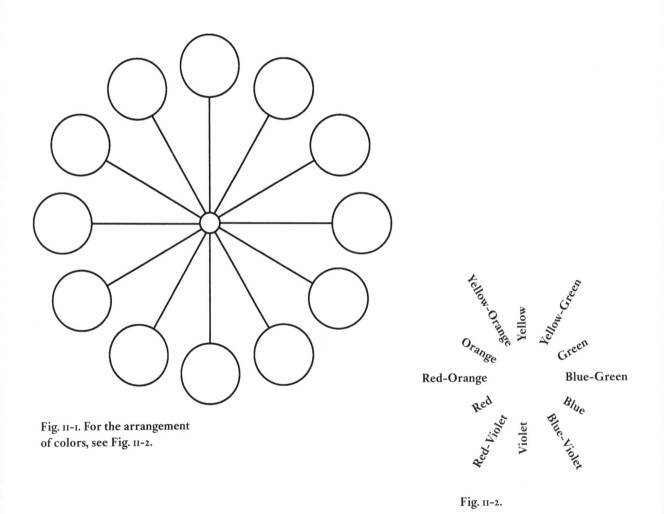

Fig. 11-1. For the arrangement of colors, see Fig. 11-2.

Yellow-Orange Yellow Yellow-Green
Orange Green
Red-Orange Blue-Green
Red Blue
Red-Violet Violet Blue-Violet

Fig. 11-2.

THE NEW DRAWING ON THE RIGHT SIDE OF THE BRAIN

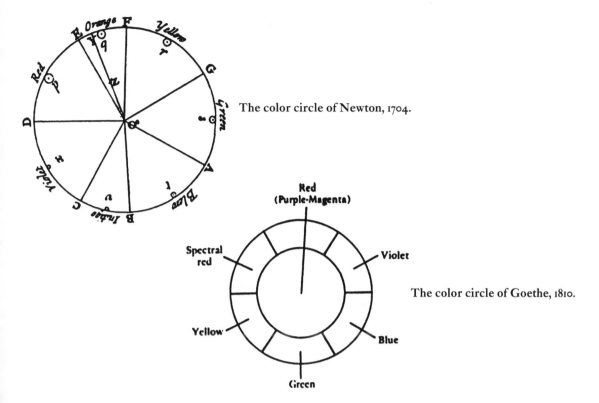

The color circle of Newton, 1704.

The color circle of Goethe, 1810.

physicist and mathematician Isaac Newton and the German poet and scholar Johann Goethe.

What is the purpose of constructing a color wheel? Simply put, to set in your mind the structure of color. The three primary hues—yellow, red, and blue—are the basic building blocks of color. Theoretically, all other colors are derived from these three. Next come the three secondary hues—orange, violet, and green—born of primary parents. And then follows the third generation, the six tertiary (third-level) hues—yellow-orange, red-orange, red-violet, blue-violet, blue-green, and yellow-green. The color wheel has a total of twelve hues, arranged like the numbers on the face of a clock.

Use your colored pencils to match the color wheel (Figure II-3) in the color section. You can trace the pattern in Figure II-1 onto a piece of bond paper, or you can color directly on the pattern in the book. Bear down hard with your colored pencils to produce the most intense hues possible.

"Hues which approach red have almost universally been considered as warm colors and those which tend toward blue as cool. Fire and sunlight and the glow of brisk circulation of blood are all associated with warmth.

"The colors of the sky and distant mountains and cool waters are generally bluish. When the body is chilled its color tends toward a bluish hue. These reasons naturally make us associate red, orange, and yellow with warmth, and blue, blue-green, and blue-violet with coolness."

— Walter Sargeant
The Enjoyment and Use of Color, 1923

Psychologist Guy T. Buswell, in his 1935 study, *How People Look at Pictures*, noted that although initial fixation tends to be roughly in the center of a painting, the eye generally moves first to the left and then to the right. Dr. Buswell speculated that this is a carry-over from reading.

Russian artist Wassily Kandinsky agreed with Buswell about center-to-left-to-right scanning, but disagreed about the reason. Kandinsky's explanation:

"The picture is facing us, therefore its sides are reversed. Just as when we meet someone, we shake their right hand—which is on the left as we face each other."

Kandinsky continued: "The left side of an image is dominant, therefore, just as our right hand is (usually) the leading or strongest hand."

— W. Kandinsky
Point and Line to Plane,
1945

Those of you familiar with color wheels will notice that I have used the usual order for colors on the wheel: yellow at the top, violet at the bottom; the cool colors of green, blue-green, blue, and blue-violet on the right side; the warm hues of yellow, yellow-orange, orange, red-orange, and red on the left (see Figure II-2).

I believe that this is the correct placement in terms of the complicated crossover system of the brain, the visual system, and the language of art. The left side of an image is addressed by the (usually) dominant right eye, which is controlled by the left hemisphere (stay with me; it is complicated!). In the language of art, the left side of an image carries the connotations of dominance, aggression, and forward movement. The right side, scanned after the left side, is addressed by the left eye, controlled by the right brain. The right side of an image, in the language of art, carries the connotations of passivity, defensiveness, and blocked movement.

In this zigzag fashion, the left hemisphere, right eye, and the left side of the color wheel are linked to the sun, daylight, and warmth—and also to dominance, aggression, and forward movement. Conversely, the right hemisphere, left eye, and right side of the wheel are linked to the moon, nighttime, and coolness—and thus also to passivity, defensiveness, and distance. Most color wheels are oriented in this fashion, apparently purely on intuition. Russian artist Wassily Kandinsky, one of the great colorists of art history, put his intuitions into words in the margin quotation.

The purpose, then, of constructing the color wheel is to set in your mind which colors are opposite each other on the wheel. Blue is opposite orange, red is opposite green, yellow-green is opposite red-violet. These opposites are called complements. The root of the word "complement" is "complete." This means that complements form the closed system previously proposed by Dr. Peter Smith as a requirement for an esthetic response. Perceived together in proper relationship, complements seem to satisfy the needs of R-mode and the visual system for completion.

You can use your color wheel to practice determining which

hues are complements. This knowledge should be learned so thoroughly that it becomes as automatic as 2 + 2 = 4.

Taking the first steps in color drawing

Before you begin, please read all of the instructions.

I will use the Degas drawing on pink paper (Figure 11-6) as the basis for instructions, but please choose any subject that appeals to you: a group of objects for a still-life drawing, a person who will pose for a figure drawing or a portrait, another reproduction of a master drawing, a photograph that appeals to you, or a self-portrait (the artist always has one available model!).

1. Choose a sheet of colored paper, not necessarily pink.
2. The original Degas drawing measures 16⅛" x 11¼". Measure and lightly draw with pencil a format of that size.
3. Choose two colored pencils, one dark and one light, in colors you feel harmonize with the color of your paper.

Some suggestions on this point: If your paper is soft blue, for example, choose pencils of the opposite (that is, the complementary) hue—in this case, orange. Your choice, then, could be flesh (pale orange) and dark brown (which is actually a dark orange). If your paper is soft violet, your choices could be cream (pale yellow) and dark purple (or burnt umber, which has a slightly violet cast). Degas used "soft black graphite" (which has a slightly greenish cast) for his dark tones, which he accented with black crayon, and a cool white to complement his (warm) pink paper.

An aside

An important point: have confidence in your color choices! Guided by some basic L-mode knowledge of the structure of color (for example, the use of complements), your R-mode will know when color is right. Within the guidelines, follow your intuition. Try out the hues on the back of the paper. Then say to yourself, "Does that feel right?" and listen to what you feel. Don't argue with yourself—I should say, with your L-mode. We have limited your choices to three: the paper and two pencils. Given

The brain's "need" for the complement is most clearly demonstrated by the phenomenon called "after-image," which is still not entirely understood.

To cause an after-image, color a circle of intense red about an inch or so in diameter. Make a tiny black dot in the center of the red. Make a similar dot in the center of a second, blank sheet of paper.

Holding the two sheets side-by-side, gaze at the red-hued circle for about a minute. Then quickly shift your gaze to the dot on the second, blank sheet. You will "see" the complement to red (green) emerge on the blank paper the same shape, the same size as the original red circle.

You can experiment with *any hue,* and your mind/brain/visual system will produce the exact complement of any hue. This is termed the negative after-image. If you experiment with two hues, *both* complements will appear. In some instances, the original hue (called a positive after-image) will appear as an after-image, but in the *negative* spaces of the original shapes, which appear empty of color.

these limits, you are sure to produce harmonious color.

Bear in mind that color most often "goes wrong" when students without knowledge of color use too many hues. They often throw together a variety of hues, chosen at random from the color wheel. Such combinations are difficult—often impossible—to balance and unify, and even beginning students sense that something isn't working. This is the reason for limiting the palette in these first exercises to a few hues and their related lights and darks. And I encourage you to continue to limit your palette until you have wider experience with color.

Having said that, I will reverse the thought and suggest that at some point, you may want to go wild with color, throwing everything together to see what happens. Buy a sheet of brightly colored paper and use every color you have on it. Create discordant color. Then try to pull it together, perhaps with dark or dull colors. You may be able to make it work—or you may like it in its discordant state! Much of contemporary art uses discordant color in very inventive ways. Let me emphasize, however, that you should attempt discordant color by design and not by mistake. Your R-mode will always perceive the difference, perhaps not immediately, but over a period of time. Ugly color is not the same as discordant color. Discordant color is not the same as harmonious color. For these first exercises, we shall concentrate on creating harmonious color, because it more readily provides basic knowledge about color.

Now, to continue:

4. Notice that Degas gridded his drawing with evenly spaced horizontal and vertical guide lines, just as he gridded his dancer without color on page 157. A grid with squares about $2\frac{1}{2}$" will be about right for the size of your format.

 Try to follow Degas's thinking in his use of the grid: What points was he looking for? Note the obvious points of crossed grid lines at the elbow and at the dancer's right toe.

 Start with the grid, using your dark-colored pencil to lightly draw the lines. Call up your new skills of drawing: edges, spaces, relationships of angles and proportions, and

light logic. Use the grid as a boundary for the negative spaces around the head, arms, hands, and feet. Use negative space to draw the ballet shoes. Carefully work out the proportions of the head: Check the eye level and the central axis. Notice what a small proportion of the whole head is occupied by the features; do not enlarge these features! Check the position of the ear (review proportions in Chapter Eight, if necessary). Complete the "dark" drawing before starting on the "light."

5. Now, for the fun part—the heightening of the drawing. Heightening is the technical term that refers to the technique of using pale-colored chalk or pencil to depict light falling on a subject.

First, determine the logic of the light falling on the dancer. Where is the source of the light? As you can see, this light source is located just above the dancer and slightly off to her left. Light falls on her forehead and right cheek. Her head throws a shadow on her right shoulder, and the light streams across her left shoulder and falls on her chest and left breast. Bits of light fall on her left toe and right heel as well.

Now use your light-colored pencil to heighten the drawing. You may need to alternately use your dark pencil to deepen the shadow-shapes. Grasp with your mind that the middle tones are supplied by the value of the colored paper. Try to see the color of the paper as value. This is difficult. Imagine for a moment that the world has turned to shades of gray, as though twilight has fallen, draining color from your paper but leaving the value in the form of a gray. Where on a value scale would that gray be, relative to white and black? Then, relative to that value, where is the darkest dark in Degas's drawing? Where is the lightest light? Your task is to match these values in your drawing.

When you have finished: Pin your drawing to a wall, stand back, and enjoy your first small step into color. Some student drawings using colored pencil are shown in the color section. As you see, very few colors were used in each of the drawings. Student Thu Ha Huyung used the largest number of colors (four plus black and white) in her *Girl in a Flowered Hat* (Figure 11-22).

"To me, painting—all painting—is not so much the intelligent use of color as the intelligent use of value. If the values are right the color cannot help but be right."

—Joe Singer
How to Paint in Pastels, 1976

Based on his teaching at Yale University, the great colorist Josef Albers wrote that there are no rules of color harmony, only rules of *relationships of quantity* of colors:

"Independent of harmony rules, any color 'goes' or 'works' with any other color, presupposing that their quantities are appropriate."

—Josef Albers
The Interaction of Color,
1962

Another view on harmony in color:

"After learning to see color as value, the next step is learning to see color as *color.*"

—Professor Don Dame
California State
University, Long Beach

A Heightened Self-Portrait

A wonderful example for this exercise is found in Figure 11-7, the self-portrait by the German artist Käthe Kollwitz.

Exercise:

1. Set up lights and a mirror. Arrange your drawing materials so that you can both draw and observe yourself.

2. Take the pose and spend a few moments studying the logic of the lights and shadows created by your lighting setup. Where is the lightest light? The darkest dark? Where are the cast shadows and the crest shadows? Where are the highlights and the reflected lights?

3. Lightly sketch your self-portrait on colored paper, checking the proportions carefully.

4. Quickly paint in the negative space, using black ink thinned slightly with water and a fairly large brush (a one-inch-wide housepainter's brush will do, with ink poured in a small bowl).

5. Use a dark colored pencil to define features and shadows.

6. Use a white or cream pencil to heighten the drawing, using hatches that follow the curves of your face and features.

The colors she used were canary yellow and ultramarine blue (near complements), magenta and dark green (near complements), and black and white (opposites).

Thu Ha's color is harmonious because it is balanced and colors are repeated from area to area. (See Josef Albers's statement in the margin of page 239.) The pale magenta of the lips is repeated in the pink flower. The green of the leaves reappears in the hair. The blue of the blouse reappears in the eyes and hat. The black is used for the shadow-shapes, and the white heightens the lights. And, finally, the yellow of the hair is a lighter value of the ochre paper that forms the ground and middle value.

If you haven't yet tried a colored-pencil portrait on a colored ground, I urge you to find a model or to draw a self-portrait, following the suggestions in the margin. Because the colored ground so beautifully supplies the middle-value tones, you are sure to enjoy this project. With the middle-value ground in place, it almost seems that the drawing is half-complete before you start. Recall that in Chapter Ten your rubbed-graphite ground supplied the middle-value tones, the eraser provided the lights, and the darkest dark of your pencil supplied the dark shadows. The transition from that drawing to drawing in color on a colored ground is a very short step.

Another project: An ugly corner as cityscape

You might also enjoy trying a cityscape similar to the student drawing *The Arrow Hotel* in Figure 11-24. This drawing was the result of an assignment to my students to "Go out and find a truly ugly corner." (Regrettably, ugly corners are all too easy to find in most of our cities.) Using the perceptual skills of seeing edges, spaces, and relationships of angles and proportions, students were directed to draw exactly what they saw—including signs, lettering, everything—placing great emphasis on negative space. The project was completed by following the directions for the cityscape provided below.

I believe you'll agree that ugliness was transformed into something approaching beauty in the student's drawing. This is

another instance of the transformative power of the artist's way of seeing. One of the great paradoxes of art is that subject matter is not of prime importance in creating beauty.

Directions for the cityscape:

1. Find your corner, the uglier the better.

2. Sit in your car to do the drawing, or use a folding stool to sit on the sidewalk.

3. You will need an 18" x 24" board to draw on, and an 18" x 24" piece of ordinary white paper. Draw a format edge about an inch in from the edges of the paper. Use a pencil to draw the cityscape. A viewfinder and a transparent grid will help in sighting angles and proportions.

4. Use negative space almost exclusively to construct the drawing. All details, such as telephone lines, lettering, street signs, and girders, are to be drawn in negative space. This is the key to success in this drawing. (But that is true for almost every bit of drawing that you do!) Remember that negative space, clearly observed and drawn, reminds the viewer of that for which we all long—unity, the most basic requirement of a work of art.

5. When you have finished the drawing, return home and choose a piece of 18" x 24" colored paper or colored cardboard. Transfer your on-site drawing to the colored paper, using carbon paper or graphite transfer paper, available in art supply stores. Be sure to transfer your format edge to the colored ground.

6. If you want to try a simple complementary arrangement as used in *The Arrow Hotel,* choose two colored pencils that harmonize with your paper, one dark and one light. *The Arrow Hotel* provides a satisfying color scheme because the color is balanced: the yellow-green of the paper is balanced by the dark, dull red-violet pencil, and the light tones are supplied by the cream-colored pencil, which relates to the yellow-green ground and acts as a near-complement to the red-violet.

About cityscapes, American abstract artist Stuart Davis said:

"I am an American, born in Philadelphia of American stock. I paint what I see in America.

"Some things that have made me want to paint . . . skyscraper architecture, the brilliant color of gasoline stations; chain store fronts and taxi-cabs; electric signs . . . Earl Hines' hot piano and jazz music in general."

— Stuart Davis, 1943

A half-serious caution: If you draw in a public place, you will soon be besieged by spectators wondering what in the world you are drawing—and why. I can't help you with this problem.

One thing is certain: A lonely person need only to start drawing in public places to be lonely no more.

Because most people believe they *prefer* bright colors, the following is a difficult concept to grasp:

Just as negative spaces are equally important as objects, dull colors (low-intensity colors) are equally important as bright (high-intensity) colors.

The simplest way to reduce the intensity of a given hue is to add a neutral gray or black. This method, however, often seems to *drain color* from a hue in the same way that twilight dims and weakens colors.

A second way is to mix a color with some of its complementary hue. This method seems to *leave the color unabated,* and richly, strongly dull—not weakly dull. Low-intensity hues mixed this way greatly assist in harmonizing color schemes.

Believing that the second way is preferable, my friend and colleague Professor Don Dame, an expert colorist, frequently refuses to allow his students to even *buy* black.

Expanding harmonious color

We have explored complementary color schemes in the exercises above. Two additional ways of arranging harmonious color are monochromatic schemes and analogous schemes.

Monochromatic color, meaning variations of a single hue, is an interesting experiment with color. Choose a colored paper and use all the pencils you have in hues related to that color. In her *Umbrella Still Life* (Figure 11-17), student Laura Wright used variations on a theme of orange—the color orange in all its transformations, from dark brown to the pale orange of the paper.

Analogous color is an arrangement of hues close to one another on the color wheel—red, orange, and yellow; blue, blue-green, and green, for example. Student Ken Ludwig's drawing, *Large Stuffed Eagle* (Figure 11-18), is an analogous arrangement of red, red-orange, yellow-orange, and pink chalk rubbed into white paper. (Using pastel chalk is explained in the next section.) Ken used pen and black India ink in short, hatched strokes to draw the eagle. You might try this combination of a rubbed chalk ground (which again supplies the middle value) and ink lines for a variety of subjects—animals, birds, flowers—to practice analogous color.

Pressing on to a pastel world

Your next purchase should be a set of pastels, which are pure pigments pressed into round or square chalks (sometimes called "pastel crayons") using a minimum of binder. You can buy a basic set of twelve chalks (ten hues plus black and white) or a larger set of up to one hundred hues. But be assured that the small basic set is sufficient for these first exercises.

I must warn you that pastels have some serious drawbacks. They are quite soft and break easily. They rub off on your hands and clothes, spread colored dust wafting through the air, and produce a drawing that is extremely fragile.

But there is a positive side. Pastels are almost pure pigment, and the colors are lovely—as clear and brilliant as oil paints. Pastels, in fact, are the drawing medium closest to painting. Pastel drawings are often referred to as "pastel paintings."

Because pastels come in a wide range of pure and mixed hues, a student beginning in color can experience something very close to painting without the difficulties encountered in mixing paints on a palette, contending with turpentine, stretching canvas, and dealing with other technical problems of painting.

For many reasons, therefore, pastels are an ideal medium to provide a transitional midpoint between drawing and painting. For an example of the proximity of pastels to painting, look at the exquisite pastel paintings by the eighteenth-century French artist Jean-Baptiste-Simeon Chardin in Figures 11-9 and 11-10. Chardin, often called the "artists' artist," has portrayed himself in his green eyeshade and his wife in her demure headdress. Examine Chardin's marvelous use of color, bold yet restrained. These two drawings are masterpieces of portraiture and of pastel painting.

One of the main differences between exercises with colored pencil and pastel drawing is in the quantity of applied color relative to the ground. Student Gary Berberet's *Self-Portrait* (Figure 11-16) illustrates expanded use of color to construct the entire image.

For the exercise that follows, I will use as my model the pastel drawing *Head of a Young Girl*, by the French painter Odilon Redon (Figure 11-15). Redon's free use of pastel color in the negative space of the drawing will inspire you to experiment with this medium.

Redon's mystical and lyrical work spanned the end of the nineteenth century and the beginning of the twentieth. His pastel drawings have been linked to the writing of Poe, Baudelaire, and Mallarmé, and all are connected conceptually to Surrealism, a period in early twentieth-century art that focused on dream symbolism. The yellow lizard in Redon's drawing, juxtaposed to the dreamlike serenity of the girl's head, is reminiscent of Surrealist symbolism.

Before you begin, please read all of the instructions.

1. Find a model or a suitable subject. Arrange a light so that the background is illuminated, providing a pale negative space behind your model's head.

Surrealist artists were fascinated by psychological meanings of colors. Oddly, each hue has both a positive and negative connotation in most cultures. For example, consider the following:

White: innocence *and* ghostliness

Black: restful strength *and* depression

Yellow: nobility *and* treason

Red: ardent love *and* sin

Blue: truth *and* despondency

Purple: dignity *and* grief

Green: growth *and* jealousy

To correct a mistake in pastel, begin by brushing off the wrong marks with a paintbrush. Then use a kneaded eraser (a soft malleable eraser available in craft or art supply stores) to "lift" or blot the color without rubbing. You can even scrape the paper carefully with a small knife, then blot again and draw in your corrections.

2. Choose a piece of pastel paper in any soft color. Pastel paper has a sharp "tooth" to grasp and hold the dry pigment. Redon used a soft gray-blue paper.

3. Choose a medium-dark pastel crayon for the line drawing of the head. Choose three harmonizing light pastels for the light negative space behind the head.

4. Pose your model and draw the head in semi-profile—that is, with the model turned very slightly off true profile view.

5. Calling on your five basic drawing skills, draw the head using the dark pastel you have chosen. (Redon used a sepia pastel, a dulled violet.) Using your imagination, or using objects in the room, complete your composition by adding objects or parts of objects. (Redon added part of a clock—a recurrent Surrealist symbol—and a falling lizard.)

6. Using your three pale pastels, work up the negative space surrounding the head. Use crosshatching rather than filling the area solidly, so that light and air are retained in your drawing.

A special point: Look at your three pale pastels and decide which is the darkest (lowest) in value, which is in the middle, and which is the lightest. Then use the lowest-value chalk for the first layer of hatches, the middle for the next, and the lightest for the last and final layer of hatches. This sequencing of colors from dark first to light last is the sequencing required for most painting mediums (with the exception of watercolor, which is usually worked from light first to dark last). In working with pastels, the dark-to-light sequencing helps to keep your colors clear and fresh. Reversing this sequence can result in muddy color. This point will help you to see why practice with pastels eases the transition to painting.

7. Complete your drawing with bold colors of your choice. You may prefer to harmonize your color by staying with complements or analogous hues, or you may prefer discordant hues that are anchored in the composition by repeating or echoing areas of each color. (In Redon's drawing, you will notice that each of the intense hues is echoed in one or more additional small areas.)

Start your drawing now. You will need about an hour and perhaps a bit more to complete the drawing. Be sure to give your model a rest at midpoint in the hour! Try to work without interruption, and ask your model not to converse with you while you are drawing. Your R-mode needs to be completely free of distraction.

When you have finished: Pin up your drawing, stand back, and regard your work. Check the balance of the color. Then turn your drawing upside down and check the color again. If any hue seems to pop out of the composition, somehow not locked into the color arrangement, some slight adjustment needs to be made. The color may need to be repeated somewhere, or it may need darkening, lightening, or dulling (by lightly hatching a bit of the complement over the hue). Have faith in your judgment and in your R-mode ability to perceive coherence—and incoherence. When the color is right, you will know it!

Summing up

In this book, we have covered the basic skills of drawing: from edges to negative spaces to relationships to lights and shadows to color in drawing. These skills will lead you directly to the world of painting and new ways of expressing yourself through art.

Drawings stand on their own as works of art, and paintings stand on their own as works of art. But drawing also becomes part of painting—the underpinning, so to speak—just as language skills become the underpinning of poetry and literature. So, drawing merges with painting and a new direction beckons. Your journey has only just begun.

On the question of the purpose of painting, the French nineteenth-century artist Eugene Delacroix wrote:

"I have told myself a hundred times that painting—that is, the material thing called a painting—is no more than a pretext, the bridge between the mind of the painter and that of the spectator."

— Eugene Delacroix
in *Artists on Art*, 1967

12

The Zen of Drawing: Drawing Out the Artist Within

Ellsworth Kelly, *Apples* (1949). Pencil.
Collection, The Museum of Modern Art, New York.
Gift of John S. Newburry.

AT THE BEGINNING OF THIS BOOK I said that drawing is a magical process. When your brain is weary of its verbal chatter, drawing is a way to quiet the chatter and to grasp a fleeting glimpse of transcendent reality. By the most direct means your visual perceptions stream through the human system—through retinas, optic pathways, brain hemispheres, motor pathways—to magically transform an ordinary sheet of paper into a direct image of your unique response, your vision of the perception. Through your vision, the viewer of the drawing—no matter what the subject—can find you, see you.

Furthermore, drawing can reveal much about you to yourself, some facets of you that might be obscured by your verbal self. Your drawings can show you how you see things and feel about things. First, you draw in R-mode, wordlessly connecting yourself to the drawing. Then shifting back to your verbal mode, you can interpret your feelings and perceptions by using the powerful skills of your left brain—words and logical thought. If the pattern is incomplete and not amenable to words and rational logic, a shift back to R-mode can bring intuition and analogic insight to bear on the process. Or the hemispheres might work cooperatively in countless possible combinations.

The exercises in this book, of course, encompass only the very beginning steps toward the goal of knowing your two minds and how to use their capabilities. From here on, having caught a glimpse of yourself in your drawings, you can continue the journey on your own.

Once you have started on this path, there is always the sense that in the next drawing you will more truly see, more truly grasp the nature of reality, express the inexpressible, find the secret beyond the secret. As the great Japanese artist Hokusai said, learning to draw never ends.

Having shifted to a new mode of seeing, you may find yourself looking into the essence of things, a way of knowing tending toward the Zen concept of satori, as described in the quotation of D. T. Suzuki. As your perceptions unfold, you take new approaches to problems, correct old misperceptions, peel

away layers of stereotypes that mask reality and keep you from clear seeing.

With the power of both halves of the brain available to you and the myriad possible combinations of the separate powers of the hemispheres, the door is open to your becoming more intensely aware, more capable of controlling some of the verbal processes that can distort thinking—sometimes even to the extent of causing physical illness. Logical, systematic thinking is surely essential for survival in our culture, but if our culture is to survive, understanding how the human brain molds behavior is our urgent need.

Through introspection, you can embark on that study, becoming an observer and learning, to some degree at least, how your brain works. In observing your own brain at work, you will widen your powers of perception and take advantage of the capabilities of both its halves. Presented with a problem, you will have the possibility of seeing things two ways: abstractly, verbally, logically—but also holistically, wordlessly, intuitively.

Use your twofold ability. Draw everything and anything. No subject is too hard or too easy, nothing is unbeautiful. Everything is your subject—a few square inches of weeds, a broken glass, an entire landscape, a human being.

Continue to study. The great masters of the past and of the present are readily available at reasonable cost in books of drawings. Study the masters, not to copy their styles, but to read their minds. Let them teach you how to see in new ways, to see the beauty in reality, to invent new forms and open new vistas.

Observe your style developing. Guard it and nurture it. Provide yourself with time so that your style can develop and grow sure of itself. If a drawing goes badly, calm yourself and quiet your mind. End for a time the endless talking to yourself. Know that what you need to see is right there before you.

Put your pencil to paper every day. Don't wait for a special moment, an inspiration. As you have learned in this book, you must set things up, position yourself, in order to evoke the flight to the other-than-ordinary state in which you can see clearly.

"Set yourself to practice drawing, drawing only a little each day, so that you may not come to lose your taste for it, or get tired of it. . . . Do not fail, as you go on, to draw something every day, for no matter how little it is, it will be well worth while, and will do you a world of good."

— Cennino Cennini
Il Libro Dell'Arte, c. 1435

Through practice, your mind will shift ever more easily. By neglect, the pathways can become blocked again.

Teach someone else to draw. The review of the lessons will be invaluable. The lessons you give will deepen your insight about the process of drawing and may open new possibilities for someone else.

Drawing skills six and seven

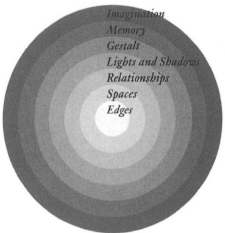

In the Introduction, I mentioned that I have proposed two additional skills beyond the five basic component skills of seeing edges, spaces, relationships, lights and shadows, and the gestalt. My colleagues and I have not found more than these seven skills over the past decade, and it's possible there are no more. Again, mediums, styles, and subject matter form an endless study, and all seven of the basic skills benefit by a lifetime of practice and refinement. But for basic understanding of the perceptual processes of drawing, the seven skills seem sufficient at this time. I'll briefly review skills six and seven.

Perceptual skill six: Drawing from memory

Skill six is essentially drawing from memory. Students yearn for this skill, but it is difficult. Drawing is a visual task and most artists have great problems drawing from memory except for those images they have drawn before. If someone asked me to draw a picture of an antique railway engine, for example, I could not do that because I don't know what it looks like. If I could see a picture, or go to view the object, then I could draw it. Curiously, this occasionally comes as a surprise to people who don't draw. They seem to think that an artist is someone who can draw anything.

Drawing from memory can be trained. The nineteenth-century French artist Edgar Degas, so the story goes, forced his students to study the model posing in the basement of a building and then climb to the seventh floor to do their paintings of the posed model. No doubt this was effective visual memory training!

For training yourself in visual memory, the key is to decide to remember—in a sense, to take a visual "snapshot" of an image you want to retain in memory. This means developing your ability to image—to see something with your mind's eye well enough that later you can "look at" the image. Then, using the first five skills, you draw the image "seen in the mind's eye."

Additionally, whatever you draw will etch itself into your memory. Call up those images; see again the master drawings you have studied, the faces of friends you have drawn. Image also scenes that you have never viewed, and draw what you see through your mind's eye. Drawing will give the image a life and reality of its own.

Perceptual skill seven: The "dialogue"

Skill seven takes us all the way to the art of the museums, I believe. I briefly outlined some main aspects of this skill in Chapter Ten, page 221. The artist has a vague idea, let's say, to draw a creature that never existed, perhaps a winged dragon. The artist has a vague imagined image and begins to draw, making a few marks that perhaps indicate the head of the dragon. Those marks trigger an imagined extension and elaboration of, say, the head and neck. The artist "sees" or envisions these elaborated details on the paper. The artist then draws in the imagined extension with new marks. That triggers an expanded image, perhaps the body and wings, now "seen" on the drawing. The artist is now able to draw those parts. And so the drawing progresses as a result of this "dialogue" between the imagined creature in the drawing which the artist makes real with the pencil marks. This dialogue continues until the artwork is finished.

You experienced this skill to some extent in your light/shadow drawings, and you can now nurture this beginning. You will find it most satisfying, I assure you. One way to practice the dialogue is to find or make stained paper, stained perhaps with spilled coffee or smeared paint or even mud. Let the paper dry and then try to "see" images in the stains. Reinforce these images with pencil or pen or colored pencil. This is the so-called "da

Vinci device." Renaissance artist Leonardo da Vinci recom-
mended that student artists should practice seeing fanciful
images in the stained walls of the city in order to improve their
imaging abilities.

Clearly, these skills have other applications. Use your imag-
ing ability to solve problems. Look at a problem from several
viewpoints and different perspectives. See the parts of the prob-
lem in their true proportion. Instruct your brain to work on the
problem while you sleep or take a walk or do a drawing. Scan the
problem to see all of its facets. Image dozens of solutions without
censoring or revising. Play with the problems in the antic/serious
intuitive mode. The solution is very likely to present itself nicely
when you least expect it.

Drawing on the capabilities of the right side of your brain,
develop your ability to see ever more deeply into the nature
of things. As you look at people and objects in your world, imag-
ine that you are drawing them, and then you will see differently.
You will see with an awakened eye, with the eye of the artist
within you.

Afterword: Is Beautiful Handwriting a Lost Art?

TODAY, HANDWRITING IS NO LONGER a subject of interest. Like the times tables, moral sayings, and polite manners at tea parties, handwriting—if it is thought of at all—is relegated to quaint customs of the past century. Yet when I ask a group of people, "How many of you would like to improve your handwriting?" nearly all the hands go up. If I ask "Why?" the answers vary: "I want my handwriting to look better . . . to be more readable . . . to be good enough to be proud of."

This response has surprised me. Handwriting has virtually been discarded as a school subject, at least beyond the third or fourth grade. Out of curiosity, I scoured my home library of books on the topics of education, school art programs, drawing, painting, art history, the brain and brain-hemisphere functions for index

Forgers copy signatures upside down. This trick probably works for the same reason that upside-down drawing works. As an exercise, try copying the signatures above upside down.

The Palmer method drill.

entries on handwriting. I found nothing, not a word on the subject.

Next, I searched the university library: indexes of books on art education, drawing, and brain function—again, nothing. Early education books, of course, had entries on teaching the alphabet letters and words, and I found a few books specifically on handwriting—most of them published in England, where handwriting skills apparently still receive considerable attention. When I opened these books and skimmed through them, however, I was struck by my immediate reaction of sinking dismay at the tedium of the exercises. All of the worst aspects of public education came flooding back to me as memories of boring tasks, boringly taught, with no possibility of escape.

And yet I know that handwriting is important, and the group response I described above indicates that others feel that way too. In fact, of all the ways we express ourselves nonverbally, none is quite so personal as our handwriting— so personal and important that our signatures are legally protected as a mark of identity. Unlike other ways we use to express our individuality, we have sole ownership of our handwriting. It is a personal possession that no other person is allowed to use or imitate.

In past centuries, handwriting was considered an art. Every school had its master or mistress of penmanship, and in the nineteenth century much time and attention was consumed in perfecting the extravagant loops and swirls of Copperplate script. In America in the early decades of this century, our schoolchildren assiduously studied the venerable Palmer method, derived from a beautiful Spencerian

script. By the late 1930s, however, the Palmer method had given way to an unlovely manuscript printing called "ball-and-stick" lettering for very young children, with a shift from lettering to cursive, or "real," writing by around fourth grade. This shift was mainly a matter of making joining marks between the "ball-and-stick" letters.

Responding to educational theories in the 1940s and 1950s about encouraging individuality and avoiding rote learning, teachers encouraged each child to use the style of writing that felt comfortable, within limits of legibility and correctness of letter forms. Children had a choice of size and slant of letters, sometimes even the choice of staying with printing, and teachers expected that each child's handwriting would more or less settle down to a legible form. Beauty was not an issue. Legibility was sufficient.

But writing is an art form. Using line, one of the most basic elements of art, handwriting can function as a means of artistic self-expression. Like drawing, handwriting employs certain conventional forms that have agreed-upon meanings. Over centuries, the letters of the alphabet have evolved into shapes of great beauty that communicate verbally, yet at the same time can convey subtle nonverbal intentions and reflections of the mind of the writer/artist. This is what we have lost. In my opinion, legibility is not enough. Educational theorists have sold handwriting short.

Can we regain this lost art? I think we can, by linking writing once again to the esthetic purposes of drawing. There is little difference between making a drawing in line and "draw-

The Palmer method is joined, looped, and linked.

Ball-and-stick letters are round, unjoined, and upright.

This is surely the low-water mark of handwriting—awkward to the hand, without flow, and totally unrelated to the historical development of handwriting.

Have soft eyes and a gentle manner.

Shodo painting by William Reed.

David Harris

David Harris

David Harris

Write your signature three times. First, your usual signature; next, your best "hand"; last, your "odd hand" signature.

ing" a signature, sentence, or paragraph. The purpose is the same: to convey information about the subject and to express the personality of the writer/artist. This nonverbal expression is subconsciously perceived and understood by the reader/viewer. Consider what William Reed, an expert on Japanese calligraphy, has to say:

> *Shodo* paintings [cursive calligraphy] are like pictures of the subconscious mind. They are not final statements, but rather instant snapshots of the personality at the time of writing. That personality can be developed and strengthened through *Ki* practice. On the other hand, careless calligraphy is also a form of practice, reinforcing bad habits and stunting the growth of the personality.

While we may never attain the disciplined aesthetic of the Oriental mind, surely we can bring beauty back into handwriting—not the ornate beauty of past centuries, but rather a modern beauty of ease, clarity, and coherence. I will recommend a few general principles and a few exercises, and I will hope against hope that you won't get that awful sinking feeling of boredom. I urge you, at the least, to give the exercises a try.

The basic perceptual skills of writing/drawing

1. First, review the short section on handwriting in Chapter Two. Then, on a sheet of plain paper, write your signature just as you usually sign your name.

2. Underneath that signature, write your name again, this time using your most beautiful

"hand." Write slowly, drawing the letters with care.

3. Last, write your name one more time underneath the second version. This time, however, use the other hand: If you are right-handed, use your left hand, and if left-handed, use your right hand.

Now, compare these three "drawings." The line expresses everything, and the communication is very clear. All you have to do is ask yourself, "If three people of equal qualifications were to apply for a position and these were their signatures, who would get the job?"

To improve your handwriting, therefore, the first step is to decide that it *does* matter; your writing sends a distinct message. The next step is to think about what message you want to convey. Reliability? Intelligence? Masculinity? Femininity? Humor? Sophistication? Clarity? (These, of course, are all positive messages. Writing can also convey such negative messages as carelessness, indifference, deviousness, laziness, instability, and egotism. But I'll assume you won't choose one of these qualities.)

Keeping *style* in mind as a final goal, let us see how the perceptual skills of drawing can help your handwriting to become more beautiful.

Drawing the contours of the alphabet

1. The perception of edges: Try a Pure Contour Drawing of your handwriting. Tape a piece of paper down. Choose a pen or pencil that you like, with the width of line that feels comfortable to you. Turn away from the taped-down paper, so that it is out of

As children grow and change, so will their handwriting.

— **Ornella Santoli**
How to Read Handwriting

ABCDEFGHIJKLMN
OPQRSTUVWXYZ
a b c d e f g h i j k l m n
o p q r s t u v w x y z

Christopher Jarman designed this alphabet with the aim of using simple, economical letters that can be written with any type of writing implement.

ABCDEFGH
IJKLMNOPQ
RSTUVWXYZ
a b c d e f g h i j k
l m n o p q r s t u
v w x y z 1234567890.

The "looped" style, based on the Palmer method.

a b c d e f g h i j k l
l m n o p q r s t u v w
x y z

Student example of "pure" or "blind contour" hand-writing.

Signature of George III, king of England.

An actual "blind contour" signature: George III, when blind.

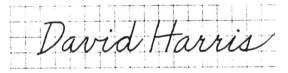

Negative-space letters.

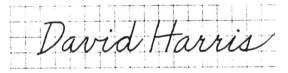

Write your signature again. Using graph paper helps to see the negative spaces.

sight. Holding the pen or pencil, place your writing hand on the paper and hold this book in the other hand, open to this page.

2. Choose one of the alphabets illustrated here and copy each letter, first the lowercase, then the capitals. Draw each letter very slowly, millimeter by millimeter, at the same slow pace that your eyes move along the contours, paying attention to each detail and observing the beauty of each form.

3. When you have finished the alphabets, lowercase and capitals, write your name three times, very slowly, visualizing in your mind's eye the ideal forms of the letters. Then, turn and look at your writing. I think you will be surprised. Even unable to see what you were writing, and even with the awkward position of Pure Contour Drawing, you will find your handwriting improved immediately, because *you were paying close attention to details of the letterforms.* Notice how beautifully spaced your letters are, and how you stayed "on the line," even though you couldn't see what you were doing.

4. Next, using the technique of Modified Contour Drawing, repeat the exercise above. Place your plastic grid or a sheet of lined paper under your writing paper, to provide a guideline. Place this book where you can see the examples of alphabets. Choose one and copy it letter by letter, drawing very slowly. Then, write your signature again three times, or copy a few sentences from the text.

When you have finished: Compare your last "drawings" with the first. You will have made progress already, simply by paying attention and slowing down.

Using the negative spaces of handwriting

In Japanese as well as in European/American calligraphy, the negative spaces of the letters are as important as the lines we generally think of as constituting the letters. Examine the alphabets, first for *enclosed*, rounded negative spaces: *a, b, d, g, o, p, q.*

1. Practice these rounded negative spaces. Try not to think that you are drawing the letter *o*, for example. Think—decide!—that you are drawing the space inside and that it is a beautiful shape, embraced by the line with its precise closure. Write your signature again, paying special attention to any closed, rounded negative shapes.

2. Next search the lowercase alphabets for closed, elongated negative shapes, some above the line, some below: *b, f, g, j, k, l, q, y, z.* Draw these letters now, again focusing on the negative shapes. Try to make all the closed, elongated negative shapes the same in size and in shape. Write your signature again, paying special attention to closed, elongated negative shapes.

3. Continue with each of the main shapes of spaces—for example, the negative shape of *n, m, h, v, w, y.* These letters have *mounded* negative spaces. Draw a series of *m*'s and *n*'s, really concentrating on the negative mounds. Make each negative mound the same—same size, same shape.

4. Try the *open* negative space of the letters *c, k, v, w,* and *z.* Check the margin model for the exact shape of these spaces.

Fill in your loops to check their consistency of size.

Each letter needs its own negative space.

Decide on a slant, then use sighting to keep the slant consistent.

Pledge to The Flag

I pledge allegiance to the flag of the United States of America and to the republic for which it

Pledge of Allegiance

I pledge allegiance to the flag of the United States of America and to the republic for which it stands - one nation under God, indivisible, with liberty and justice for all.

5. Try the pointed negative space of the letters *i, j, t*. Make sure that you place the dot over the *i* so that it precisely lines up with the tip of the letter.

6. Try the negative shapes of the "odd" letters *s, r, x*. Note that each letter can be visualized in negative space in two ways:

 a. The interior negative spaces: the spaces inside the letters.

 b. The exterior negative spaces: the spaces outside the letters.

For exterior negative spaces, imagine a format drawn around each letter. For the "short" lower-case letters, the basic format is a square. For letters with ascenders ("tall" letters), imagine a rectangle two boxes high, resting on the line. For letters with descenders (*g, y*, etc.), the two-box rectangle drops half of the rectangle below the line.

The key point about the exterior negative spaces is that each letter needs its space (its format). Notice how the slanted letter fits inside the format. To practice exterior negative spaces, obtain a sheet of graph paper for ready-made formats.

Sighting a beautiful hand

In art, the word *relationships* expresses a constant theme. As you have learned, art is relationship—parts brought into beautiful relationships with one another and with the whole, thus creating that most treasured attribute of art, unity. The same holds true for the art of handwriting. Precisely the same skills will shape your handwriting into closely related parts, fitted into a rhythmic, coherent, *unified* whole, thus creating

beauty—beautiful handwriting.

Recall that in learning to draw, you learned the skill of perceiving relationships of angles (angles relative to the constants, vertical and horizontal) and proportions (in relation to one another). Let's apply that skill to handwriting.

The main task is first to decide on a slant—an angle relative to vertical—and, second, to use the slant without deviation. This gives your handwriting a beautiful rhythm. More than any other aspect, consistent slant will give your writing coherence and unity.

It doesn't really matter what angle you choose, but be aware that slant conveys a message, subconsciously understood by your reader. A slightly forward slant conveys energy and measured, forward action. A backward slant conveys caution, a conservative pace. An extreme forward slant conveys eagerness, or perhaps a bit of recklessness. Perfectly vertical writing conveys sobriety, a bias toward formality.

(Please be assured that these ideas are not taken from graphology. Graphologists have gone off into fanciful theories; for example, "Large loops on the letter y indicate that the writer is greedy, because the loops look like money bags." This is nonsense.)

Slant of line is part of the language of art and, without question, the language of line used in handwriting is related to the principles of art—the basic precepts of composition, balance, movement, rhythm, and placement. Just as art expresses the intent of the artist, so does handwriting.

To practice consistent slant, place one sheet of ruled paper over another.

This is an example of the Simple Modern style of handwriting. It is a new style in this complete form but none of the forms or ideas contained in it are themselves original or new.

Decide on the proportions that are pleasing to you, then use them consistently.

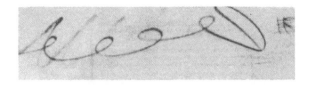

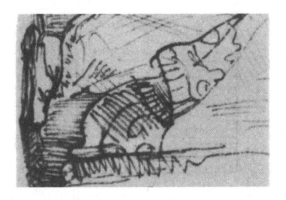

In drawing, different styles of line have names: the bold line, the pure line, the repeated line, the lost-and-found line, the nervous line, the hard line, the soft line, and many others.

Consistency is the key

To control consistency of slant and proportions, try the following exercises:

1. Place one sheet of lined paper over another, with the lines of the bottom sheet running vertically, at right angles to the horizontal lines of the top sheet. Adjust the bottom sheet until the angle seems right to you. (You may want to try several different slants.) Practice writing your signature, or copying a paragraph of text, aligning the slant to a perfectly consistent angle. At the same time, focus on forming the negative spaces of the letters.

2. The second part of sighting relationships is *sighting proportions.* In handwriting, this aspect is second in importance only to consistent slant. The main task is to decide on size relationships for your writing and to use the proportions consistently.

There are several proportions you will need to decide on. First, try out some alternatives, then decide on a proportional space to leave *between* words (the width of the letter *o* is one possible choice). Then, use that proportional spacing consistently. Decide on the size relationship between short and tall letters, and use that relationship consistently. Decide on how far down the descenders will drop relative to the tall letters and the short letters, and use that relationship consistently. The key word, of course, is *consistency.* But also keep in mind that these relationships carry subtle messages, as you can see in the examples on page 263.

3. Practice sighting angles and proportions. Write your signature and copy a few sen-

tences from the text. As you write, allow your eyes to scan the whole picture you are creating with your "drawing" to check that the relationships are consistent.

Seeing the lights and shadows in handwriting

This aspect of handwriting emerges from the "value" of your hand, the lightness or darkness—that is, fineness or heaviness—of your line, the closeness or distance of the individual letters to one another.

Your writing tool, of course, affects the line. The most important point here is that you should use a certain pen or pencil by choice, not by accident.

I find it so odd that art students are often extremely fussy about having just the right pencil, perfectly sharpened, for drawing. But when it comes to writing, they will unthinkingly use the dullest, scratchiest pencil or pen. Each activity deserves the same care. Drawing, sketching, handwriting—it's all the same. In each, you are expressing yourself.

Therefore, I recommend that you try out the lightness or darkness of various kinds of pencils or pens, then decide on one that fits your style of writing and conveys the message you want to send. A heavy, dark line, for example, conveys power and muscular (or intellectual) strength. A thin, fine, precise line conveys a fine sensibility and elegance. A medium line that varies in width (from a flexible pen point, for example) conveys an aesthetic, almost poetic, personality, a person aware of the nuances of meaning in visual information. A wide, sturdy

You may prefer a bold line

Perhaps a fine, flowing line fits your style.

You may prefer a modified form of lettering.

Wide spacing gives an open feeling.

Close spacing conveys a "dark" intensity.

Small letters are quiet, like someone whispering.

"Round" writing seems guileless and frank.

Conscious choice of handwriting style gives you control over the effect your writing has on others.

yesterday

Handwriting can stand considerable mauling before it becomes entirely illegible, but why make it so hard for others to read?

Good handwriting

... gives ease and pleasure to your reader.

line conveys a rugged, natural personality, close to the earth.

Another means by which the lights and shadows are conveyed in handwriting is through the closeness of the letters. If you write the letters of words very closely, with the lines of writing spaced closely, your writing will be dark and close. If you write letterforms that are spaced more openly and your lines are far apart, your handwriting will be full of light and air.

Dark writing is neither better nor worse than light, but it *is* different. Again, the point is: What do you want to convey to the viewer of your handwriting? Dark writing conveys intensity and passion, like someone whispering intensely in your ear. Light writing conveys openness and enthusiasm, like someone calling "Hello!" from across the room. The choice is yours, but it should be a conscious choice.

Summing up

Once you have absorbed and practiced the basic fundamentals of beautiful handwriting, you will be free to develop your individual style. As your handwriting changes to a more artistic style, you will find it interesting to observe the reactions these changes cause. I think you will be pleasantly surprised.

I hope this brief review of the expressive qualities of handwriting is helpful and inspiring. I believe the Japanese are right in their insistence on the importance of nonverbal messages and in their conviction that the way we write affects our personalities.

I urge my readers who are parents to let teachers know that you are interested in beauty, wherever it might be encouraged. Help teachers to understand that you want your children to experience handwriting as an art form so that they will know the joy of creating beauty in simple acts of daily life.

I believe teachers will welcome your interest in beauty. Teachers, after all, are the very ones whose eyes and sensibilities are assaulted by ugly handwriting, the very ones who must struggle with illegibility and with nonverbal messages of disunity, carelessness, and indifference.

Making one's handwriting more beautiful may seem a very small way to increase the total amount of beauty in the world. But, still, the widest ocean is made up of very small drops of water.

Postscript

For teachers and parents

As a teacher and a parent, I've had a very personal interest in seeking new ways of teaching. Like most other teachers and parents, I've been well aware—painfully so, at times—that the whole teaching/learning process is extraordinarily imprecise, most of the time a hit-and-miss operation. Students may not learn what we think we are teaching them and what they do learn may not be what we intended to teach them at all.

I remember one clear example of the problem of communicating what is to be learned. You may have heard of or gone through a similar experience with a student or your child. Years ago, the child of a friend whom I was visiting arrived home from his day at school, all excited about something he had learned. He was in the first grade and his teacher had started the class on reading lessons. The child, Gary, announced that he had learned a new word. "That's great, Gary," his mother said. "What is it?" He thought a moment, then said, "I'll write it down for you." On a

little chalkboard the child carefully printed, HOUSE. "That's fine, Gary," his mother said. "What does it say?" He looked at the word, then at his mother, and said matter-of-factly, "I don't know."

The child apparently had learned what the word *looked like*—he had learned the visual shape of the word perfectly. The teacher, however, was teaching another aspect of reading—what words mean, what words stand for or symbolize. As often happens, what the teacher had taught and what Gary had learned were strangely incongruent.

As it turned out, my friend's son always learned visual material best and fastest, a mode of learning consistently preferred by a certain number of students. Unfortunately, the school world is mainly a verbal, symbolic world, and learners like Gary must adjust, that is, put aside their best way of learning and learn the way the school decrees. My friend's child, fortunately, was able to make this change, but how many other students are lost along the way?

This forced shift in learning style must be somewhat comparable to a forced change in handedness. It was a common practice in former times to make individuals who were naturally left-handed change over to right-handedness. In the future, we may come to regard forcing children to change their natural learning modes with the same dismay that we now regard the idea of forcing a change in handedness. Soon we may be able to test children to determine their best learning styles and choose from a repertoire of teaching methods to ensure that children learn *both* visually and verbally.

Teachers have always known that children learn in different ways and, for a long time now, people who have the responsibility for educating youngsters have hoped that the advances in brain research would shed some light on how to teach all students equally well. Until about fifteen years ago, new discoveries about the brain seemed to be useful mainly to science. But these discoveries are now being applied to other fields and the recent research that I've outlined in this book promises to provide a firm basis for fundamental changes in techniques of education.

David Galin, among other researchers, has pointed out that teachers have three main tasks: first, to train both hemispheres—not only the verbal, symbolic, logical left hemisphere, which has always been trained in traditional education, but also the spatial, relational, holistic right hemisphere, which is largely neglected in today's schools; second, to train students to use the cognitive style *suited to the task at hand;* and third, to train students to be able to bring both styles—both hemispheres—to bear on a problem in an integrated manner.

When teachers can pair the complementary modes or fit one mode to the appropriate task, teaching and learning will become a much more precise process. Ultimately, the goal will be to develop both halves of the brain. Both modes are necessary for full human functioning and both are necessary for creative work of all kinds, whether writing or painting, developing a new theory in physics, or dealing with environmental problems.

This is a difficult goal to present to teachers, coming as it does at a time when education is under attack from many quarters. But our society is changing rapidly, and the difficulties of foreseeing what kinds of skills future generations will require are increasing. Although we have so far depended on the rational, left half of the human brain to plan for our children's future and to solve the problems they might encounter on the way to that future, the onslaught of profound change is shaking our confidence in technological thinking and in the old methods of education. Without abandoning training in traditional verbal and computational skills, concerned teachers are looking for teaching techniques that will enhance children's intuitive and creative powers, thus preparing students to meet new challenges with flexibility, inventiveness, and imagination and with the ability to grasp complex arrays of interconnected ideas and facts, to perceive underlying patterns of events, and to see old problems in new ways.

What can you, as parents and teachers, hope to accomplish right now in terms of teaching both halves of children's brains? First, it's important that you know the specialized functions and styles of our hemispheres. Books such as this one can provide you with a basic understanding of the theory and also with the expe-

rience of making cognitive shifts from one mode to another. I believe that this personal experiential knowledge is extremely important, perhaps essential, before teachers try to transmit the knowledge to others.

Second, you need to help students to become aware of the different ways they can respond to the same material. For example, you might have students read one passage for facts and ask for verbal or written responses. The same passage might then be read for meaning or underlying content accessible through imagery and metaphoric thought. For this learning mode, you might require as a response a poem, painting, dance, riddle, pun, fable, or song. As another example, certain kinds of arithmetic and mathematics problems require linear, logical thought. Others require imaginary rotations of forms in space or manipulations of numbers, which are best accomplished by mentally producing patterned visualizations. Try to discover—either through noting your own thought processes or observing your students—which tasks utilize the style of the right hemisphere, which require the style of the left, and which require complementary or simultaneous styles.

Third, you might experiment with varying the conditions in your classroom—at least those conditions over which you have some control. For example, talking among students or constant talking by a teacher probably tends to lock students fairly rigidly into left-hemisphere mode. If you can cause your students to make a strong shift to R-mode, you will have a condition that is very rare in modern classrooms: silence. Not only will the students be silent, they will be *engaged* in the task at hand, attentive and confident, alert and content. Learning becomes pleasurable. This aspect alone of R-mode is worth striving for. Be sure that you yourself encourage and maintain this silence.

As additional suggestions, you might experiment with rearranging the seating or the lighting. Physical movement, especially patterned movement such as dancing, might help to produce the cognitive shift. Music is conducive to R-mode shifts. Drawing and painting, as you have seen in this book, produce strong shifts to R-mode. You might experiment with private languages, perhaps

inventing a pictorial language with which the students can communicate in your classroom. I recommend using the chalkboard as much as possible—not just to write words but also to draw pictures, diagrams, illustrations, and patterns. Ideally, all information should be presented in at least two modes: verbal and pictographic. You might experiment with reducing the verbal content of your teaching by substituting nonverbal communication when that mode seems suitable.

Last, I hope you will consciously use your intuitive powers to develop teaching methods and communicate those methods to other teachers through workshops or teachers' journals. You are probably already using many techniques—intuitively or by conscious design— that cause cognitive shifts. As teachers, we need to share our discoveries, just as we share the goal of a balanced, integrated, whole-brain future for our children.

As parents, we can do a great deal to further this goal by helping our children develop alternate ways of knowing the world—verbally/analytically and visually/spatially. During the crucial early years, parents can help to shape a child's life in such a way that words do not completely mask other kinds of reality. My most urgent suggestions to parents are concerned with the use of words, or rather, not using words.

I believe that most of us are too quick to name things when we are with small children. By simply naming a thing and letting it go at that when a child asks, "What is that?" we communicate that the name or label is the most important thing, that naming is sufficient. We deprive our children of their sense of wonder and discovery by labeling and categorizing things in the physical world. Instead of merely naming a tree, for example, try also guiding your child through an exploration of the tree both physically and mentally. This exploration may include touching, smelling, seeing from various angles, comparing one tree with another, imagining the inside of the tree and the parts underground, listening to the leaves, viewing the tree at different times of the day or during different seasons, planting its seeds, observing how other creatures—birds, moths, bugs—use the tree, and so on. After discovering that every object is fascinating and com-

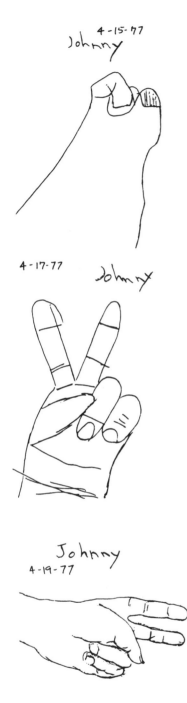

4-15-77 Johnny

4-17-77 Johnny

Johnny 4-19-77

Drawings by a fourth-grade student: Three lessons, April 15 to April 19, 1977. Instructional period: four days.

plex, a child will begin to understand that the label is only a small part of the whole. Thus taught, a child's sense of wonder will survive, even under our modern avalanche of words.

In terms of encouraging your child's artistic abilities, I recommend providing a very young child with plenty of art materials and the kind of perceptual experiences described above. Your child will progress through the developmental sequence of child art in a relatively predictable manner, just as children progress through other sequential stages. If your child asks for help with a drawing, your response should be, "Let's go look at what you're trying to draw." New perceptions will then become part of the symbolic representations.

Both teachers and parents can help with the problems of adolescent artists, which I discussed in the text. As I mentioned, realistic drawing is a stage that children need to pass through at around age ten. Children want to learn to see, and they deserve all the help they require. The sequence of exercises in this book—including the information on hemisphere functions in somewhat simplified form—can be used with children as young as eight or nine. Subjects that suit the interests of adolescents (for example, well-drawn realistic cartoons of heroes and heroines in action poses) can be used for upside-down drawing. Negative space and contour drawing also appeal to children at this age, and they readily incorporate the techniques into their drawing. (See the illustration of a ten-year-old fourth-grade student's progress over four days of instruction.) Portrait drawing has a special appeal for this age group, and adolescents can do quite accomplished drawings of their friends or family members. Once they overcome their fear of failure at drawing, youngsters will work hard to perfect their skills, and success enhances their self-concept and self-confidence.

But more important for the future, drawing, as you have learned through the exercises in this book, is an effective way of gaining access to and control over the functions of the right hemisphere. Learning to see through drawing may help children to later become adults who will put the whole brain to use.

For art students

Many successful contemporary artists believe that realistic drawing skills are not important. It is true, generally speaking, that contemporary art does not necessarily require drawing skill, and good art—even great art—has been produced by modern artists who can't draw. They are able to produce good art, I suspect, because their aesthetic sensibilities have been cultivated by means other than the traditional, basic teaching methods of art schools: drawing and painting from the model, the still life, and the landscape.

Since contemporary artists often dismiss drawing ability as unnecessary, beginning art students are placed in a double bind. Very few students feel secure enough about their creative abilities and about their chances for success in the art world to dispense altogether with schooling in art. Yet when they encounter the kind of modern art shown in galleries and museums—art that doesn't appear to require traditional skills at all—they feel that traditional methods of instruction don't apply to their goals. To break the double bind, students often avoid learning to draw realistically and settle as quickly as possible into narrow conceptual styles, emulating contemporary artists who often strive for a unique, repeatable, recognizable "signature" style.

The English artist David Hockney calls this narrowing of options a trap for artists (see the quotation in the margin). It is surely a dangerous trap for art students, who too often force themselves to settle into repetitive motifs. They may try to make statements with art before they know what they have to say.

Based on my teaching experience with art students at various skill levels, I'd like to make several recommendations to all art students, especially beginning art students. First, don't be afraid to learn to draw realistically. Gaining skills in drawing, the basic skill of all art, has never blocked the sources of creativity. Picasso, who could draw like an angel, is a prime illustration of this fact, and the history of art is replete with others. Artists who learn to draw well don't always produce boring and pedantic realistic art. The artists who do produce such art would no doubt produce

"To me, moving into more naturalism was a freedom. I thought, if I want to I could paint a portrait; this is what I mean by freedom. Tomorrow if I want, I could get up, I could do a drawing of someone, I could draw my mother from memory, I could even paint a strange little abstract picture. It would all fit in to my concept of painting as an art. A lot of painters can't do that—their concept is completely different. It's too narrow; they make it much too narrow. A lot of them, like Frank Stella, who told me so, can't draw at all. But there are probably older painters, English abstract painters, who were trained to draw. Anybody who'd been in art school before I had must have done a considerable amount of drawing. To me, a lot of painters were trapping themselves; they were picking such a narrow aspect of painting and specializing in it. And it's a trap. Now there's nothing wrong with the trap if you have the courage to just leave it, but that takes a lot of courage."

— David Hockney

boring and pedantic abstract or nonobjective art as well. Drawing skill will never hinder your work but will certainly help it.

Second, be clear in your mind about *why* learning to draw well is important. Drawing enables you to see in that special, epiphanous way that artists see, no matter what style you choose to express your special insight. Your goal in drawing should be to encounter the reality of experience—to see ever more clearly, ever more deeply. True, you may sharpen your aesthetic sensibilities in ways other than drawing, such as meditation, reading, or travel. But it's my belief that *for an artist* these other ways are chancier and less efficient. As an artist you will be most likely to use a visual means of expression, and drawing sharpens the visual senses.

And last, draw every day. Carrying a small sketchbook will help you remember to draw frequently. Draw anything—an ashtray, a half-eaten apple, a person, a twig. I repeat this recommendation given in the last chapter of the text because for art students it is especially important. In a way, art is like athletics: If you don't practice, the visual sense quickly gets flabby and out of shape. The purpose of your daily sketchbook drawing is not to produce finished drawings, just as the the purpose of jogging is not to get somewhere. You must exercise your vision without caring overly much about the products of your practice. You can periodically cull the best examples from your drawings, throwing out the rest or even throwing out everything. In your daily drawing sessions, the desired goal should be to see ever more deeply.

Glossary

Abstract Art. A translation into drawing, painting, sculpture, or design of a real-life object or experience. Usually implies the isolation, emphasis, or exaggeration of some aspect of the artist's perception of reality. Should not be confused with nonobjective art.

Awareness. Consciousness; the act of "taking account" of an object, person, or the surroundings. Possible synonyms are seeing or cognition.

Basic Unit. A "starting shape" or "starting unit" chosen from within a composition for the purpose of maintaining correct size relationships in a drawing. The Basic Unit is always termed "One" and becomes part of a ratio, as in "1:2."

Blank. An egg-shaped oval, drawn on paper to represent the basic shape of the human head. Because the human skull, seen from the side, is a different shape than the skull seen from the front, the side-view blank is a somewhat differently shaped oval than front-view blank.

Central Axis. Human features are more or less symmetrical and are bisected by an imaginary vertical line in the middle of the face. This line is called the central axis. It is used in drawing to determine the tilt of the head and to place the features.

Cerebral Hemispheres. The outermost part of the forebrain, clearly separated into two halves on the right and left sides of the brain. Consists essentially of the cerebral cortex, corpus callosum, basal ganglia, and limbic system.

Cerebrum. The main division of the brain in vertebrates, consisting of two hemispheres. It is the last part of the brain to evolve and is of critical importance in all kinds of mental activity.

Cognitive Shift. A transformation from one mental state to another, e.g., from L-mode to R-mode or vice versa.

Composition. An ordered relationship among the parts or elements of a work of art. In drawing, the arrangement of forms and spaces within the format.

Conceptual Images. Imagery from internal sources (the "mind's eye") rather than from external, perceived sources; usually simplified images; often abstract rather than realistic.

Contour Line. In drawing, a line that represents the shared edges of a form, a group of forms, or forms and spaces.

Corpus Callosum. A massive, compact bundle of axons connecting the right and left cerebral cortices. The corpus callosum allows the two halves, or hemispheres, of the cerebral cortex to communicate directly with one another.

Creativity. The ability to find new solutions to a problem or new modes of expression; the bringing into existence of something new to the individual and to the culture. Writer Arthur Koestler added the requirement that the new creation should be socially useful.

Crosshatching. A series of intersecting sets of parallel lines used to indicate shading or volume in a drawing.

Edge. In drawing, the place where two things meet (for example, where the sky meets the ground); the line of separation between two shapes or a space and a shape.

Expressive Quality. The slight individual differences in the way each of us perceives and represents our perceptions in a work of art. These differences express an individual's inner reactions to the perceived stimulus as well as the unique "touch" arising from individual physiological motor differences.

Eye Level. In perspective drawing, a horizontal line on which lines above and below it in the horizontal plane appear to converge. In portrait drawing, the proportional line that divides the head in half horizontally; the location of the eyes at this halfway mark on the head.

Foreshortening. A way to portray forms on a two-dimensional surface so that they appear to project from or recede behind a flat surface; a means of creating the illusion of spatial depth in figures or forms.

Format. The particular shape of a drawing or painting surface—rectangular, circular, triangular, etc.; the proportion of the surface, e.g., the relationship of the length to the width in a rectangular surface.

Grid. Evenly spaced lines, running horizontally and vertically at right angles, that divide a drawing or painting into small squares or rectangles. Often used to enlarge a drawing or to aid in seeing spatial relationships.

Hemispheric Lateralization. The differentiation of the two cerebral hemispheres with respect to function and mode of cognition.

Holistic. In terms of cognitive functions, the simultaneous processing of an array of information in a total configuration as opposed to sequential processing of its separate parts.

Image. *Verb:* to call up in the mind a mental copy of something not present to the senses; see in the "mind's eye." *Noun:* a retinal image; the optical image of external objects received by the visual system and interpreted by the brain.

Imagination. A recombination of mental images from past experiences into a new pattern.

Intuition. Direct and apparently unmediated knowledge; a judgment, meaning, or idea that occurs to a person without any known process of reflective thinking. The judgment is often reached as a result of minimal cues and seems to "come from nowhere."

Key. In drawing, the lightness or darkness of an image. A high-key drawing is light or pale in value; a low-key drawing is dark or low in value.

Learning. Any relatively permanent change in behavior as a result of experience or practice.

Left Hemisphere. The left half (oriented according to your left) of the cerebrum. For most right-handed individuals and a large proportion of left-handed individuals, verbal functions are in the left hemisphere.

L-Mode. A state of information processing characterized as linear, verbal, analytic, and logical.

Negative Spaces. The areas around positive forms that share edges with the forms. Negative spaces are bounded by the outer edges by the format. "Interior" negative spaces can be part of positive forms: For example, the whites of the eyes can be regarded as interior negative spaces useful for drawing the irises.

Nonobjective Art. Art that makes no attempt to reproduce the appearance of real-life objects or experiences or to produce the illusion of reality. Also called "nonrepresentational art."

Perception. The awareness, or the process of becoming aware, of objects, relations, or qualities—either internal or external to the individual—by means of the senses and under the influence of previous experiences.

Picture Plane. An imaginary construct of a transparent plane, like a framed window, that always remains parallel to the vertical plane of the artist's face. The artist draws on paper what he or she sees beyond the plane as though the view were flattened on the plane. Inventors of photography used this concept to develop the first cameras.

Realistic Art. The objective depiction of objects, forms, and figures attentively perceived. Also called "naturalism."

Right Hemisphere. The right half (oriented according to your right) of the cerebrum. For most right-handed individuals and a large proportion of left-handed individuals, spatial, relational functions are in the right hemisphere.

R-Mode. A state of information processing characterized as simultaneous, holistic, spatial, and relational.

Scanning. In drawing, checking points, distances, degrees of angles relative to vertical or horizontal, relative sizes, etc.

Sighting. In drawing, measuring relative sizes by means of a constant measure (the pencil held at arm's length is the most usual measuring device); determining relative points in a drawing—the location of one part relative to some other part. Also, determining angles relative to the constant's vertical and horizontal.

Split-Brain Patients. Individuals who had been suffering from intractable epileptic seizures and whose medical problems were relieved by a surgical operation. The procedure separates the two hemispheres by severing the corpus callosum. The procedure is rarely done and split-brain patients are few in number.

States of Consciousness. A largely unresolved concept, consciousness is used in this book to mean the awareness, continually changing, of what passes in one's own mind. An alternate state of consciousness is one that is perceived as noticeably different from ordinary, waking consciousness. Familiar alternate states are daydreaming, sleep dreaming, and meditation.

Symbol System. In drawing, a set of symbols that are consistently used together to form an image, for example, a figure. The symbols are usually used in sequence, one appearing to call forth another, much in the manner of writing familiar words, in which writing one letter leads to writing the next. Symbol systems in drawn forms are usually set in childhood and often persist throughout adulthood unless modified by learning new ways to draw.

Value. In art, the darkness or lightness of tones or colors. White is the lightest, or highest, value; black is the darkest, or lowest, value.

Visual Information Processing. The use of the visual system to gain information from external sources and the interpretation of that sensory data by means of cognition.

Zen. A system of thought that emphasizes a form of meditation called *zazen*. Zazen begins with concentration, often on puzzles wholly impervious to solution through reason. Concentration leads to *samadhi*, a "state of oneness" in which the meditator gains insight into the unity of things in the world. The meditator strives to move through further stages to the final stage of Zen, *satori*, or "no mind," a brilliantly clear state of mind in which the details of every phenomenon are perceived, yet without evaluation or attachment.

Bibliography

Albers, Josef. *The Interaction of Color.* New Haven: Yale University Press, 1962.

Arguelles, J. *The Transformative Vision.* Berkeley, Calif.: Shambhala Publications, 1975.

Arnheim, R. *Art and Visual Perception.* Berkeley, Calif.: University of California Press, 1954.

Ayrton, M. *Golden Sections.* London: Methuen, 1957.

Berger, J. *Ways of Seeing.* New York: Viking Press, 1972.

Bergquist, J. W. *The Use of Computers in Educating Both Halves of the Brain.* Proceedings: Eighth Annual Seminar for Directors of Academic Computational Services, August 1977. P.O. Box 1036, La Cañada, Calif.

Blakemore, C. *Mechanics of the Mind.* Cambridge: At the University Press, 1977.

Bliss, J., and J. Morella. *The Left-Handers' Handbook.* New York: A & W Visual Library, 1980.

Bogen, J. E. "The Other Side of the Brain." *Bulletin of the Los Angeles Neurological Societies* 34 (1969): 73–105.

———. "Some Educational Aspects of Hemispheric Specialization." *UCLA Educator* 17 (1975): 24–32.

Bruner, J. S. "The Creative Surprise." In *Contemporary Approaches to Creative Education,* edited by H. E. Gruber, G. Terrell, and M. Wertheimer. New York: Atheneum Press, 1962.

———. *On Knowing: Essays for the Left Hand.* New York: Atheneum, 1965.

Buswell, Guy T. *How People Look at Pictures.* Chicago: Chicago University Press, 1935.

Buzan, T. *Use Both Sides of Your Brain.* New York: E. P. Dutton, 1976.

Carra, C. "The Quadrant of the Spirit." *Valori Plastici* 1 (April–May 1919): 2.

Carroll, L., pseud. See Dodgson, C. L.

Collier, G. *Form, Space, and Vision.* Englewood Cliffs, N.J.: Prentice-Hall, 1963.

Connolly, C. *The Unquiet Grave: A Word Cycle by Palinurus.* New York: Harper and Brothers, 1945.

Corballis, M., and I. Beale. *The Psychology of Left and Right.* Hillsdale, N.J.: Lawrence Erlbaum Associates, 1976.

Cottrell, Sir Alan. "Emergent Properties of Complex Systems." In *The Encyclopedia of Ignorance,* edited by R. Duncan and M. Weston-Smith. New York: Simon & Schuster, 1977.

Critchley, M. *Music and the Brain.* Springfield, Ill.: Charles C. Thomas, 1977.

Davis, Stuart. Quoted in "The Cube Root." In *Art News* XLI, 1943, 22–23.

Delacroix, Eugene. In *Artists on Art,* edited by Robert Goldwater and Marco Treves. London: Pantheon Books, 1945.

Descartes, René. *Fourth Discourse on Method, Optics, Geometry, and Meteorology,* 1637.

Dodgson, C. L. [pseud. Carroll, L.] *The Complete Works of Lewis Carroll,* introduction by A. Woollcott. London: Nonesuch Press, 1939.

Edwards, B. "Anxiety and Drawing." Master's thesis, California State University at Northridge, 1972.

———. "An Experiment in Perceptual Skills in Drawing." Ph.D. dissertation, University of California, Los Angeles, 1976.

Edwards, B., and D. Narikawa. *Art, Grades Four to Six.* Los Angeles: Instructional Objectives Exchange, 1974.

English, H. B., and Ava C. English. *A Comprehensive Dictionary of Psychological and Psychoanalytical Terms.* New York: David McKay Company, Inc., 1974.

Ernst, M. *Beyond Painting.* Translated by D. Tanning. New York: Wittenborn, Schultz, 1948.

Ferguson, M. *The Brain Revolution.* London: Davis-Poynter, 1974.

Flam, J. *Matisse on Art.* New York: Phaidon, 1973.

Franck, F. *The Zen of Seeing.* London: Wildwood House, 1973.

Franco, L., and R. W. Sperry, "Hemisphere Lateralization for Cognitive Processing of Geometry," *Neuropsychologia,* 1977, Vol. 15, 107–14.

Friend, D. Composition: *A Painter's Guide to Basic Problems and Solutions.* New York: Watson-Guptill Publications, 1975.

Gardner, H. *The Shattered Mind: The Person After Damage.* New York: Alfred A. Knopf, 1975.

Gazzaniga, M. "The Split Brain in Man." In *Perception: Mechanisms and Models,* edited by R. Held and W. Richards, p. 33. San Francisco, Calif.: W. H. Freeman, 1972.

Gladwin, T. "Culture and Logical Process." In *Explorations in Cultural Anthropology,* edited by W. H. Goodenough, pp. 167–77. New York: McGraw-Hill, 1964.

Goldstein, N. The Art of Responsive Drawing. Englewood Cliffs, N.J.: Prentice-Hall, 1973.

Gregory, R. L. *Eye and Brain: The Psychology of Seeing.* 2nd ed., rev. New York: McGraw-Hill, 1973.

Grosser, M. *The Painter's Eye.* New York: Holt, Rinehart and Winston, 1951.

Hadamard, J. *An Essay on the Psychology of Invention in the Mathematical Field.* Princeton, N.J.: Princeton University Press, 1945.

Hall, E. T. *The Silent Language.* Garden City, N.Y.: Doubleday, 1959.

Hearn, Lafcadio. *Exotics and Retrospectives.* New Jersey: Literature House, 1968.

Henri, R. *The Art Spirit.* Philadelphia, Pa.: J. B. Lippincott, 1923.

Herrigel, E. Quoted in *The Joy of Drawing.* London: The Oak Tree Press, 1961.

Hill, E. *The Language of Drawing.* Englewood Cliffs, N.J.: Prentice-Hall, 1966.

Hockney, D. *David Hockney,* edited by N. Stangos. London: Thames and Hudson, 1977.

Hoffman, Howard. V*ision & the Art of Drawing.* Englewood Cliffs, N.J.: Prentice-Hall, 1989.

Huxley, A. L. *The Art of Seeing.* London: Harper and Brothers, 1942.

———. *The Doors of Perception.* London: Chatto & Windus, 1954.

James, W. *The Varieties of Religious Experience*. London: Longmans & Co, 1902.

Jaynes, J. *The Origin of Consciousness in the Breakdown of the Bicameral Mind*. Boston: Houghton Mifflin, 1976.

Jung, C. G. *Man and His Symbols*. London: Aldus Books in association with W H Allen, 1964.

Kandinsky, W. *Point and Line to Plane*. Chicago: Solomon Guggenheim Foundation, 1945.

———. *Concerning the Spiritual in Art*. New York: Wittenborn, 1947.

Keller, H. A. *The World I Live In*. London: Hodder and Stoughton, 1908.

Kipling, R. *Rudyard Kipling's Verse*. London: Hodder & Stoughton, 1927.

Koestler, A. *The Sleepwalkers*. London: Hutchinson, 1959.

Krishnamurti, J. *The Awakening of Intelligence*. London: Gollancz, 1973.

———. "Self Knowledge." In *The First and Last Freedom*, p. 43. New York: Harper and Row, 954.

———. *You Are the World*. New York: Harper and Row, 1972.

Levy, J. "Differential Perceptual Capacities in Major and Minor Hemispheres," *Proceedings of the National Academy of Science*, Vol. 61, 1968, 1151.

———. "Psychobiological Implications of Bilateral Asymmetry." In *Hemisphere Function in the Human Brain*, edited by S. J. Dimond and J. G. Beaumont. New York: John Wiley and Sons, 1974.

Levy, J., C. Trevarthen, and R. W. Sperry. "Perception of Bilateral Chimeric Figures Following Hemispheric Deconnexion," *Brain*, 95, 1972, 61–78.

Lindaman, E. B. *Thinking in Future Tense*. Nashville: Broadman Press, 1978.

Lindstrom, M. *Children's Art: A Study of Normal Development in Children's Modes of Visualization*. Berkeley, Calif.: University of California Press, 1957.

Lord, J. *A Giacometti Portrait*. New York: Museum of Modern Art, 1965.

Lowenfeld, V. *Creative and Mental Growth*. New York: Macmillan, 1947.

Matisse, H. *Notes d'un peintre*. In *La grande revue*. Paris, 1908.

McFee, J. *Preparation for Art*. San Francisco, Calif.: Wadsworth Publishing, 1961.

McKim, R. *Experiences in Visual Thinking*. Monterey, Calif.: Brooks/Cole Publishing, 1972.

Munsell, Albert. *A Color Notation*. Baltimore: Munsell Color Co., 1926.

Newton, Isaac. *Opticks*, Book 1, Part 2. 1st ed., London, 1704.

Nicolaides, K. *The Natural Way to Draw*. Boston: Houghton Mifflin, 1941.

Ornstein, R. E. *The Psychology of Consciousness*. London: Penguin, 1975.

Orwell, G. "Politics and the English Language." In *In Front of Your Nose*, Vol. 4 of *The Collected Essays, Journalism and Letters of George Orwell*, 4 volumes, edited by S. Orwell and I. Angus. London: Secker & Warburg, 1968.

Paivio, A. *Imagery and Verbal Processes*. New York: Holt, Rinehart and Winston, 1971.

Paredes, J., and M. Hepburn. "The Split-Brain and the Culture-Cognition Paradox." *Current Anthropology* 17 (March 1976): 1.

Pascal, B. *Pensées: Thoughts on Religion and Other Objects*, edited by H. S. Thayer and E. B. Thayer. New York: Washington Square Press, 1965.

Piaget, J. *The Language and Thought of the Child*. London: Routledge & Kegan Paul, 1959.

Pirsig, R. M. *Zen and the Art of Motorcycle Maintenance*. Bodley Head, 1974.

Ponomarev, L. *In Quest of the Quantum*. Trans. by N. Weinstein. Moscow: Mir Publishers, 1973.

Reed, William. *Ki: A Practical Guide for Westerners*. Tokyo: Japan Publications, 1986.

Rock, I. "The Perception of Disoriented Figures." In *Image, Object, and Illusion*, edited by R. M. Held. San Francisco: W. H. Freeman, 1971.

Rodin, A. Quoted in *The Joy of Drawing*. London: The Oak Tree Press, 1961.

Samples, B. *The Metaphoric Mind*. Reading, Mass.: Addison-Wesley Publishing, 1976.

————. *The Wholeschool Book*. Reading, Mass.: Addison-Wesley Publishing, 1977.

Samuels, M., and Samuels, N. *Seeing With the Mind's Eye*. New York: Random House, 1975.

Sargeant, Walter. *The Enjoyment and Use of Color*. New York: Charles Scribner's Sons, 1923.

Shah, I. *The Exploits of the Incomparable Mulla Nasrudin*. New York: E. P. Dutton, 1972.

Shepard, R. N. *Visual Learning, Thinking, and Communication,* edited by B. S. Randhawa and W. E. Coffman. New York: Academic Press, 1978.

Singer, J. *How to Paint in Pastels*. New York: Watson-Guptil Publishers, 1976.

Smith, Peter. "The Dialectics of Color." In *Color for Architecture,* T. Porter and B. Mikellides. New York: Van Nostrand Reinhold, 1976.

Sperry, R. W. "Hemisphere Disconnection and Unity in Conscious Awareness." *American Psychologist* 23 (1968): 723–33.

————. "Lateral Specialization of Cerebral Function in the Surgically Separated Hemispheres," in *The Psychophysiology of Thinking,* edited by F. J. McGuigan and R. A. Schoonover. New York: Academic Press, 1973, 209–29.

Sperry, R. W., M. S. Gazzaniga, and J. E. Bogen, "Interhemispheric Relationships: the Neocortical Commissures; Syndromes of Hemisphere Disconnection," *Handbook of Clinical Neurology,* edited by P. J. Vinken and G. W. Bruyn. Amsterdam: North-Holland Publishing Co., 1969, 273–89.

Stein, G. *Picasso*. London: B. T. Batsford, 1938.

Suzuki, D. T. *The Gospel According to Zen,* edited by R. Sohl and A. Carr. New York: New American Library, 1970.

Tart, C. T. "Putting the Pieces Together." In *Alternate States of Consciousness,* edited by N. E. Zinberg. New York: Macmillan, 1977.

————. *States of Consciousness*. New York: E. P. Dutton, 1975.

Taylor, J. *Design and Expression in the Visual Arts*. New York: Dover Publications, 1964.

Verity, Enid. *Color Observed*. New York: Van Nostrand Reinhold and Company, 1980.

Walter, W. G. *The Living Brain*. New York: W. W. Norton, 1963.

Wittrock, M. C., et al. *The Human Brain*. Englewood Cliffs, N.J.: Prentice-Hall, Inc., 1977.

Zaidel, E., and R. Sperry. "Memory Impairment after Commisurotomy in Man." *Brain* 97 (1974): 263–72.

Index

Page numbers in *italics* refer to illustrations.

A

abstraction, 80, 142, 170

adolescents, 69, 70, 75–81, *78, 79*, 121, 272

after-image, 237

Age of Spiritual Machines, The (Kurzweil), XXIII

Albers, Josef, 239, 240

Alberti, Leone Battista, 96, 102

Allan, Heather, 23–24, *24*

analog drawing, XIV, XVI

Anglo-Saxon, 36

animals, 29, 30, 46

Archimedes, 39

Army poster, *60*

Arnold, Elizabeth, *194*

artists, 2, 3, 4, 5, 7, 54, 55, 62, 63, 128, 162, 206
 drawing as metaphor for, 23–24
 left-handed, 43
 police, 170
 Renaissance, 139, 142, 143–45, *143, 144*, 213, 217, 252

Art of Painting After the Italian Manner, The (Elsum), 96

Aztecs, *43*

B

ball-and-stick letters, 255, *255*

Ball-Kingston, Cindy, *154*

Basic Unit, 140, *141*, 146–49, *146, 147, 148*, 151, 153, 154, 180, 183

in composition, 116, 123–26, *124, 125, 126*, 129–30, 131
 definition of, 124–26

Beckett, Samuel, 122, 123

Berberet, Gary, 243

Bergland, Richard, *XX*

Bergquist, J. William, 38

Blakemore, Colin, 80

blanks, 168–70, *168*, 173–74, *174*, 210–13, *211, 212, 222*

Bloomer, Carolyn M., 196

Bogen, Joseph E., 32, 37

bold line, *25*

Bomeisler, Brian, 23–24, *24, 119, 190, 203, 218, 223, 226*

brain, hemispheres of, XII, XVII, *XX,* XXII–XXV, 7, 8, 28–47, *30,* 81, 82, 151, 162, 163, 197–98, 248–50

 color and, 231–32

 conflict between, 33, 34

 corpus callosum of, XXIV–XXV, *30,* 31–35

 crossover connections of, 29, *29,* 35, 236

 cultural customs and, 36–37

 developmental changes in, 63

 as dominant vs. subordinate, 30–31, 32, 35, 38, 46, 80, 121, 236

 educational system and, XXIV, 31, 39–41, 268–72

 information processing in, 32–35, 38–39, 42

 injuries of, 30, 162, 198

 language functions in, 30, 32, 42–43, 62

 lateralization of, 42–43, 63–65, 88, 121

 in linguistic terminology, 35–37, 38

 location controversy regarding, XXII, XXIV

 politics and, 36

 reality perception in, 32, 35

 in split-brain studies, 31–35, 38, 46

 ways of knowing in, 37, 38

 see also handedness; L-mode; R-mode

Broekhuijsen, Jerome, *191*

broken line, *25*

Bruer, John T., XXIV

Buhler, Karl, 81

Burbank, Brenda, 72

Buswell, Guy T., 236

bypassing technique, 188

C

Caldwell, Randa, *158*

California Institute of Technology, 31–34

calligraphy, 25, 204

 Japanese, 256, *256, 259*

Carpenter (Van Gogh), 170–72, *172*

Carra, Carlo, 63

Carroll, Lewis, 41, 42, *47,* 62, *84*

cartoons, *72,* 76, *77,* 232

cave painting, *2,* 94

central axis, 168, *168,* 210, 211, *211,* 215, *215, 216*

Cézanne, Paul, 122–23, *122*

Chardin, Jean-Baptiste–Simeon, 243

children, 7, 68–85, 170, 267–72

 adolescent, 69, 70, 75–81, *78, 79,* 121, 272

 composition by, 74–75, *78,* 120–21, *121*

 infants, 70–71

 portrait views preferred by, 213–14

 tiered perspective used by, 142

 see also symbol system, childhood

Children's Art (Lindstrom), 69, 77

Child Seated in a Wicker Chair (Homer), *135*

chopped-off skull error, 167–74, *167, 168, 169, 170, 171, 172, 174, 175*

circular form, 71

cityscapes, 240–41

Clottes, J., 94

cognitive neuroscience, XXII–XXIII

Collier, Graham, 145

color, XXI, 142, 157, 196, 230–45

 after-image of, 237

 balanced, 232, 233, 238, 240

 basics of, 232–34

 brain hemispheres and, 231–32

 in cityscapes, 240–41

 complementary, 233, 236–37, 238

 cool vs. warm, 235, 236, 238

 emotional response to, 231–32

 exercise for, 237–40

 harmonious, 232, 238, 239, 240, 242

 hue of, 232, 233, 235, 237

 intensity of, 231, 232, 233, 238, 242

 pastels and, 242–45

 primary, 235

 psychological meanings of, 243

 secondary, 235

 supplies for, 233–34

 ugliness and, 240–41

 value of, 232, 233, 238, 239, 240

 wheel of, 234–37, *234, 235*

colored paper, 233–34, 237–40

colored pencils, 233, 235, 237–40

Complete Letters of Vincent Van Gogh, The, 102, *103*

complexity, stage of, 75–77, *76, 77*

composition, 12, 74, 75, 113, 119–26, 140, 154, 227

 Basic Unit in, 116, 123–26, *124, 125, 126,* 129–30, 131

 by children, 74–75, *78,* 120–21, *121*

 definition of, 119, 120

 format in, 120–23, *121, 122,* 124, 126, 127, 130, 133

 unified, 120, 123

computers, xxiii, 28, 38

Connolly, Cyril, 40

consciousness, altered states of, 4, 5, 46, 54, 61, 62–63, 84–85, 91, 177

contour drawing, 88–113, 117

 of handwriting, 257–58, *258*

 see also modified contour drawing; pure contour drawing

copying of masterworks, 178–80, 200–204

corporate training seminars, XIII, XIV–XVI

corpus callosum, XXIV–XXV, *30,* 31–35

Courbet, Gustave, 196, *197,* 200–204

crafts projects, 70

Cranach, Lucas, *214*

creativity, 3, 5, 6–8, 9, 40

 definition of, 38–39, 210

Crick, F.H.C., 28

crosshatching, 195, 207–9, *207, 208, 209*

Crowe, Dana, *159*

cubes, 79–80, *79*

cubism, 80

D

Dame, Don, 239, 242

Dancer Adjusting Her Slipper (Degas), *157,* 233

"da Vinci device," 251–52

Davis, Stuart, 241

Degas, Edgar, *157,* 233, 237–39, 250

Delacroix, Eugene, 245

DePhillippo, Sandy, *134*

"Dialectics of Color, The" (Smith), 232

Draughtsman Making a Perspective Drawing of a Woman (Dürer), 143–45, *143, 144*

drawing, 2–9, 45, 54–55, 248–52

 altered states of consciousness in, 4, 5

 by animals, 28

 by art students, 273–74

 creativity of, 6–8, 9

 definition of, 99, 110

 difficulty at start of, 105, 123–26

 handedness and, 45–46

 as learnable skill, 3

 as magical ability, 2–3

 as metaphor for artist, 23–24

 in public places, 152, 241

 realistic, 8

 seeing and, 4

 working up of, 132

drawing materials, 13–14, *13*

Drawing on the Artist Within (Edwards), XIV

driving, XVIII, XIX, 138

 freeway, 5, 84

Dürer, Albrecht, 6, 80, *82,* 122–23, *122,* 172, *174*

 picture-plane device of, 102, 143–45, *144, 145*

E

edges, XIV, XVIII, XIX, XXI, 14, 75, *78,* 116, 138, *149,* 150, 157, 163, 177, 196

 in contour drawing, 90, 92, 94–96, 97–98, 108, 109, 117

 definition of, 94–95, 119

 of format, *see* formats

 shared, 95, 96, 109, 119, 124

educational system, xxiv, 31, 39–41, 253–54, 267–72

Egyptians, ancient, 142

Einstein, Albert, 56–57, *56, 58*

Elderfield, John, 125

Elgart, Elliot, 104

Elsum, John, 96

English, H. B. and Ava C., 231

eraser, 52, 108, 109, 132

 as drawing tool, 196, 201, *201*

Ernst, Max, 91

esthetic response, 232, 236

expressiveness, XIV, XIX, 21–24, 73, 118, 152, 170, 211, 224

 nonverbal, 21–23, 256

eyeballing, 151, 156

eyedness, 42

F

Fabric of Mind, The (Bergland), *XX*

facial recognition, XXIII, 8, 162, 163

Feline Felicity (Sheeler), 204, *205,* 209

figure drawings, *208,* 209

 by children, 71–73, *71, 72, 73, 78*

 sighting in, *157*

Firmin, Lisbeth, *134, 191*

Flagg, James Montgomery, *60*

Flam, J., XXIII

flowers, *XXV*

footedness, 42

foreshortening, 60, 97–98, 123, *135,* 143–45, *144,* 151, *156, 157*

formats, 97, 106, 108, 119, 150, 152, 153, 179

 composition within, 120–23, *121, 122,* 124, 126, 127, 130, 133

 definition of, 96, 120

 shapes of, 120, *120*

Four Heads (Dürer), *174*

fractals, 93

Franck, Frederick, 4, 213

French, 36

Freud, Sigmund, 45

Fuseli, Henry, 194, 195–96, *195*

G

Galin, David, 38, 269

Gardner, Howard, 6

Gazzaniga, Michael S., 32, 33

genetic factors, 42

George III, King of England, *258*

German horse and rider drawing, 60, *64*

gestalt, XIV–XVI, XVIII, XIX, 96, 117, 162, 163, 198

gestures, 38

Girl in a Flowered Hat (Huyung), 239–40

Gladwin, Thomas, 53

global (whole) skills, XVII–XX, *XIX,* 158, 210

 component skills of, XVIII–XX, 96, 117

Goethe, Johann, 235, *235*

Goldwyn, Samuel, 6

grid, 52, 96, 99–101, 107, 143, 144

Grosser, Maurice, 4

H

Halsman, Philippe, *56, 58*

handedness, 30, 36, 37, 40, 41–46, *43*

 ambidexterity in, 41, 42, 43, 45

 changed from left to right, 36, 42, 43, 45, 268

 drawing and, 45–46

 right/left confusion in, 45

hands, 29, 35–37, *72, 98*

 foreshortened, 97–98

 as "hard to draw," 76

 in linguistic terminology, 35–36, 37

 modified contour drawing of, 97–99, *97,* 105–12, *107, 108, 109, 111, 112*

 pre-instruction drawing of, 15, 16

 pure contour drawing of, 89–92

 in split-brain studies, 33–34

handwriting, XXI, 3, 253–66

 consistency of, 262–63

contour drawing of, 257–58, *258*

forging of, *57,* 253

hand position in, 43

left-hand preference for, 41–42

lights and shadows in, 263–64

as line, 21–23, 255–56

mirror, 42

negative spaces of, *258,* 259–60, *259*

sighting of, 260–63, *260, 261*

slant of, *260,* 261, *261, 262*

upside-down, *57, 253*

Harking, Brian, *105*

Head of Young Girl (Redon), 243, 244

Head of a Youth with a Red Cap (Cranach), *214*

Hearn, Lafcadio, 232

Helmholtz, Hermann von, 45

Henri, Robert, *5,* 8, *55,* 94, *156,* 225

Hepburn, M. J., 53

heraldry, 231

Herrigel, E., 21

Hill, Edward, 70, 88

Hockney, David, 273

Hokusai, Katsushita, 248

Holbein, Hans, 98, *98*

 picture plane used by, 103

Homer, Winslow, *135*

Hopper, Edward, 205, *206*

Huxley, Aldous, 7, 41

Huyung, Thu Ha, 239–40

I

I Ching, 37

imagination, drawing from, XIX, 8, 221, 251–52

Imamoto, Mauro, *227*

Impressionism, 99

Incas, *43*

infants, 70–71

Ingres, Jean-Auguste Dominique, *25*

inventions, XIII

J

James, William, 61

Jane Burden, Later Mrs. William Morris, as Queen Guinevere (Rossetti), *199*

Japanese calligraphy, 256, *256, 259*

Japanese prints, *23*

Jarman, Christopher, 257

K

Kandinsky, Wassily, 236

Kay, Alan, 142

Keller, Helen, 230

Kennedy, Grace, *139, 190, 226*

Kipling, Rudyard, 40

Kiyonobu I, Torii, *23*

Kiyotada, Torii, *23*

Klee, Paul, 82

Koestler, Arthur, 38

Kollwitz, Käthe, 240

Krishnamurti, J., XVI, 248

Kuroyama, Laurie, *140*

Kurzweil, Ray, XXIII

L

landscapes, *155*

recalled childhood, 74–75, *75*

stage of, 73–75, *74*

language, 30, 32, 52, 62, 65, 81, 121

of art, 236, 261

grammar of, 138

lateralization of, 42–43

terms for left and right, 35–37, 38

Large Stuffed Eagle (Ludwig), 242

Latin, 36, 142

Lawrence, D. H., 84

learning, transfer of, XIII–XIV

Left-Handers' Handbook, The (Bliss and Morella), 43

Legros, Alphonse, *208,* 209

Leonardo da Vinci, 4, 14, 42, 43, 102, 251–52

Levy, Jerre, 32, 33, 38, 41

Lewis-Williams, D., 94

lights and shadows, XIV, XVIII, XX, XXI, 96, 108, 109, 116, 117, 128–29, 138, *155,* 163, 186, 189, 194–227

continuous tone in, 209–10

crosshatching in, 195, 207–9, *207, 208, 209*

exercise for, 200–204

in handwriting, 263–64

R-mode in perception of, 194, 196–98, *198*

seeing and, 204–7

see also self-portraits

limbic system, 231

Lindaman, Edward B., 224

Lindstrom, Miriam, 69, 77

line, XXI, 23, 142, 196

handwriting as, 21–23, 255–56

styles of, 25, *25, 262*

L-mode, XVI, XX, XXII, XXIII, 46, 65, 88, 113, 118, 129, 163, 178, 223–24

characteristics of, 33, 37, 38–40, 44, 80, 82

cognitive shift from, 50, 54–55, 57–58, 60–62, 63

colors and, 231–32

contour drawing and, 89, 92, 93, 94, 108

formal perspective as, 145

navigation by, 53, 54

sighting as, 138, 139–40, 145

upside-down images rejected by, 60–61, 113

see also brain, hemispheres of; R-mode; symbol system, childhood

Ludwig, Ken, 242

M

Marchand, André, XXIII

Marks, Judi, 92

masklike effect, 170

Matisse, Henri, XXIII, 4, 118, 125, *125,* 170

Mayas, *43*

memory, drawing from, XIX, 250–51

as pre-instruction exercise, 15, 16–17

Milne, A. A., 45

Miro, Joan, 121, *121*

mirror handwriting, 42

mirror images, 50–54, 113

Mme. Pierre Gautreau (Sargent), 178–80, *179, 180, 199*

models, 104, 125, 143–44, 198–99, 213, 214, 243–45, 250

 for profile portraits, 167–68, 170, *171, 181, 182–89, 190, 191*

modified contour drawing, 94, 96–112, 215–16, 258

 on picture plane, 96–104, *97, 100, 101*

 position for, 105, *106*

 toning of paper in, 106–7, *107,* 110

Molloy, Naveen, 77

Morisot, Berthe, 204, *204*

Munsell, Albert, 238

Myers, Ronald, 31

N

Natural Way to Draw, The (Nicolaides), 88, 89

navigation, 53, 54

Nebes, Robert, 32

negative spaces, xiv, xv, 16, 96, 116–35, *116, 117,* 155, *155, 157,* 174, 177, 196

 cognitive shift and, 132–33, *133*

 description of, 117–19

 of drawn chairs, *118, 119, 123,* 127–32, *129, 131, 132, 134, 135*

 functions of, 123

 of handwriting, *258,* 259–60, *259*

 importance of, 118

positive forms vs., 117–19, 120, 121–22, *122,* 155, 196

see also composition

Newton, Isaac, 234–35, *235*

Nicolaides, Kimon, 3, 88–89, *89,* 233

nonverbal expression, 21–23, 256

Nude Woman with a Staff (Dürer), *122*

O

Observer, objective, 46

Olimpio Fusco (Sargent), *199*

O'Neil, Jeanne, *118*

Ornstein, Robert, 82

Orwell, George, 93, 169, *169*

P

painterly style, 23

painting, xxi, 196, 239, 245

 Shodo, 256

Palmer method handwriting, 255, *255,* 257

Paredes, J. A., 53

pastels, 242–45

perceptual illusions, 164–67, *164, 165, 166*

 Vase/Faces, 50–54, *50,* 61, 95, 113

perceptual skills, xiv–xv, xviii–xx, 17–18, 21, 40, 96, 117

"Perceptual Skills in Drawing" (Edwards), xii

Personages with Star (Miro), *121*

perspective, 9, 96, 102, 104, 117, 138, 142–59, *153, 154, 158,* 196

 definition of, 142–43

 distance in, 75, *140,* 143, 164–65, *164*

 exercise for, 152–56, *153*

foreshortening in, 60, 97–98, 123, *135,* 143–45, *144,* 151, *156, 157*

 formal vs. informal, 145, *145,* 158

 linear, 142

 Renaissance, 139, 142, 143–45, *143, 144*

 tiered, 142

 vanishing points in, 143, 145, *145*

perspective devices, *100,* 102–3, *103*

photography, 99, 152, 169

Picasso, Pablo, 22, 25, 57–61, *58, 60,* 73, 79, 170, 273

picture plane, 96–104, *97, 100, 101,* 108, 110

 description of, 99

 historical use of, 102–3

 portraits and, 103

 sighting and, 139, 140, 144, 150–51, *150,* 156

 single view through, 103–4

 three-dimensional space and, 104

picture plane, plastic, 13, 96–98, 104, 105, 107–8, *107,* 110, 119, 143, 146–49, *146, 148,* 153, 154, 155, 178, 179–80, 181, 182, 183

picture-plane devices, 102, 143–45, *144, 145*

Pines, Maya, 32

Poincaré, Henri, 37, 39

police artists, 170

politics, 36, 37

Portfolio, 13–14

Portrait of Igor Stravinsky (Picasso), *58*

Portrait of the Artist (Fuseli), 194, 195–96, *195*

portraits, 8, 170

basic poses of, 198–99

copying of masterwork, 178–80, 200–204

picture plane used for, 103

proportions of, *see* proportions, in portraits

see also profile portraits; self-portraits

positive forms, 117–19, 120, 121–22, *122, 155,* 196

Preacher (White), 156

pre-instruction self-portraits, 14–24, 69, 224–25

primitive art, 170

Principles of Art, 119

Prismacolor, 233

problem solving, XIII, 6, *55,* 142

at corporate training seminars, XIV–XVI

profile portraits, 23–24, *24, 78,* 158, 162–91, 198, 199, 213, 214, 218

blanks for, 168–70, 169, 173–74, *174*

childhood symbol systems and, 162–63, 177, 188

exercise for, 180–89, *182, 183, 184, 185, 186, 188*

models for, 167–68, 170, *171,* 181, 182–89, *190, 191*

proportions in, 162, 163, 164–77; *see also* proportions, in portraits

showing of, 189–91

proportion, 96, 117, 124, 131, 138, 139, 140–51, 156, 196, 222–23

Basic Unit of, *see* Basic Unit

exercise for, 146–51

perceptual illusions of, 164–67, *164, 165, 166*

ratios in, 139, 140–42, *141,* 147–49, *147, 148, 156*

scale in, 130, *141, 146,* 147

proportions, in portraits, 162, 163, 164–77, 210–18, 222–23

blanks for, 168–70, *168,* 173–74, *174,* 210–13, *211, 212, 222*

central axis in, 168, *168,* 210, 211, *211,* 215, *215, 216*

chopped-off skull error in, 167–74, *167, 168, 169, 170, 171, 172, 174,* 175

clothing in, 187, *188*

collar in, 188, *188,* 222

diagrammed, *170, 212, 222*

ear placement in, 167, 175–77, *175, 176,* 184–85, *187,* 213, 218, 222

eye level in, 167–70, 174, *174,* 184–85, 210, 211, *211,* 215, *215, 216*

eyes in, 163, 184, 188, *188,* 212, 214, 216–17

in full-face view, 210–13, 222–23

hair in, 167, 170, 186, 222–23

neck in, 176, *176,* 187, 188, *188,* 213, 222

nose in, 184, 211, 214, 216, 217, 222

nostril in, 184, *185,* 222

in three-quarter view, 170, *171,* 213–18, 223, *227*

Proud Maisie (Sandys), 186, *187*

Psychology of Left and Right, The (Corbalis and Beale), 31

Pure Contour Drawing, 88–94, *91, 92, 94,* 113, 177, 178

of handwriting, 257–58, *258*

paradox of, 93–94

student showing of, 94, *95*

pure line, *25*

R

Ramirez, Lupe, *138*

ratios, 139, 140–42, *141,* 147–49, *147, 148, 156*

realism, XVIII, XIX, 8, 24, 35, 75, 80, 124

stage of, 78–81, *78, 79*

recalled childhood landscapes, 74–75, *75*

Redon, Odilon, 243, 244

Reed, William, 256, *256*

relationships, XIV, XVIII, XIX–XX, XXI, 52, 96, 109, 124, 138–59, *138, 139,* 163

horizontal and vertical in, 99–101, 130, 131, 139, 140, *141,* 144, 149–51, *149,* 177

see also perspective; proportion; sighting

Rembrandt van Rijn, 4, *25*

Renaissance, 139, 142, 143–45, *143, 144,* 213, 217, 252

right/left confusion, 45

R-mode, XV, XX, XXII, XXIII, 35, 45, 61, 138, 145, 162, 163, 223–24, 248, 270–71

ah-ha! response and, XVII–XVIII, 39

characteristics of, 33, 37, 38–40, 44, 62–63, 65, 85

color and, 232, 236

navigation by, *53, 54*

in perception of lights and shadows, 194, 196–98, *198*

see also brain, hemispheres of; L-mode

R-mode, cognitive shifts to, xx, 3, 4, 5, 7, 8, 46, 50–65, 81, 84–85, 88, 92, 94, 108, 178

 conscious control of, 62, 85, 162

 negative spaces and, 132–33, *133*

 recognition of, 61–62, 85, 91, 131

 upside-down drawing exercise for, 55–62, *58, 60,* 63, *64*

 Vase/Faces exercise for, 50–54, *54,* 61

Rockefeller, Nelson, 43

Rodin, Auguste, *XXV,* 6

Rossetti, Dante Gabriel, *199*

Rubens, Peter Paul, *135*

S

Saint Jerome, Study for the (Dürer), *82*

Salk, Jonas, 180

Sandys, Anthony Frederick Augustus, *187*

Santoli, Ornella, *257*

Sargeant, Walter, *235*

Sargent, John Singer, 178–80, *179, 180, 199*

scale, 130, *141, 146,* 147

 of value, 194–95

scanning, left-to-right, 236

scribbling stage, 70–71, *71*

seeing, XI, XXV, 3, 4, 7, 8, 9, 16, 45, 55, 81–82, 162–68, 204–7

self-expression, 21–24

 handwriting as, 21–23

 see also expressiveness

Self-Portrait (Berberet), 243

Self-Portrait (Courbet), 196, *197,* 200–204

Self-Portrait (Hopper), 205, *206*

Self-Portrait (Morisot), 204, *204*

self-portraits, 15, 16–21, *18, 19–20,* 194, 195, 210–27, 240

 blanks for, 210–13, *211, 212, 222*

 copying of masterwork, 200–204

 exercise for, 218–25

 full-face, 189, 210–13, *211, 212,* 214, 222–23, *222, 226*

 pre-instruction, 14–24, 69, 224–25

 proportions in, 210–18, 222–23; *see also* proportions, in portraits

 showing of, 225–27, *226, 227*

 suggestion for, 225

 three-quarter, 189, 210, 213–18, *214, 215, 216, 218,* 222, 223, 227

sex differences, 75–76, *76*

Shah, Indries, 35

Sheeler, Charles, 204, *205,* 209

Shepard, Roger N., 3, 165, *165*

Shodo paintings, 256

sighting, XIX–XX, 138–59, *138, 139, 157, 159*

 of angles, 139, 140–42, *141,* 144, 146, 149–51, *149, 150,* 177

 eyeballing in, 151, 156

 of handwriting, 260–63, *260, 261*

 paradoxes of, 139, 140–42

 picture plane and, 139, 140, 144, 150–51, *150, 156*

 second-guessing of, 154

 see also perspective; proportion

Singer, Joe, 238, 239

Sketches with Two Sowers (Van Gogh), *98*

Smith, Peter, 232, 236

spaces, XIV, XV, XVIII, XIX, XXI, 16, 75, 96, 109, *109,* 113, 138, 139, 163

 negative, *see* negative spaces

 three-dimensionality of, 104, 139, 142, 194, 195

Sperry, Roger W., XII–XIII, XVII, XX, XXII, XXIII–XXIV, 31–34

"Split-Brain and the Culture-Cognition Paradox, The" (Paredes and Hepburn), *53*

split-brain studies, 31–35, 38, 46

 tests used in, 33–34

stained paper, 251–52

Stein, Gertrude, 4

Stephan, Michael, 50

still-lifes, XI, 8, 122–23

Stravinsky, Igor, 57–61, *58, 60,* 113

Studies of Arms and Legs (Rubens), *135*

Study for "Madame X" (Sargent), *199*

stuttering, 43

Surrealism, 243

Suzuki, D. T., 248

symbol system, childhood, 17–18, 63–65, 68–85, 88, 118, 214–15

 complexity stage of, 75–77, *76, 77*

 landscape stage of, 73–75, *74*

 in pictures that tell stories, 72–73, *72, 73*

 in profile portraits, 162–63, 177, 188

 realism stage of, 78–81, *78, 79*

scribbling stage of, 70–71, *71*

seeing influenced by, 81–85

sex differences in, 75–76, *76*

T

Tappen, Heather, *191*

Tart, Charles T., 46, 54, 85

thinking modes, XIII–XIV, XVII, XXII, 31, 32–35, 38–39, 42

 see also L-mode; R-mode

Three Studies of Hands (Holbein), *98*

Through the Looking-Glass and What Alice Found There (Carroll), 42, *84*

Thurber, James, *232*

Tiepolo, Giovanni Battista, *57*

tiered perspective, 142

time, sense of, 40, 44, 62, 63, 85

toning, 106–7, *107*, 110, 116, 127–28, *128*, 130, 152

touch, sense of, 89

Trevarthen, Colwyn, 31, 32

Trukese, *53, 54*

"Two-Sided Man, The" (Kipling), 40

U

Umbrella Still Life (Wright), 242

upside-down drawing, XII, XXIV, 55–62, *57, 58, 60,* 63, *64,* 113, 135, 177, 178, *253*

V

value, XXI, 12, 194–96, 232, 233, 238, 239, 240

 scale of, 194–95

Van Gogh, Vincent, 9, 14, 98, *98,* 170–73, *172, 173, 211*

 perspective device of, 102–3, *103*

Vase/Faces illusion, 50–54, *50,* 61, 95, 113

Vase of Tulips, The (Cézanne), *122*

Verity, Enid, 230

Viewfinders, 13, *14,* 96, 97–98, 99, 101, *101,* 104, 105, 106, 119, 124, 126, *126,* 146, 153, 154, 179, 182

Vogel, Phillip, 32

volume, 110

W

Waller, Fats, 50

Watts, Alan, 122, 123

website, author's, 14

wheel of color, 234–37, *234, 235*

White, Charles, *156*

white spaces, *see* negative spaces

Winter Landscape (Rembrandt), *25*

Woman in a Hat (Nicolaides), *89*

Woman Mourning (Van Gogh), 172, *173*

Wright, Laura, 242

Y

Yin and *Yang,* 37

Young, J. Z., 31

Young Woman in White, Red Background (Matisse), 125, *125*

Z

Zen, 24, 122, 248